# HEINRICH
# VON KLEIST
# BY
# FRANK STELLA.

# Heinrich von Kleist
## by
# Frank Stella

## Werkverzeichnis
## der
## Heinrich von Kleist-Serie

Minerva. Jenaer Schriften zur Kunstgeschichte. Band 11

anlässlich der Ausstellung

des Kunsthistorischen Seminars mit Kustodie der Friedrich Schiller-Universität Jena und der JENOPTIK AG Jena

*Heinrich von Kleist*
*by*
*Frank Stella*

in Zusammenarbeit
mit
Frank Stella

unter der Schirmherrschaft
von

Dr. Bernhard Vogel, Thüringer Ministerpräsident
Dr. h.c. Lothar Späth, Vorstandsvorsitzender der JENOPTIK AG.

Der Thüringer Staatskanzlei, Erfurt, dem Thüringer Ministerium für Wissenschaft, Forschung und Kunst, Erfurt,
der JENOPTIK AG, Jena, der Ernst Abbe-Stiftung, Jena, der Würth-Gruppe Adolf Würth GmbH, Künzelsau,
dem Druckhaus Gera, Erfurt / Gera und der Gesellschaft der Freunde und Förderer der Friedrich Schiller-Universität
dankt der Herausgeber für die Unterstützung bei der Realisierung von
Werkverzeichnis, Ausstellung und Ausstellungsbegleiter ebenso wie

Frank Stella.

Jena
27. März – 4. Juni 2001
Galerie der JENOPTIK AG und ehemalige Arbeiter- und Bauern-Fakultät, vordem Thüringer Oberlandesgericht

Hildesheim
Roemer- und Pelizaeus-Museum

Stuttgart
Württembergischer Kunstverein Stuttgart

Berlin
Galerie Akira Ikeda

Singapore
Singapore Tyler Print Institute Limited (STPI)

# HEINRICH VON KLEIST BY FRANK STELLA.

**Werkverzeichnis
der
Heinrich von Kleist-Serie**

mit
Beiträgen
von

Franz-Joachim Verspohl, Martin Warnke, Wolfram Hogrebe und Robert K. Wallace

herausgegeben
von
Franz-Joachim Verspohl
in
Zusammenarbeit mit
Anna-Maria Ehrmann-Schindlbeck und Ulrich Müller

Kunsthistorisches Seminar mit Kustodie · JENOPTIK AG · Verlag der Buchhandlung Walther König

Jena · Köln 2001

## Dank

Seit die Thüringer Landesuniversität, die Friedrich Schiller-Universität, Frank Stella 1996 die Ehrendoktorwürde verlieh, kommt der Künstler häufig und gern nach Jena. Er nimmt lebhaft an den Geschicken der Alma mater, der Stadt und des Freistaates Anteil. Dies ist keine Selbstverständlichkeit. Denn Frank Stella gehört zu den Künstlern, die weltweit viele Ehrungen erhalten haben. Erst am 24. Januar 2001 erhielt er die *Gold Medal* des *National Arts Club* in New York. Er selbst ist als wahrer Kosmopolit auf allen Kontinenten zu Hause und kann auf ein Itinerar zurückblicken, das seines gleichen sucht. Seine Kunstwerke sind weltweit zu sehen und prägen mit ihrem unverwechselbaren Habitus Museen, Verwaltungs- und Industriegebäude, Theater und Plätze.

Um so glücklicher darf sich Jena schätzen, dass ihm der Künstler derartige Aufmerksamkeit schenkt. Die Begeisterung Frank Stellas für die mitteldeutsche Kultur- und Industrieregion resultiert zu einem gewissen Teil aus seinem Interesse an den Veränderungen, welche diese Landschaft seit der politischen Wende erlebt. Die Bürger Thüringens fördern und gestalten nicht nur einen grundlegenden politischen Umbruch mit, sondern tragen zugleich zu einem zukunftweisenden wirtschaftlichen und sozialen Wandel bei. In Jena haben sich alte Industrien überlebt und sind dank glücklicher Planung neue Technologien heimisch geworden, die sich in der Wechselwirkung mit der universitären Forschung zu entfalten und zu entwickeln suchen.

Die Parallelen zur Wende an der Schwelle der Moderne um 1800 sind unübersehbar. Damals wie heute scheint bewusster als in anderen Epochen, dass nichts dauerhaft und selbstverständlich, dass alles beständig im Fluss ist. Frank Stella hat oft darauf hingewiesen, dass diese Umbrüche nicht regionalspezifisch sind. Sie ereignen sich ebenso am Hudson River oder in der Industrielandschaft des Ruhrgebietes, sie sind universal. Um so mehr drängt sich die Frage auf, welche Konstanten in diesem Wandel unverzichtbar sind und wie ihr Überdauern gesichert werden kann.

Dass die Dynamik von Wandel und Konstanz ihren Begleiter in Kultur und Kunst sucht, ist keineswegs neu. Die *Weimarer Klassiker* und die *Jenaer Romantiker* waren die Wegbereiter eines flexiblen Denkens jenseits dogmatischer Festlegungen und fundamentaler Fixierungen. Sie öffneten mit ihren neuartigen Sichtweisen den Blick für erweiterte Weltbilder. Heute scheint gegenwärtiger als je zuvor, dass die ästhetische Weltsicht bei der Gestaltung der Lebenswelt und der Bewältigung der Gemeinschaftsaufgaben eine treibende Kraft darstellt. Deshalb versuchen Künstler wie Frank Stella, künstlerische Impulse zu vermitteln und Kunstwerke an die Öffentlichkeit zu adressieren, welche neben den utilitären Sachzwängen die höheren Aufgaben des Menschen in das Blickfeld rücken.

Die Wechselwirkung zwischen Kunst und Leben bereichert, wie bereits von Goethe, Novalis und von Kleist wussten, nicht nur beide Sphären, sondern hebt sie erst auf das Niveau höherer Geselligkeit.

Daher ist zuerst Frank Stella zu danken, welcher Jena seine Aufmerksamkeit schenkt. Ohne seine unermüdliche Hilfe und philanthropische Natur wäre die Realisierung der Ausstellung *Heinrich von Kleist by Frank Stella* nicht denkbar gewesen, ebenso wenig wie dieser Catalogue Raisonné und die Herausgabe seiner Schriften in einem zweiten Band.

Darüber hinaus ist den Schirmherren der Ausstellung, dem Ministerpräsidenten des Freistaates Thüringen Dr. Bernhard Vogel und dem Vorsitzenden des Vorstands der JENOPTIK AG Dr. h.c. Lothar Späth zu danken, ohne deren Zuspruch und Förderung die Jenaer Unternehmungen mit Frank Stella kaum möglich geworden wären. Auch den Thüringer Ministerien für Finanzen sowie Wissenschaft, Forschung und Kunst gebührt Dank für ideelle und finanzielle Unterstützung.

Sowohl der Altrektor der Friedrich Schiller-Universität, Prof. Dr. Georg Machnik, als auch der gegenwärtige Amtsinhaber, Prof. Dr. Karl-Ulrich Meyn, haben erheblich Anteil am Gelingen der Projekte. Besonderer Dank gilt auch dem Kanzler der Universität, Dr. Klaus Kübel, welcher zwar den Notwendigkeiten des universitären Alltagslebens sein Hauptaugenmerk zuwenden muss, aber zugleich weiß, dass exzellente Wissenschaft ihr Pendant in einer ebenso exzellenten Kunst- und Kulturpflege sucht. Selbst wenn die Mittel, welche die Universität für derartige Auf-

gaben zur Verfügung stellen kann, eher bescheiden sind, so haben das Kanzleramt und die ihm zugeordneten Dezernate immer Wege gefunden, die Vorhaben realisieren zu helfen. Daher gilt der Dank den Dezernenten Udo Hätscher, Gottfried Stief, Dr. Stephan Keiser und Dr. Jürgen Spindler ebenso wie ihren Mitarbeitern und den Handwerkern, welche die Ausstellungen und Installationen mit Sorgfalt vorbereitet haben. In diesen Dank sind auch die Mitarbeiter der Kustodie und die Mitglieder des Kunsthistorischen Seminars eingeschlossen.

Unser Dank gilt auch den Mitarbeitern der JENOPTIK AG, deren Mitwirkung sich gerade bei der logistischen Vorbereitung der Ausstellung, der Regelung der Leihverträge und des Transports, bewährt hat, insbesondere Dr. Silke Opitz.

Ohne die finanzielle Hilfe der JENOPTIK AG, der Würth-Gruppe Adolf Würth GmbH, Künzelsau, der Thüringer Staatskanzlei, des Ministeriums für Wissenschaft, Forschung und Kunst, der Ernst Abbe-Stiftung sowie der Gesellschaft der Freunde und Förderer der Friedrich Schiller-Universität wären die Projekte Frank Stellas gar nicht erst erwogen worden. Ihnen sei besonders herzlich gedankt.

Doch was wären Ausstellungen ohne die Kunstwerke? Da sich viele der neuen Gemälde, Reliefs und Skulpturen Frank Stellas bereits in privaten Kunstsammlungen befinden oder vom Kunsthandel betreut werden, ist besonders den Leihgebern zu danken, welche großzügig bereit waren, ihre Schätze nach Jena zu geben. Wir haben Barbara Mathes, New York, Bernard Jacobson, London, Rolf und Erika Hofmann, Berlin, der DaimlerChryssler AG, Stuttgart, der Richard Gray Gallery, Chicago / New York, der Sueyun Locks Gallery, Philadelphia, S. I. Newhouse, New York, Sperone Westwater, New York und vielen anderen Leihgebern, die nicht genannt werden wollen, besonders herzlich zu danken.

Der Dank gilt auch Jürgen Taudien, Direktor des Druckhauses Gera, Rainer Wächter und den Mitarbeitern des Unternehmens, welche seit 1995 die Minerva-Bände mit hohem Anspruch gedruckt und hergestellt haben. Walther König, Köln, danken wir für sein verlegerisches Engagement.

Dass die Ausstellung vom Württembergischen Kunstverein Stuttgart, dem Roemer- und Pelizaeus-Museum in Hildesheim und von der Galerie Akira Ikeda in Berlin übernommen wird, erleichtert nicht nur die Durchführung des Vorhabens, sondern trägt dazu bei, das neuere Werk Frank Stellas bundesweit zugänglich und seinen Rang erkennbar zu machen. Wir danken Dr. Eleni Vassilika, Dr. Andreas Jürgensen, Akira Ikeda und seiner Tochter Kanae für ihre Mitwirkung an der Ausstellung.

Nicht zuletzt gilt der Dank all denen, die mit ihrer Begeisterung für das jüngste Werk von Frank Stella den Mut der Veranstalter gefördert haben, das Wagnis dieses nicht nur für Jena bedeutsamen Ereignisses einzugehen. Wir danken Hans Strelow, Dorothée und Lenhard Holschuh, Martin Warnke, Wolfram Hogrebe und Horst Bredekamp mit vielen, die uns mit Rat und Anregungen zur Seite standen.

Anna-Maria Ehrmann-Schindlbeck
Ulrich Müller
Franz-Joachim Verspohl

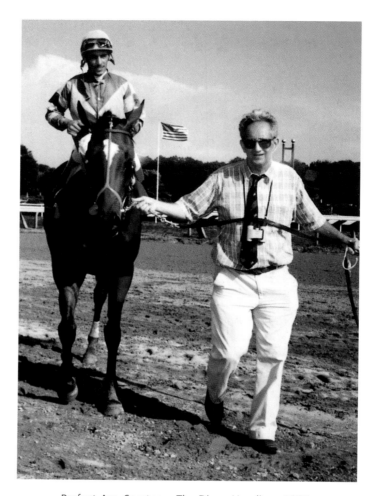

Perfect Arc, Saratoga, The Diana Handicap 1995,
Photography.

# Heinrich von Kleist
## by
## Frank Stella

Kleist 1978 – Heinrich von Kleist. The Marquise of O– and Other Stories. Transl. David Luke and Nigel Reeves. Harmondsworth, Middlesex: Penguin Books.

Kleist 1985, I – Heinrich von Kleist. Sämtliche Werke und Briefe. Ed. Helmut Sembdner. München: Carl Hanser Verlag. Vol. 1.

Kleist 1985, II – Heinrich von Kleist. Sämtliche Werke und Briefe. Ed. Helmut Sembdner. München: Carl Hanser Verlag. Vol. 2.

Kleist 1995 – Heinrich von Kleist. Plays. Ed. Walter Hinderer. German Library Vol. 25. New York: Continuum Publishing Company.

Miller / Kleist 1982 – Philip B. Miller. An Abyss Deep Enough. Letters of Heinrich von Kleist with a Selection of Essays and Anecdotes. New York: E. P. Dutton.

*Kleist: Love Letters*
*Kleist: Liebesbriefe*

**Tafel / Plate I**
*To Wilhelmine von Zenge, Frankfurt-on-Oder, May 30, 1800  [LL#1]*
*An Wilhelmine von Zenge, Frankfurt a. d. Oder, den 30. Mai 1800 [LL#1]*
1998
Mixed media on cast aluminum
12 ¹/₂ x 14 x 9 ¹/₂" / 31.8 x 35.6 x 24.1 cm
London, Courtesy of Bernard Jacobson Gallery
(FS 380)

Miller / Kleist 1982, 35–37.
Kleist 1985, II, 505–508.

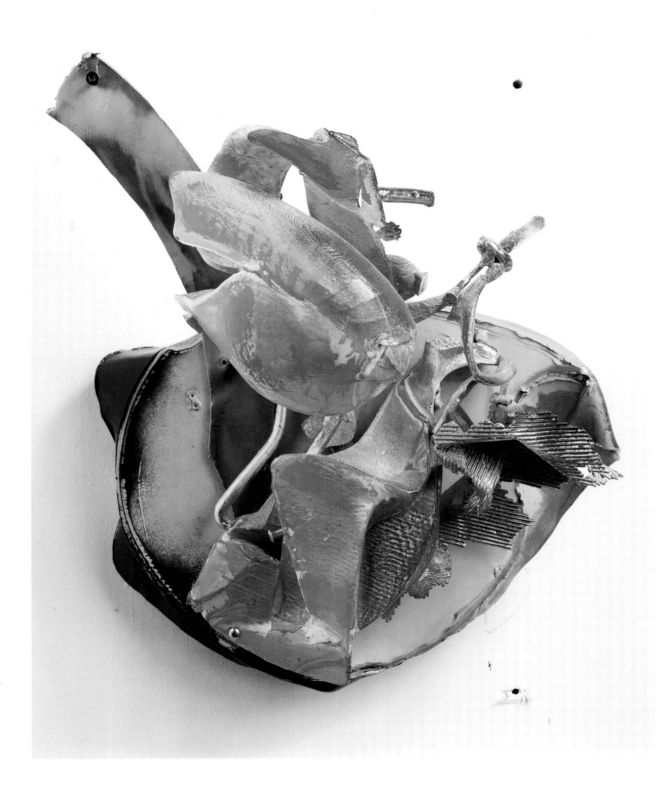

**Tafel / Plate II**

*To Wilhelmine von Zenge, Berlin, August 16, 1800  [LL#2]*
*An das Stiftsfräulein Wilhelmine v. Zenge, Hochwürden und Hochwohlgeboren zu Frankfurt a. O.,*
*Berlin, den 16. August 1800 [LL#2]*
1998
Mixed media on cast aluminum
21 x 14 x 10 ½" / 53.3 x 35.6 x 26.7 cm
New York, Courtesy of S. I. Newhouse
(FS 381)

Miller / Kleist 1982, 38–41.
Kleist 1985, II, 515–522.

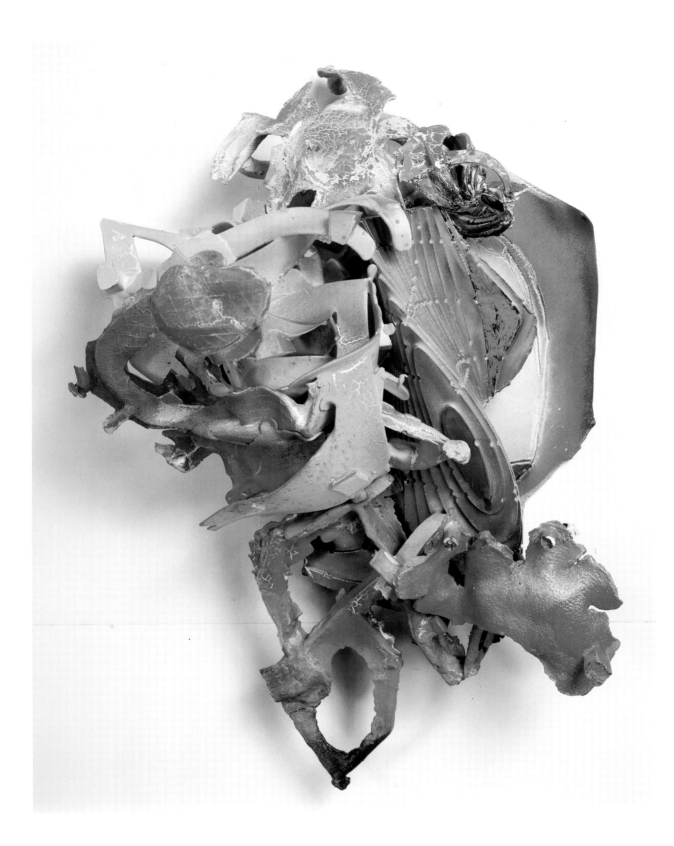

**Tafel / Plate III**

*To Wilhelmine von Zenge, Pasewalk, August 20, 1800 [LL#3]*

*An das Stiftsfräulein Wilhelmine v. Zenge Hochwürden und Hochwohlgeboren zu Frankfurt a. O.,*
*Pasewalk, den 20. August 1800 [LL#3]*

1998
Mixed media on cast aluminum
15 x 11 ¹/₂  x 8" / 38.1 x 29.2 x 20.3 cm
New York, Courtesy of Barbara Mathes Gallery
(FS 382)

Miller / Kleist 1982, 41–43.
Kleist 1985, II, 522–525.

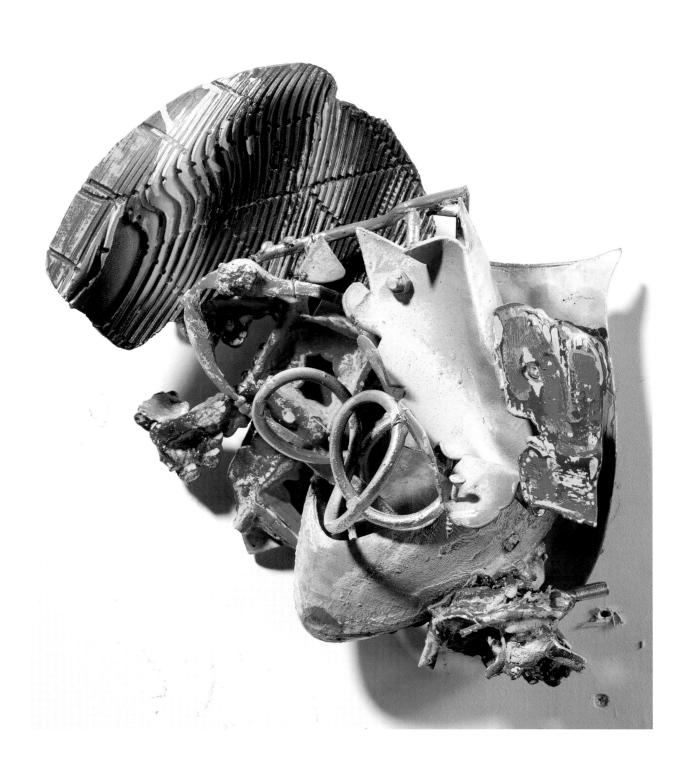

**Tafel / Plate IV**

*To Wilhelmine von Zenge, Coblentz, near Pasewalk, August 21, 1800 [LL#4]*
*An Wilhelmine von Zenge, Coblentz bei Pasewalk, den 21. August 1800 [LL#4]*
1998
Mixed media on cast aluminum
14 ¹/₂ x 16 x 11 ¹/₄" / 36.8 x 40.6 x 28.6 cm
San Francisco, Helen Diller
(FS 383)

Miller / Kleist 1982, 45–47.
Kleist 1985, II, 527–531.

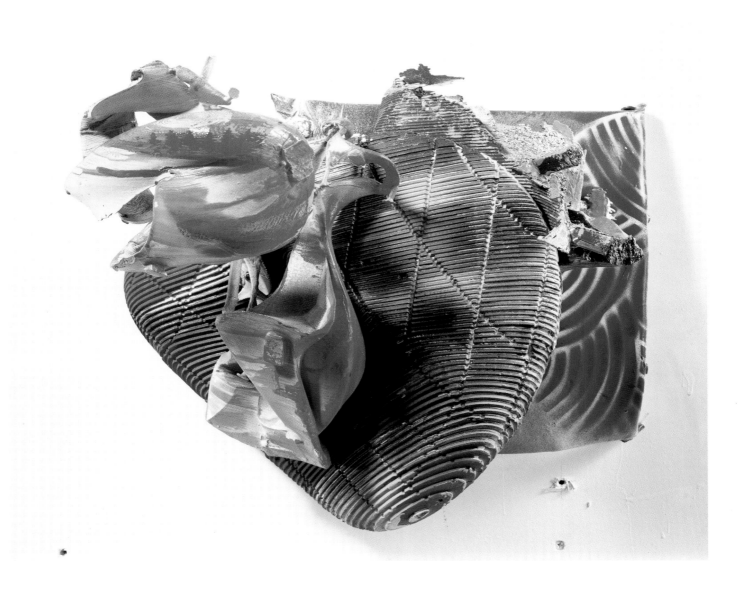

**Tafel / Plate V**

*To Wilhelmine von Zenge, Leipzig, August 30 and September 1, 1800 [LL#5]*
*An das Stiftsfräulein Wilhelmine v. Zenge Hochwürd. und Hochwohlgeb. zu Frankfurt a. d. Oder, Leipzig,*
*den 30. August (und 1. September) 1800 [LL#5]*
1998
Mixed media on cast aluminum
16 x 10 ½ x 9 ¼" / 40.6 x 26.7 x 23.5 cm
New York, Courtesy of Barbara Mathes Gallery
(FS 384)

Miller / Kleist 1982, 48–50.
Kleist 1985, II, 534–538.

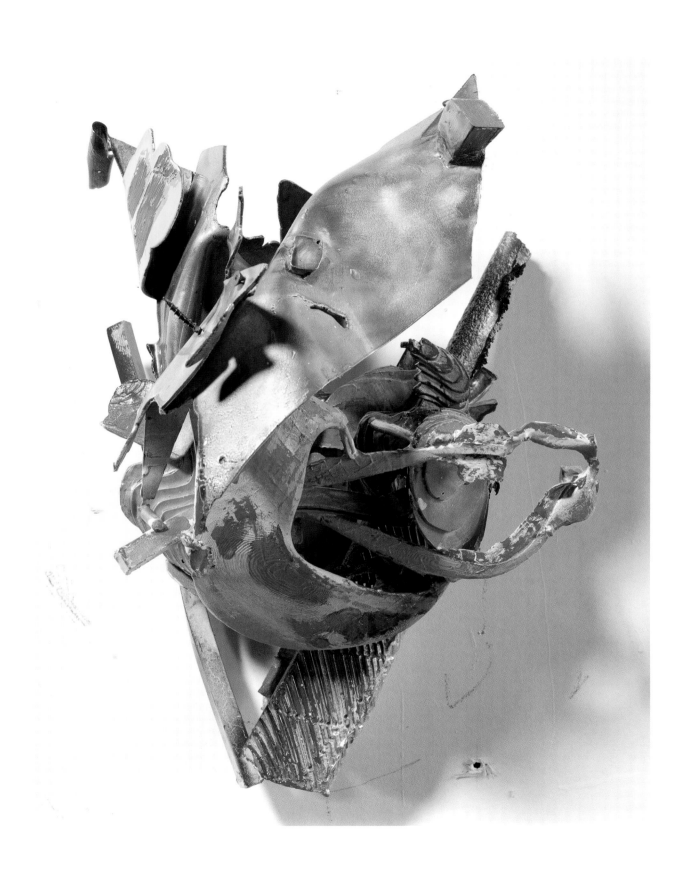

**Tafel / Plate VI**

*To Wilhelmine von Zenge, Dresden, September 3, 1800, 5 A. M. (and September 4) [LL#6]*
*An Fräulein Wilhelmine von Zenge Hochwohlgeb. zu Frankfurt a. d. O., Dresden, den 3. September 1800,*
*früh 5 Uhr (und 4. September) [LL#6]*
1998
Mixed media on cast aluminum
20 ¹/₂ x 15 ¹/₂ x 10 ¹/₂" / 52.1 x 39.4 x 26.7 cm
Chicago, Courtesy of Richard Gray Gallery
(FS 385)

Miller / Kleist 1982, 50–52.
Kleist 1985, II, 538–546.

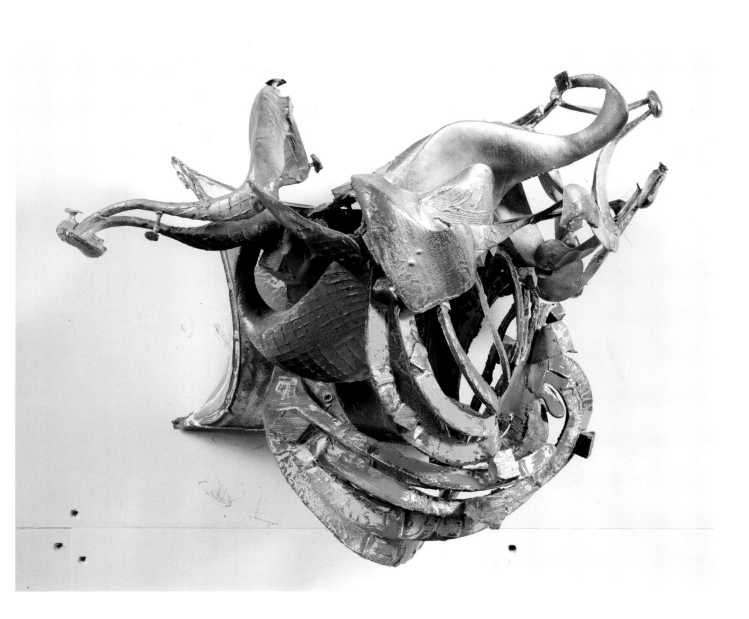

**Tafel / Plate VII**

*To Wilhelmine von Zenge, Chemnitz, September 5, 1800, 8 A. M. [LL#7]*

*An das Stiftsfräulein Wilhelmine von Zenge, Hochwürden und Hochwohlgeb. zu Frankfurt a. d. Oder,*
*frei bis Berlin [Berlin abzugeben bei dem Kaufmann Clausius in der Münzstraße.] Chemnitz, den 5. September,*
*morgens 8 Uhr [LL#7]*

1998
Mixed media on cast aluminum
16 x 13 x 11 ½" / 40.6 x 33.0 x 29.2 cm
New York, Courtesy of Barbara Mathes Gallery
(FS 386)

Miller / Kleist 1982, 52–53.
Kleist 1985, II, 547–548.

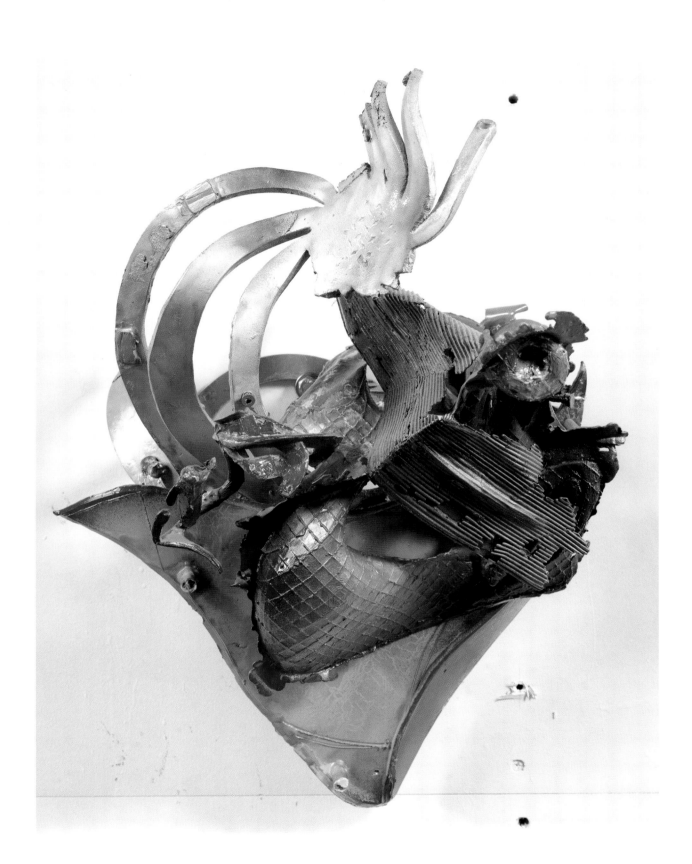

**Tafel / Plate VIII**

*To Wilhelmine von Zenge, Würzburg, September 11 and 12, 1800 [LL#8]*
*An das Stiftsfräulein Wilhelmine v. Zenge Hochwürd. und Hochwohlgeb. zu Frankfurt a. d. Oder –*
*frei bis Leipzig. Würzburg, den 11. (und 12.) September 1800 [LL#8]*
1998
Mixed media on cast aluminum
16 x 12 x 10" / 40.6 x 30.5 x 25.4 cm
New York, Courtesy of S. I. Newhouse
(FS 387)

Miller / Kleist 1982, 55–58.
Kleist 1985, II, 554–558.

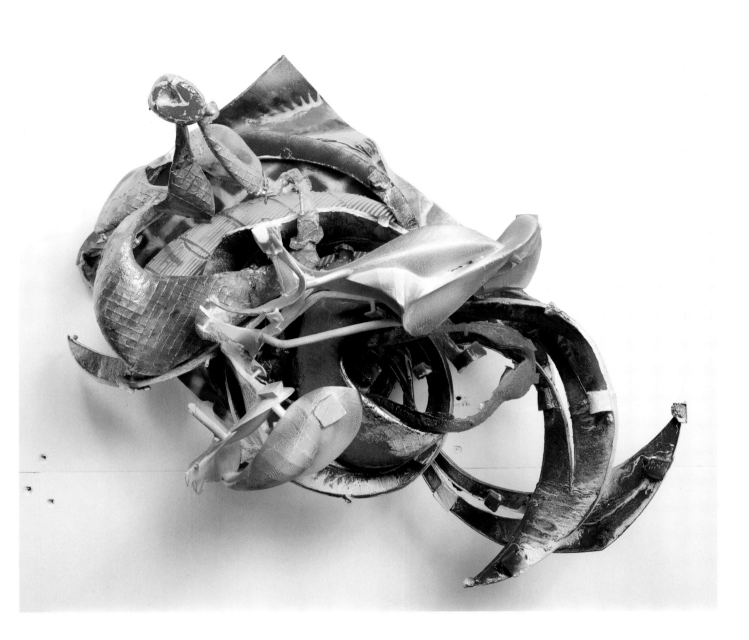

**Tafel / Plate IX**

*To Wilhelmine von Zenge, Göttingen, June 3, 1801 [LL#9]*
*An Wilhelmine von Zenge, Göttingen, den 3. Juni 1801 [LL#9]*
1998
Mixed media on cast aluminum
20 x 16 ½ x 13" / 50.8 x 41.9 x 33 cm
New York, Courtesy of Barbara Mathes Gallery
(FS 388)

Miller / Kleist 1982, 107–109.
Kleist 1985, II, 654–658.

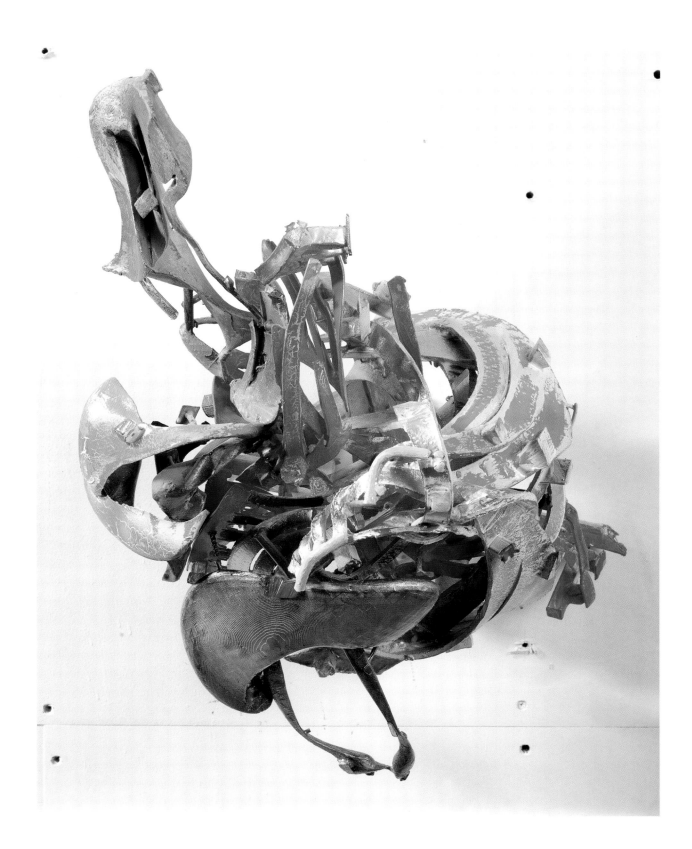

**Tafel / Plate X**
*To Wilhelmine von Zenge, Paris, July 21, 1801 [LL#10]*
*An Wilhelmine von Zenge, Paris, den 21. Juli 1801 [LL#10]*
1998
Mixed media on cast aluminum
24 x 17 ¹/₂ x 12" / 61 x 44.5 x 30.5 cm
New York, Courtesy of Barbara Mathes Gallery
(FS 389)

Miller / Kleist 1982, 113–116.
Kleist 1985, II, 667–671.

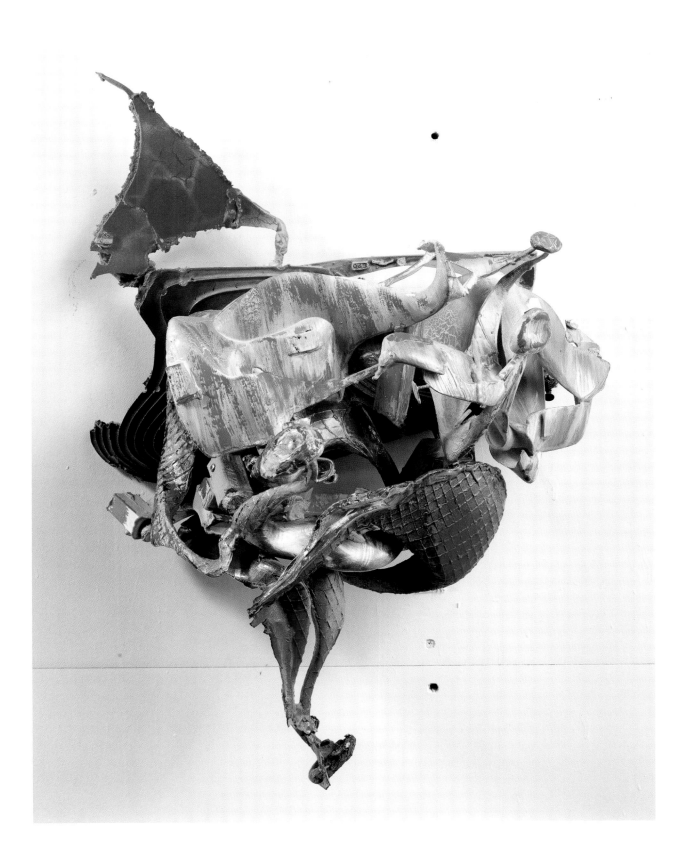

**Tafel / Plate XI**

*To Caroline von Schlieben, July 18, 1801 [LL#11]*
*An Karoline von Schlieben, Paris, den 18. Juli 1801 [LL#11]*
1999
Mixed media on cast aluminum
14 1/2  x 9 1/2 x 10" / 36.8 x 24.1 x 25.4 cm
London, Courtesy of Bernard Jacobson Gallery
(FS 459)

Miller / Kleist 1982, 109–112.
Kleist 1985, II, 659–667.

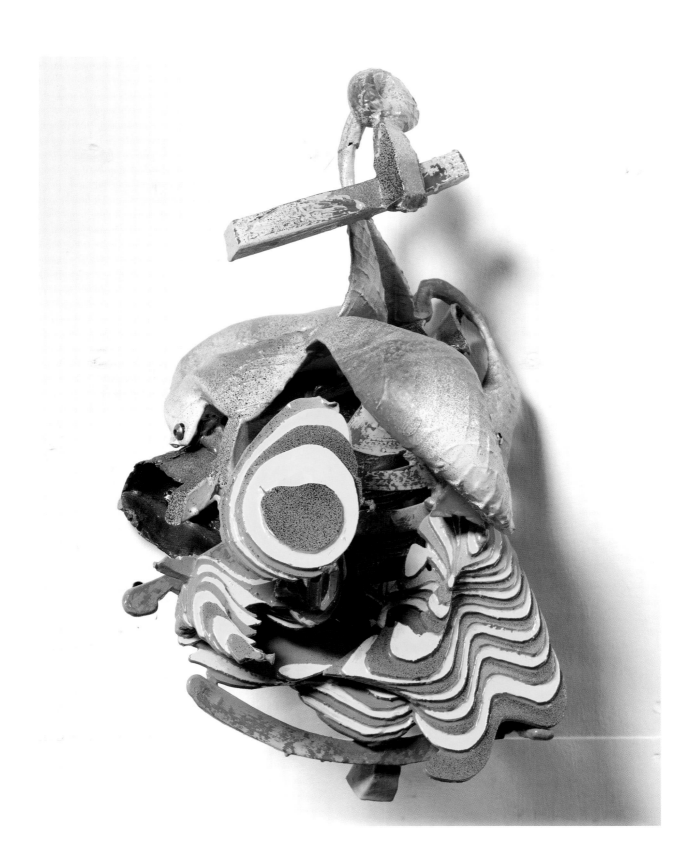

**Tafel / Plate XII**

*To Adolfine von Werdeck, Paris, July 28, 29, 1801 [LL#12]*
*An Adolfine von Werdeck, Paris, den 28. (und 29.) Juni 1801 [LL#12]*
1999
Mixed media on cast aluminum
15 x 13 x 8" / 38.1 x 33 x 20.3 cm
New York, Frank Stella
(FS 460)

Miller / Kleist 1982, 116–122.
Kleist 1985, II, 671–679.

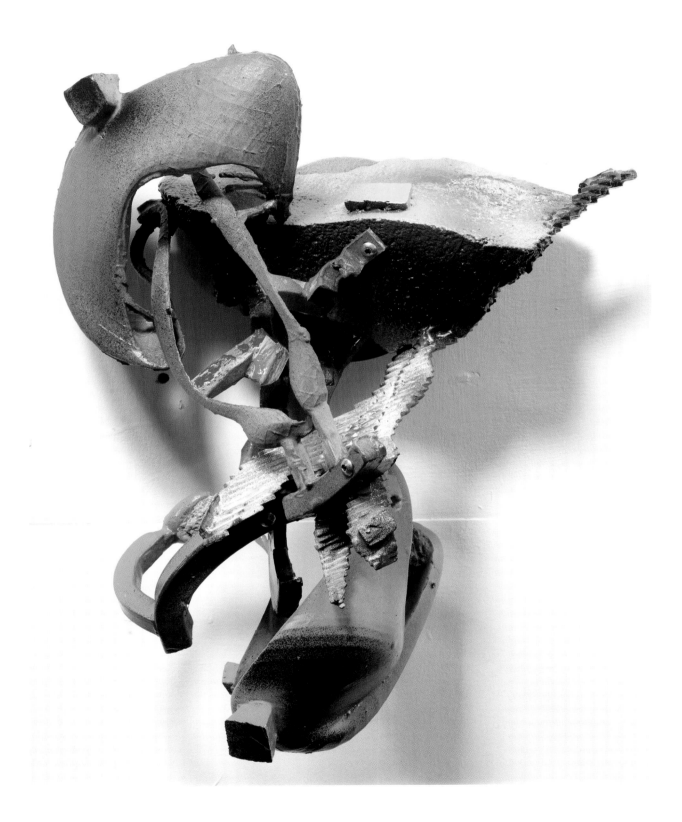

**Tafel / Plate XIII**
*To Luise von Zenge, Paris, August 16, 1801 [LL#13]*
*An Luise von Zenge, Paris, den 16. August 1801 [LL#13]*
1999
Mixed media on cast aluminum
22 x 15 x 12" / 55.9 x 38.1 x 30.5 cm
Lausanne, Private Collection
(FS 461)

Miller / Kleist 1982, 126–129.
Kleist 1985, II, 685–691.

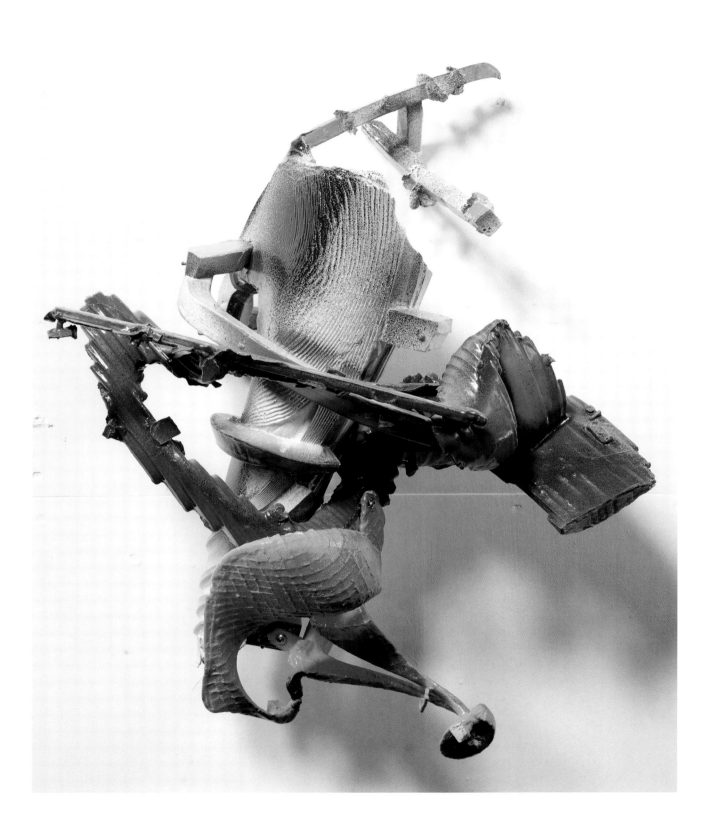

**Tafel / Plate XIV**

*To Adolfine von Werdeck, Paris and Frankfurt-on-Main, November 1801 [LL#14]*
*An Adolfine von Werdeck, [Paris und Frankfurt am Main, November 1801] [LL#14]*
1999
Mixed media on cast aluminum
17 1/2 x 16 1/2 x 9" / 44.5 x 41.9 x 22.9 cm
New York, Courtesy of Barbara Mathes Gallery
(FS 462)

Miller / Kleist 1982, 134–138.
Kleist 1985, II, 700–704.

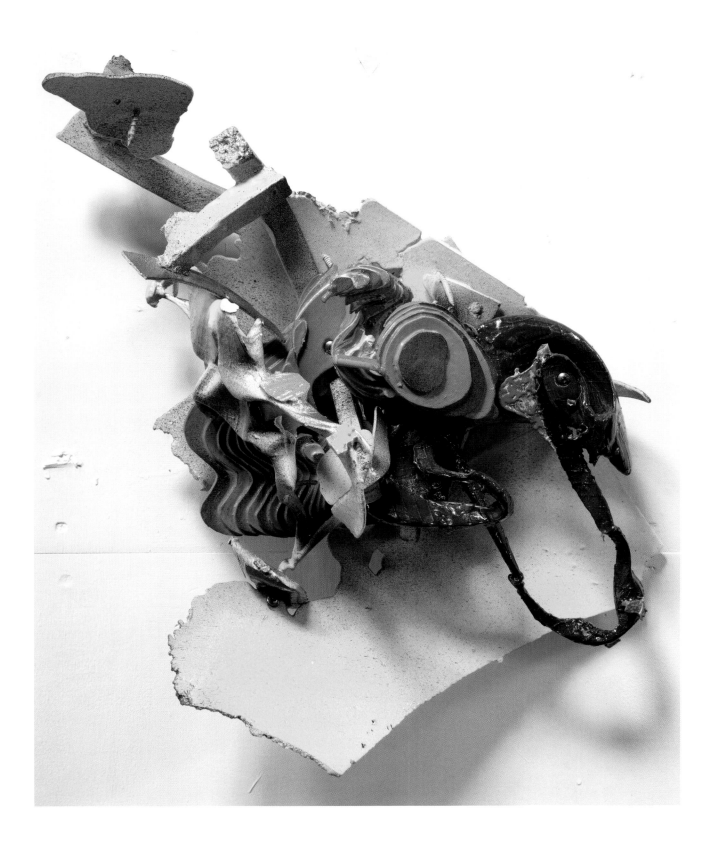

**Tafel / Plate XV**

*To Ulrike von Kleist, Bern, January 12, 1802 [LL#15]*
*An Ulrike von Kleist, Bern, den 12. Januar 1802 [LL#15]*
1999
Mixed media on cast aluminum
17 x 16 ¹/₂ x 12" / 43.2 x 41.9 x 30.5 cm
New York, Courtesy of Barbara Mathes Gallery
(FS 463)

Miller / Kleist 1982, 141–143
Kleist 1985, II, 711–716.

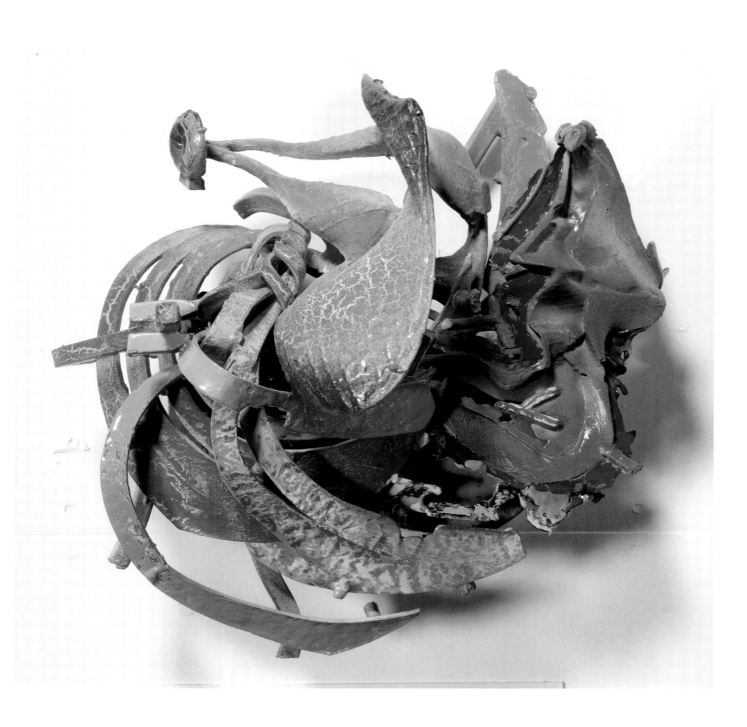

# Kleist: Correspondence
# Kleist: Briefwechsel

**Tafel / Plate XVI**
*To Heinrich Lohse, Dresden, April 1803 [C#1]*
*An Heinrich Lohse [Dresden, April 1803] [C#1]*
1999
Mixed media on cast aluminum
13 1/2 x 21 x 12" / 34.3 x 53.3 x 30.5 cm
New York, Courtesy of Barbara Mathes Gallery
(FS 464)

Miller / Kleist 1982, S. 149–150.
Kleist 1985, II, 731–732.

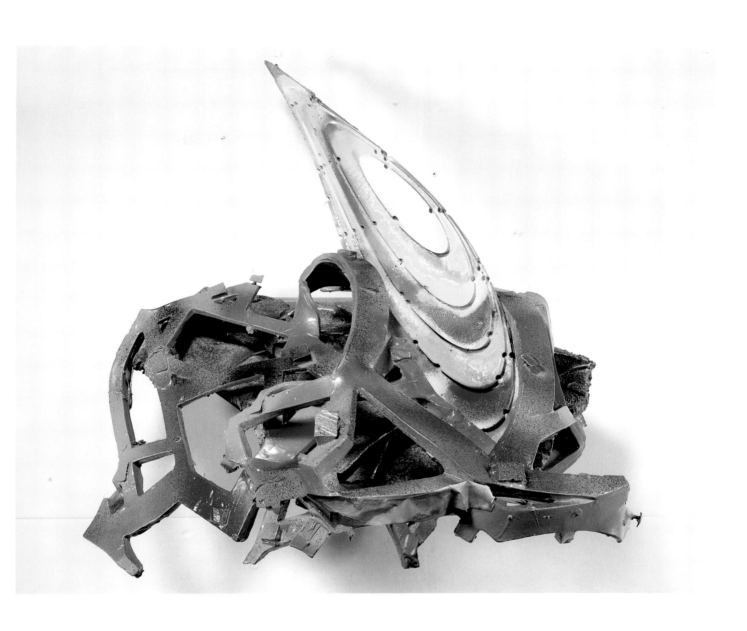

**Tafel / Plate XVII**

*To Ernst von Pfuel, Berlin, January 7, 1805 [C#2]*
*An Herrn Ernst von Pfuel, ehemals Lieutenant im Regiment Sr. Majestät des Königs, Hochwohlgeb. zu Potsdam,*
*Berlin, den 7. Januar 1805 [C#2]*
1999
Mixed media on cast aluminum
50 1/2 25 1/2 x 16" / 128.3 x 64.8 x 40.6 cm
London, Courtesy of Bernard Jacobson
(FS 465)

Miller / Kleist 1982, 159–160.
Kleist 1985, II, 748–750.

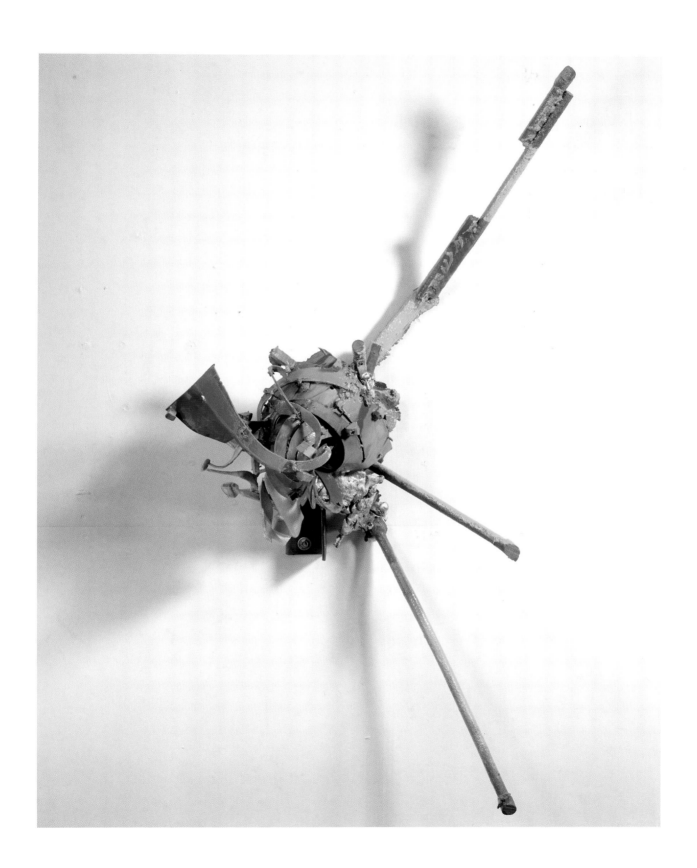

**Tafel / Plate XVIII**

*To Karl Baron von Stein zum Altenstein, Königsberg, November 13, 1805 [C#3]*
*An Karl Freiherrn zu Stein zum Altenstein, Königsberg, den 13. November 1805 [C#3]*
1999
Mixed media on cast aluminum
16 ¹/₂ x 16 x 18″ / 41.9 x 40.6 x 45.7 cm
London, Courtesy of Bernard Jacobson @ Newburgh, Polich Art Works
(FS 466)

Miller / Kleist 1982, 161–162.
Kleist 1985, II, 758–759.

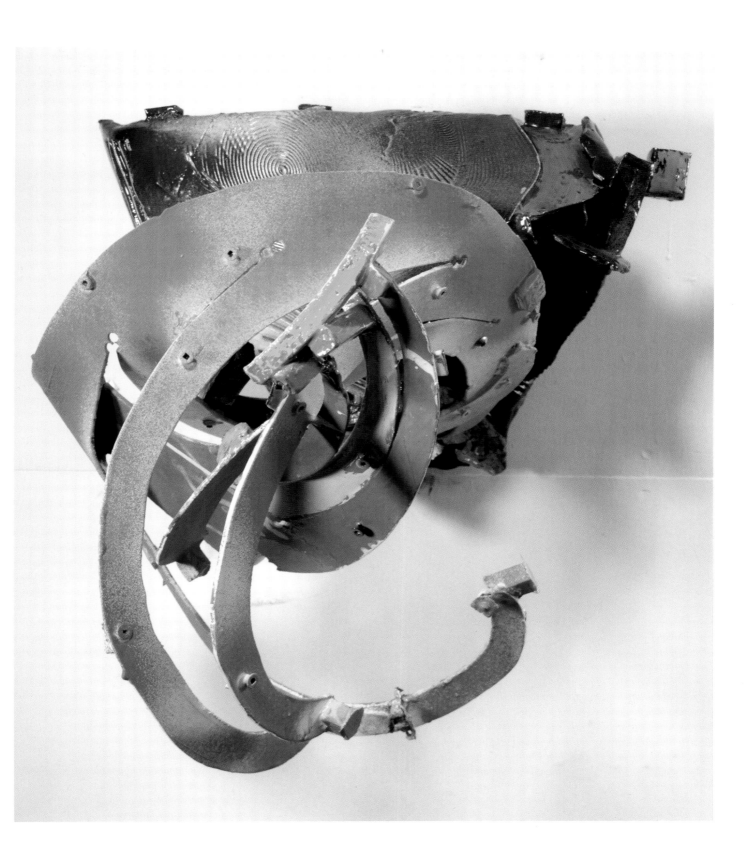

**Tafel / Plate XIX**

*To Otto August Rühle von Lilienstern, Königsberg, October 31, 1806 [C#4]*
*An Otto August Rühle von Lilienstern, [Königsberg,] den 31. [August 1806] [C#4]*
1999
Mixed media on cast aluminum
24 1/2 x 17 1/2 x 13" / 62.2 x 44.5 x 33 cm
London, Courtesy of Bernard Jacobson Gallery
(FS 467)

Miller / Kleist 1982, 165–167.
Kleist 1985, II, 767–770.

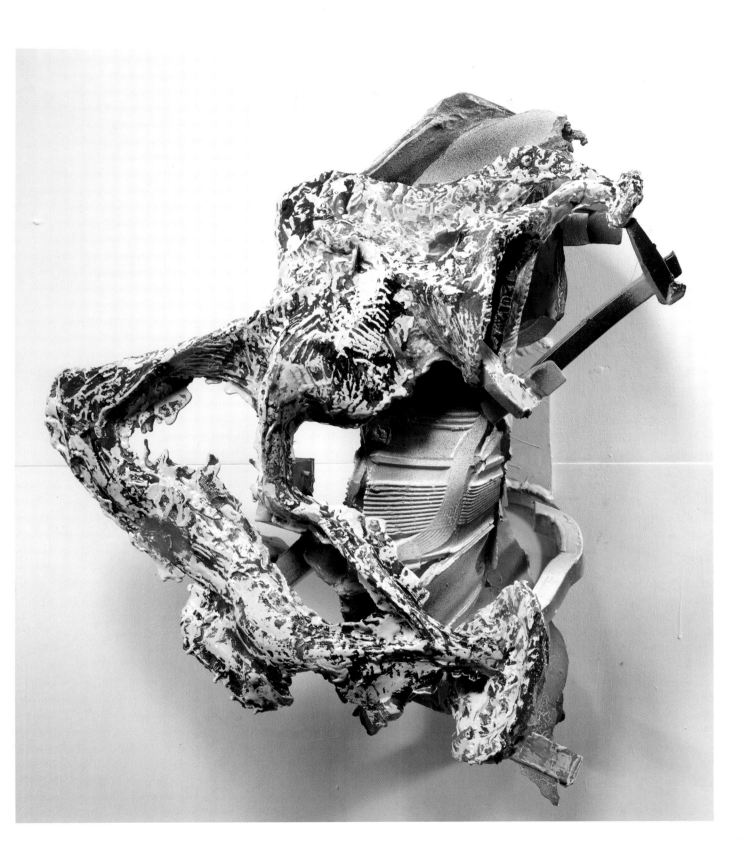

**Tafel / Plate XX**

*To Johann Wolfgang von Goethe, Dresden, January 24, 1808 [C#5]*
*An Johann Wolfgang von Goethe, Dresden den 24. Jan. 1808 [C#5]*
1999
Mixed media on cast aluminum
21 x 17 x 13" / 53.3 x 43.2 x 33 cm
Philadelphia, Courtesy of Sueyun Locks Gallery
(FS 468)

Miller / Kleist 1982, 178–179.
Kleist 1985, II, 805–806.

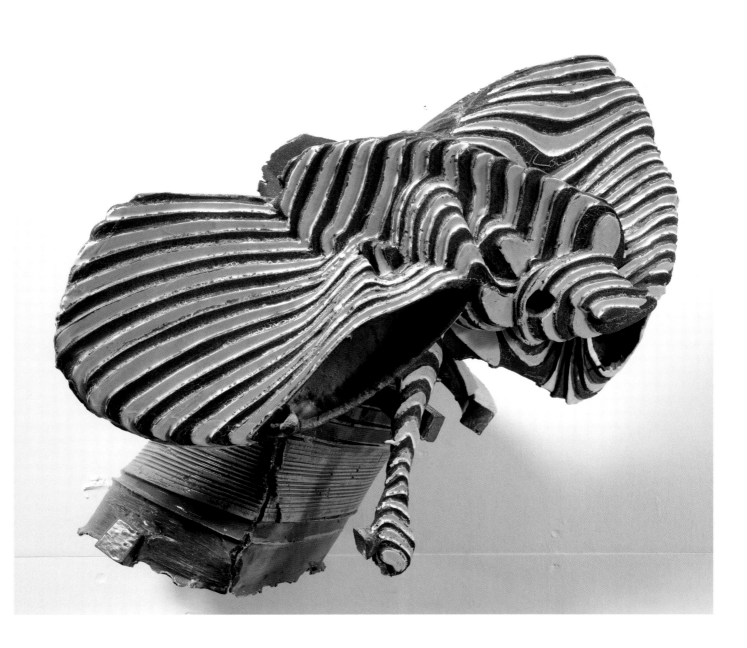

**Tafel / Plate XXI**

*To Heinrich von Collin, Dresden, December 8, 1808 [C#6]*
*An Heinrich Joseph von Collin, Dresden, den 8. Dezmbr. 1808 [C#6]*
1999
Mixed media on cast aluminum
20 1/2 x 25 1/2 x 12" / 52.1 x 64.8 x 30.5 cm
Chicago, Courtesy of Richard Gray Gallery
(FS 469)

Miller / Kleist 1982, 181–182
Kleist 1985, II,  818.

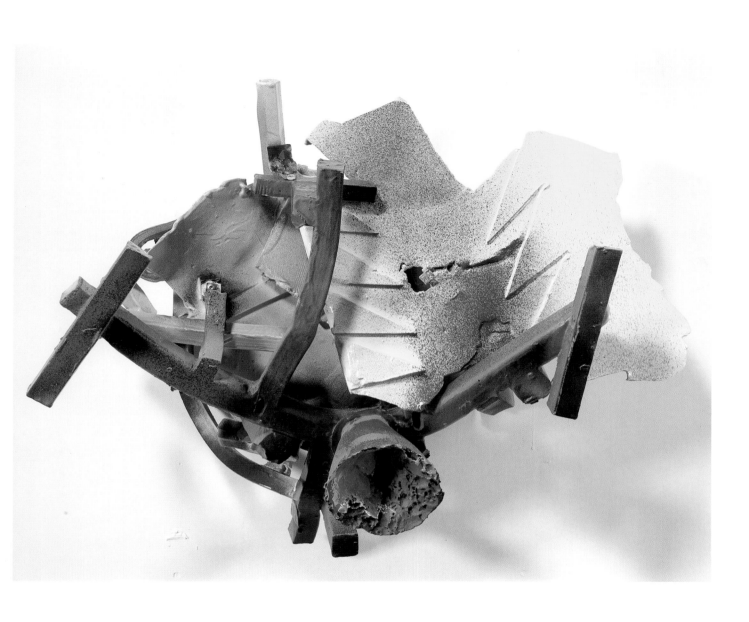

**Tafel / Plate XXII**

*To August Wilhelm Iffland, Berlin, August 10, 1810 [C#7]*
*An August Wilhelm Iffland, Berlin, den 10. August 1810 [C#7]*
1999
Mixed media on cast aluminum
25 x 14 x 16 $^1/_2$" / 63.5 x 35.6 x 41.9 cm
New York, Courtesy of Barbara Mathes Gallery
(FS 470)

Miller / Kleist 1982, 185.
Kleist 1985, II, 836.

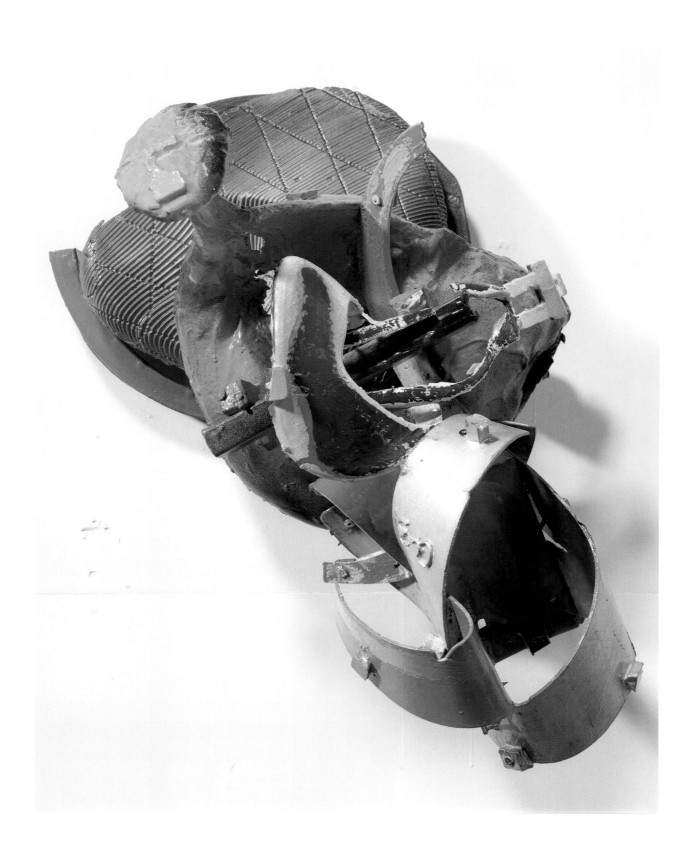

**Tafel / Plate XXIII**
*To Achim von Arnim, Berlin, October 14, 1810 [C#8]*
*An Achim von Arnim, [Berlin,] den 14. Okt. 1810 [C#8]*
1999
Mixed media on cast aluminum
20 1/2 x 27 x 18" / 52.1 x 68.6 x 45.7 cm
München, Regina Hesselberger
(FS 471)

Miller / Kleist 1982, 189.
Kleist 1985, II, 839–840.

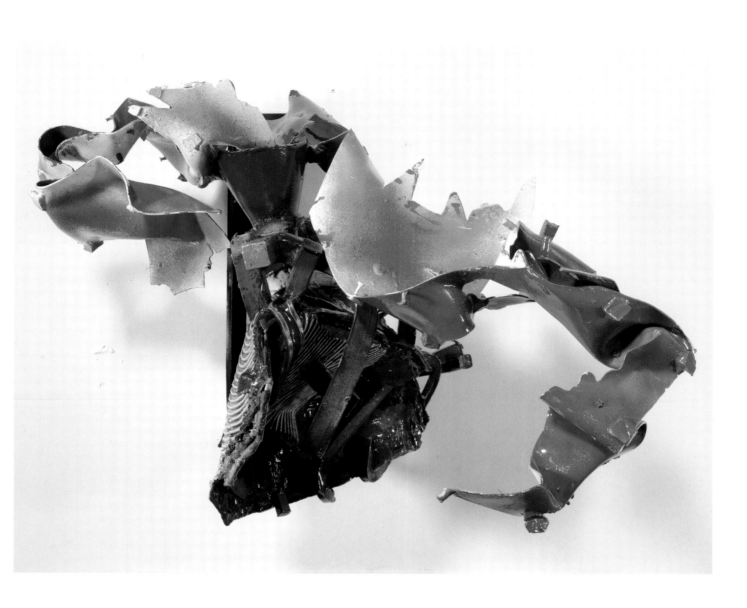

**Tafel / Plate XXIV**
*To Eduard Prince von Lichnowsky, Berlin, October 23, 1810 [C#9]*
*An*
*Eduard Prinz von Lichnowsky, [Berlin,] den 23. Okt. 1810 [C#9]*
1999
Mixed media on cast aluminum
17 1/2 x 17 1/2 x 17 1/2" / 44.5 x 44.5 x 44.5 cm
London, Courtesy of Bernard Jacobson Gallery
(FS 472)

Miller / Kleist 1982, 190.
Kleist 1985, II, 840.

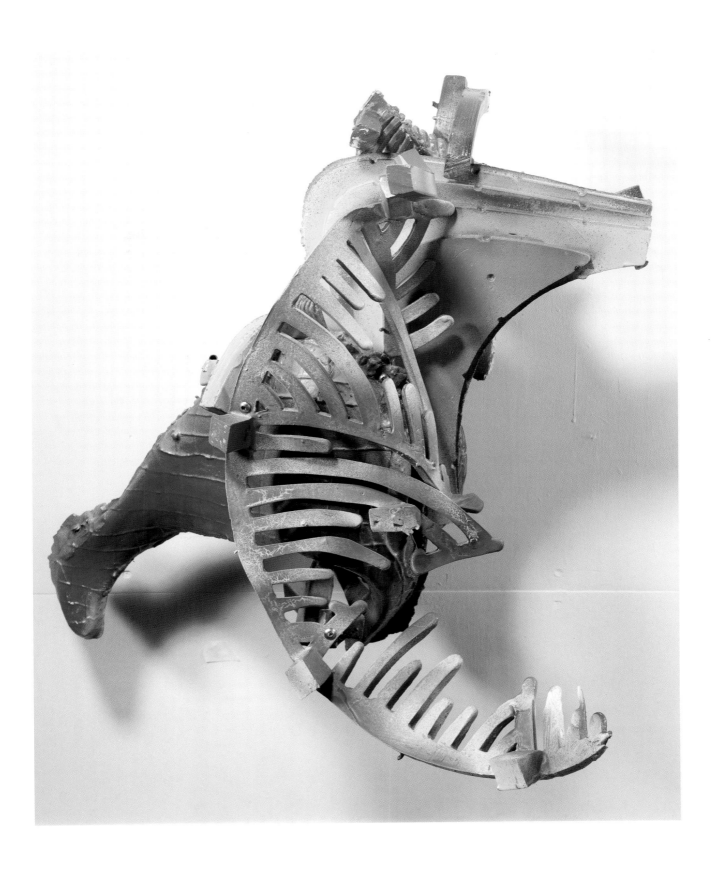

**Tafel / Plate XXV**

*To Friedrich de la Motte Fouqué, Berlin, April 25, 1811 [C#10]*
*An Friedrich de la Motte Fouqué, [Berlin,], den 25. April 1811 [C#10]*
1999
Mixed media on cast aluminum
29 x 26 ½ x 13" / 73.7 x 67.3 x 33 cm
New York, Courtesy of Barbara Mathes Gallery
(FS 473)

Miller / Kleist 1982, 191–192.
Kleist 1985, II, 860–862.

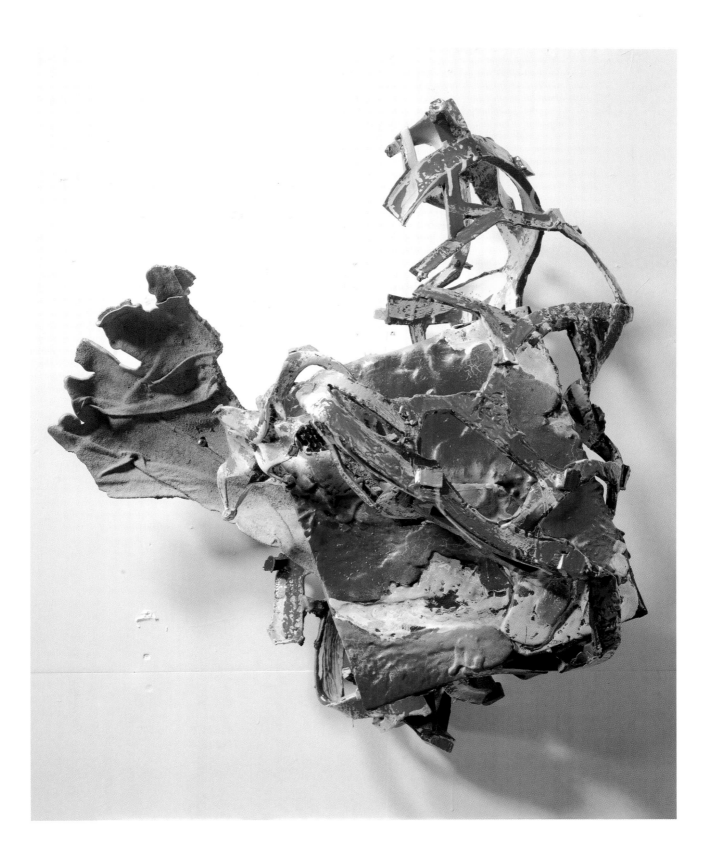

**Tafel / Plate XXVI**

*To Professor Friedrich Schütz, April 26, 1811 [C#11]*
*An Friedrich Karl Julius Schütz, [Berlin,] den 26. April 1811 [C#11]*
1999
Mixed media on cast aluminum
19 x 19 x 14 ½" / 48.3 x 48.3 x 36.8 cm
New York, Courtesy of Barbara Mathes Gallery
(FS 474)

Miller / Kleist 1982, 193.
Kleist 1985, II, 862.

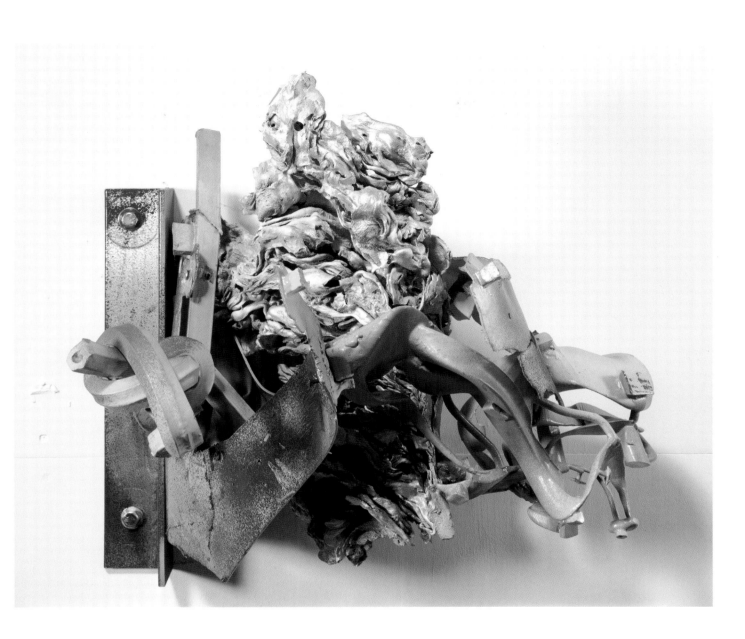

**Tafel / Plate XXVII**
*To King Frederick William III of Prussia, Berlin, June 17, 1811 [C#12]*
*An Friedrich Wilhelm III., Berlin, den 17. Juni 1811 [C#12]*
1999
Mixed media on cast aluminum
20 ½ x 20 ½ x 21" / 52.1 x 52.1 x 53.3 cm
Chicago, Courtesy of Richard Gray Gallery
(FS 475)

Miller / Kleist 1982, 193–195.
Kleist 1985, II, 869–871.

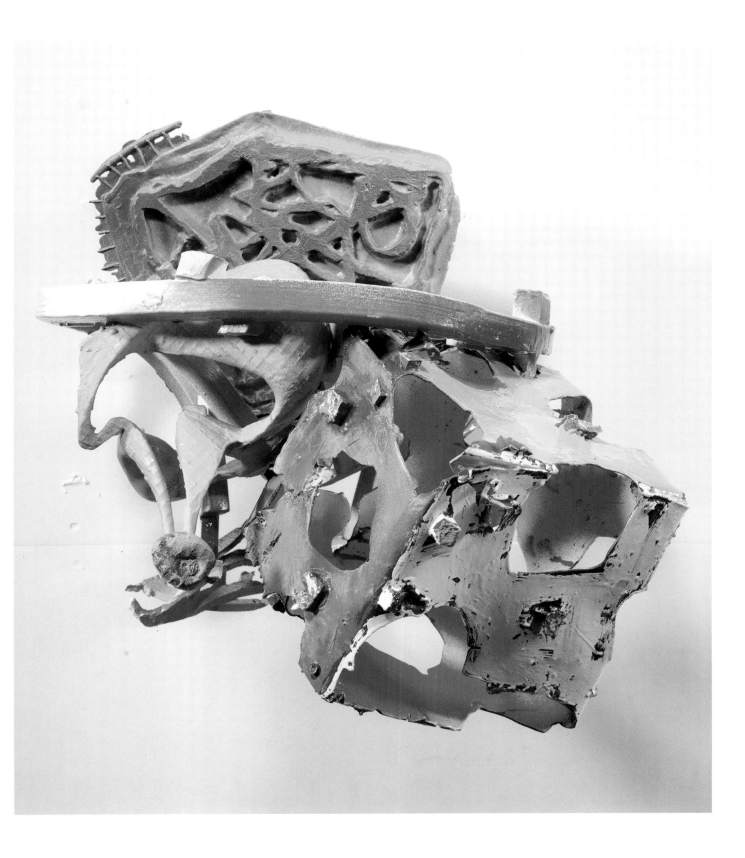

# Kleist: Anecdotes
# Kleist: Anekdoten

**Tafel / Plate XXVIII**
*JONAS [A#1]*
*Anekdote [Jonas] [A#1]*
1999
Mixed media on cast aluminum
28 x 40 x 29 ½" / 71,1 x 101,6 x 74,9 cm
New York, Frank Stella
(FS 408)

Miller / Kleist 1982, 270.
Kleist 1985, II, 271.

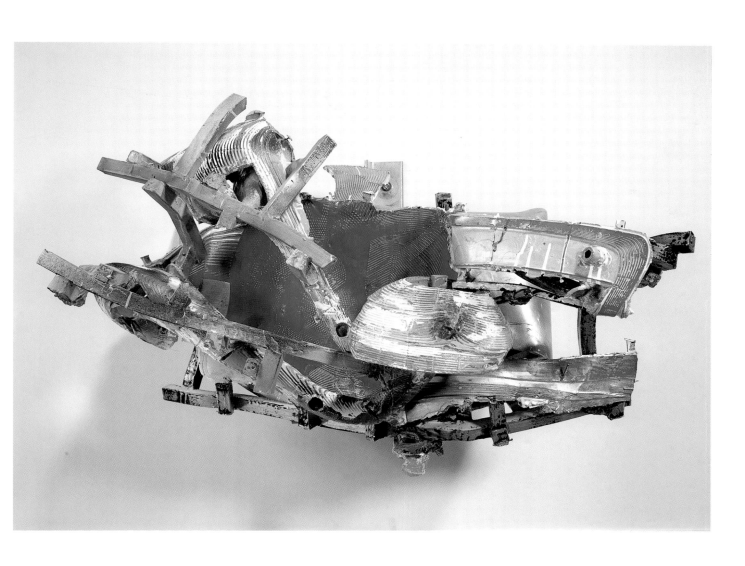

**Tafel / Plate XXIX**

*FRENCH TACTICS: AN EXAMPLE FOR ALL [A#2]*
*FRANZÖSISCHES EXERZITIUM das man nachahmen sollte  [A#2]*
1999
Mixed media on cast aluminum
33 x 50 ½ x 42 ½" / 83.8 x 128.3 x 108 cm
Chicago, Courtesy of Richard Gray Gallery
(FS 451)

Miller / Kleist 1982, 262.
Kleist 1985, II, 269.

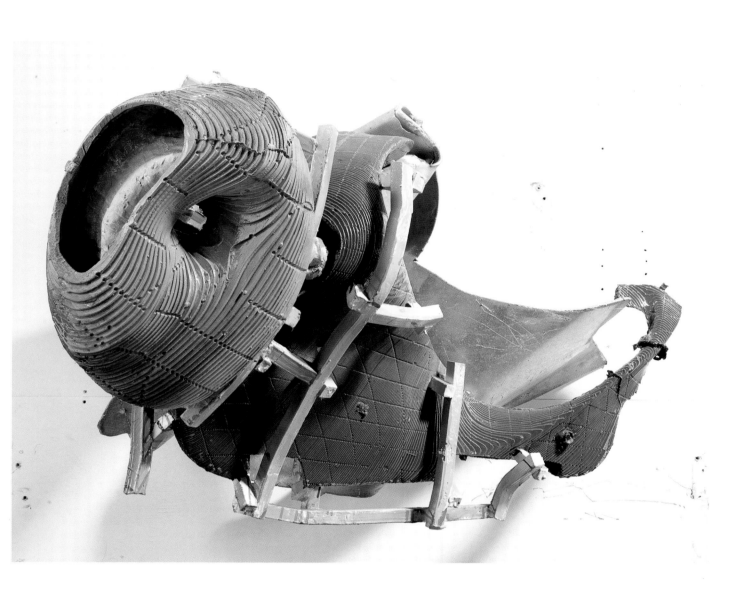

**Tafel / Plate XXX**
*THE MONK AND THE CONDEMNED MAN [A#3]*
*ANEKDOTE [Der Kapuziner und der Verurteilte] [A#3]*
1999
Mixed media on cast aluminum
44 x 59 x 36 ½" / 111.8 x 149.9 x 92.7 cm
Philadelphia, Courtesy of Sueyun Locks Gallery
(FS 452)

Miller / Kleist 1982, 261.
Kleist 1985, II, 270.

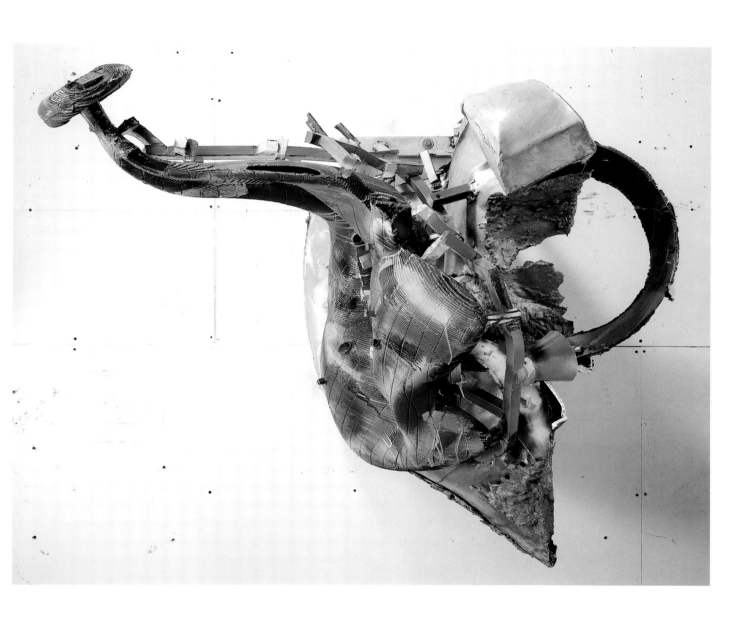

**Tafel / Plate XXXI**

*MOTHER LOVE [A#4]*
*MUTTERLIEBE [A#4]*
1999
Mixed media on cast aluminum
48 ½ x 37 x 56" / 123.2 x 94 x 142.2 cm
New York, Courtesy of Barbara Mathes Gallery
(FS 453)

Miller / Kleist 1982, 289.
Kleist 1985, II, 277.

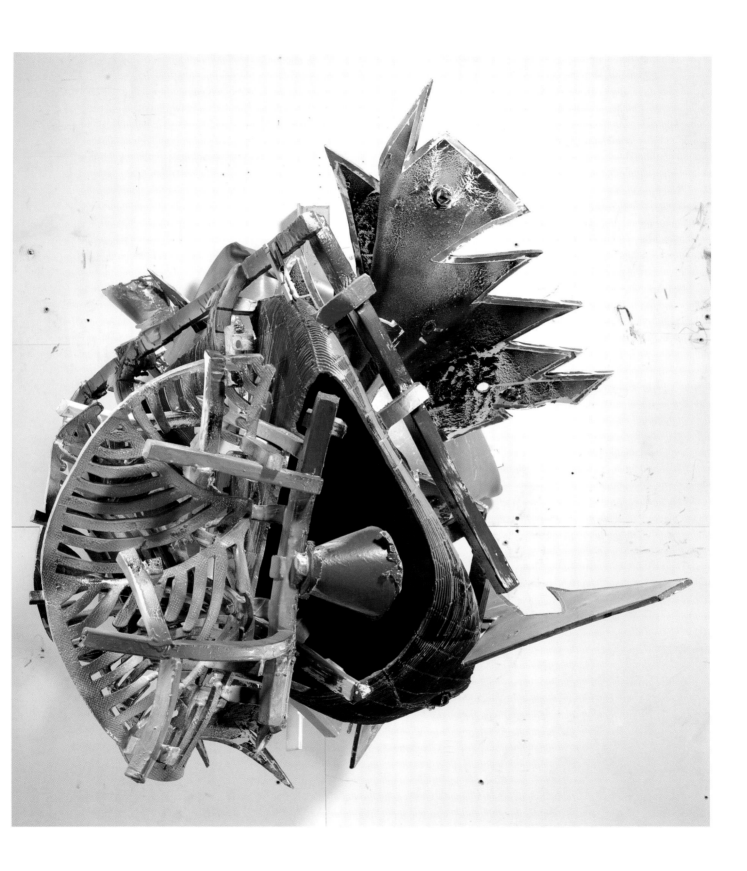

**Tafel / Plate XXXII**
*BOXERS [A#5]*
*ANEKDOTE [Baxer] [A#5]*
1999
Mixed media on cast aluminum
53 x 54 ¹/₂ x 40" / 134.6 x 138.4 x 101.6 cm
London, Courtesy of Bernard Jacobson Gallery
(FS 454)

Miller / Kleist 1982, 269.
Kleist 1985, II, 270–271.

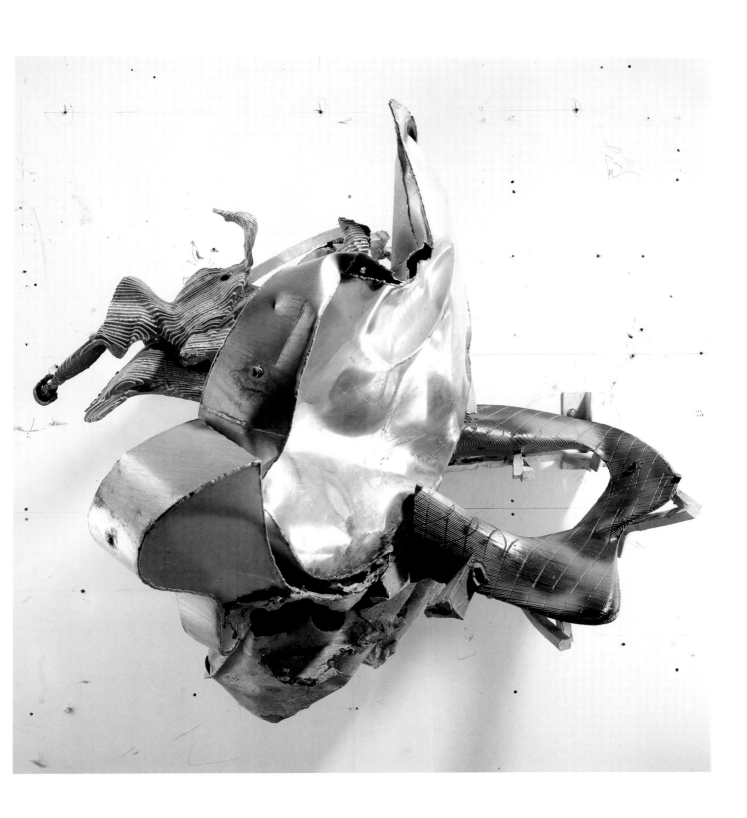

**Tafel / Plate XXXIII**
*FROM THE LAST PRUSSIAN WAR [A#6]*
*ANEKDOTE AUS DEM LETZTEN PREUSSISCHEN KRIEGE [A#6]*
1999
Mixed media on cast aluminum
58 x 46 x 28" / 147.3 x 116.8 x 71.1 cm
New York, Courtesy of Barbara Mathes Gallery
(FS 455)

Miller 1982, 264–265.
Kleist 1985, II, 263–265.

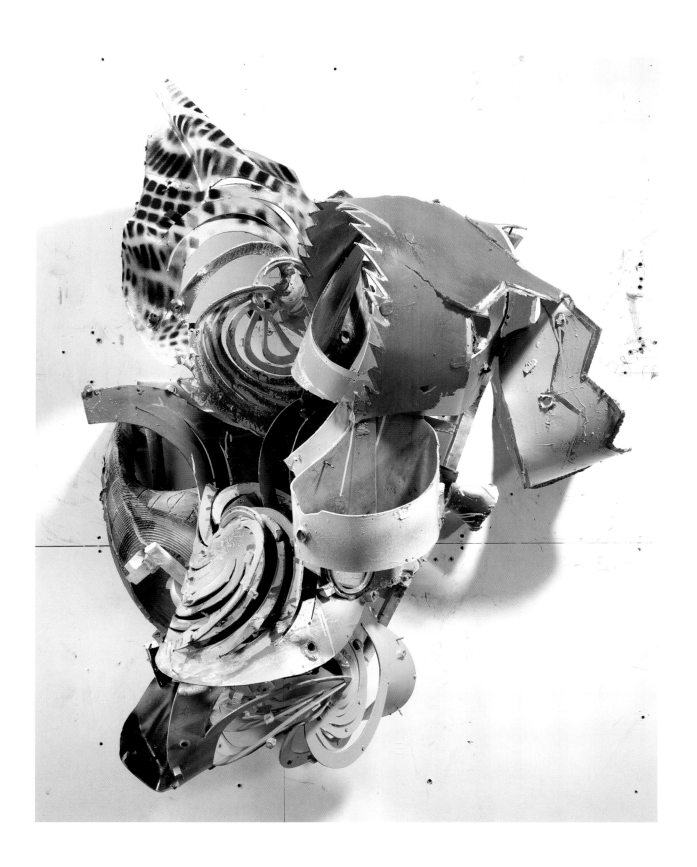

**Tafel / Plate XXXIV**
*ANECDOTE FROM THE RECENT WAR [A#7]*
*ANEKDOTE AUS DEM LETZTEN KRIEGE [A#7]*
1999
Mixed media on cast aluminum
32 x 34 x 29" / 81.3 x 86.4 x 73.7 cm
Philadelphia, Courtesy of Sueyun Locks Gallery
(FS 456)

Miller / Kleist 1982, 268.
Kleist 1985, II, 268.

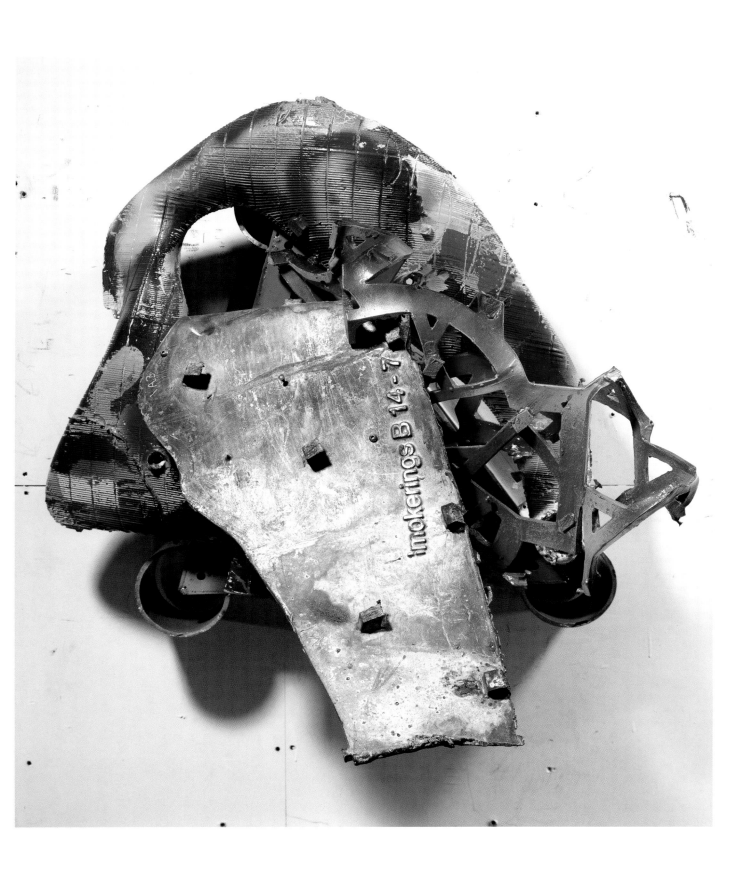

**Tafel / Plate XXXV**
*THE PERPLEXED MAGISTRATE [A#8]*
*DER VERLEGENE MAGISTRAT Eine Anekdote [A#8]*
1999
Mixed media on cast aluminum
34 x 29 x 30" / 86.4 x 73.7 x 76.2 cm
Philadelphia, Courtesy of Sueyun Locks Gallery
(FS 457)

Miller 1982, 267.
Kleist 1985, II, 262–263.

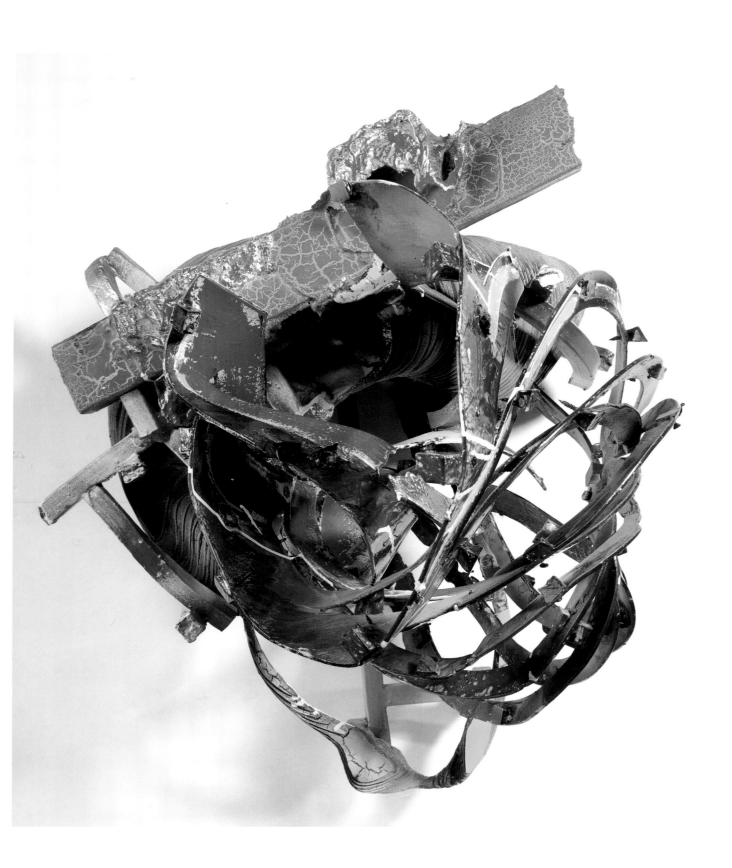

**Tafel / Plate XXXVI**
*NEWS OF THE DAY [A#9]*
*TAGESBEGEBENHEIT [A#9]*
1999
Mixed media on cast aluminum
37 x 38 $\frac{1}{2}$ x 17" / 94 x 97.8 x 43.2 cm
New York, Courtesy of Barbara Mathes Gallery
(FS 458)

Miller / Kleist 1982, 273.
Kleist 1985, II, 262.

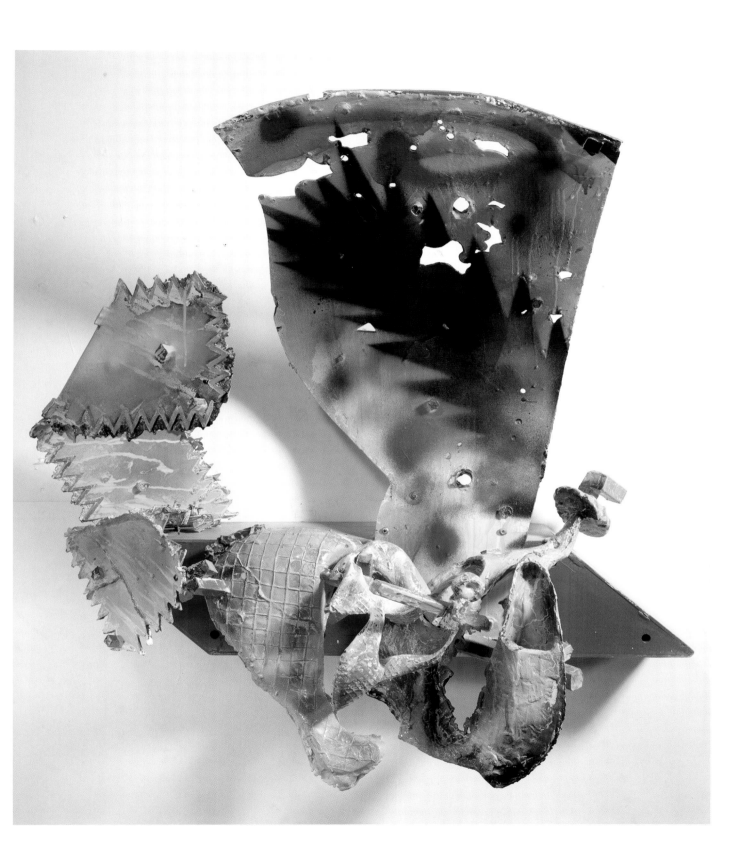

# Kleist: Essays & Journalism
# Kleist: Kleine Schriften und Theaterkritik

**Tafel / Plate XXXVII**
*USEFUL INVENTIONS: PROJECT FOR A CANNONBALL POSTAL SYSTEM [EJ#1]*
*NÜTZLICHE ERFINDUNGEN [1] Entwurf einer Bombenpost [EJ#1]*
1999
Mixed media on cast aluminum
41 x 21 x 11" / 104.1 x 53.3 x 27.9 cm
New York, Courtesy of Barbara Mathes Gallery
(FS 476)

Miller / Kleist 1982, 245–246.
Kleist 1985, II, 385–386.

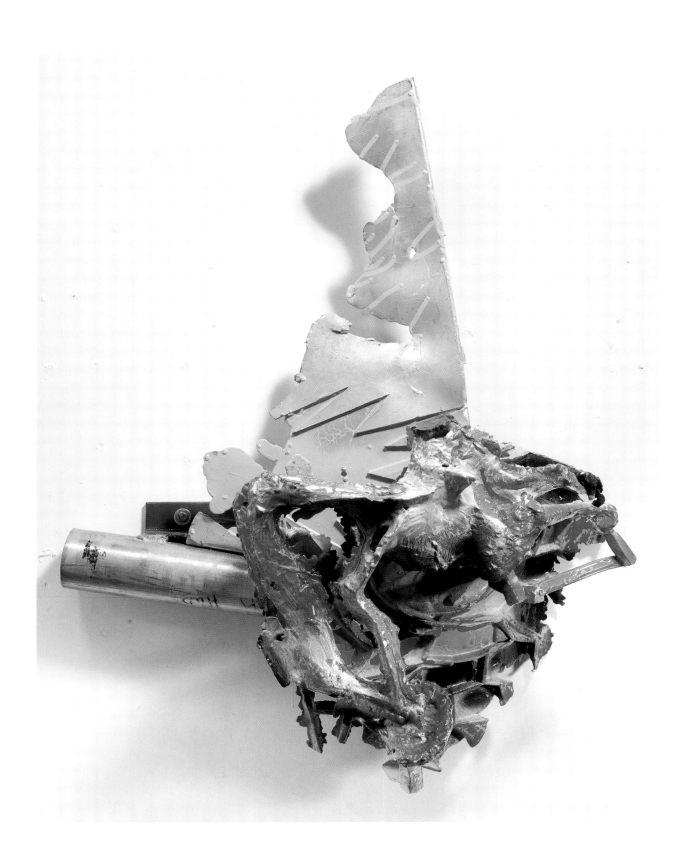

**Tafel / Plate XXXVIII**
*A PAINTER'S LETTER TO HIS SON [EJ#2]*
*BRIEF EINES MALERS AN SEINEN SOHN [EJ#2]*
1999
Mixed media on cast aluminum
40 x 34 x 25" / 101.6 x 86.4 x 63.5 cm
New York, Courtesy of Barbara Mathes Gallery
(FS 477)

Miller / Kleist 1982, 240.
Kleist 1985, II, 328–329.

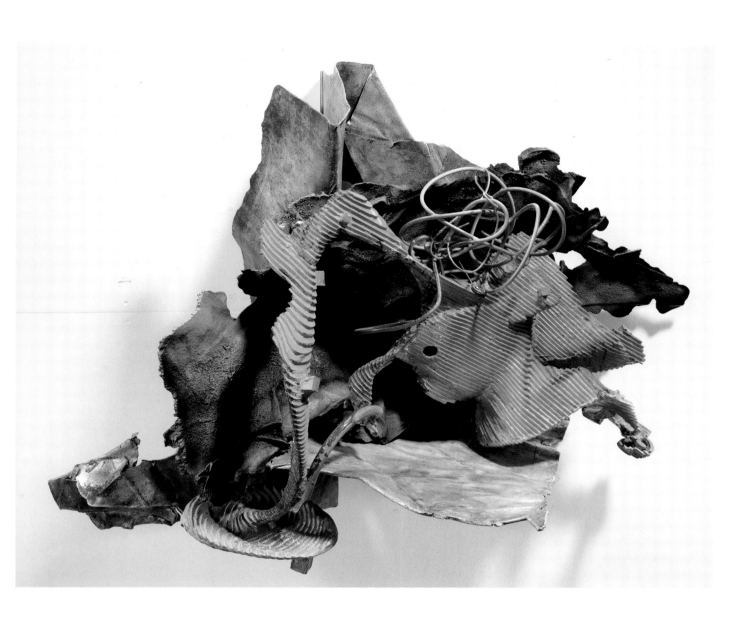

**Tafel / Plate XXXIX**
*A PASSAGE FROM THE HIGHER CRITICISM [EJ#3]*
*EIN SATZ AUS DER HÖHEREN KRITIK An \* \* \* [EJ#3]*
1999
Mixed media on cast aluminum
35 x 48 x 10" / 88.9 x 121.9 x 25.4 cm
Philadelphia, Courtesy of Sueyun Locks Gallery
(FS 478)

Miller / Kleist 1982, 241.
Kleist 1985, II, 346–347.

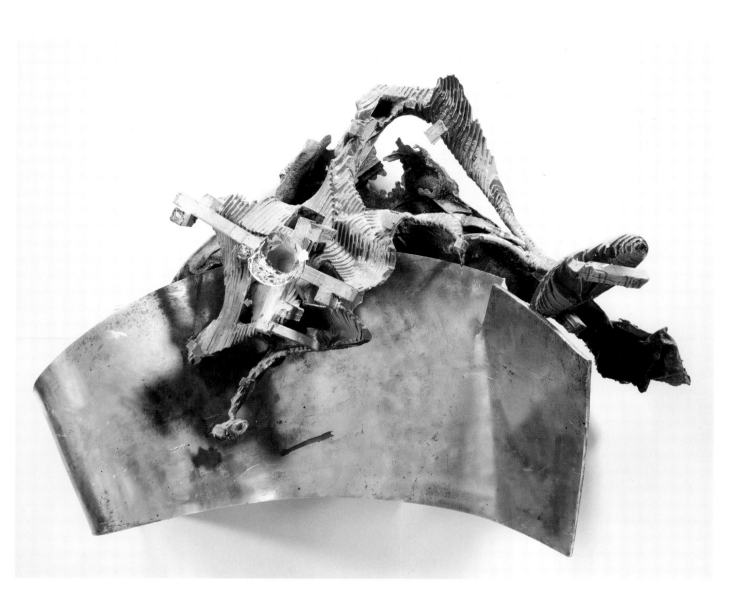

*THEATER CRITICISM: ‚CENDRILLON'* (variation 1) [EJ#4]
*KLEINE SCHRIFTEN THEATER [6] Schreiben aus Berlin / Den 28. Oktober [1810] (Variante 1)[EJ#4]*
1999
Mixed media on ceramic
destroyed summer 2000 / zerstört im Sommer 2000
(FS 479)

Miller / Kleist 1982, 244.
Kleist 1985, II, 411–412.

*THEATER CRITICISM: ‚CENDRILLON'* (variation 2) [EJ#5]
*KLEINE SCHRIFTEN THEATER [6] Schreiben aus Berlin / Den 28. Oktober [1810] (Variante 2)[EJ#5]*
1999
Mixed media on ceramic
destroyed summer 2000 / zerstört im Sommer 2000
(FS 480)

Miller / Kleist 1982, S. 244.
Kleist 1985, II, 411–412.

**Tafel / Plate XL**
*THEATER CRITICISM: ‚CENDRILLON' [EJ#6]*
*KLEINE SCHRIFTEN THEATER [6] Schreiben aus Berlin / Den 28. Oktober [1810] [EJ#6]*
2001
Mixed media on cast aluminum
40 x 36 x 22" / 101.6 x 91.4 x 55.9 cm
New York, Frank Stella
(FS 481)

Miller / Kleist 1982, 244.
Kleist 1985, II, 411–412.

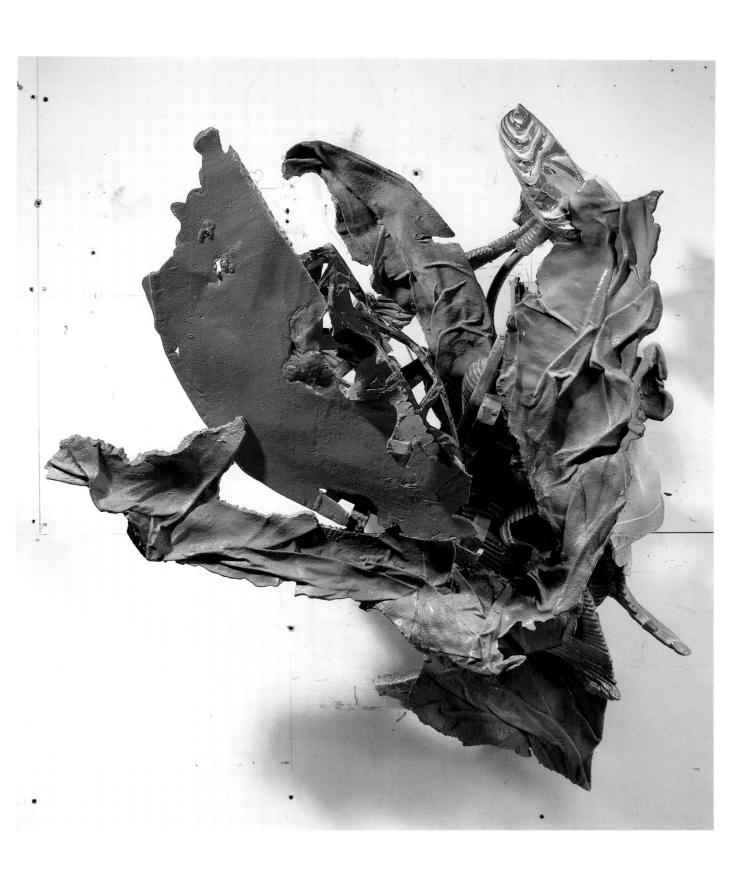

**Tafel / Plate XLI**
*THEATER CRITICISM: IFFLAND [EJ#7]*
*KLEINE SCHRIFTEN THEATER [1] Den 2. Oktober [1810]: Ton des Tages, Lustspiel von Voß [EJ#7]*
1999
Mixed media on cast aluminum
22 x 47 x 14 ¹/₂″ / 55.9 x 119.4 x 36.8 cm
New York, Courtesy of Barabara Mathes Gallery
(FS 482)

Miller / Kleist 1982, 243.
Kleist 1985, II, 408.

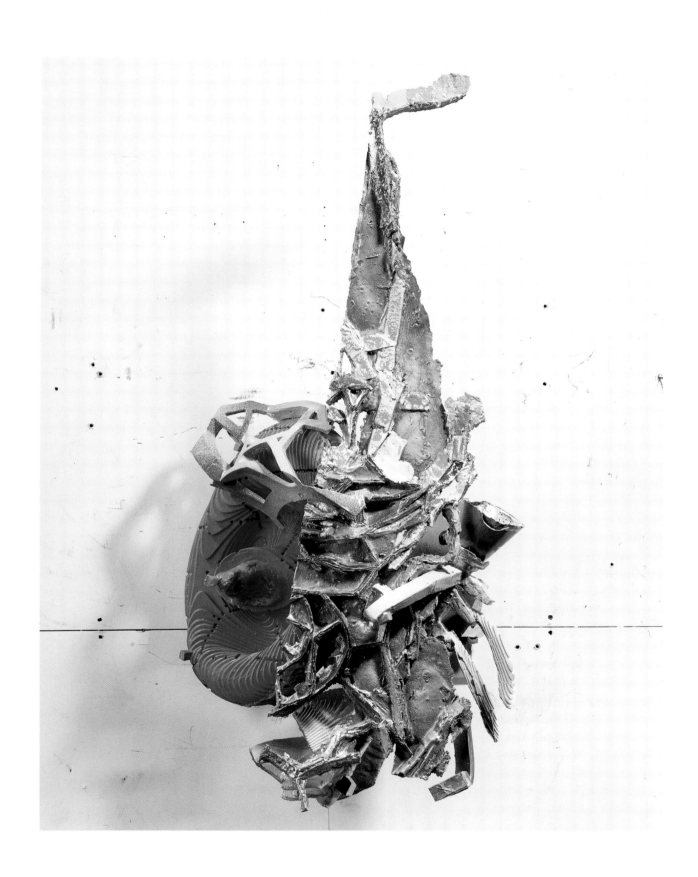

**Tafel / Plate XLII**

*CALENDER THOUGHTS [EJ#8]*
*KALENDERBETRACHTUNG den 10. März 1811 [EJ#8]*
1999
Mixed media on cast aluminum
32 x 39 x 27" / 81.3 x 99.1 x 68.6 cm
Berlin, Rolf und Erika Hoffmann
(FS 483)

Miller / Kleist 1982, 252.
Kleist 1985, II, 407.

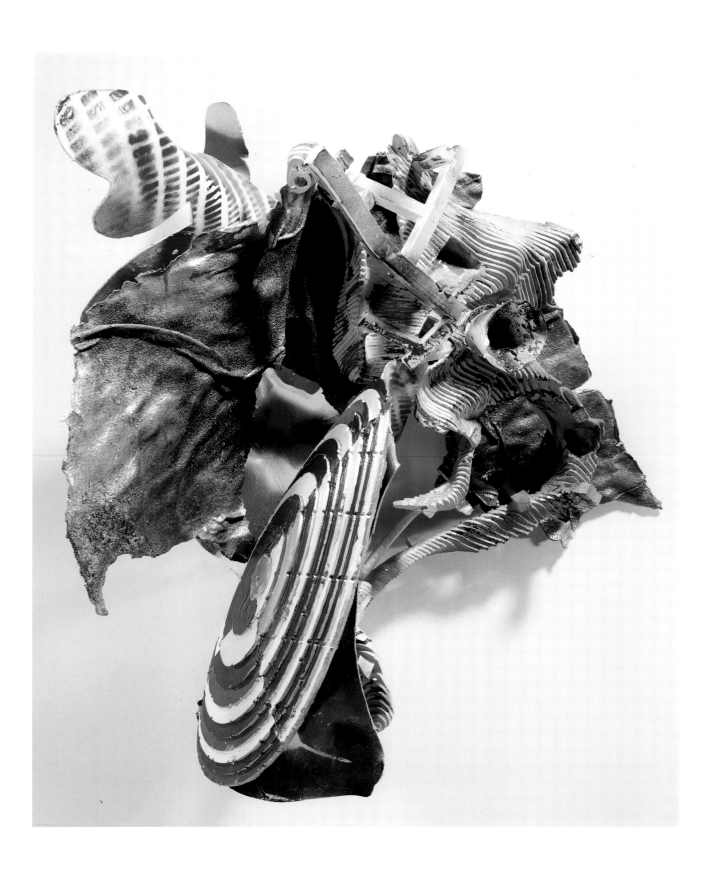

# Kleist: Quotations (from 'The Betrothal in Santo Domingo')
# Kleist: Zitate (aus ‚Die Verlobung in St. Domingo')

**Tafel / Plate XLIII**
*'At Sainte Luce!' [Hoango] [Q#1]*
*'In Sainte Lüze!' [Hoango] [Q#1]*
1998
Mixed media on cast aluminum
117 x 108 x 68" / 297.2 x 274.3 x 172.7 cm
Philadelphia, Stephen B. Klein
(FS 390)

Kleist 1978, 268.
Kleist 1985, II, 194.

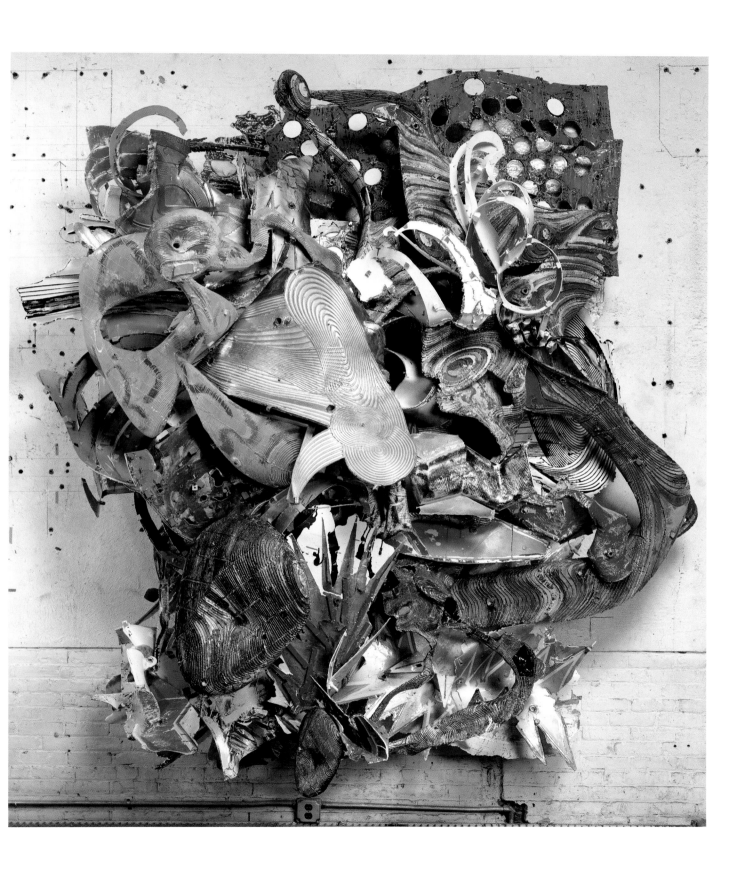

**Tafel / Plate XLIV**
*'At Sainte Luce,' [Herr Strömli] [Q#2]*
*'In Sainte Lüze!' [Herr Strömli]* [Q#2]
1998
Mixed media on cast aluminum
125 x 99 x 68" / 317.5 x 251.5 x 172.7 cm
New York, Courtesy of Akira Ikeda
(FS 391)

Kleist 1978, 268.
Kleist 1985, II, 194.

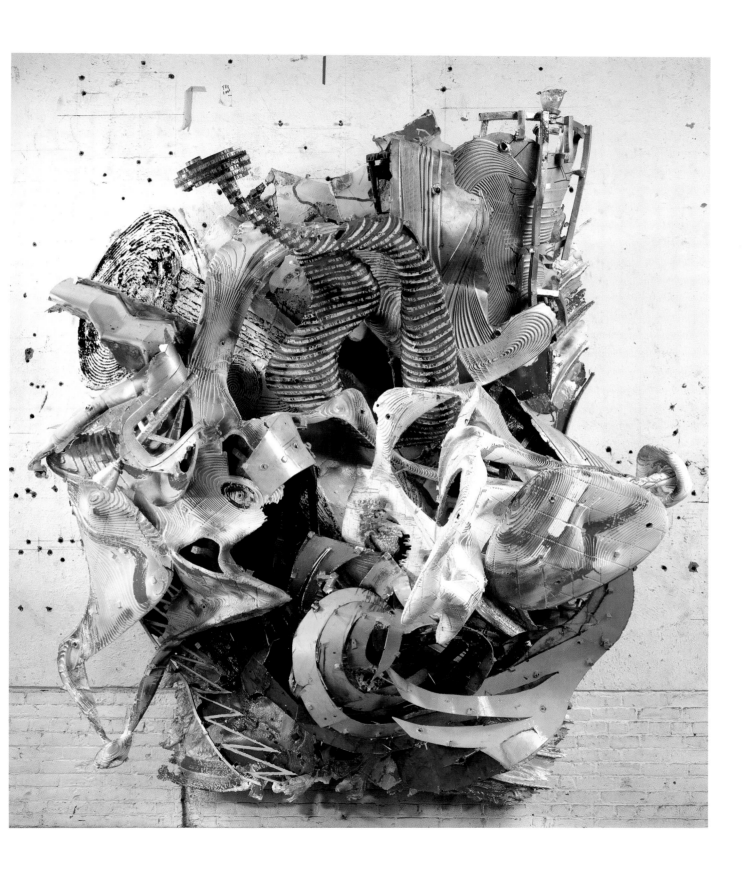

**Tafel / Plate XLV**
*'Oh!' cried Toni [Q#3]*
*'Ach', rief Toni [Q#3]*
1998
Mixed media on cast aluminum
80 x 56 x 28" / 203.2 x 142.2 x 71.1 cm
London, Courtesy of Bernard Jacobson Gallery
(FS 392)

Kleist 1978, 266.
Kleist 1985, II, 193.

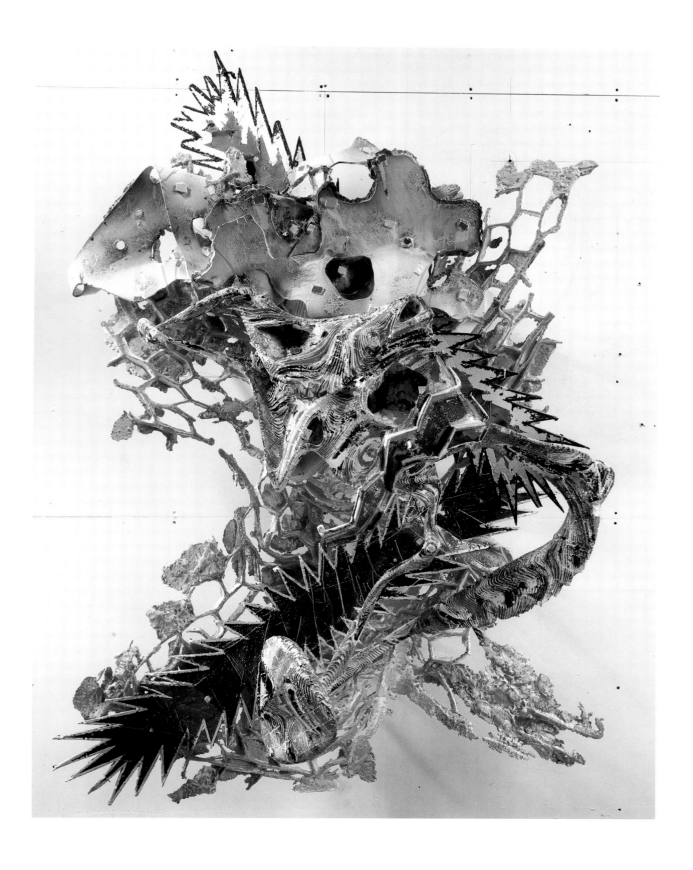

**Tafel / Plate XLVI**
*'Why?' [Gustav] [Q#4]/*
*'Weshalb?' [Gustav] [Q#4]*
1998
Mixed media on cast aluminum
87 x 84 x 30" / 221 x 213.4 x 76.2 cm
New York, Courtesy of Sperone Westwater
(FS 393)

Kleist 1978, 266.
Kleist 1985, II, 193.

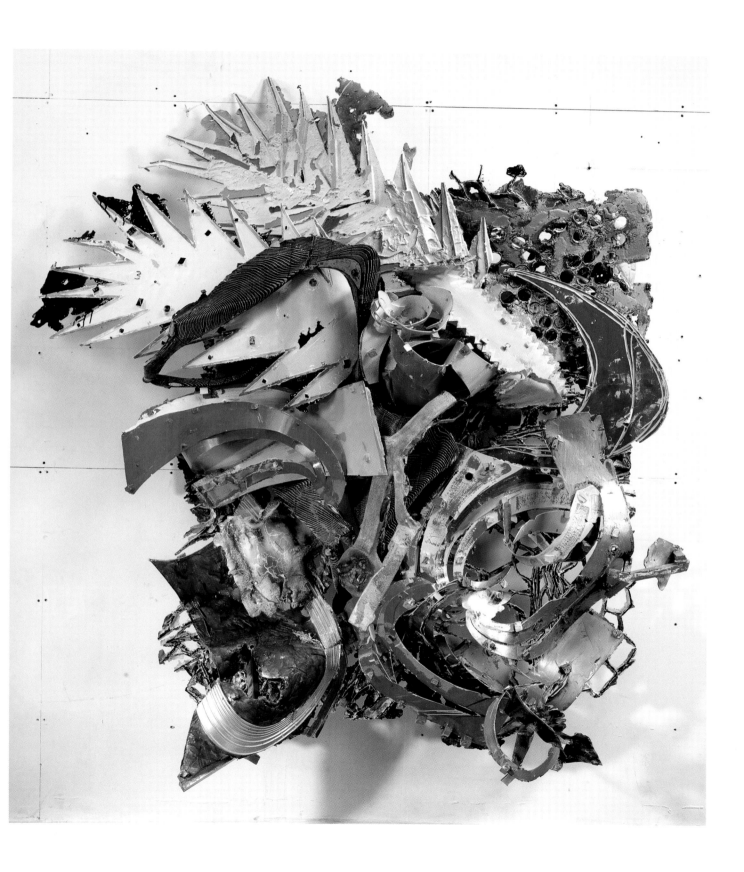

**Tafel / Plate XLVII**
*'Her name was Marianne Congreve'* [Q#5]
*'Ihr Name war Mariane Congreve'* [Q#5]
1998
Mixed media on cast aluminum
80 x 59 x 40" / 203.2 x 149.9 x 101.6 cm
New York, Courtesy of Sperone Westwater
(FS 394)

Kleist 1978, 245.
Kleist 1985, II, 173.

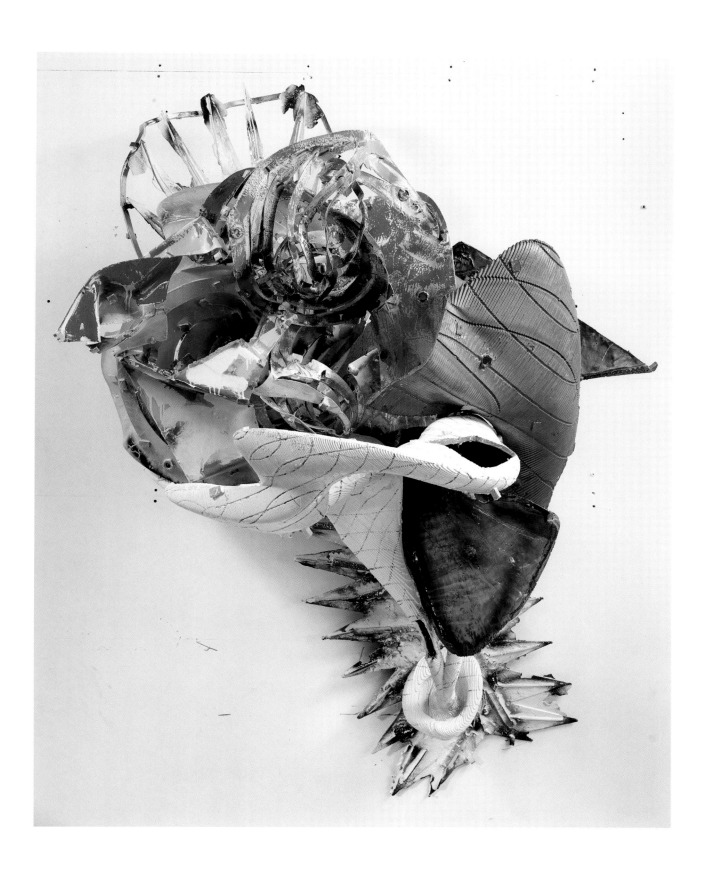

**Tafel / Plate XLVIII**
*'Why, heaven save us!' exclaimed the old woman [Babekan] [Q#6]*
*'Ei, mein Himmel!', rief die Alte [Babekan] [Q#6]*
1998
Honeycomb and cast aluminum
84 x 60 x 52" / 213.4 x 152.4 x 132.1 cm
Berlin, Rolf und Erika Hoffmann
(FS 395)

Kleist 1978, 236–237.
Kleist 1985, II, 164.

Die Zählung der *Kleist: Quotations* setzt mit No. Q#8 fort.

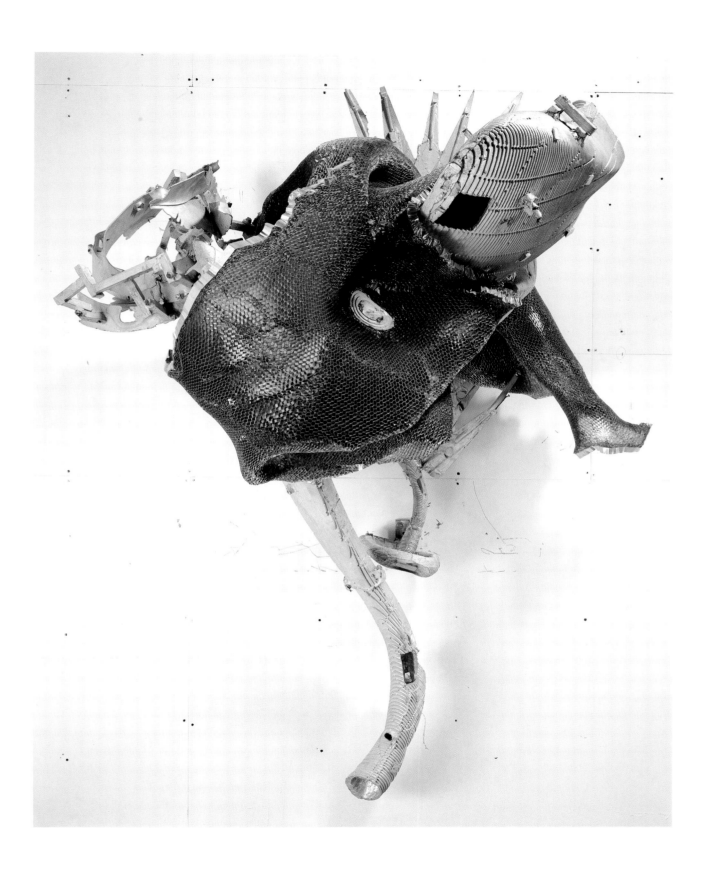

**Tafel / Plate XLIX**
*Nanky [Q#8]*
*Nanky [Q#8]*
1998
Mixed media on cast aluminum
56 x 46 x 32" / 142.2 x 116.8 x 81.3 cm
New York, Courtesy of Sperone Westwater
(FS 396)

Kleist 1978, 234.
Kleist 1985, II, 162.

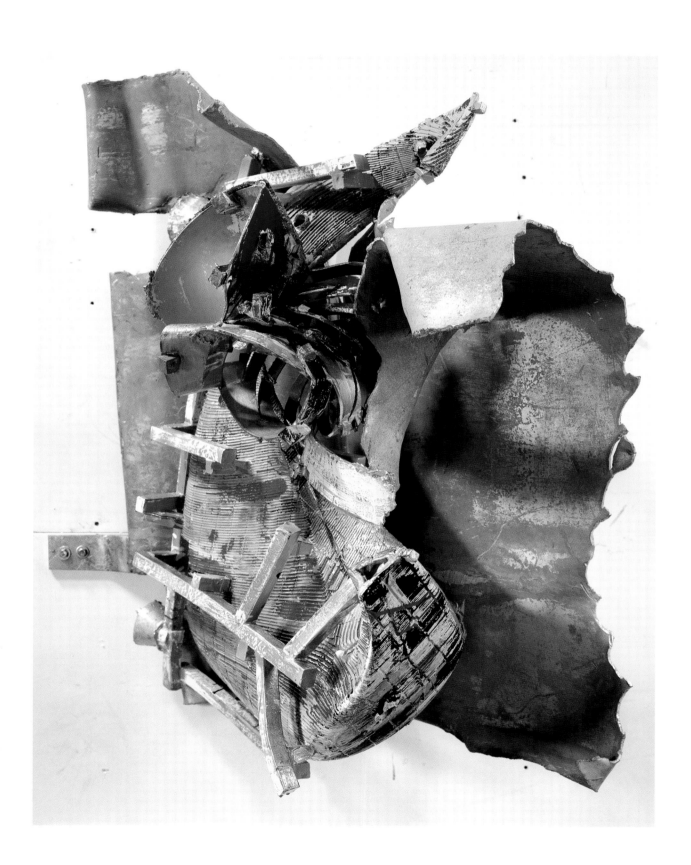

**Tafel / Plate L**
*Seppy [Q#9]*
*Seppy [Q#9]*
1998
Mixed media on cast aluminum
40 x 60 x 36" / 101.6 x 152.4 x 91.4 cm
New York, Courtesy of Sperone Westwater
(FS 397)

Kleist 1978, 234.
Kleist 1985, II, 162.

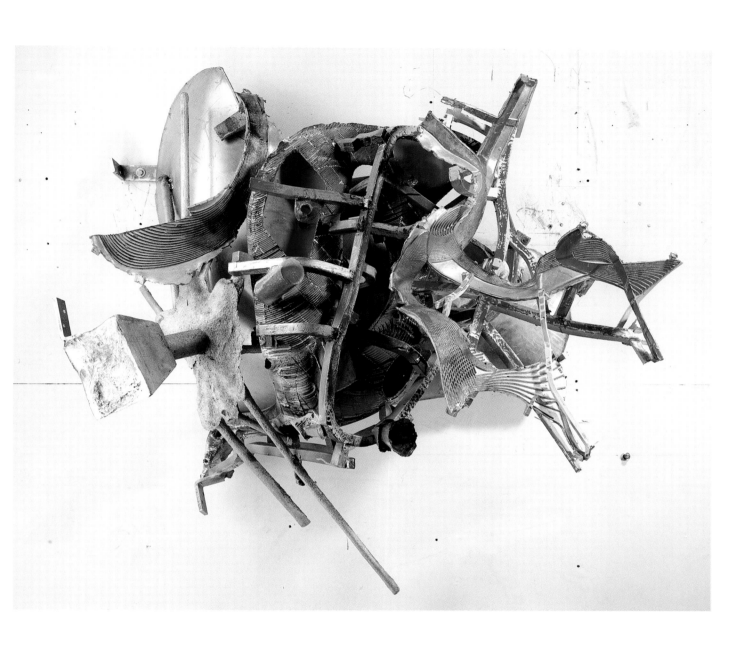

**Tafel / Plate LI**
*Komar [Q#10]*
*Komar [Q#10]*
1998
Mixed media on cast aluminum
48 x 50 x 36" / 121.9 x 127 x 91.4 cm
New York, Courtesy of Sperone Westwater
(FS 398)

Kleist 1978, 240.
Kleist 1985, II, 168.

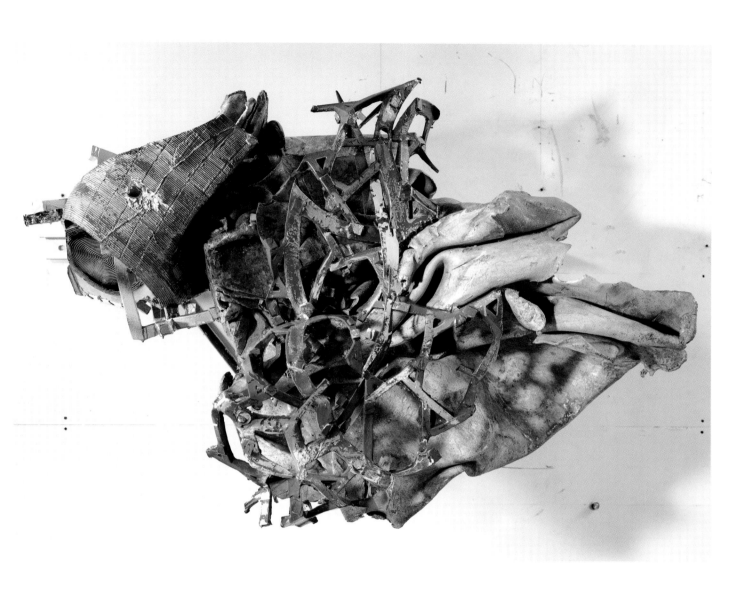

**Tafel / Plate LII**
*Konelly [Q#11]*
*Konelly [Q#11]*
1998
Mixed media on cast aluminum
46 x 36 x 38" /116.8 x 91.4 x 96.5 cm
New York, Courtesy of Sperone Westwater
(FS 399)

Kleist 1978, 244.
Kleist 1985, II, 172.

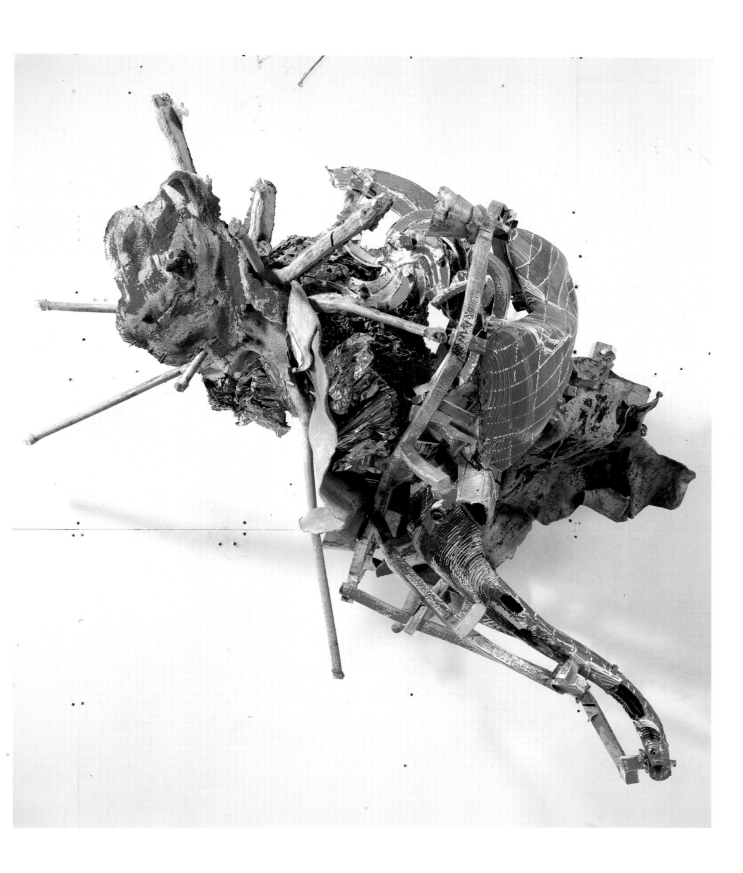

**Tafel / Plate LIII**
*'… on the banks of the Aar' [fields] [Q#12]*
*'… an den Ufern der Aar' [Felder] [Q#12]*
1998
Mixed media on cast aluminum
48 x 50 x 27" / 121.9 x 127 x 68.6 cm
New York, Frank Stella
(FS 400)

Kleist 1978, 247.
Kleist 1985, II, 175.

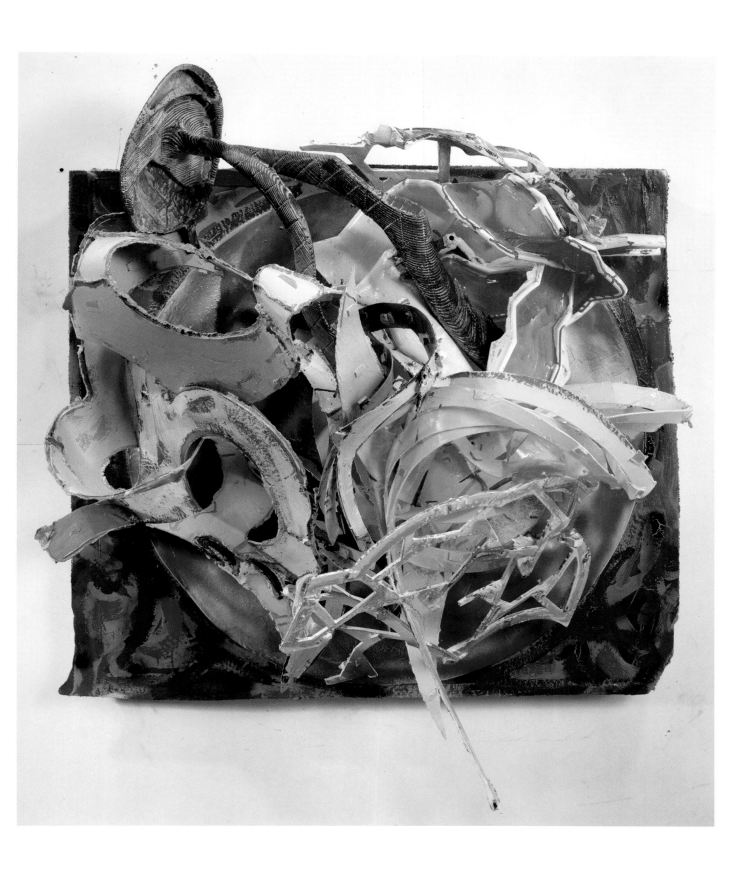

**Tafel / Plate LIV**
*'... on the banks of the Aar' [gardens] [Q#13]*
*'... an den Ufern der Aar' [Gärten]) [Q#13]*
1998
Mixed media on cast aluminum
55 x 58 x  38" / 139.7 x 147.3 x 96.5 cm
New York, Frank Stella
(FS 401)

Kleist 1978, 247.
Kleist 1985, II, 175.

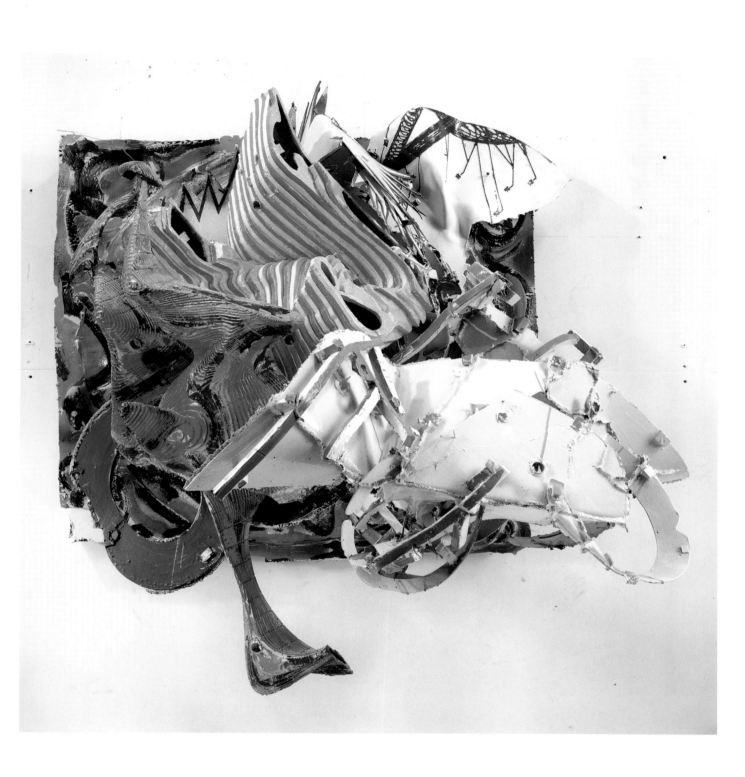

**Tafel / Plate LV**

*'... on the banks of the Aar' [meadows] [Q#14]*
*'... an den Ufern der Aar' [Wiesen] [Q#14]*
1998
Mixed media on cast aluminum
58 x 51 x 30" / 147.3 x 129.5 x 76.2 cm
New York, Frank Stella
(FS 402)

Kleist 1978, 247.
Kleist 1985, II, 175.

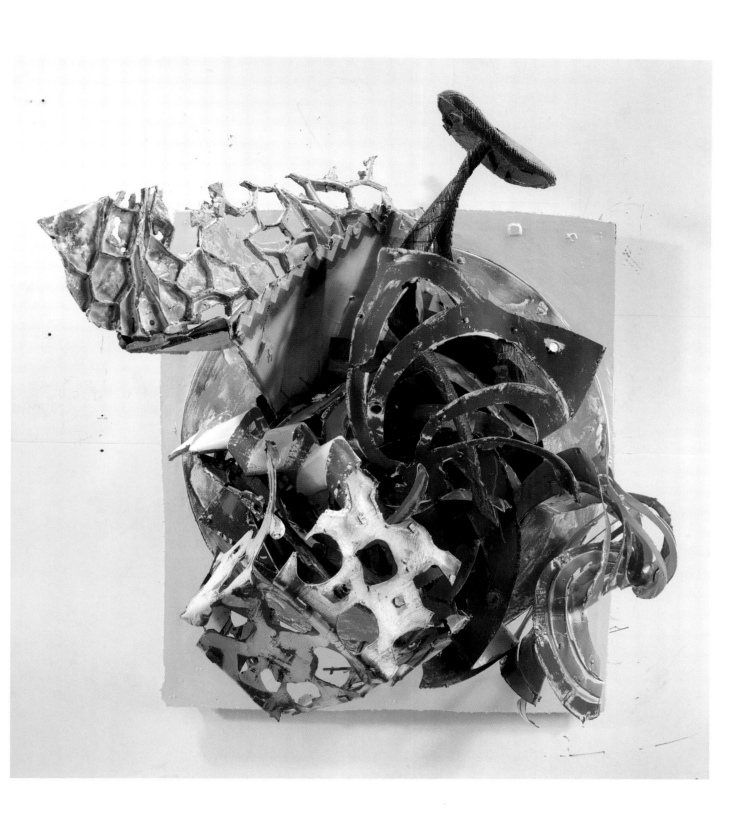

**Tafel / Plate LVI**
*'… on the banks of the Aar' [vineyards] [Q#15]*
*'… an den Ufern der Aar' [Weinberge] [Q#15]*
1998
Mixed media on cast aluminum
56 x 51 x 35" / 142.2 x 129.5 x 88.9 cm
New York, Frank Stella
(FS 403)

Kleist 1978, 247.
Kleist 1985, II, 175.

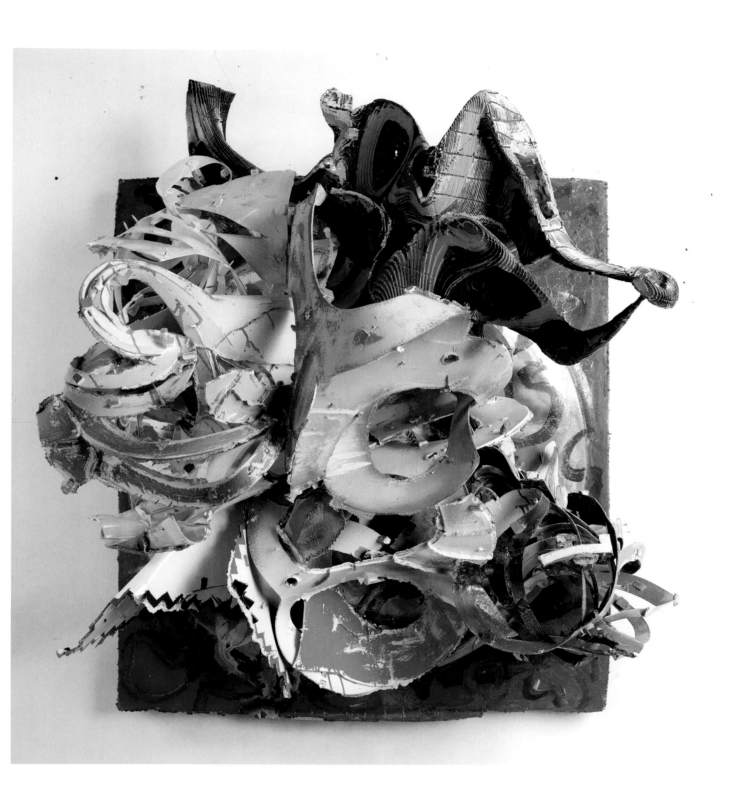

*Kleist: Novellas*
*Kleist: Erzählungen*

**Tafel / Plate LVII**
*Michael Kohlhaas (From an old chronicle) [N#1]*
*MICHAEL KOHLHAAS (Aus einer alten Chronik) [N#1]*
1999
Collage on paper
82 x 540" / 208.3 x 1371.6 cm
New York, Frank Stella @ Newburgh, Polich Art Works
(FS 491)

Kleist 1978, 114–213.
Kleist 1985, II, 9–103.

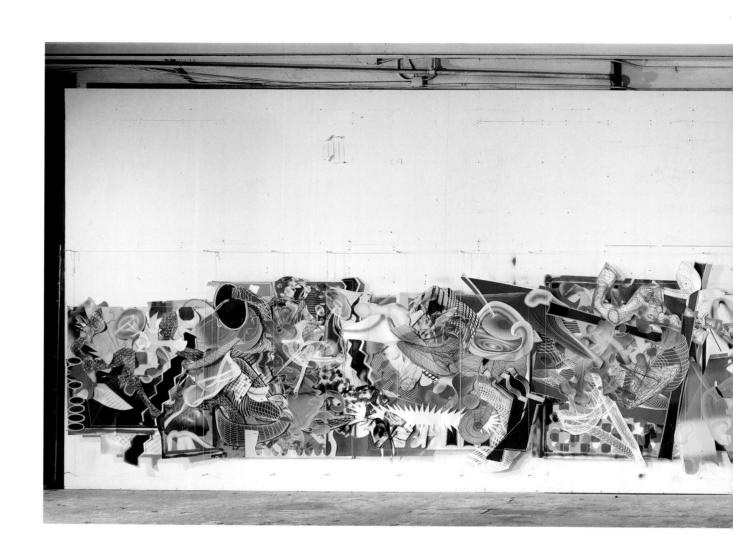

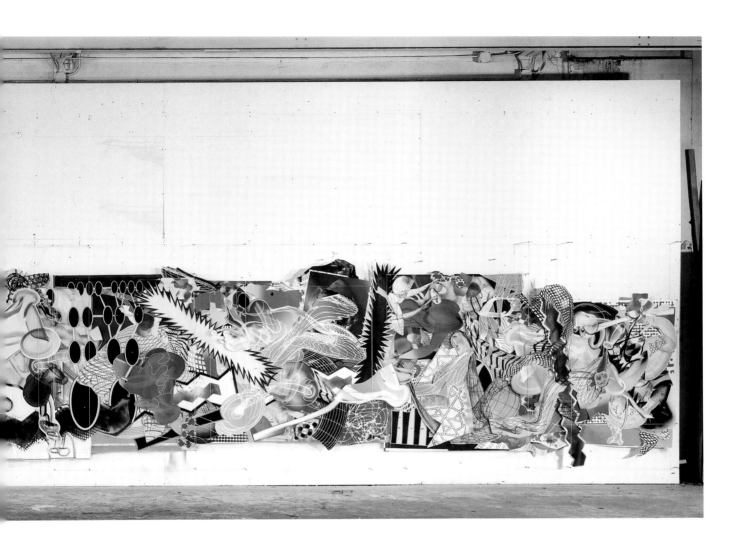

**Tafel / Plate LVIII**

*Michael Kohlhaas (From an old chronicle) #1–# 9 [N#1]*
*MICHAEL KOHLHAAS (Aus einer alten Chronik) #1–# 9 [N#1]*
2000
Acrylic on canvas
9 Panels, each 168 x 168" / 9 Teile, jedes 426.7 x 426.7 cm
New York, Frank Stella @ Newburgh, Polich Art Works
(FS 611–619)

Kleist 1978, 114–213.
Kleist 1985, II, 9–103.

*Michael Kohlhaas (From an old chronicle) #1 [N#1]*
*MICHAEL KOHLHAAS (Aus einer alten Chronik) #1 [N#1]*

*Michael Kohlhaas (From an old chronicle) #2 (inverted) [N#1]*
*MICHAEL KOHLHAAS (Aus einer alten Chronik) #2 (versetzt) [N#1]*

*Michael Kohlhaas (From an old chronicle) #3 [N#1]*
*MICHAEL KOHLHAAS (Aus einer alten Chronik) #3 [N#1]*

*Michael Kohlhaas (From an old chronicle) #4 (inverted) [N#1]*
*MICHAEL KOHLHAAS (Aus einer alten Chronik) #4 (versetzt) [N#1]*

*Michael Kohlhaas (From an old chronicle) #5 [N#1]*
*MICHAEL KOHLHAAS (Aus einer alten Chronik) #5 [N#1]*

*Michael Kohlhaas (From an old chronicle) #6 (inverted) [N#1]*
*MICHAEL KOHLHAAS (Aus einer alten Chronik) #6 (versetzt) [N#1]*

*Michael Kohlhaas (From an old chronicle) #7 [N#1]*
*MICHAEL KOHLHAAS (Aus einer alten Chronik) #7 [N#1]*

*Michael Kohlhaas (From an old chronicle) #8 (inverted) [N#1]*
*MICHAEL KOHLHAAS (Aus einer alten Chronik) #8 (versetzt) [N#1]*

*Michael Kohlhaas (From an old chronicle) #9 [N#1]*
*MICHAEL KOHLHAAS (Aus einer alten Chronik) #9 [N#1]*

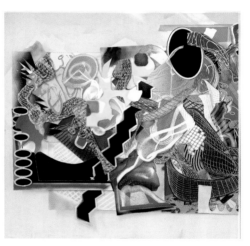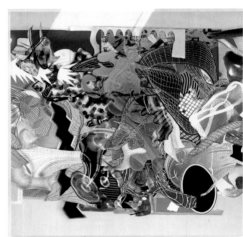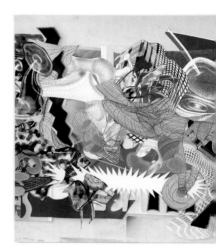

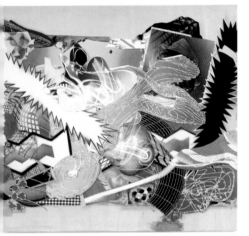 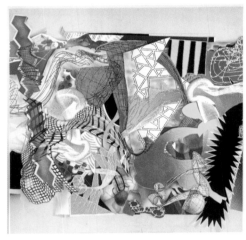 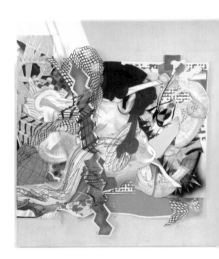

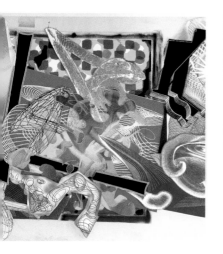 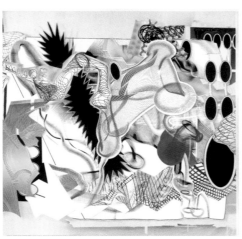 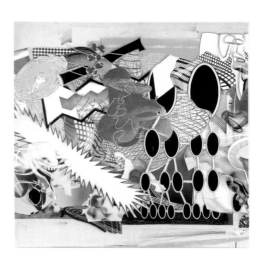

**Tafel / Plate LIX**

*The Marquise of O- (Based on a true incident, the setting of which has been transposed from the north to the south) [N#2]*
*DIE MARQUISE VON O... (Nach einer wahren Begebenheit, deren Schauplatz vom Norden nach dem Süden verlegt worden) [N#2]*
1998
Collage on paper
60 x 260" / 152.4 x 660.4 cm
London, Courtesy of Bernard Jacobson Gallery
(FS 493)

Kleist 1978, 68–113.
Kleist 1985, II, 104–143.

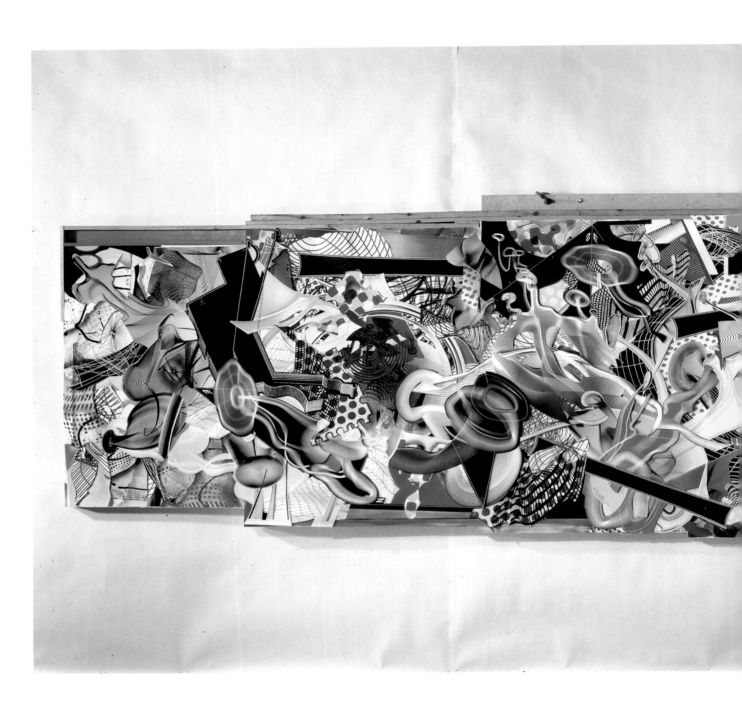

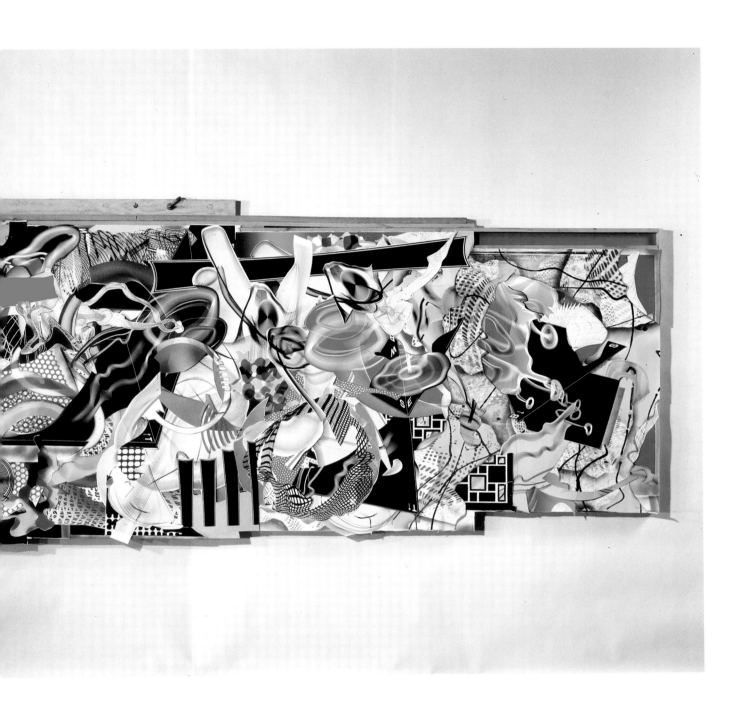

**Tafel / Plate LX**

*The Marquise of O- (Based on a true incident, the setting of which has been transposed from the north to the south) [N#2]*

*DIE MARQUISE VON O... (Nach einer wahren Begebenheit, deren Schauplatz vom Norden nach dem Süden verlegt worden) [N#2]*

1998
Mixed media on canvas
10' x 43' 4" / 304.8 x 1320.8 cm (7 panels, various sizes)
London, Courtesy of Bernard Jacobson Gallery@ Newburgh, Polich Art Works
(FS 405)

Kleist 1978, 68–113.
Kleist 1985, II, 104–143.

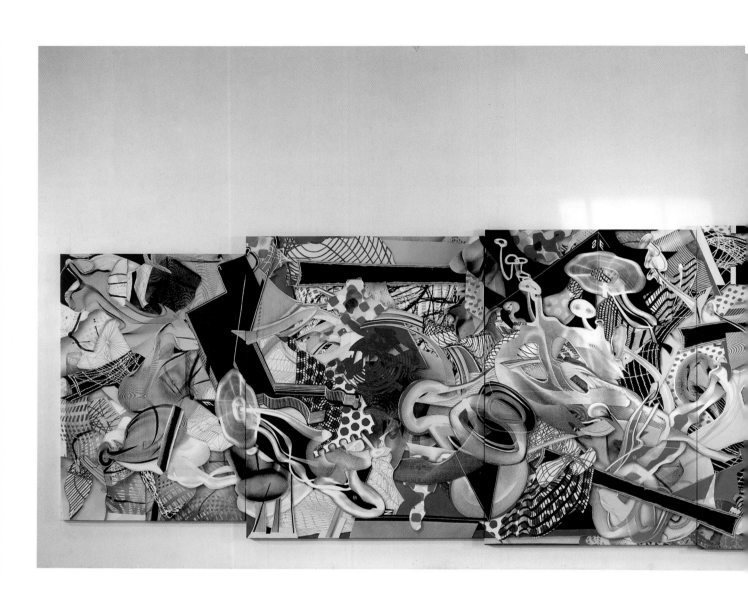

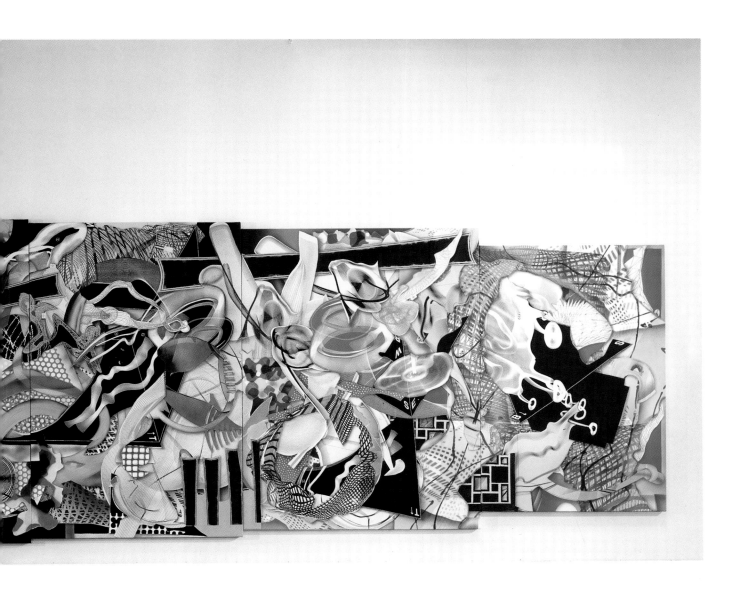

**Tafel / Plate LXI**
*The Earthquake in Chile [N#3]*
*DAS ERDBEBEN IN CHILI [N#3]*
1999
Collage on paper
60 x 228" / 152.4 x 579.1 cm
New York, Frank Stella@ Newburgh, Polich Art Works
(FS 494)

Kleist 1978, 51–67.
Kleist 1985, II, 144–159.

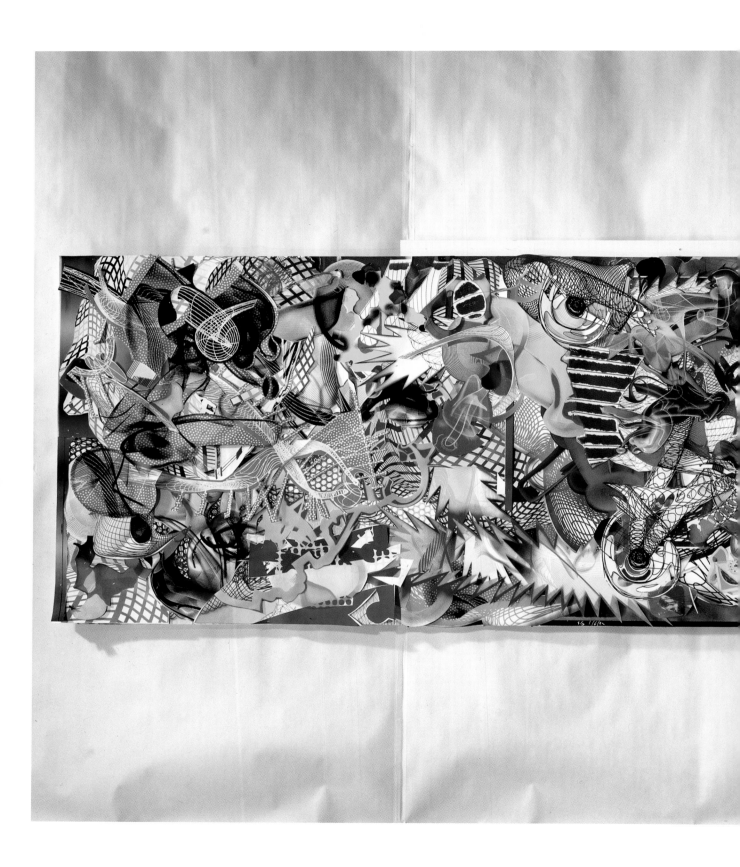

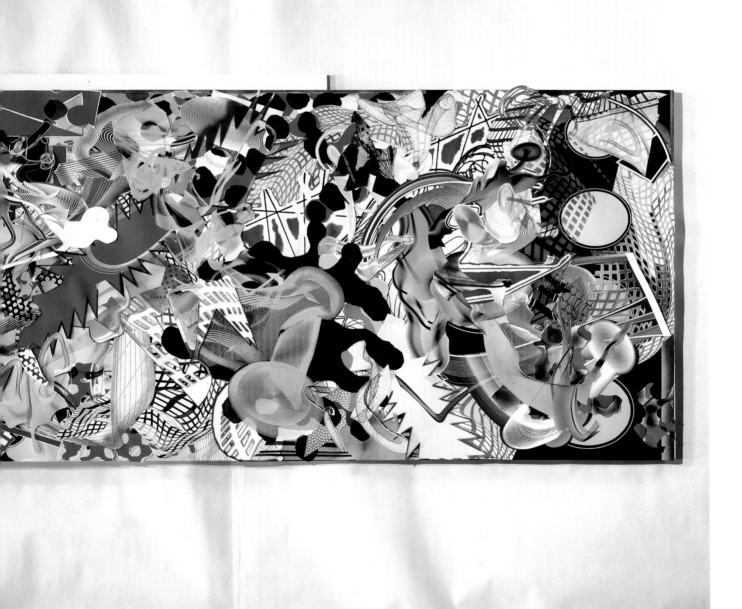

**Tafel / Plate LXII**
*The Earthquake in Chile [N#3]*
*DAS ERDBEBEN IN CHILI [N#3]*
1999
Mixed media on canvas
12' 2" x 40' 5" / 370.84 x 1231.9 cm
New York, Frank Stella@ Newburgh, Polich Art Works
(FS 406)

Kleist 1978, 51–67.
Kleist 1985, II, 144–159.

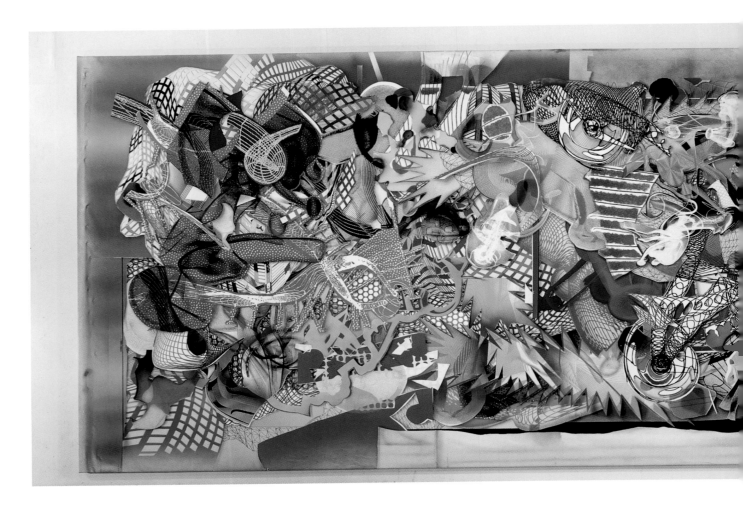

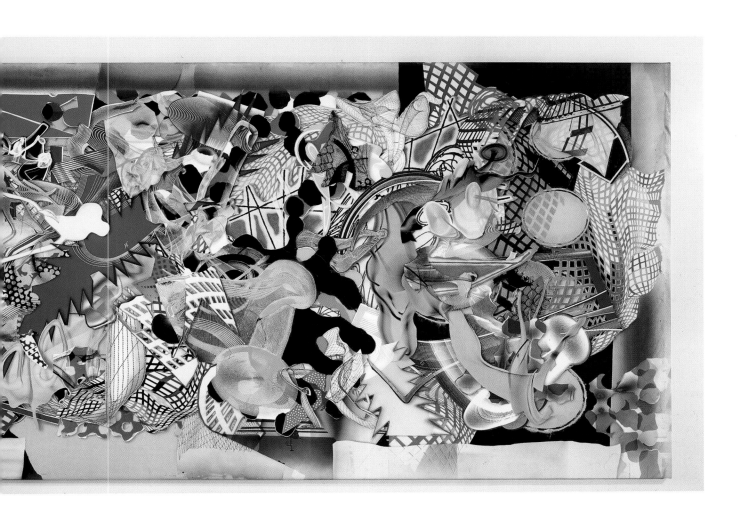

**Tafel / Plate LXIII**
*The Betrothal in Santo Domingo [N#4]*
*DIE VERLOBUNG IN ST. DOMINGO [N#4]*
1999
Collage on paper
60 x 240" / 152.4 x 609.6 cm
New York, Frank Stella@ Newburgh, Polich Art Works
(FS 495)

Kleist 1978, 231–269.
Kleist 1985, II, 160–195.

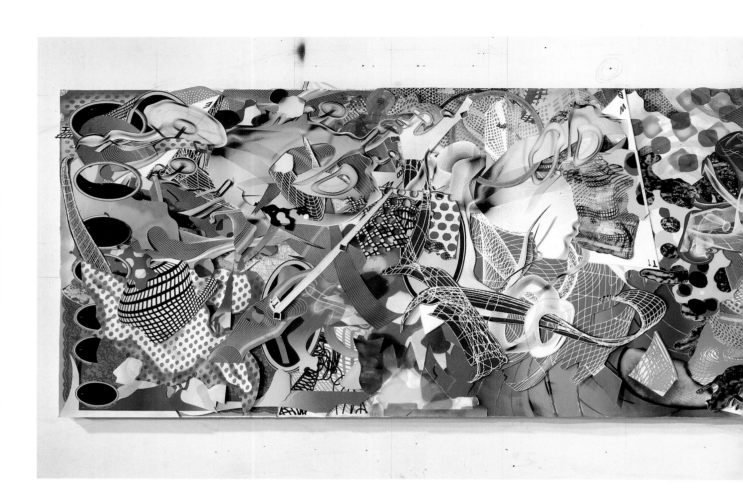

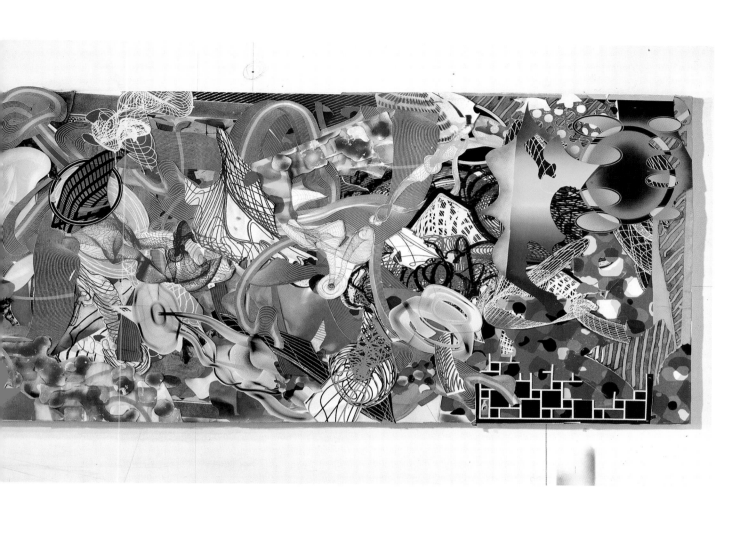

**Tafel / Plate LXIV**
*The Betrothal in Santo Domingo [N#4]*
*DIE VERLOBUNG IN ST. DOMINGO [N#4]*
1999
Mixed media on canvas
10' x 41' 6" / 304.8 x 1264.92 cm (4 panels 10' x 10' each / je 304.8 x 304.8 cm)
New York, Frank Stella@ Newburgh, Polich Art Works
(FS 407)

Kleist 1978, 231–269.
Kleist 1985, II, 160–195.

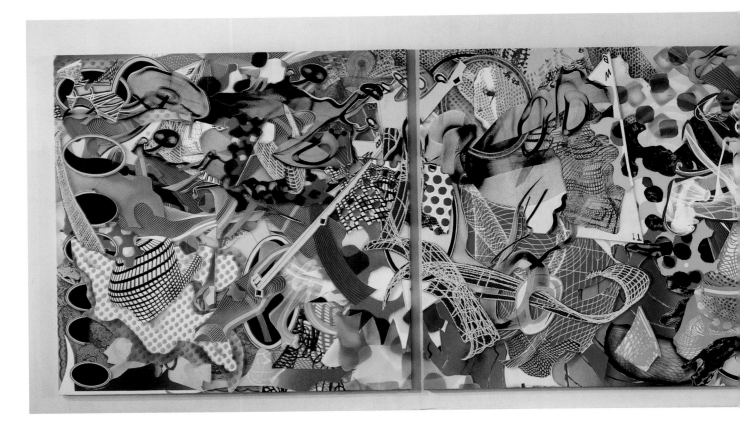

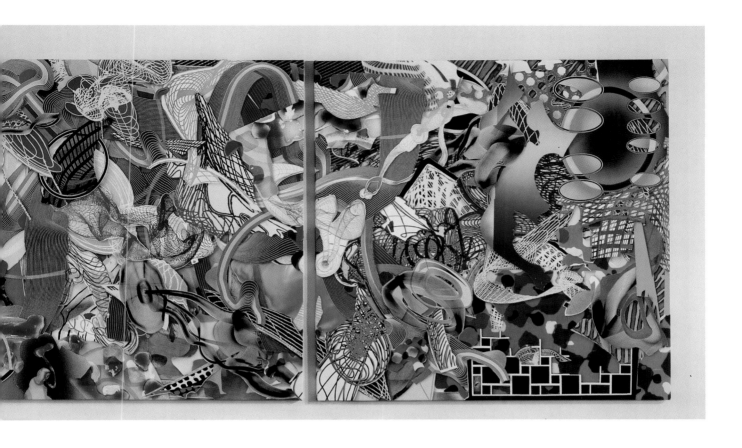

**Tafel / Plate LXV**

*The Beggarwoman of Locarno [N#5]*
*DAS BETTELWEIB VON LOCARNO [N#5]*
1999
Collage on paper
94 ¹/₂ x 200" / 240 x 508 cm
Philadelphia, Courtesy of Sueyun Locks Gallery
(FS 490)

Kleist 1978, 214–216.
Kleist 1985, II, 196–198.

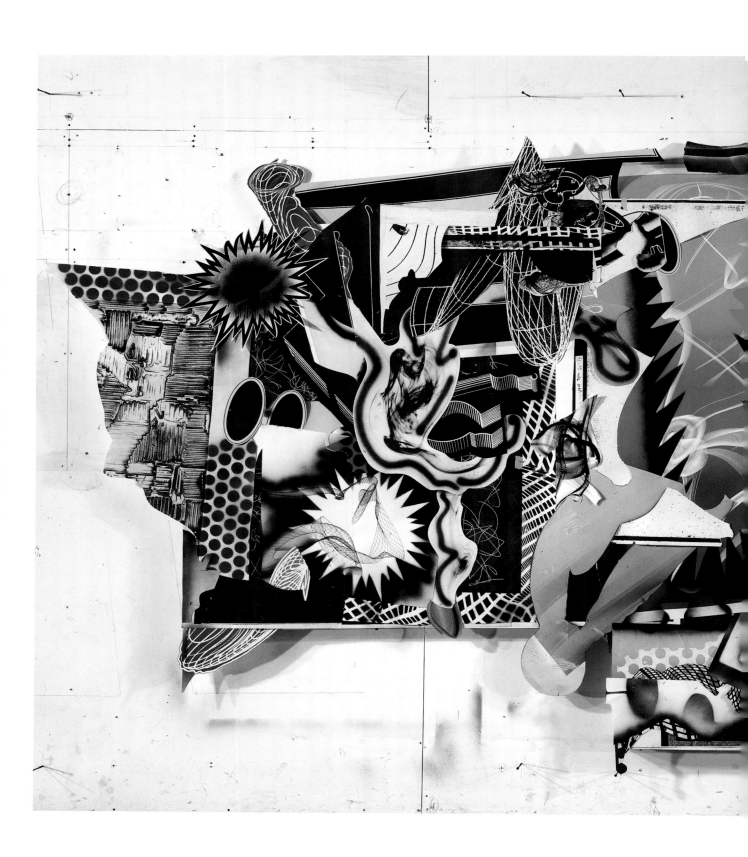

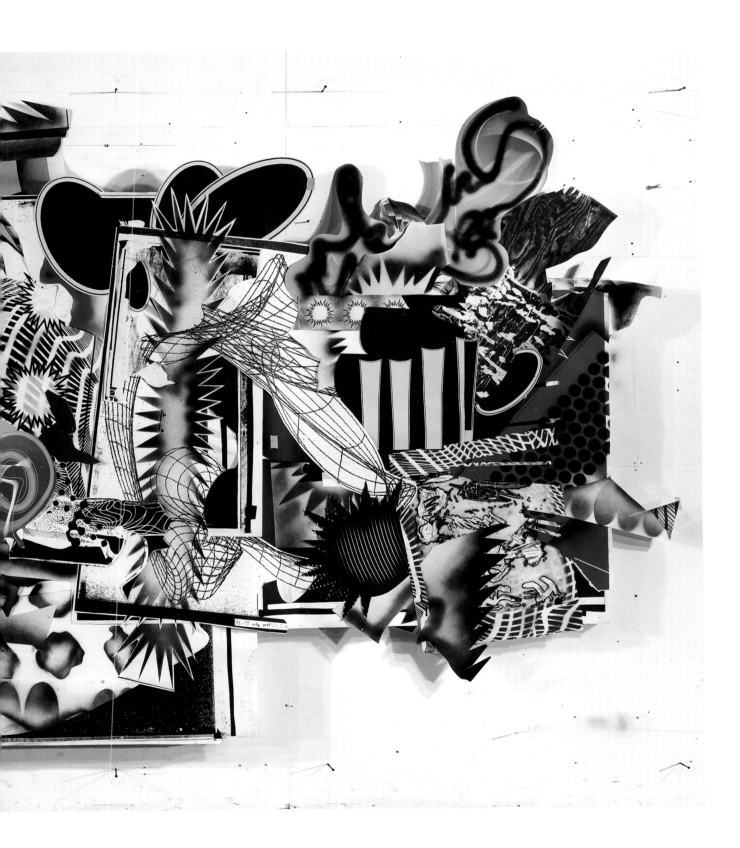

**Tafel / Plate LXVI**
*The Beggar Woman of Locarno [N#5]*
*DAS BETTELWEIB VON LOCARNO [N#5]*
2000
Acrylic on canvas
10' 10" x 19' / 330.2 x 579.1 cm
New York, Frank Stella@ Newburgh, Polich Art Works
(FS 608)

Kleist 1978, 214–216.
Kleist 1985, II, 196–198.

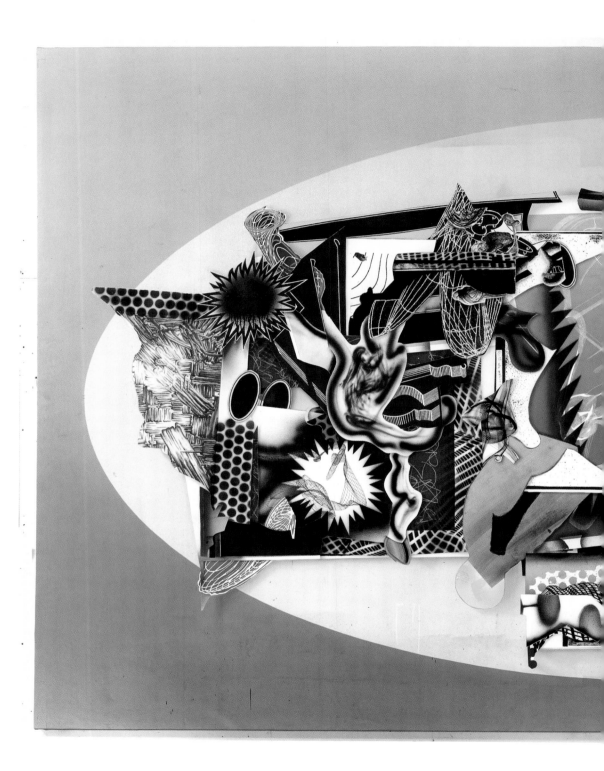

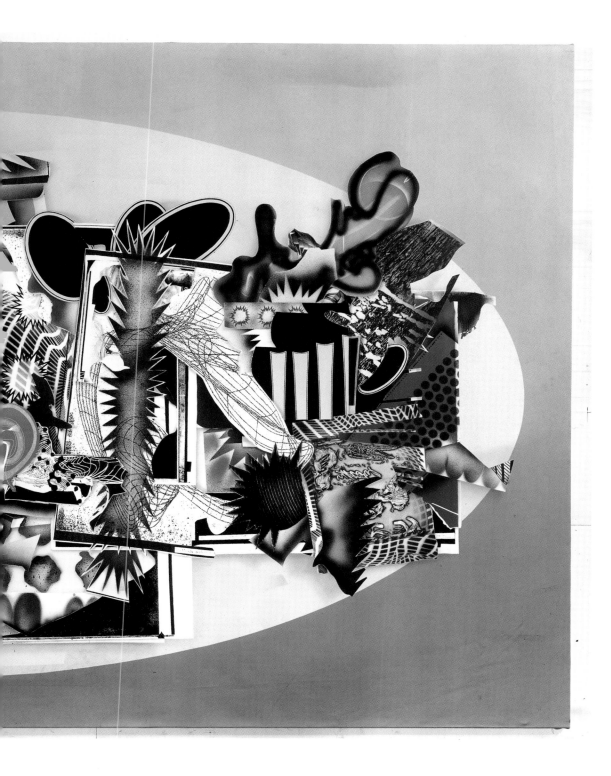

**Tafel / Plate LXVII**
*The Foundling [N#6]*
*DER FINDLING [N#6]*
1999
Collage on paper
85 x 253"/ 215.9 x 642.6 cm
New York, Frank Stella@ Newburgh, Polich Art Works
(FS 489)

Kleist 1978, 270–286.
Kleist 1985, II, 199–215.

*The Foundling [N#6]*
*DER FINDLING [N#6]*
Work in progress
Mixed media on canvas
(FS 643)

Kleist 1978, 270–286.
Kleist 1985, II, 199–215.

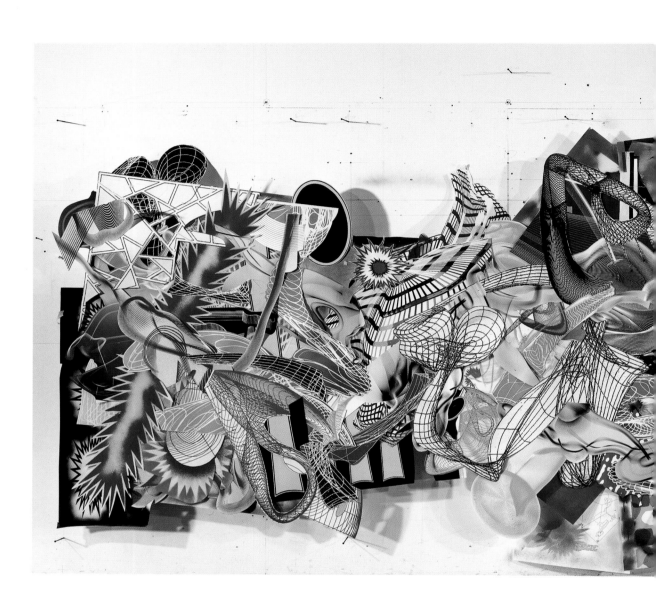

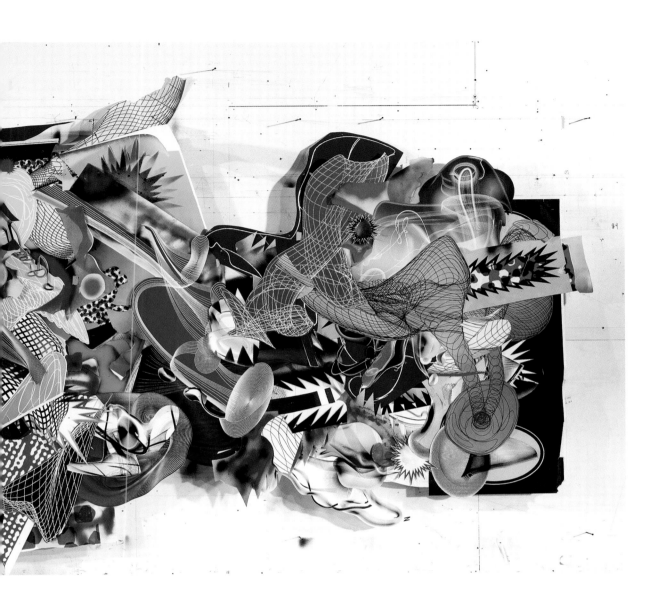

**Tafel / Plate LXVIII**
*St Cecilia or The Power of Music (A legend) [N#7]*
*DIE HEILIGE CÄCILIE oder DIE GEWALT DER MUSIK (Eine Legende) [N#7]*
1998
Collage on paper
83 ½ x 210" / 212.1 x 533.4 cm
New York, Frank Stella@ Newburgh, Polich Art Works
(FS 492)

Kleist 1978, 217–230.
Kleist 1985, II, 216–228.

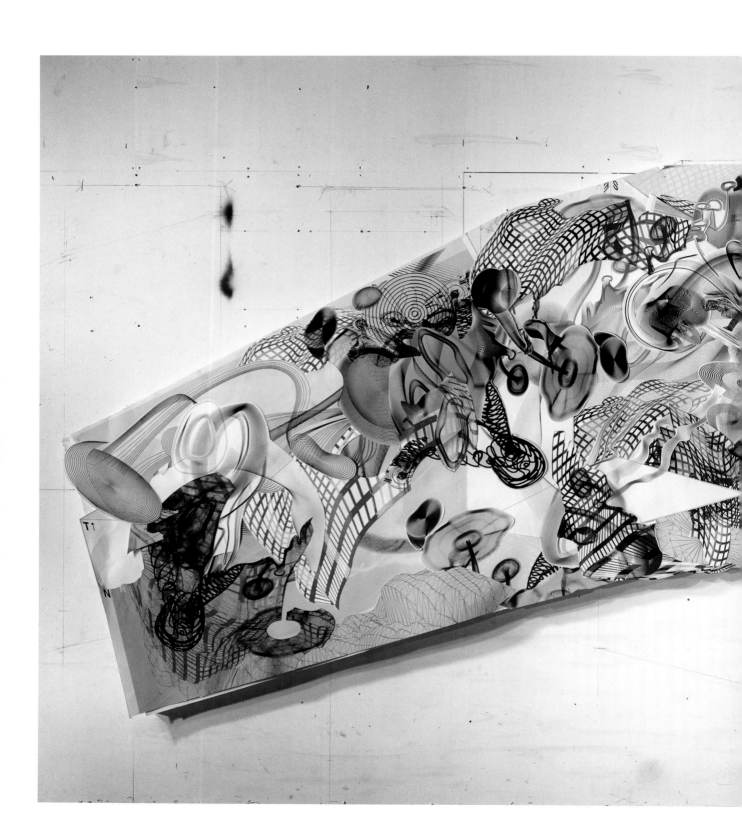

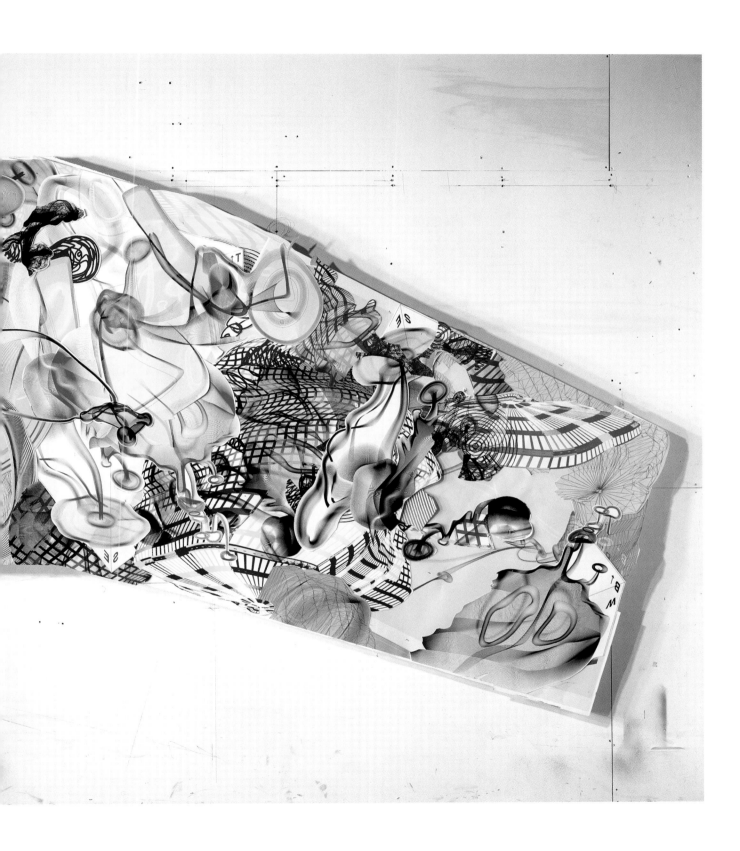

**Tafel / Plate LXIX**

*St Cecilia or The Power of Music (A legend) [N#7]*
*DIE HEILIGE CÄCILIE oder DIE GEWALT DER MUSIK (Eine Legende) [N#7]*
1998
Mixed media on canvas
10' 5" x 41' 5" / 317.5 x 1262.4 cm (5 panels irregular quadrilaterals)
London, Courtesy of Bernard Jacobson Gallery@ Newburgh, Polich Art Works
(FS 404)

Kleist 1978, 217–230.
Kleist 1985, II, 216–228.

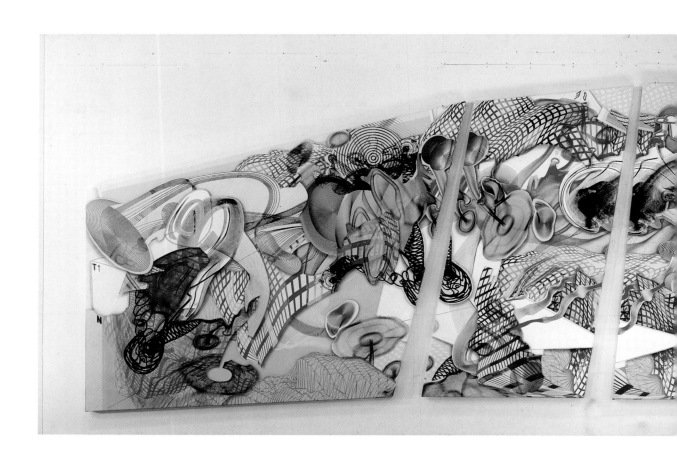

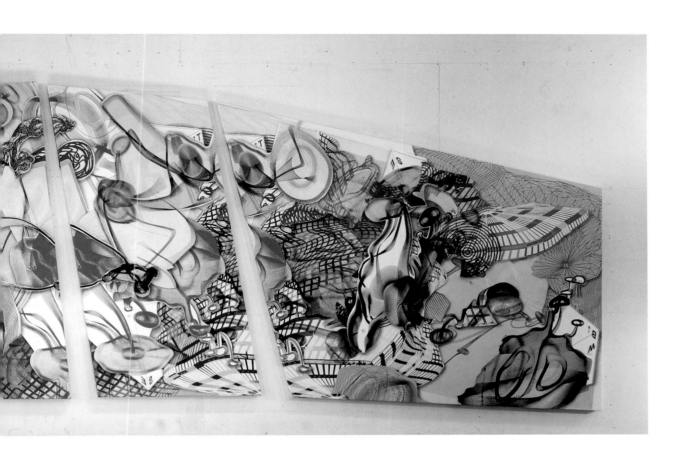

**Tafel / Plate LXX**
*The Duel [N#8]*
*DER ZWEIKAMPF [N#8]*
1999
Collage on paper
95 x 328" / 241.3 x 833.1 cm
New York, Frank Stella
(FS 488)

Kleist 1978, 287–320.
Kleist 1985, II, 229–261.

*The Duel  [N#8]*
*DER ZWEIKAMPF [N#8]*
Work in progress
Mixed media on canvas
(FS 642)

Kleist 1978, 287–320.
Kleist 1985, II, 229–261.

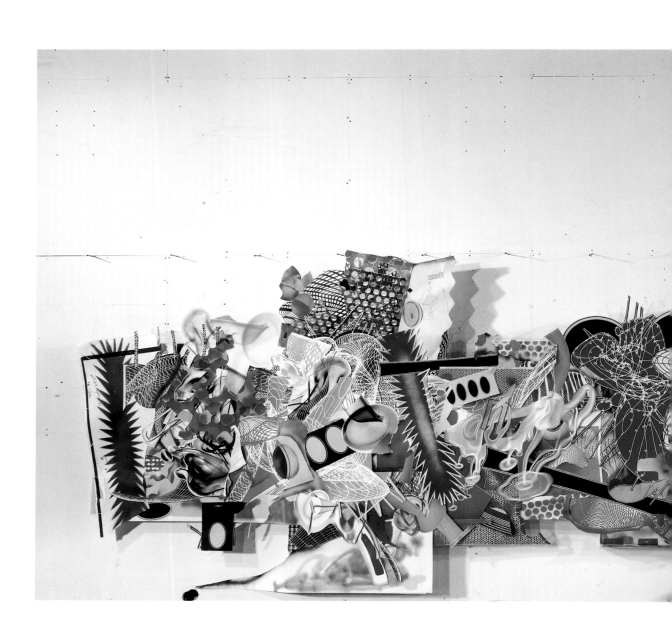

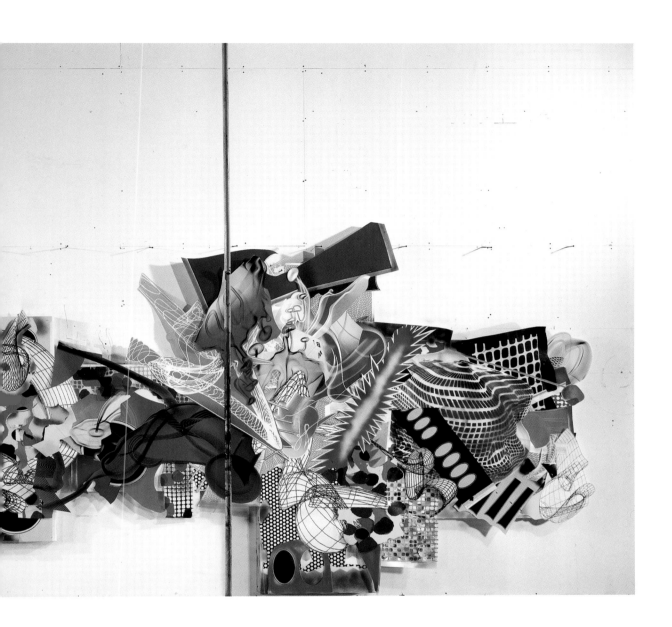

# Kleist: Dramas
# Kleist: Dramen

**Tafel / Plate LXXI**
*The Broken Jug. A Comedy [D#3] (maquette)*
*Der zerbrochene Krug. Ein Lustspiel [D#3] (maquette)*
1998
Polypropelene, wood
18 x 22 x 24" / 45.7 x 55.9 x 61 cm
New York, Frank Stella
(FS 640)

Kleist 1995, 1– 90.
Kleist 1985, I, 175–244.

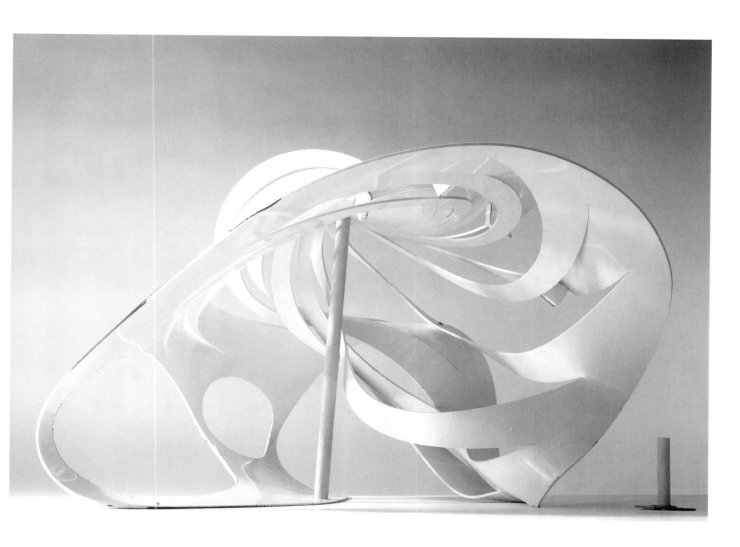

**Tafel / Plate LXXII**
*The Broken Jug. A Comedy [D#3] (computer maquette)*
*Der zerbrochene Krug. Ein Lustspiel [D#3] (computer maquette)*
1998
Plastic FDM (fused deposition modeling)
18 x 22 x 24" appx / etwa 45.7 x 55.9 x 61 cm
New York, Frank Stella
(FS 486)

Kleist 1995, 1–90.
Kleist 1985, I, 175–244.

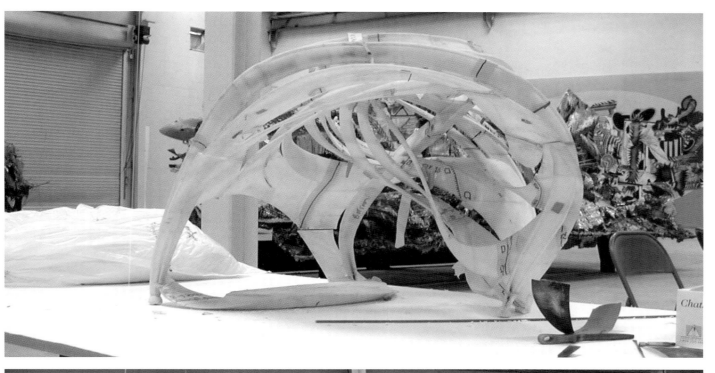

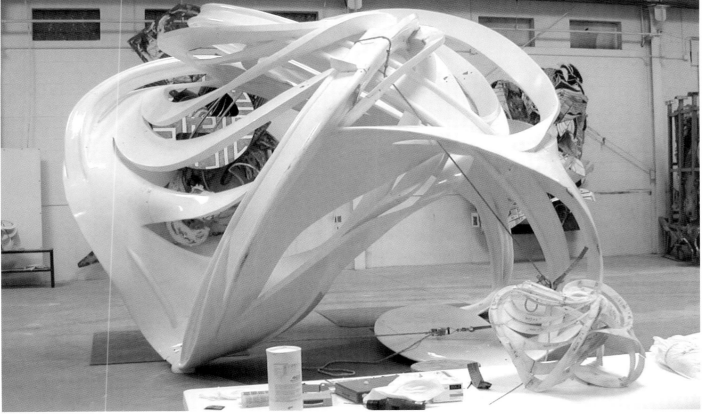

**Tafel / Plate LXXIII**
*The Broken Jug. A Comedy [D#3] 1 x*
*Der zerbrochene Krug. Ein Lustspiel [D#3] 1 x*
1999
Painted fiberglas and wood
12' x 14' 6" x 15' / 365.8 x 442 x 457.2 cm
New York, Frank Stella
(FS 485)

Kleist 1995, 1–90.
Kleist 1985, I, 175–244.

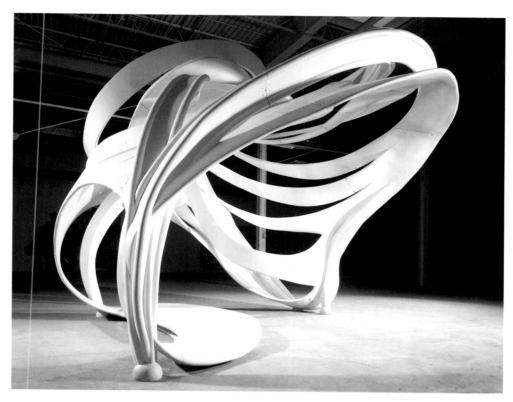

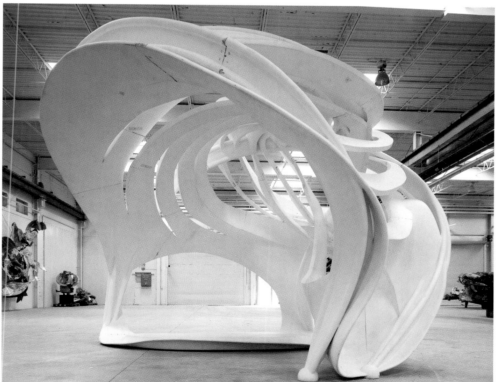

**Tafel / Plate LXXIV**
*The Broken Jug. A Comedy [D#3] 3 x*
*Der zerbrochene Krug. Ein Lustspiel [D#3] 3 x*
2001
Painted fabricated aluminum
34' x 46' x 44' appx. / 1036.3 x 1402.1 x 1341.1 cm
New York, Frank Stella
(FS 641)

Kleist 1995, 1–90.
Kleist 1985, I, 175–244.

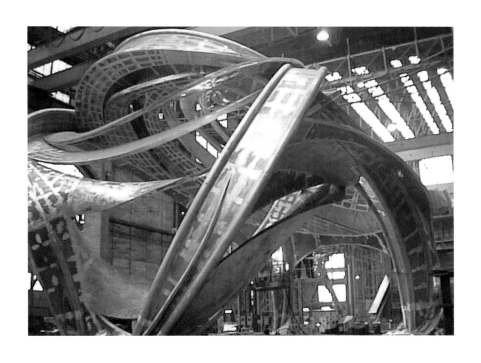

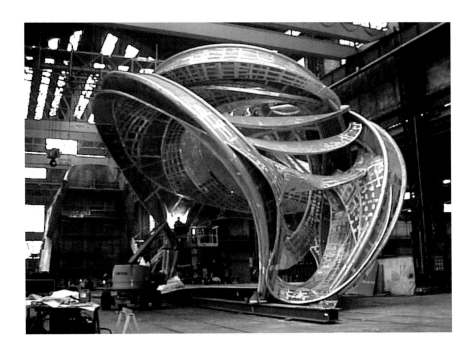

**Tafel / Plate LXXV**
*Amphitryon. A Comedy after Molière [D#4]. Puerto Rico 3rd Millenium Proposal*
*Amphitryon. Ein Lustspiel nach Moliére [D#4]. Vorschlag für Puerto Ricos III. Millenium Monument*
29 x 54 x 44" / 73.7 x 137.2 x 111.8 cm
Plastic, wood
New York, Frank Stella
(FS 645)

Kleist 1995, 91–164.
Kleist 1985, I, 245–320.

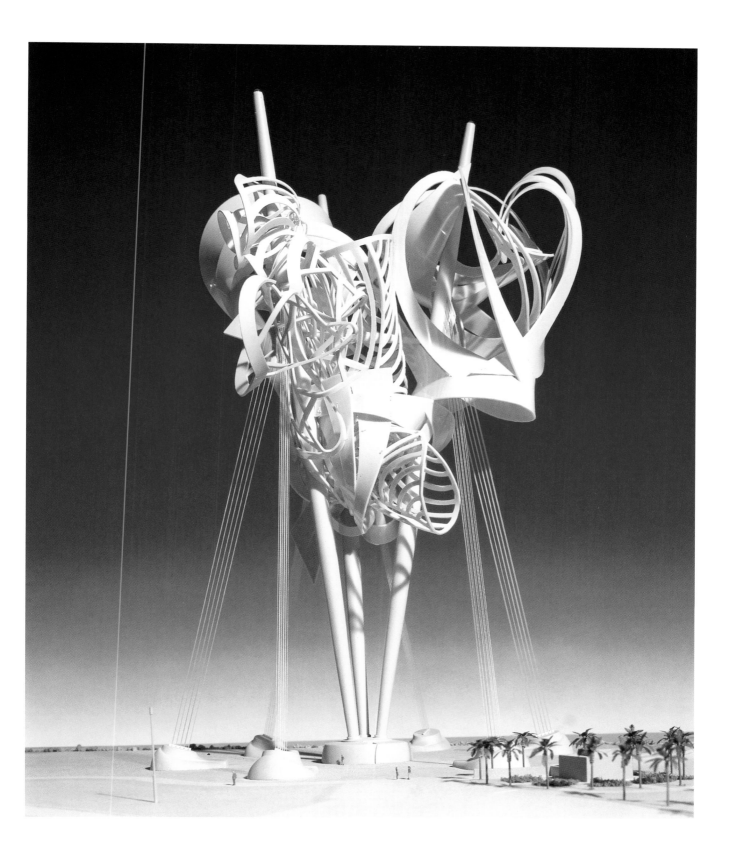

**Tafel / Plate LXXVI**

*Penthesilea. A Tragedy [D#5]. River Sculpture Proposal for Hildesheim*
*Penthesilea. Ein Trauerspiel [D#5]. Vorschlag für eine Skulptur am Fluss in Hildesheim*
1996
Plastic, stainless steel, fiberboard
27 x 55 x 48" / 68.6 x 139.7 x 121.9 cm
New York, Frank Stella
(FS 644)

Kleist 1995, 165–268.
Kleist 1985, I, 321–428.

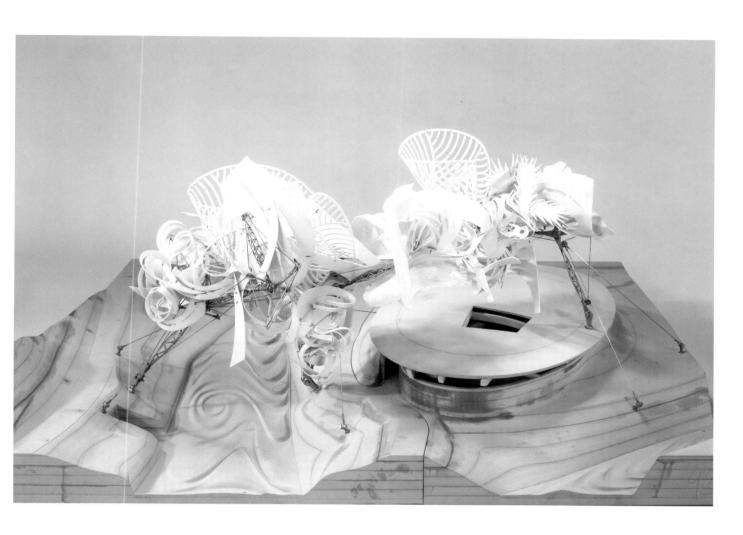

**Tafel / Plate LXXVII**

*Prince Frederick Arthur of Homburg, General of Cavalry. Maquette [D#8]*
*Prinz Friedrich Arthur von Homburg, General der Reuterei. Maquette [D#8]*
1996
Plastic, wood, steel
41 x 47 x 39"/ 104.1 x 119.4 x 99.1 cm
New York, Frank Stella@ Newburgh, Polich Art Works
(FS 602)

Kleist 1995, 270.
Kleist 1985, I, 630.

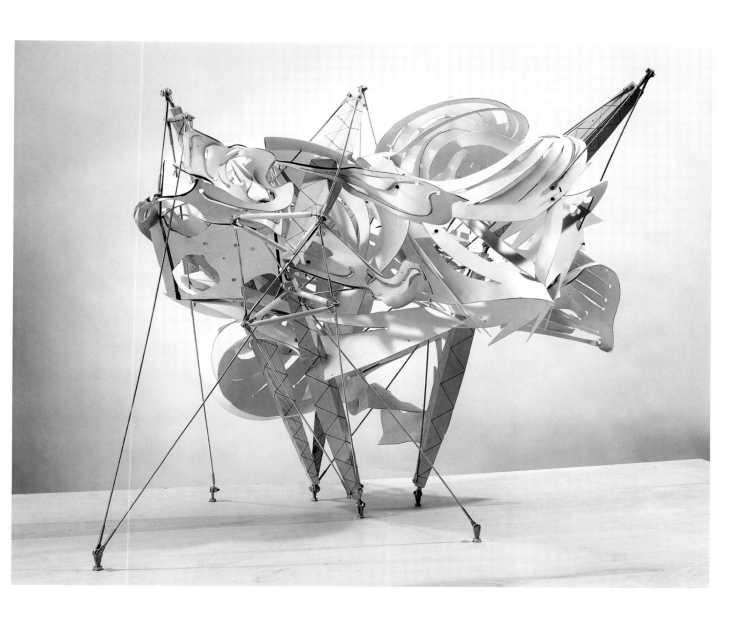

**Tafel / Plate LXXVIII**

*Prince Frederick Arthur of Homburg, General of Cavalry. 1 x [D#8]*
*Prinz Friedrich Arthur von Homburg, General der Reuterei. 1 x [D#8]*
1999
Spandasteel, aluminum, paint on fiberglass, carbon fiber
127 x 156 x 135" / 322.6 x 396.2 x 342.9 cm
Stuttgart, Sammlung DaimlerChryssler
(FS 419)

Kleist 1995, 270.
Kleist 1985, I, 630.

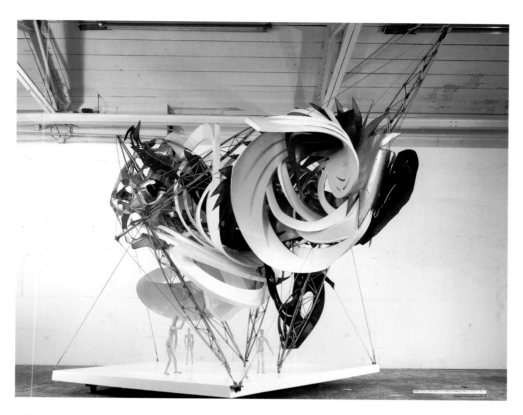

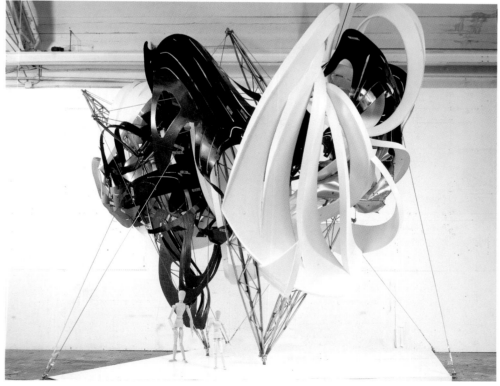

**Tafel / Plate LXXIX**

*Prince Frederick of Homburg. A Play. 3  x [D#8]*
*Prinz Friedrich von Homburg. Ein Schauspiel. 3 x [D#8]*
2001
Spandasteel, aluminum, paint on fiberglass, carbon fiber
366 x 564 x 492" / 929.6 x 1432.6 x 1249.7 cm
New York, Frank Stella
(FS 420)

Kleist 1995, 269–341.
Kleist 1985, I, 629–709.

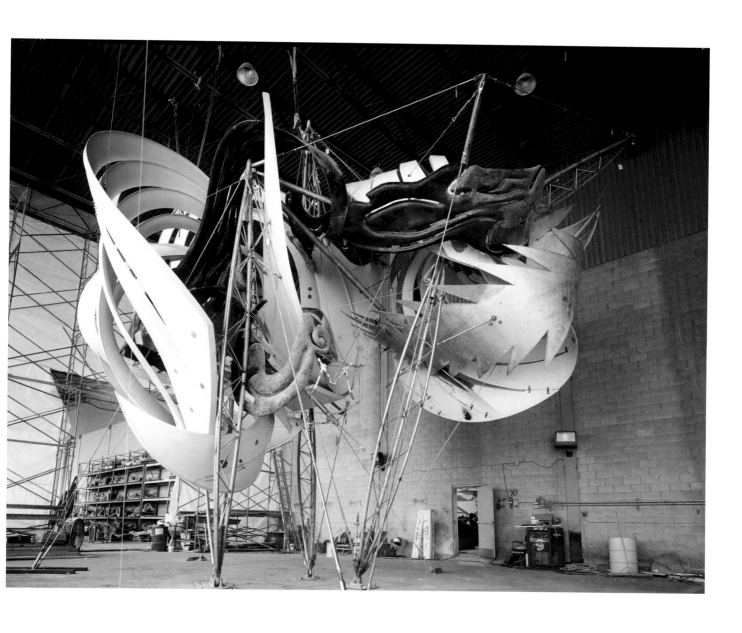

*Frank Stella zum 65. Geburtstag am 12. Mai 2001*

# Herrliche Kunst[1]

*Changing Rules*

Für die Dauer seiner Ausstellung *FRANK STELLA at two thousand. Changing the Rules* im Museum of Contemporary Art in Miami vom 19. Dezember 1999 bis zum 21. März 2000 mietete der Künstler von der Firma *Mogul Media* an der Kreuzung der vielbefahrenen Highways BQE und LIE in Queens[2] jeweils eine Billboard in einer Fahrrichtung an, die auf das Ereignis in Florida aufmerksam machen sollten. Beidseitig warben die monumentalen Werbeflächen mit eigens hergestellten Plakatdrucken für die Werkschau der jüngsten Skulpturen und Gemälde. Auf einer der Bildflächen (Abb. / fig. 1) waren das Gemälde *Cantahar* aus dem Jahre 1998, gerahmt von den Skulpturen *The Broken Jug. A Comedy / Der zerbrochene Krug. Ein Lustspiel*, 1999, und, allerdings fragmentiert, *Chatal Huyuk Level VI B*, 1999, abgebildet. Die Rückseite der Billboard nahm das Bild *The Beggarwoman of Locarno / Das Bettelweib von Locarno* von 1999 ein (Abb. / fig. 2), linksbündig vor schwarzem Grund ergänzt um den Hinweis auf die Ausstellung in Miami. Die zweite Werbetafel füllte in ganzer Breite ein Druck des Gemäldes *The Earthquake in Chili / Das Erdbeben von Chili* aus dem Jahre 1999 (Abb. / fig. 3, 4). Nur ein schmaler horizontaler Streifen oberhalb des Plakats blieb frei und erlaubte die Nennung des englischen Bildtitels sowie das Kürzel des ausstellenden Museums MoCA. In die Leerfläche der unregelmäßig abschließenden Unterkante des Bildes ließ sich noch der deutsche Titel setzen *Das Erdbeben in Chili*.

Die Eigenwerbung Frank Stellas erinnert an die Praxis europäischer Künstler, die sich durch Weckung der Aufmerksamkeit zu empfehlen suchten. Doch unterscheidet sie sich in einem wesentlichen Gesichtspunkt von deren Wettbewerbsformen in der höfischen und städtischen Kultur. Sie macht ausschließlich auf die Kunst selbst aufmerksam, indem sie ihr *höheres geistiges Vermögen – changing the rules –* und ihre *besondere Dignität*[3] als artifizielle Leistung hervorhebt, während der Hofkünstler, Hoflieferant oder Zunftmeister stets mit der Besonderheit seiner Kunst auch ihren repräsentativen Nutzen zur Geltung bringen musste. Demzufolge war die eigentliche künstlerische Absicht von politischen Interessen überlagert, welche die Rezeption der Kunst und den gesellschaftlichen Legitimationsdruck der Künstler bis in die Gegenwart wesentlich mitprägen. In Amerika dagegen stellten sich diese Verpflichtungen nicht. Bereits in den frühen Versuchen, eine eigenständige Kunstszene zu fördern, zeichnet sich als selbstverständliche Voraussetzung der Wunsch ab, allein auf die genuin künstlerischen Anliegen aufmerksam zu machen und den Schaueffekt ausschließlich in den Dienst der Kunst zu stellen. Er war dem Kunstwerk um seiner selbst willen eingeschrieben und unterstützte seine Eigenwirkung.

Bereits eine der frühen Inkunabeln der amerikanischen Malerei, Charles Wilson Peales *The Staircase Group* (Abb. / fig. 5), verstand es, den Schauwert und die künstlerische Dimension auf diese zweifache Weise zu verschmelzen. Charles Wilson Peales[4] 1795 entstandenes Gemälde, welches heute im Philadelphia Museum of Art zu sehen ist,

---

1   Zum Terminus *herrlich* vgl. Heinrich von Kleist, Empfindungen vor Friedrichs *Seelandschaft*, in: Ders., Sämtliche Werke und Briefe, München 1993, Bd. 2, S. 327. Der Text beginnt mit dem Satz *Herrlich ist es, in einer unendlichen Einsamkeit am Meeresufer, unter trübem Himmel, auf eine unbegrenzte Wasserwüste, hinauszuschauen.* Dieser Anfang lässt zunächst offen, ob von Kleist das Gemälde Friedrichs oder eine geschaute Landschaft meint. Der Kunstgriff steigert die Neugierde, wo der Dichter die Unterschiede zwischen der Natursicht und dem Anblick des Bildes sieht. Der Terminus *herrlich* wird hier auch als Annäherung an Frank Stellas Begriff *exalted art* verstanden, welchen der Künstler in seinem zweiten Jenaer Vortrag verwendete. Frank Stella trug seine Thesen im Rahmen einer Podiumsdiskussion der Sektion *Bild und Bildlichkeit. Formelle und informelle Wissensformen im späten 20. Jahrhundert* des XXV. Deutschen Kunsthistorikertages am 20. März 1999 vor. Sie werden erstmals in Frank Stella, *The Writings by Frank Stella*, Hg. Franz-Joachim Verspohl / Ulrich Müller, Jena / Köln 2001 publiziert unter dem Titel *Exalted Art (first draft)*.
2   Brooklyn-Queens und Long Island Expressways.
3   Vgl. Martin Warnke, Hofkünstler. Zur Vorgeschichte des modernen Künstlers, Köln 1985, S. 9.
4   Charles Wilson Peale, 1741–1827, war während seiner frühen Jahre in Annapolis, Maryland, als Sattler, Taschenuhr- und Uhrmacher und Silberschmied tätig. Als er sah, wie grobschlächtig die zeitgenössischen Porträtmaler von Annapolis arbeiteten, nahm er Malunterricht bei John Hesselius, 1728–1788, Sohn des schwedischen Gustavus Hesselius. Später reiste er nach Boston und besuchte John Smiberts Studio, wo er John Singleton Copley traf. 1766 wurde er von einer Gruppe von Förderern aus Maryland nach London geschickt, um drei Jahre in Benjamin Wests Atelier zu verbringen. West und Peale wurden enge Freunde. Sie korrespondierten auch miteinander, als Peale nach Amerika zurückging. West sandte den Söhnen Anweisungen in den bildenden Künsten, als sie begannen, ihren eigenen Weg als Maler zu gehen. Peale, überaus vielseitig, gründete 1786 eines der ersten amerikanischen Museen in Philadelphia, welches auch Malerei ausstellte, aber überwiegend Naturalien sammelte und präsentierte.

bildete gleichsam das Frontispiz der ersten Ausstellung der *Columbianum Academy* in Philadelphia 1795, zu deren Wegbereitern er gehörte. Die Akademie war Vorläufer der ältesten, heute noch bestehenden Kunstakademie Amerikas, der 1807 gegründeten Pennsylvania Academy of Fine Arts. Das durch seine Trompe l'oeil-Effekte bereits ungewöhnliche Gemälde wurde in seiner Wirkung noch dadurch gesteigert, dass der Künstler es statt mit dem üblichen Bilder- mit einen Türrahmen einfasste und auf eine auf dem Galerieboden ruhende Treppenstufe setzte, welche sich illusionistisch im Bild zu einer links ausschwingenden Wendeltreppe ergänzt. Angesichts der optischen Verwirrung, die das Bild stiftet, fällt es dem Betrachter schwer, das Sujet eindeutig zu bestimmen. Intendierte Peale ein Genrebild oder ein Doppelporträt? In der Tat stellt Charles Wilson Peale zwei seiner Söhne lebensgroß dar, welche auf die Vornamen *Raphaelle* and *Titian* hörten und später ebenfalls wie ihr Vater Maler wurden.[5] Zwar lassen sich in der europäischen Bildtradition verwandte Bildmotive zum Vergleich heranziehen, aber das Gemälde wird dadurch unverwechselbar, dass Charles Wilson Peale auf der ersten verbildlichten Stufe der Treppe ein abgelegtes Eintrittsticket zur Ausstellung der *Columbianum Academy* wiedergab, das den Täuschungseffekt vollkommen machte.

Die Täuschung (deception) ist nicht nur das Thema des Billets, sondern des Bildes in seiner Gesamtheit. Rembrandt Peale, der dritte malende Sohn Charles Wilson Peales, berichtet in einer für sich sprechenden, aber zugleich den seit der Antike wirkmächtigen kunsttheoretischen Topos der wirklichkeitsnahen Mimesis transportierenden Anekdote,[6] wie der 1789 gewählte erste amerikanische Präsident George Washington reagierte, als er das Bild in der Ausstellung der *Columbianum Academy* sah. Als der erste Mann der jungen Nation das Bild passieren wollte und sich ihm zuwandte, wich er zurück, machte einen Bogen, zog seinen Hut und verbeugte sich freundlich vor den beiden gemalten Jünglingen. Die Geschichte belegt den doppelten Erfolg des Malers. Das Gemälde vermag den Betrachter nicht nur zu täuschen, sondern es zieht auf besondere Weise auch die Aufmerksamkeit auf sich. Es verschafft sich selbst Raum, indem es den Betrachter räumlich distanziert, welcher sich jedoch gleichzeitig angezogen fühlt. Das leblos dingliche Tableau wirkt wie ein erlebbares *Lebendes Bild*. Es wird als *tableau vivant* erfasst.

Darüber hinaus belegt die Anekdote den von der europäischen Tradition völlig abweichenden Status der Kunst in den Vereinigten Staaten. Es ist nicht an ihr, politischen Instanzen Referenz zu erweisen oder diese von Untergegebenen einzufordern, die in ihr die institutionelle Repräsentation zu sehen gewohnt waren – und dies nicht nur in den Staatsporträts, denen der Untertan Reverenz zu erweisen hatte; vielmehr verneigt sich das amerikanische Staatsoberhaupt vor der Kunst und den Künstlern und anerkennt die Eigenständigkeit der künstlerischen Sphäre. Daher war politischen Vereinnahmungsversuchen oder Invektiven gegen die Künste in Amerika kein langfristiger Erfolg beschieden, wie der Ausgang derartiger Versuche nach dem Zweiten Weltkrieg beweist.[7]

So beiläufig Peales Gemälde für die Stilgeschichte der amerikanischen Kunst reklamiert wird, so aussagekräftig ist es für die amerikanische Malerei in ihrer Gesamtheit, ja die moderne Kunst überhaupt. Sie musste sich stets Aufmerksamkeit verschaffen, die Sinne und das Gefühl herausfordern, was figurativen Malern mit illusionistisch veristischem und Spannung erzeugendem Erzählstil schon bei einigem Talent gelingt und Künstler wie Michelangelo da Caravaggio, Edouard Manet und Pablo Picasso, um nur drei der von Frank Stella hoch geschätzten Künstler zu nennen,[8] zu vollendeter Meisterschaft führten. Allen drei gelang es, die Oberfläche des Bildes aufzubrechen und seine Anziehungskraft nicht nur über das Motiv, sondern vielmehr über die formale Bildgestaltung zu erhöhen. In ihrer haptischen Autonomie sind da Caravaggios *Johannes der Täufer mit dem Widder*, um 1600 entstanden und in mehreren Versionen überliefert, Manets Buffetfräulein in *Un bar aux Folies-Bergère* von 1882 ebenso wie Picassos monumentale weibliche Akte aus der Zeit um 1920 selbstreferentiell; aber sie erreichen jenseits des innerbildlichen Umfeldes, wie Frank Stella beobachtet hat,[9] auch ihren Adressaten, den Beschauer, weil er in den dynamischen Bildraum integriert wird und am Geschehen teilhat. Die Handlung wird in der Darstellung nicht angehalten,

---

5 Charles Wilson Peale benannte seine Kinder zunächst nach Künstlern. Neben den erwähnten Söhnen trug ein dritter den Namen Rembrandts, eine Tochter hörte auf den Angelica Kauffmanns; später wählte er für seine Kinder Namen von Wissenschaftlern, wie Linnaeus und Franklin.

6 C. Plinius d. Ä., Naturkunde, Hg. Roderich König / Gerhard Winkler, München 1978, Bd. 35, S. 71 ff. Plinius leitet den Abschnitt mit dem programmatischen Satz *Imagines adeo similitudinis indiscretae pinxit* ein.

7 Gemeint ist der McCarthyism; vgl. Serge Guilbaut, How New York Stole the Idea of Modern Art. Abstract Expressionism, Freedom, and Cold War, Chicago 1983, S. 205.

8 Frank Stella, Working Space. The Charles Eliot Norton Lectures 1983–84, Cambridge, Massachusetts / London 1986, bes. S. 23 ff.

9 Frank Stella, Working Space. The Charles Eliot Norton Lectures 1983–84, Cambridge, Massachusetts / London 1986, bes. S. 23 ff, S. 71 ff.

sie bleibt unabgeschlossen oder, wie Paul Klee sagen konnte, ihrer *Genesis* ist *Dauer* verliehen.[10] Der moderne Künstler legt bei der Motivwahl des *fruchtbaren Augenblicks* der Darstellung den Akzent auf seine *Dauer* und nicht, wie es noch Gotthold Ephraim Lessing für unverzichtbar erklärte, auf die *unveränderliche Dauer, [...] was sich nicht anders als transitorisch denken lässt.*[11] Liegt der Schwerpunkt bei Lessing auf der durch den Sehakt eingeleiteten gedanklichen Leistung, so liegt er in der Moderne in der Animation der vorbegrifflichen Fähigkeiten.

Frank Stella selbst war dies 1959 gelungen, als die Kuratorin Dorothy Miller den erst dreiundzwanzigjährigen Maler für die Winterausstellung des Museum of Modern Art auswählte und als eines der vielversprechenden Talente in *Sixteen Americans* der New Yorker Kunstwelt vorstellte.[12] Einflussreiche Kunstkritiker reagierten mit heftiger Polemik auf die Serie der *Black Paintings*, zwischen 1958 und 1960 entstanden,[13] und erkannten offensichtlich, dass die schwarzen, modulare geometrische Einheiten bildenden Farbstreifen ein Prüfstein der Minimal Art waren und dank der Wechselwirkung mit dem als Negativfolie diskontinuierlich wahrgenommenen Malgrund den malerischen Illusionismus des Abstrakten Expressionismus erweiterten. Denn während Jackson Pollock, Mark Rothko und Barnett Newman die Malfläche als neutralen Bildgrund behandelten und als notwendigen Farbträger in Kauf nahmen, erkannte sie Frank Stella als gewichtigen bildkonstituierenden Bestandteil und bezog sie in das dialogische Verhältnis von Linie, Farbe und Tonalität ein.

Durch seine Ausbildung in Princeton war Frank Stella mit der europäischen Kunstgeschichte vertraut[14] und hatte gerade bei da Caravaggio, Manet und Picasso entdeckt, dass sie die für die Komposition prägende Dominanz eines als gegeben vorausgesetzten oder determinierten Bildraums aufgaben und ihn als flexible Größe zwischen Bestimmtheit und Unbestimmtheit behandelten, um ihren Bildgestalten einen um so plastischer wirkenden inner- und außerbildlichen Aktionsradius zu öffnen. Der sich bei dieser Behandlung zugleich diffus erweiternde und modifiziert einengende Bildraum verwandelte sich in eine dynamische Größe, welche das Kunstwerk nicht fixiert, sondern in einen Schwebezustand versetzt. Der bewegte Bildraum erlaubt auch den Bildgeschöpfen eine unmittelbarere Präsenz und Wirksamkeit, wie sie bereits Thomas Gainsborough für die von ihm porträtierten Zeitgenossen vorsah. Sie sollten so vor dem Betrachter erscheinen, als kündigten sie ihre Gegenwart mit dem Satz *Here I am* an.[15] Der Bildraum entsteht erst mit ihrem Auftreten. Die Bildgestalten verschaffen sich gleichsam ihren Aktionsraum, ein Wirkungsfeld, welches Frank Stella *working space* nennt und für sich selbst zu einem *Raum zum Arbeiten* erweitert.[16]

Er hatte sich bereits früh das Ziel gesetzt, die Bildfläche des abstrakten Bildes nicht als gegeben hinzunehmen und als plane Ebene aufzufassen, sondern in einen in der figurativen Malerei selbstverständlichen Aktionsraum zu verwandeln. Raum sollte auch in der abstrakten Malerei nicht negiert oder als neutrale Fläche vorausgesetzt werden, er sollte sich vielmehr mit dem innerbildlichen Geschehen selbst erzeugen, wie dies Charles Wilson Peale mit seinem Gemälde *The Staircase Group* gelungen war, um der Malerei in doppeltem Sinne Aufmerksamkeit und Anerkennung zu verschaffen.

Auf Grund der Struktur seiner frühen Bilder war abzusehen, dass Frank Stella das Bildformat flexibel behandeln würde und sich sowohl die *shaped canvas* als auch das Relief oder die Skulptur als Bildform zu eigen machen konnte, wie sein Werkprozess eindringlich belegt. Er überwand die letzte Hürde, welche das Experiment der Moderne zu überwinden hatte, um zu verstehen, welche Bedingungen ein Bild konstituieren – Eigenheiten, die also nicht

[10] Paul Klee, Vortrag Jena, gehalten aus Anlass einer Bilderausstellung im Kunstverein zu Jena am 26. Januar 1924, in: Ausst.-Kat. Jena 1999, Paul Klee in Jena 1924. Der Vortrag, fol. 13 v und S. 65.
[11] Gotthold Ephraim Lessing, LAOKOON oder über die Grenzen der Malerei und Poesie, Stuttgart 1964, S. 23 f.
[12] Ausst.-Kat. New York 1959, Sixteen Americans, Museum of Modern Art.
[13] Lawrence Rubin, Frank Stella. Paintings 1958 to 1965. A Catalogue Raisonné. Introduction by Robert Rosenblum, New York 1986, S. 57 ff.
[14] Frank Stella studierte in Princeton von 1954 bis 1958. Er besuchte zwar schon als Jugendlicher an der Phillips Acadamy in Andover die Malkurse von Patrick Morgan, einem Schüler Lyonel Feiningers, und belegte regelmäßig die offene Malklasse von William Seitz an seiner Universität, aber er verfolgte sein Geschichtsstudium ebenso intensiv, welches er 1958 mit dem Bachelor of Art abschloss. Während des Studiums traf er nicht nur auf Robert Rosenblum und den Kommilitonen Michael Fried, beide Kunsthistoriker, sondern lernte auch die wegweisenden amerikanischen Studien zur Kunstgeschichte von der Renaissance bis zum 19. Jahrhundert, etwa Walter Friedlaenders, kennen. Von besonderer Bedeutung war der Literaturwissenschaftler Philip B. Miller, welcher Frank Stella an Heinrich von Kleist heranführte. Er übersetzte erstmals von Kleists Briefe und Anekdoten. Vgl. Philip B. Miller, An Abyss Deep Enough. Letters of Heinrich von Kleist with a Selection of Essays and Anecdotes, New York 1982.
[15] Thomas Gainsborough an den Earl of Dartmouth am 18. April 1771. Mary Woodall (Hg.), The Letters of Thomas Gainsborough, Greenwich, Connectituct, 1963, S. 51, 53.
[16] Frank Stella, Working Space. The Charles Eliot Norton Lectures 1983–84, Cambridge, Massachusetts / London 1986, bes. S. 10 ff., S. 64 ff.

mit den jeweiligen Besonderheiten ihrer stilistischen Prägung zu verwechseln waren. Hatten Wassily Kandinsky und vor allem Paul Klee die Elemente der bildnerischen Formlehre freigelegt und Jackson Pollock und Alfred Otto Wolfgang Schulze, genannt WOLS, sie in ihren Werken an der schmalen Grenze zwischen Bild und Nicht-Bild ausgelotet, so gelang es Frank Stella, die Merkmale der Bildfläche zu bestimmen und ihren Anteil an der Bildstruktur grundsätzlich zu klären. Der Charakter des Kunstwerkes resultiert demzufolge aus dem Wechselverhältnis der modalen Binnenwirkung der Linien, Farben und Tonalitäten sowie aus ihrer Beziehung zum Malgrund. Die Qualität der malerischen Bewältigung dieses Bezugs entscheidet über die Außenwirksamkeit des Bildes.

Die Experimente Paul Klees, Wassily Kandinskys, Jackson Pollocks, WOLS' und Frank Stellas waren jedoch nicht nur für die Evolution der *bildnerischen Formlehre* von grundsätzlicher Bedeutung, sondern für die ästhetische Weltsicht schlechthin. Hatte die romantische Literatur als erste *das Fehlen einer stabilen Regelung zwischen dem Sensiblen und dem Intelligiblen* erkannt,[17] so leiteten die Genannten aus dieser Einsicht nicht die Sehnsucht nach einem verlorenen Ursprung in der Ferne ab, vielmehr fanden sie die Lösung in ihrer unmittelbaren Nähe, in den Bedingungen künstlerischer Arbeit selbst, indem sie alle tradierten Bildvorstellungen als normative Besonderheiten bloßstellten und zugleich zu relativen Größen und absoluten Werten machten. Bereits Carl Einstein konnte resümieren, dass jede Norm letzten Endes intuitive Willkür sei und die *Realität stets vom Menschen erfunden* werde. Die *mantische Besessenheit* der Romantik wandelt sich in der Moderne des 20. Jahrhunderts zu einem *klar verständlichen Gestaltungswillen*,[18] dem die numinose Seite der Kunst jedoch keineswegs geopfert wird. Vielmehr erhält sie in der abstrakten Malerei erst wieder ihre Gültigkeit; denn die neue Konstitution des Kunstwerks lässt es nicht mehr zu, das Werk als Kommentar des Lebens zu verstehen. Es wird zu seiner Ergänzung.[19]

Die aufgebrochene Bildoberfläche

Angesichts ihrer Eigenheit kamen die Billboards an den Highways, welche Frank Stella im Jahre 2000 in Dienst nahm, seinen Werkbedingungen entgegen. Ihre Konstitution und ihre Wirkungsweise entsprechen den dynamisierten Bildgründen des Künstlers. Die Reklametafeln schweben auf hohen Masten über der Autobahn. Ihre Flächen umgibt der Himmel, von dem sie sich auch bei Dunkelheit durch Beleuchtung abheben. Das Licht bestimmt wesentlich ihre Größenwirkung mit, die sich gerade auch während der Vorbeifahrt noch einmal modifiziert. Die Poster von Frank Stellas Gemälden und Skulpturen sind für die sich nähernden Autofahrer zunächst nur vage fixierbare, farbige Tupfer, die sich nach und nach vergrößern und plötzlich, nur für den Bruchteil von Sekunden, eine anschaulich erfassbare bildliche Einheit ergeben, welche unmittelbar danach wieder entschwindet.

Nur in einer Momentaufnahme ist das Schaubild präsent. Aber genau dieser Moment, da der Betrachter erstmals vor ein Bild tritt und es unmittelbar erlebt, ist es, welcher über das Wohl und Wehe seiner Aufnahme entscheidet. Denn der noch *ungegliederte, unartikulierte Gesamteindruck [ist] keineswegs unbestimmt*, sondern lediglich sprachlich noch nicht fassbar. Der *anschauliche Charakter* des Kunstwerks löst ein grundlegendes emotionales Erlebnis aus, welches die weitere Deutung des Kunstwerks als nachhaltige Sinnschicht prägt.[20] In diesem Moment vermag das Kunstwerk vom Betrachter Besitz zu ergreifen oder ihn kalt zu lassen. Das in diesem Bruchteil von Sekunden erzeugte Gefühl vermag ihn neugierig zu stimmen, zum Verweilen und Hinschauen zu bewegen und die ursprüngliche Wahrnehmung in ein sehendes Ausharren und ein erkennendes Vermögen zu verwandeln.

Die Bandbreite der Techniken zu Gunsten dieser Anziehungsfähigkeit der Bilder ist heute leichter zu übersehen, weil sie in der Vielfalt der modernen Medien einschließlich der Werbung ablesbar ist. Daher nimmt es nicht Wunder, dass die Reklame auch der bildenden Kunst als Folie oder Quelle dient. Gleichwohl käme es einer Untertreibung gleich, wenn behauptet würde, die Malerei der Moderne stehe in einem epigonalen Verhältnis zur Werbung. Im Gegenteil, jene bedient sich der bildenden Kunst bis auf den heutigen Tag. Die Verwertung der Flächigkeit der kubistischen Malerei, der konstruktiven Zerlegung der Bildgegenstände, der mit der Collagetechnik ermöglichten

[17] Vgl. Jean-François Lyotard, Vorstellung, Darstellung, Undarstellbarkeit, in: Ders. u. a., Immaterialität und Postmoderne, Berlin 1985, S. 99.

[18] Carl Einstein, Picasso, in: Ders., Werke. 1929–1940, Wien / Berlin 1985, Bd. 3, S. 86.

[19] Bereits Novalis beschreibt die Einbildungskraft als *Ergänzungstrieb*: *Aus der Anziehungskraft, wenn man sie Kraft nennen will, da sie eigentlich positiver Mangel ist, entsteht der Trieb.* Novalis, Philosophische Studien der Jahre, 1795 / 96, in: Ders., Schriften, Hg. Richard Samuel, Stuttgart / Berlin / Köln / Mainz 1981, Bd. 2, S. 225.

[20] Vgl. Hans Sedlmayr, Pieter Bruegel: Der Sturz der Blinden, in: Ders., Epochen und Werke. Gesammelte Schriften zur Kunstgeschichte, Mittenwald 1977, Bd. 1, S. 324.

Aufhebung des homogenen Bildraumes und der surrealen Verknüpfung sinnverschiedener Darstellungsmuster und Symbolwerte gehören zum festen Vokabular der Werbesprache,[21] welche sich in der Folge auf die grundlegenden Experimente der bildnerischen Formlehre Paul Klees stützen konnte. Mit Charles Wilson Peales The Staircase Group und vielen Schlüsselwerken der Moderne hat die Werbung gemein, dass sie in einem Prozess des Gebens und Nehmens die bildlichen Fähigkeiten und Verfahren entwickelten, Attraktion, Anziehung zu erzeugen, emotionale Bewegung auszulösen und Bilder zu entwerfen, die aus der Geschichte des visuellen Gedächtnisses nicht mehr wegzudenken sind.

Allerdings hat sich die wortmächtige Kunsttheorie der Moderne selbst schwer getan, sich offen zur affektiven Seite der Kunst zu bekennen. In ihren Traktaten und Manifesten betonte sie stets den hohen formalen Anspruch oder warb für ihren Funktionalismus.[22] Sie enthielt sich in selbstgewählter Askese der Kritik tonangebender Kunstliteratur, die sie, um ihr Respekt zu verschaffen, auf ihre rein intellektuellen Dimensionen festzulegen versuchte und an deren anschaulichen Qualitäten sie die formale Logik ihrer Genese hervorhob. Der Affekt, durch den Kontrast von Versunkenheit (absorption) und Theatralik (theatricality) ins Bild gesetzt,[23] mochte der figurativen Malerei des 18. und frühen 19. Jahrhunderts noch ihren Glanz zu verleihen, die Moderne hatte formal konsequent und folglich geistig zu sein.[24] In gewisser Weise wirkte hier das normative System des Akademismus nach, welcher der Kunst ein strengen Regeln unterworfenes Korsett verordnet hatte und sie an der Norm der Form maß.[25] Als sich die Malerei des frühen 20. Jahrhunderts den erneuten Versuchen der Indienstnahme durch die Architektur zu entziehen suchte und Poesie und Expressivität in die Moderne hinüberzuretten wünschte,[26] war sie schon deshalb vogelfrei, weil sie ihre Anregungen an den Bildlösungen von Kindern und von als geistig primitiv oder verwirrt geltenden Schöpfern zu messen begann.[27]

Doch um keine Zweifel an der hohen Intention und Bildwürdigkeit seiner Werke aufkommen zu lassen, entschied sich kein geringerer als Paul Klee, die Darstellung selbst mit dem von ihm gewählten Werktitel zu konfrontieren, indem er beide in unmittelbarer Nachbarschaft in das Gemälde integrierte.[28] Text und Bild konnten nun in einen direkten Wettstreit treten und sich wechselseitig messen. Paul Klee förderte zielgerichtet das jede Bildrezeption voraussetzende Oszillieren zwischen unmittelbarer anschaulicher Sinnlichkeit und sukzessiver zeitlicher Lektüre, zwischen sehendem Sehen und begrifflicher Reflexion. In der Folgezeit galt der Bildtitel nicht mehr ausschließlich als deskriptive Bezeichnung, sondern als Vehikel der Lesarten bildnerischer Formen.

Auch Frank Stella hat bereits die den Beginn seiner professionellen Künstlerlaufbahn prägenden Werke nicht nur mit sprechenden, sondern zugleich hochgradig symbolisch besetzten Titeln versehen. Bereits die Werke der Serie der Black Paintings tragen emotional außerordentlich besetzte Bezeichnungen, welche wie ‚Arbeit Macht Frei' von 1958 und ‚Die Fahne Hoch!' von 1959 bereits seit ihrer ersten öffentlichen Ausstellung hätten aufmerken lassen müssen. Was hat den Künstler zu solchen Titeln bewogen? Waren sie intentional schon bei der Bildentstehung mitgedacht oder sind sie, wie im Falle Jackson Pollocks nachträglich vergeben worden? Inwiefern koinzidiert der Titel mit der Darstellung, oder umgekehrt, auf welche Weise setzt sie sich mit ihm auseinander?

Die Grausamkeit der Kunst

Der Titel ‚Arbeit Macht Frei' erinnert an die dunkelste Phase der Geschichte des 20. Jahrhunderts und war die Legitimation des Nationalsozialismus für systematischen Mord. Wollte Frank Stella diese unfassbare Dimension mit dem gleichnamigen Bild der Erinnerung gegenwärtig halten? Oder ging es ihm darum, das grausame Verbrechen mit

[21] Vgl. Franz-Joachim Verspohl, Kunst in der Werbung, Werbung als Kunst, in: Günther H. Reith (Hg.), 1888–1988. 100 Jahre Lingner-Werke Dresden–Düsseldorf, Bühl 1988, S. 74–90.
[22] Etwa im Futurismus und russischen Konstruktivismus.
[23] Vgl. Robert Rosenblum, Transformations in Late Eighteenth Century Art, Princeton, New Jersey, 1967 und Michael Freed, Absorption and Theatricality. Painting and Beholder in the Age of Diderot, Chicago / London 1980
[24] Vgl. Wassily Kandinsky, Über das Geistige in der Kunst, Bern 1963 (7).
[25] Vgl. Ernst H. Gombrich, Norm and Form. Studies in the Art of the Renaissance, London / New York 1966, S. 129 ff.
[26] Beispielhaft wird die Differenz am Bauhaus in Dessau ausgefochten, als Hannes Meyer 1928 sein Direktor wurde und alle Künste der funktionalen Baugestaltung nachordnen wollte. Vgl. Hans M. Wingler, Das Bauhaus, Bramsche 1968 (2), S. 148 ff.
[27] Daher blieben Versuche, den Künstlern mentale Störungen nachzuweisen, kein Einzelfall. Vgl. exemplarisch den Fall Paul Klee in: Ausst.-Kat. Jena 1999, Paul Klee in Jena 1924. Der Vortrag, S. 176 ff.
[28] Vgl. Osamu Okuda, Paul Klee: Buchhaltung, Werkbezeichnung und Werkprozess, in: Wolfgang Kersten (Hg.), Radical Art History, Zürich 1997, S. 375 ff.

der unabdingbaren Konsequenz künstlerischen Ausdrucks zu verbinden? Ohne dass die eine oder die andere Analogie zur verbindlichen Ausgangsfrage der Interpretation des Bildes gemacht werden müsste, erweckt das Gemälde den Eindruck unerschrockener Folgerichtigkeit, welche mit der Konsequenz absoluter Gewalttätigkeit verglichen werden könnte. (Abb. / fig. 6) Bereits Carl Einstein äußerte über Pablo Picassos Bilder, sie kämen *einem Mord an der unmittelbaren Natur gleich*. Er habe begriffen, *dass der Tod der Realität eine unerlässliche Bedingung für die Schaffung eines eigenständigen Werkes sei*, zeichne aber andererseits, *was psychisch wahr und menschlich unmittelbar ist*.[29]

In ,*Arbeit Macht Frei*' teilt ein bildzentriertes Achsenkreuz die Leinwand in vier gleiche Felder, in denen sich jeweils dem rechten Winkel der vier Querrechtecke folgende und daher ihren Richtungsverlauf ändernde Farbstreifen so lange verjüngen, bis am oberen und unteren Bildrand ausschließlich der horizontale Balken als schmale Fläche übrig bleibt. Das Gemälde ,*Die Fahne Hoch!*' unterscheidet sich zunächst nur darin von ,*Arbeit Macht Frei*', dass es die Binnengliederung im Hochformat aufgreift, so dass sich die Farbwinkel an den Bildrändern links und rechts zu senkrechten Farbstreifen verkürzen. In beiden Bildern suggerieren diese Randzonen jeweils den Eindruck, als setze sich auch hier der Richtungswechsel im rechten Winkel fort. Die Täuschung ist eine Folge des Freiraums zwischen den Streifen, welcher sie, da er ein passiver Begleiter ist, zunächst nur von einander trennt. Andererseits käme die Irritation nicht zustande, wenn der Künstler der Komposition nicht das Fadenkreuz zugrundegelegt und es nicht als den die Abfolge bedingenden Auslöser festgelegt und willkürlich gesetzt hätte. Die artifizielle Setzung hebt sich jedoch in der Wechselwirkung von passiven Linien und Farbstreifen auf. Das Gemälde erscheint als gegebene Einheit, deren System in sich selbst schlüssig ist und dessen Kräfte sich ohne äußeres Zutun entfalten. Das Bild ist zu einem selbstreferentiellen Wirkungsfeld mit eigenständiger Dynamik geworden.

Die Schärfe und Unerbittlichkeit, mit der Frank Stella gerade in diesen beiden zur Gruppe der *Rectilinear Patterns* zählenden Gemälde die malerische Konstruktion in eine unumstößliche, nicht mehr aus dem visuellen Gedächtnis wegzudenkende absolute Form verwandelt hat, deuten sich in den Bildtiteln an. Sie alle sind, wie Robert Rosenblum schrieb, verbunden mit dem *wide spectrum of human sorrows, from New York tenements (,Arundel Castle') and a Chicago cemetery (Getty Tomb) to a London insane asylum (Bethlehem's Hospital) and the Nazi concentration camp at Auschwitz (Arbeit Macht Frei). Such elucidations helped to deny the usual early response to these paintings – that they were thoroughly hermetic and cerebral – and to confirm the growing revelation that they reflect an awareness of such universal gloom that they may even end up as younger-generation counterparts to the sober, life-denying mood of many of Rothko's own late series paintings.*[30]

Doch nicht nur an den Titeln der frühen Werkserie wird diese Spannung ablesbar. Sie ist dem malerischen Verfahren Frank Stella inhärent und wird an seinem Umgang mit der Tonalität des Bildes nachvollziehbar. Im Gegensatz zu ,*Die Fahne Hoch!*', wo die *rivulets*, wie Robert Rosenblum die Leerstellen zwischen den schwarzen Farbbahnen nennt, den Farbton der Leinwand durchscheinen lassen, sind in ,*Arbeit Macht Frei*' die schmalen, linear wirkenden Zwischenräume ebenfalls farbig. Der Auftrag dünnflüssiger schwarzer Farbe verleiht dem Bild eine diffus dunkle Tonalität, deren das Licht absorbierende Tiefe dem Kunstwerk hohe Symbolkraft verleiht.

Es zeigt sich, dass Frank Stella bereits in diesen frühen Gemälden das künstlerische Repertoire der Moderne beherrscht und bewusst einsetzt. Er kennt nicht nur die Grundlagen der *bildnerischen Formlehre*, sondern weiß um die vielschichtigen Dimensionen ihrer Wirkung. Die von Frank Stella willkürlich festgelegte und definierte, aber ikonisch wirkende, sich jeder *empirischen Kommensurabilität*[31] entziehende Bildstruktur antwortet, stilgeschichtlich betrachtet, auf die modal erzeugt wirkenden Bildformen der Malerei des Abstrakten Expressionismus und des Color Field Painting, obwohl hier die malende Hand wie in Jackson Pollocks drip paintings ganz ausgeschaltet war oder wie in Barnett Newmans color fields keinen expressiven Entfaltungsrahmen besaß. Gleichwohl hinterlassen gerade diese Werke eine kontingente Wirkung und wecken eher unbestimmte Assoziationen, welche jedoch im Moment ihrer Evokation wieder zerstört werden. Hier dient die Unbestimmtheit von Form und Raum ihrer unendlichen Metamorphose. Bei Frank Stella verschafft die Bildlogik den Bildelementen eigene dynamische Energien wie

[29] Carl Einstein, Picasso, in: Ders., Werke. 1929–1940, Wien / Berlin 1985, Bd. 3, S. 83 f.
[30] Robert Rosenblum, in: Lawrence Rubin, Frank Stella. Paintings 1958 to 1965. A Catalogue Raisonné. Introduction Robert Rosenblum, New York 1986, S. 11.
[31] Max Imdahl, Ikonik. Bilder und ihre Anschauung, In: Gottfried Boehm (Hg.). Was ist ein Bild?, München 1994, S. 324.

sie die Gestalten in den ereignisreichen Bildtableaus der figurativen Malerei haben. Ihre selbstreferentielle Absolutheit ist, so paradox es klingt, eine relative Größe.

Auf welche Weise gelangte Frank Stella zu dieser Bildform, dem es, als er zu malen begann, scheinen musste, als sei von Jackson Pollock, Barnett Newman und Morris Louis bereits alles gesagt? Blieb ihm eine andere Möglichkeit, wie er später indirekt bekannte, als die Kunst, die er beerbt hatte, zu häuten.[32] Jackson Pollock hatte bereits in *Out of the Web: Number 7, 1949* aus dem Jahre 1949, heute in der Stuttgarter Staatsgalerie, dieses Verfahren angewandt. Er schnitt aus dem Farbgemenge des informell-polyfokalen *All over* seiner Gewebebilder unregelmäßige Stücke heraus, ohne die Leinwand zu verletzen, und versuchte, der unbestimmbaren Hintergrundtiefe des Farbgemenges mit den *cut outs* eine erhabene Dimension zurückzugeben, die er als rein formale Qualität begriff. Das Relief sollte sich optisch-haptisch in den Distanzraum zwischen Bildoberfläche und Betrachter ausdehnen. Durch Barnett Newman wurde diese bildnerische Vorgabe ideell überhöht und in Anlehnung an die Rezeption der Romantik zur *Erhabenheit* (*sublime*) des Kunstwerks umgedeutet. Es sollte mit dem Gefühl der Gegenwärtigkeit die Raum-Zeit-Erfahrung verschmelzen und das *Selbst, schrecklich und konstant* zum *Gegenstand von Malerei und Skulptur* machen.[33]

Frank Stella wollte sich jedoch auf diesen zugespitzten Subjektivismus nicht berufen und betonte die Ergänzungsfunktion der Kunst gegenüber dem Selbst, die er als Vermächtnis in einem der letzten Werke des greisen Tizian aufgehoben sah,[34] der *Schindung des Marsyas*, welche 1673 Karl von Liechtenstein, Bischof von Olmütz, für seine Sammlung erwarb und die von dort in den erzbischöflichen Palast von Kremsier (Kroměříž) gelangte.[35] Sollte der venezianische Malerfürst in dem Bild eine Summe seines künstlerischen Schaffens gezogen haben, hinterließ er eine grausame Botschaft. Auf Befehl des Gottes der Musen muss sich ein freilich hypertropher Künstler unter Qualen, wie sie nur Märtyrer für ihren Glauben zu erdulden hatten, schinden lassen. Die Häutung wird dem Altmeister zur Metapher der künstlerischen Arbeit. Das Malen ist eine Schindung des leibhaftig Gesehenen und Gefühlten und zugleich seine Bannung auf eine dinghafte Leinwand, die sich unter einer Vielzahl von Bildern behaupten muss und Aufmerksamkeit erheischen will. Das Bild soll seinen Dingcharakter überwinden und aus sich heraus *leben* mit der für den Künstler ambivalenten Konsequenz, dass seine Leistung sich aufhebt und nur noch indirekt, als Wissen der Nachwelt zur Geltung kommt.

Die Grausamkeit der Kunst ist demnach doppelter Natur. Einerseits hat sie ihre Ursache im schöpferischen Werkprozess, dessen Gewalttätigkeit Werner Herzog in seinem Film *Fitzcarraldo* im Spannungsfeld von brutaler Besessenheit und Schöpferwahn ausgeleuchtet hat.[36] Andererseits tilgt das Kunstwerk selbst alle Spuren des Lebendigen, um eine neue, künstlich geschaffene Wirklichkeit zu erzeugen, wie sie in der Konkurrenz zwischen *Fitzcarraldos* Opernhaus und dem tropischen Regenwald Brasiliens nachvollziehbar wird. Frank Stella hält diese doppelte Grausamkeit der Kunst in der monumentalen Skulptur *Fitzcarraldo* von 1993 und einer nicht weniger großen, zweiten Plastik mit dem Titel *Werner Herzog Eats His Shoe*, ebenfalls 1993 entstanden, gegenwärtig. Am Ende des schöpferischen Prozesses bleibt ein abgeschlossenes Kunstwerk zurück, dessen Überleben von seiner *Lebendigkeit* abhängt, damit es sich im Wettstreit mit der die Schaulust des modernen Lebens herausfordernden Dingwelt behaupten kann.

Gleichzeitig richtet sich die Grausamkeit des Künstlers jedoch auch gegen die künstlerische Tradition und seine Vorgänger oder Rivalen.[37] Als Frank Stella die monochromen Farbfelder von Barnett Newmans monumentalen Gemälden wie *Cathedra*, 1951, quasi in Streifen zerlegte, von der Leinwand zog und, in schwarze Farbe getaucht, auf seine erhabenen Malgründe auftrug, bannte er mit unübersehbar melancholischem Gestus die Farbfeldmalerei, wobei er die farbigen, von Newman selbst *Reißverschlüsse* genannten, sparsam verwendeten und schmalen, aber wirksam die monochromen Farbflächen teilenden und rhythmisierenden Farbstriche in passive Linien umwandelte und in den Dienst axial symmetrisch angelegter, geometrischer Muster stellte. Damit war bewiesen, dass auch festgelegte und definierte Bildgrößen und Bildstrukturen informell werden können und die Bildfläche in einen instan-

---

32  Vgl. Frank Stella, Working Space. The Charles Eliot Norton Lectures 1983–84, Cambridge, Massachusetts / London 1986, S. 100 ff.
33  Barnett Newman, zit. n. Armin Zweite, Barnett Newman. Bilder, Skulpturen, Graphik, Ostfildern-Ruit 1999,S. 63 ff, bes. S. 21.
34  Vgl. Ausst.-Kat. Venedig / Washington 1990 / 1991, Titian. Prince of Painters, Palazzo Ducale / National Gallery of Art, S. 370 ff.
35  Das Bild war 1983 in London und 1990 / 1991 in Venedig und Washington ausgestellt.
36  Zu Werner Herzogs Film *Fitzcaraldo* siehe Monika Steinhauser, Der Zeuge des Erhabenen. Ein Seitenblick auf Werner Herzog Film *Fitzcarraldo*, in: Kritische Berichte, Bd. 10 / 1982, Nr. 2, S. 48–56.
37  Beispielhaft zu Benvenuto Cellini Horst Bredekamp, Die Kunst des perfekten Verbrechens, in: Die Zeit, 50 / 2000, 7. Dezember, S. 51.

tanen Bildraum und seine Teilelemente in ein dynamisches Ganzes zu überführen erlauben. Frank Stella gelang bereits mit diesen frühen Bildern und in vollem Bewusstsein für die Folgen, der abstrakten Malerei jene Seite zurückzugewinnen, welche in der Kunstliteratur als eine nachgeordnete Dimension bewertet wurde, den lebendigen Raum, den Jackson Pollock und Barnett Newman eher diffus und damit der haptischen Kontrolle entzogen wirken ließen, so dass er als seine Negation oder als Sphäre einer spirituellen Wirklichkeit verstanden werden konnte.[38]

## Die Gewalt der Kunst

Frank Stella sicherte der bildenden Kunst mit der Vollendung des von Paul Klee begonnenen Experiments der bildnerischen Formlehre eine Plattform, auf der sie von der Legitimierung gegenüber den anderen Künsten frei wurde. Sie hatte sich ihr eigenes Formrepertoire geschaffen, welches sie der Vergleichbarkeit mit der Dichtung und der Musik enthob und den Rangstreit zwischen ihnen erledigte. Daher konnte die Malerei im späten 20. Jahrhundert wieder entspannter auf die anderen Künste schauen und auch dem Umgang mit der Literatur neue Dimensionen abgewinnen. Zwar nahmen die wechselseitigen Impulse für ein ranggleiches Miteinander seit dem ausgehenden 18. Jahrhundert zu,[39] doch waren es die bildenden Künste selbst, die die Zeichen der Zeit nur bedingt zu nutzen wussten, zumal der Nachweis der Bildeigenständigkeit und Bildmächtigkeit immer vermittelt erfolgt. Erst Paul Klees Nachweis der Parallelität von textlicher und bildlicher Lektüre[40] erlaubte den Künstlern, bewusster auf die Bildlichkeit der Dichtung zu schauen. Schließlich erkannten sie auch hier vergleichbare werkästhetische Voraussetzungen und Grundlagen, die mit der Literatur um 1800 besonders deutlich zutage traten.

Johann Wolfgang von Goethe, Novalis und Heinrich von Kleist entwarfen eine Sprache, in der *Worte und Figuren [...] sich in beständigem Wechsel [bestimmen]*. Novalis sehnte sich zwar nach einer *goldenen Zeit*, in der *alle Worte – Figurenworte – Mythen – und alle Figuren – Sprachfiguren – Hieroglyfen seyn werden*, in der *man Figuren sprechen und schreiben – und Worte vollkommen plastisiren, und Musiciren lernt*,[41] wusste aber um den metaphorischen Kern seiner Sehnsucht nach einer neuartigen Hieroglyphenschrift. Die Evokation von Bildern mittels Sprache und umgekehrt von Sprache mittels Bildern setzte die absolute Abstinenz von Versuchen voraus, die Gattungsebenen zu verwischen. In dieser Hinsicht hatten die Schriftkünste nach der gleichen Strenge und Grausamkeit zu verfahren wie die Bildkünste. Texte können nicht Bilder und Bilder nicht Texte sein. Sie lassen sich im jeweils anderen Medium nur durch ihre Nichtung evozieren, deren Verfahren Heinrich von Kleist auf besondere Weise nutzt. In der drangvollen erzählerischen Dichte seiner Texte bleibt kein Platz für den Entwurf von Bildern, welche sich jedoch gerade deshalb einstellen, weil sie fehlen. Der Kontext der Handlung ruft sie unwillkürlich hervor. Gleiches gilt für die Musik. Sie wird bei von Kleist nicht beschrieben, sondern durchwebt die Novelle *Die Hl. Cäcilie oder die Gewalt der Musik (Eine Legende)*. Gerade weil Heinrich von Kleist Bilder und Töne nur benennt und ihre Formen abbreviaturhaft im erzählerischen Aktionsfeld aufscheinen lässt, konnten seine Werke Frank Stella zu einer umfassenden Werkserie anregen, mit er sich zwischen 1995 und 2001 beschäftigt hat.

Frank Stellas Gemälde *St Cecilia or The Power of Music (A legend)* / *Die Hl. Cäcilie oder die Gewalt der Musik (Eine Legende)* sollte ursprünglich *Isaura* heißen. Den eher ungewöhnlichen Namen entlieh der Künstler dem Romantitel *Die Sklavin Isaura* des Brasilianers Bernardo Guimaraes. Hinter der Romanheldin verbirgt sich Maria do Carmo Jeronimo, die 1871 auf einem Landgut in Carmo de Minas, im Süden des brasilianischen Staates Minas Gerais, geboren wurde. Sie hatte zunächst als Sklavin arbeiten müssen, zumindest bis Brasilien 1888 die Sklaverei offiziell abschaffte. Dann diente sie als Hausangestellte und starb im Juni 2000 mit 129 Jahren als zu diesem Zeitpunkt älteste Frau der Welt. Bereits wesentlich früher hatten die Medien nach der historischen Vorbild für Bernardo Guimaraes' Romangestalt gesucht, sie schließlich aufgefunden und zum Medienstar aufgebaut. So konnte sie sich 1996 den ersten von drei Lebenswünschen erfüllen, das Meer bei Rio de Janeiro zu sehen und den Strand von Copacabana zu betreten. Im folgenden Jahr traf sie den Papst auf dessen Brasilienreise. Schließlich erfüllte sich auch ihr dritter Wunsch, als sie dem brasilianischen Popstar Roberto Carlos begegnete. Aus der Erfüllung ihres dritten Wunsches lässt sich auf ihre Hingabe an die Musik schließen, welche den Sklaven als ein wichtiges Symbol der Wahrung ihrer Identität und Eigenheit galt.

---

[38]  Vgl. Armin Zweite, Barnett Newman. Bilder, Skulpturen, Graphik, Ostfildern-Ruit 1999, S. 63 ff, bes. S. 99.
[39]  Vgl. Johann Wolfgang von Goethe, Winckelmann, Stuttgart 1961, S. 38.
[40]  Paul Klee, [ Schöpferische Konfession], in: Ausst.-Kat. Jena 1999, Paul Klee in Jena 1924. Der Vortrag, S. 120 ff.
[41]  Novalis, Freiberger naturwissenschaftliche Studien 1798 / 99, in: Ders., Schriften, Hg. Richard Samuel, Stuttgart / Berlin / Köln / Mainz 1983, Bd. 3, S. 123 f.

Daher ist es nicht erstaunlich, dass Frank Stella, als er daran ging, die Heinrich von Kleist- Serie zu planen, aus dessen Œuvre ohne Willkür einen neuen Titel für das bereits als Collage realisierte Gemälde entlehnen konnte. Bereits im 19. Jahrhundert war *The Power of Music* ein bildwürdiges Genre in den Vereinigten Staaten, dessen Darstellung sich der Maler William Sidney Mount (1807–1868) mehrfach widmete. Immer verband er, wie in seinem gleichnamigen Gemälde von 1847, heute im Eigentum der New Yorker *The Century Association*, mit dem Thema die Darstellung von Afroamerikanern. In *The Power of Music* lehnt ein Farbiger von schöner Gestalt an einem Scheunentor und lauscht, getrennt vom Geiger und seinen übrigen Hörern, hingebungsvoll den Klängen. Seine bildliche Isolierung hebt ihn von der Menge ab und verstärkt den Eindruck seiner Hingabe.

Dass Frank Stella die Gewalt der Musik bildlich zunächst mit der Sklavin Isaura und dann mit von Kleists Novelle verband, mag mit dem Hinweis auf Aby Warburgs Theorie über das eigenwillige Nachleben geselliger Motive, ihr Untertauchen und ihre plötzliche Wiederkehr als *Pathosformel*,[42] zwar nur psychologisch als Erklärung überzeugen, doch erlaubt der Hinweis zumindest eine Deutungsperspektive. Die Gewalt der Musik ist zugleich die Gewalt der Kunst. Beide sind herrlich und erhebend, sie ziehen in den Bann und verzaubern. Heinrich von Kleist schildert ihre Wirkung in der höchstmöglichen Form als Folge göttlich inspirierter, übernatürlicher Kraft, welche sich nur der Rezeption der Jünglinge erschließt, die zu den wenigen Zeitgenossen gehören, an denen sich ein Wunder vollzieht. Dient von Kleist diese Wirkmacht als Vorbild? Will Kunst derartig faszinieren, dass sie aus ihren Rezipienten wie aus von Kleists rebellischen Jünglingen vollends ihres Intellekts beraubte und in seligem Wahn ihr Leben beschließende Liebediener macht?

Unter dem Blickwinkel aufgeklärter Ästhetik scheint diese Vermutung eher unzulässig. Zwar liefert die Kunstgeschichte, wie auch Frank Stella wohlbekannt, zahlreiche Hinweise, dass diese absolute Wirkung wörtlich genommen worden ist. Daher liegt es nahe anzunehmen, dass sowohl von Kleists Novelle als auch das Gemälde *St Cecilia or The Power of Music (A legend)* / *Die Hl. Cäcilie oder die Gewalt der Musik (Eine Legende)* mit diesem Extrem der Wirkkraft von Kunstwerken spielen. Da ihre übernatürliche, nur der Vorstellung zugängliche Wirkung aber von Heinrich von Kleist bereits in eine vollendete symbolische Form gebracht wurde, kann sie Frank Stella nicht wiederholen wollen. Näher liegt es, dass er sich auf ihre profane heutige Form besann; denn bei einer Autofahrt durch New York am 2. März 2000 deutete er lächelnd auf die vielen Passanten mit walkmen, weil er zuvor nach der Aktualität der von Kleist-Stoffe befragt worden war; er machte beiläufig auf eine der modernen alltäglichen Formen der Gewalt der Musik aufmerksam. Zwischen dieser irdischen Suggestionskraft der Töne einerseits und der absoluten Wirkung göttlicher Sphärenmusik andererseits blieb Raum für eine epochale Ausdrucksform der Kunst.

Frank Stellas bildliche Fassung der Gewalt der Musik ist so kunstvoll, *dass man alles zum Leben vermisst, und die Stimme des Lebens dennoch [...] vernimmt*,[43] eine Maxime, welche Heinrich von Kleist schon in Caspar David Friedrichs *Seelandschaft*, besser bekannt als *Der Mönch am Meer* aus den Jahren 1809 und 1810,[44] eingelöst sah (Abb. / fig. 7). Einerseits hat dieses Bild *nichts* als den *Rahmen*, so dass es den Betrachter zu der Vorstellung verleitet, ihm seien *die Augenlider weggeschnitten*. Hier enthüllt Kunst die grausam gewalttätige Seite ihres Januskopfes. Andererseits wird Friedrichs Bild für von Kleist zum Vehikel, sich selbst beim Anblick des Werkes als *einzigen Lebensfunken* in der Welt zu begreifen.[45] Hier offenbart Kunst ihr zweites Gesicht, ihre *herrliche* Seite. Ihre Größe beruht darauf, eine Wechselwirkung zwischen dem Anspruch des Beschauers und dem *Abbruch, den [...] das Bild tat*, zu stiften. Beim Anblick der Natur *tut* diese den *Abbruch*. Das Gemälde gleicht einer negativen Darstellung, einer *Apokalypse*, und ist doch wirklichkeitsnah und wirklichkeitserweiternd, da es, freilich mit anderen Werkstoffen ausgeführt, selbst Wölfe und Füchse *zum Heulen* zu bringen vermöchte.[46] Die Anmutung von Caspar David Friedrichs *Seelandschaft* beruht auf der Synthese von grausam gewalttätiger Schöpfung und verschwenderischem Erfindungsreichtum – eine Synthese, für die gut einhundert Jahre später Paul Klee den musikalischen Terminus der *Polyphonie* einführt, welche er zum Maßstab eines vollkommenen Gemäldes macht.[47] Denn die einzelnen *Dimensionen* des Bildes sind gerade auf Grund der ihnen innewohnenden Potenz zur *Vielstimmigkeit* in wech-

42  Aby Warburg, Dürer und die italienische Antike, in: Ders., Gesammelte Schriften, Nendeln 1969, S. 446.
43  Heinrich von Kleist, Empfindungen vor Friedrichs *Seelandschaft*, in: Ders., Sämtliche Werke und Briefe, München 1993, Bd. 2, S. 327.
44  Vgl. Helmut Börsch-Supan / Karl Wilhelm Jähnig, Caspar David Friedrich. Gemälde, Druckgraphik und bildmäßige Zeichnungen, München 1973, Nr. 168.
45  Heinrich von Kleist, Empfindungen vor Friedrichs *Seelandschaft*, in: Ders., Sämtliche Werke und Briefe, München 1993, Bd. 2, S. 327.
46  Heinrich von Kleist, Empfindungen vor Friedrichs *Seelandschaft*, in: Ders., Sämtliche Werke und Briefe, München 1993, Bd. 2, S. 327 f.
47  Paul Klee, Vortrag Jena, gehalten aus Anlass einer Bilderausstellung im Kunstverein zu Jena am 26. Januar 1924, in: Ausst.-Kat. Jena 1999, Paul Klee in Jena 1924. Der Vortrag, fol. 6 r und S. 53. Der Begriff bürgert sich in der Kunstliteratur nur wenig später ein. Carl Einstein gebraucht ihn bereits mit Blick auf Picasso als konsensfähiges Merkmal, wenn er von der *Polyphonie der Oberfläche* spricht. Carl Einstein, Pablo Picasso. Einige Bilder von 1928, in: Ders., Werke. 1929–1940, Wien / Berlin 1985, Bd. 3, S. 16.

selseitigem Mitklang prädestiniert, wenn der Bildraum wie ein *gyroscope (Kreisel)* aufgebaut ist, welcher *Bewegung und Neigung aufeinander abstimmen kann (capable of accomodating movement and tilt)*. In diesem Sinne schreibt Frank Stella Paul Klees Kunsttheorie fort und vergleicht den Bildraum dem Innenraum eines Kreisels, in dem der Betrachter den Schwung und die Bewegung des Bildgeschehens erfährt (*experiencing the moment and motion of painting's action*).[48] Das Bilderlebnis wird dem Aufenthalt in einem von Orgelmusik erfüllten Kirchenraum vergleichbar.

Die monumentale Gemäldefassung der *Hl. Cäcilie oder die Gewalt der Musik* von Frank Stella besteht im Gegensatz zur gleichnamigen, kleinformatigeren Collage aus fünf *shaped canvases*. Das mehrstimmige Orgelwerk ist zerlegt und in Aktionsfelder eingeteilt. Die Teile stimmen zwar zu einem harmonischen Ganzen zusammen, aber die Hängung überwältigt nicht, wie dies vor Barnett Newmans Serie monumentaler Großformate *Who's Afraid of Red, Yellow and Blue I–IV* aus den Jahren 1966 und 1970, bereits im Werktitel als denkbares Verhalten vorweggenommen, geschehen kann. Frank Stella vermittelt eine Ahnung von der Gewalt der Kunst, aber er will sie, aufgeklärt genug, in ihrem irdischen Gewande gegenwärtig machen, als *herrliche* Kunst. Insofern hat Frank Stella wie Heinrich von Kleist Lehren aus dem Geist von Klassik und Romantik gezogen und die Regeln zu Gunsten eines Ausgleichs zwischen erhabener Wirkung und Distanz verändert.

Die Herrlichkeit der Kunst

In den beiden Novellen *Das Erdbeben in Chili* und *Die Verlobung in St. Domingo* gestehen sich die Paare nicht nur ihre Liebe, sondern erschaffen sich auch in höchster Vollkommenheit. So knapp von Kleist das Geschehen zeichnet, so abbreviaturhaft lässt er die Liebenden ebenso vollkommene Bilder des friedlichen Glücks und der Geborgenheit in arkadischen Landschaften entwerfen, die ihrer Seligkeit einen Ort geben sollen.

Die vier Landschaften Frank Stellas der *Kleist: Quotations (from ,The Betrothal in Santo Domingo') / Kleist: Zitate (aus ,Die Verlobung in St. Domingo')* mit dem jeweiligen Titel *'... on the banks of the Aar'* / *'... an den Ufern der Aar'* und den Untertiteln *[Felder], [Wiesen], [Gärten], [Weinberge]* sind in der Novelle von Kleists nur ein Stichwort des Schweizers Gustav von der Ried an seine Geliebte Toni, der diese Gegenden fremd sind und bleiben müssen, da sie Europa nie gesehen hat und nie erleben wird. Nur die Stimme des Freundes, dessen Worten Toni in innigster Nähe vertrauen kann, nimmt den Landschaften ihre Fremdheit. Die Mulattin verwandelt seinen tröstenden Hinweis auf die Besitzungen der Familie an den Ufern der Aar mit Feldern, Gärten, Wiesen und Weinbergen in vorgestellte Bilder. Die Innigkeit verleiht der Imaginationskraft der liebenden Frau Flügel. Ihr Gefühl verwandelt die knappe Aufzählung vor ihrem inneren Auge in eine Wunderwelt und lässt ein Paradies entstehen, welches sie so wirkmächtig fühlt, dass *ihre Tränen in unendlichen Ergießungen auf das Bettkissen niederflossen*.[49]

Wie sollte Frank Stella, welcher diesen wenigen Zeilen der handlungsreichen Novelle allein vier Bilder widmet, sie nicht im Sinne Heinrich von Kleists verstehen? Sollen sie etwa nicht anrühren? Sollen sie nur als malerisch vollkommener Ausdruck des *working space* gelten? Oder wollen sie nicht auch die *natürliche Grazie des Menschen* bezeugen und die *Unordnung* korrigieren, die *das Bewusstsein anrichtet*?[50]

Da Frank Stella auch von Kleists *Brief eines Malers an seinen Sohn*[51] zum Bildgegenstand gemacht hat, darf vorausgesetzt werden, dass er das Malen nicht als Askese versteht, sondern als *rechtschaffene Lust an dem Spiel, [...] Einbildungen auf die Leinwand zu bringen*.[52] Insofern unterscheidet sich seine wie auch des Dichters Intention von jenem rigorosen Künstlertum, das Dichter wie Ludwig Tieck, Honoré de Balzac oder Emile Zola beschreiben. In Tiecks *Der Runenberg*[53] verliert sich der Held an die Bergwelt und kann sich den Mitmenschen nicht mehr verständlich machen. Der nach absolutem Ausdruck strebende Künstler scheitert hier ebenso wie in Honoré de Balzacs Meisternovelle *Das unbekannte Meisterwerk*, weil er dem *Druck der Zeit*[54] ausweicht und seiner Zeitlichkeit zu ent-

48 Frank Stella, Working Space. The Charles Eliot Norton Lectures 1983–84, Cambridge, Massachusetts / London 1986, S.11. Auch in Wassily Kandinskys späten Kompositionen erkennt Frank Stella *the basically levitational and rotatable nature of abstraction*. Vgl. ebda., S. 116.
49 Heinrich von Kleist, Die Verlobung in St. Domingo, in: Ders., Sämtliche Werke und Briefe, München 1993, Bd. 2, S. 175.
50 Heinrich von Kleist, Über das Marionettentheater, Ders., Sämtliche Werke und Briefe, München 1993, Bd. 2, S. 343.
51 Heinrich von Kleist, Brief eines Malers an seinen Sohn, Ders., Sämtliche Werke und Briefe, München 1993, Bd. 2, S. 328 f.
52 Heinrich von Kleist, Brief eines Malers an seinen Sohn, Ders., Sämtliche Werke und Briefe, München 1993, Bd. 2, S. 328.
53 Ludwig Tieck, Der Runenberg, in: Ders., Der blonde Eckbert. Der Runenberg. Die Elfen. Märchen, Stuttgart 1952, S. 25 ff.
54 Joseph Beuys, Das Geheimnis der Knospe zarter Hülle. Texte 1941–1986, Hg. Eva Beuys, München 2000, S. 153.

kommen versucht.[55] Emile Zola, welcher den modernen Maler an einer symphonischen Bilddarstellung der modernen Großstadt verzweifeln lässt,[56] verliert mit seiner Paraphrase des Scheiterns den Bezug zur janusköpfigen Gestalt der zunächst von ihm selbst protegierten Moderne und offenbart, dass er seinen Schulfreund Paul Cézanne, das historische Vorbild des Romanhelden, letztlich nicht versteht. Denn gerade diesem ging es darum zu zeigen, dass, wie von Kleist es seinen weisen Maler an den ebenfalls malenden Sohn schreiben lässt, die Welt *eine wunderliche Einrichtung* ist, welche *aus den niedrigsten und unscheinbarsten Ursachen* hervorgeht.[57] Tiecks, de Balzacs und Zolas Prosastücke deuten auch an, wie eigenständig die bildenden Künste geworden sind, so dass sie sich nicht mehr mit den überlieferten metaphorischen Sprachfiguren der Literatur beschreiben lassen.

Das in der Imagination von der Welt entworfene vollkommene Bild hat seinen Anlass im Alltagsleben und strebt im Bildwerk nach höherer Lebendigkeit, die sie in figurativer Malerei aus der Synthese von Verismus und Stilisierung erreicht. Der abstrakte Maler kann sie allein als optisch-haptisch erlebbare Vision fassen, in der Statik nicht existiert. Nur in einem analogen bildnerischen Verfahren kann er auf diese Weise dem Kunstwerk eine dauerhaft gültige Unmittelbarkeit und Aufmerksamkeit verleihen. Frank Stella beruft sich in der Anlehnung an Heinrich von Kleist nicht auf dessen Schilderung der Handlungsverläufe, sondern auf die punktuellen Hinweise auf Landschaftsbilder wie die Felder, Wiesen, Gärten und Weinberge an der Aar oder auf die knappen Skizzen der handelnden Charaktere im Kontext des Geschehens, welches die abbreviaturhaft aufscheinenden Merkmale einer Gestalt allmählich freisetzt, formt und schließlich bildhaft werden lässt.

Analog zu diesem literarischen Verfahren wählt Frank Stella offene, in ihrer Bedeutung noch nicht festgelegte bildnerische Formelemente und setzt sie zu einer ebenso offen gehaltenen Bildfolie so in Beziehung, dass sie eine Wechselwirkung evozieren, aus der sich im dramaturgisch aufgebauten Prozess von willkürlichen Setzungen und aus ihnen ableitbaren gestalterischen Operationen aktive und passive Formen entwickeln, welche in Wahrheit nichts als *Linien*, *Farben* und *Tonalitäten* sind. Allerdings erlaubt ihre künstlerische Anwendung, die sowohl aus der Intuition als auch aus der Konstruktion ihre Stärke bezieht, wie bereits Paul Klee formulierte,[58] die Darstellung vielschichtiger malerischer *Dimensionen*, denen der gleiche Künstler seine über einen langen Zeitraum entfaltete, bis heute noch nicht in ihrem Umfang gesichtete und gewürdigte *bildnerische Formlehre* widmete,[59] damit *ein Werk von einer ganz grossen Spannweite durch das ganze elementare gegenständliche inhaltliche und stilistische Gebiet* denkbar wird.[60]

In ihren Methoden konnten die modernen bildenden Künstler nur bedingt an der klassischen und romantischen Literatur anknüpfen. Da sie das normative Potential des *ut pictura poesis* brechen wollten, war sie ihnen nur da nahe, wo sie sich als eine der Musik vergleichbare Schwesterkunst verhielt und zu gleichen Teilen aus der Imagination und der sinnlichen Wahrnehmung schöpfte. Paul Klees Ideal des Bildes als polyphoner Klang wurde zur Metapher einer Bildidee, nach der das Gemälde wie ein vielstimmig agierender Klangkörper angelegt ist. Die Klänge verdichten sich zu einem stimmigen Ganzen. Im übertragenen Sinne lassen sich polyphone Klänge auch in der Literatur hören, etwa in den Landschaftsvisionen von Kleists oder in Johann Wolfgang von Goethes als *wiederholte Spiegelungen* charakterisierten Sternstunden des menschlichen Lebens.[61] In dessen sich überlagernden und brechenden Erfahrungen bezeichnet ein *jugendlich seliges Wahnleben* den Beginn ästhetischer Weltsicht, die sich in der *lebhaften Erinnerung* eines Erwachsenen erweitert und in den *Nachbildern* eines *alten Liebhabers* ihre olympische Größe erreicht.

Nur eine von *sehnsüchtigem Trieb* geleitete Energie, wie sie sich in Frank Stellas unermüdlichem künstlerischem Wirken seit nunmehr einem halben Jahrhundert manifestiert, vermag es jedoch, *ein Wahrhaftes wiederherzustellen* und den Einzelnen *zu einem höhern Leben empor[zu]steigern*[62], in welchem *herrliche* Kunst ihren Platz hat und sich erschafft.

Franz-Joachim Verspohl

55  Honoré de Balzac, Das unbekannte Meisterwerk, in: Ders., Meisternovellen, Zürich 1953, S. 196 ff.
56  Vgl. Emile Zola, Das Werk, München 1976.
57  Heinrich von Kleist, Brief eines Malers an seinen Sohn, Ders., Sämtliche Werke und Briefe, München 1993, Bd. 2, S. 328.
58  Paul Klee, Vortrag Jena, gehalten aus Anlass einer Bilderausstellung im Kunstverein zu Jena am 26. Januar 1924, in: Ausst.-Kat. Jena 1999, Paul Klee in Jena 1924. Der Vortrag, fol. 1 r und S. 49.
59  Paul Klee, Beiträge zur bildnerischen Formlehre. Faksimile, Hg. Jürgen Glaesemer, Basel / Stuttgart 1979.
60  Paul Klee, Vortrag Jena, gehalten aus Anlass einer Bilderausstellung im Kunstverein zu Jena am 26. Januar 1924, in: Ausst.-Kat. Jena 1999, Paul Klee in Jena 1924. Der Vortrag, fol. 15 v und S. 69.
61  Johann Wolfgang von Goethe, Wiederholte Spiegelungen, in: Ders., Geschichte der Farbenlehre. Zweiter Teil, München 1963, S. 242.
62  Johann Wolfgang von Goethe, Wiederholte Spiegelungen, in: Ders., Geschichte der Farbenlehre. Zweiter Teil, München 1963, S. 242.

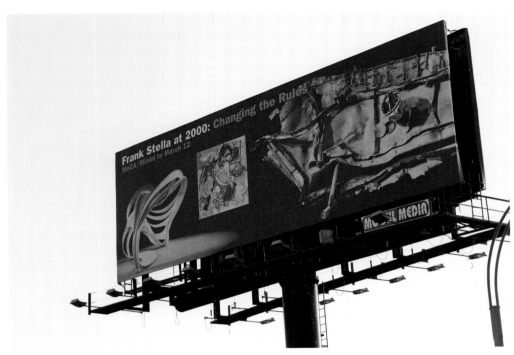

**Abb. / fig. 1**
Frank Stella, Billboard, 2000, New York City, Photography by Steven Sloman

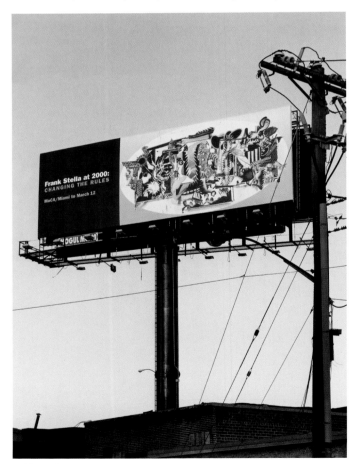

**Abb. / fig. 2**
Frank Stella, Billboard, 2000, New York City, Photography by Steven Sloman

**Abb. / fig. 3**
Frank Stella, Billboard, 2000, New York City, Photography by Steven Sloman

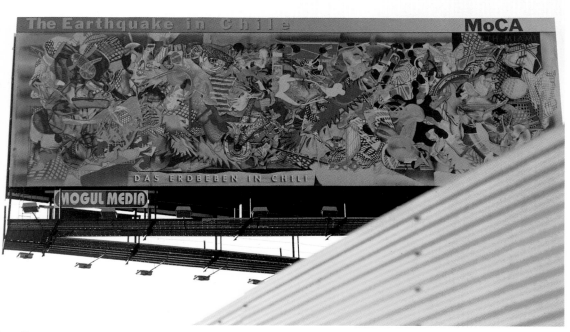

**Abb. / fig. 4**
Frank Stella, Billboard, 2000, New York City, Photography by Steven Sloman

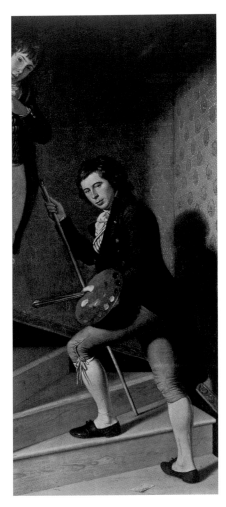

**Abb. / fig. 5**
Charles Wilson Peale, The Staircase Group, 1795, Öl auf Leinwand, Philadelphia, Museum of Art

**Abb. / fig. 6**
Frank Stella, Arbeit Macht Frei, 1958, Ölfarbe auf Leinwand, New York, Mr. and Mrs. Graham Gund

**Abb. / fig. 7**
Caspar David Friedrich, Mönch am Meer, 1809–1810, Öl auf Leinwand, Staatliche Museen zu Berlin, Nationalgalerie

**Abb. / fig. 8**
Carlo Mense, Straße mit Fahnen, 1913, Aquarell, Bonn, Rheinisches Landesmuseum

**Abb. / fig. 10**
Stuart Davis, Still Life Radio Tube, um 1931, Öl auf Leinwand, Waltham, Massachusetts,
Brandeis University, Rose Art Museum

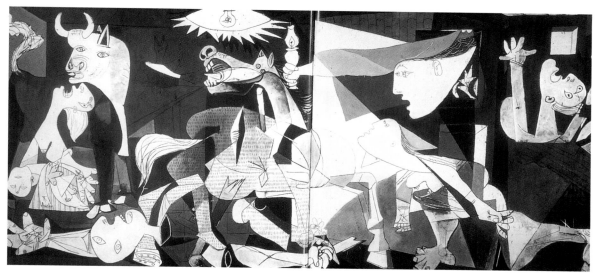

**Abb. / fig. 11**
Pablo Picasso, Guernica, 1937, Madrid, Museo Nacional Centro de Arte Reina Sofía

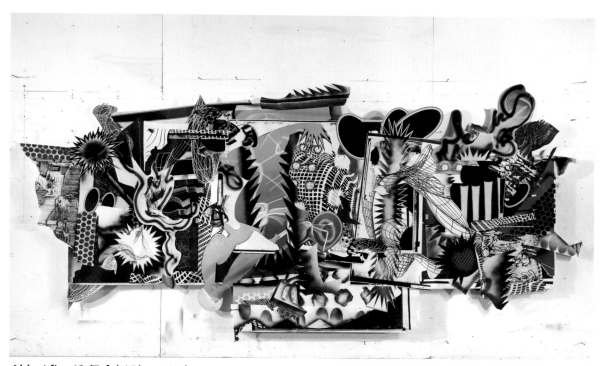

**Abb. / fig. 12 (Tafel / Plate LXV)**
Frank Stella, The Beggar Woman of Locarno / Das Bettelweib von Locarno,
1999, Collage on paper, New York, Frank Stella @ Newburgh, Polich Art Works

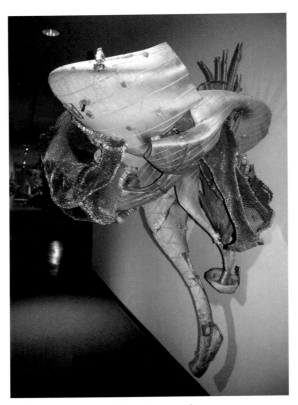

**Abb. / fig. 13 (Tafel / Plate XLVII)**
Frank Stella, 'Her name was Marianne Congreve' / 'Ihr Name war Mariane Congreve', 1998, Mixed media on cast aluminum, New York, Sperone Westwater, right side

**Abb. / fig. 14 (Tafel / Plate LXIV)**
Frau Stella, 'At Sainte Luce,' [Herr Strömli] / 'In Sainte Lüze!' [Herr Strömli], 1998, Mixed media on cast aluminum, New York, Akira Ikeda, detail

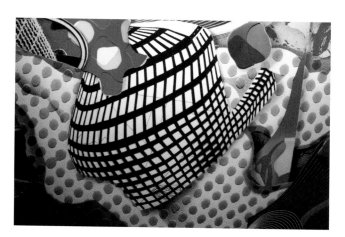

**Abb. / fig. 15 (Tafel / Plate LXIV)**
Frank Stella, The Betrothal in Santo Domingo /
Die Verlobung in St. Domingo, 1999, Mixed
media on canvas, New York, Frank Stella @
Newburgh, Polich Art Works, detail, panel I

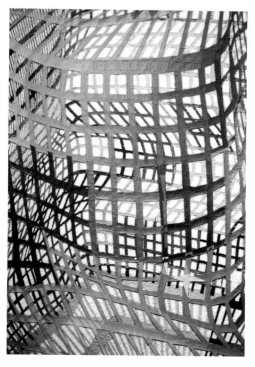

**Abb. / fig. 16 (Tafel / Plate LXIV)**
Frank Stella, The Betrothal in Santo Domingo / Die
Verlobung in St. Domingo, 1999, Mixed media on
canvas, New York, Frank Stella @ Newburgh, Polich
Art Works, detail, panel II

**Abb. / fig. 17 (Tafel / Plate LXIV)**
Frank Stella, The Betrothal in Santo Domingo / Die
Verlobung in St. Domingo, 1999, Mixed media on
canvas, New York, Frank Stella @ Newburgh, Polich
Art Works, detail, panel IV

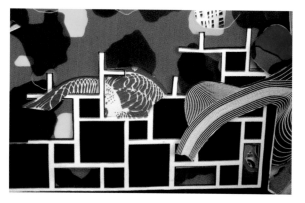

**Abb. / fig. 18 (Tafel / Plate LXIV)**
Frank Stella, The Betrothal in Santo Domingo / Die
Verlobung in St. Domingo, 1999, Mixed media on
canvas, New York, Frank Stella @ Newburgh, Polich
Art Works, detail, panel IV

# KonSTELLAtionen um KLEIST
## Das Bild zur Novelle
### Die Heilige Cäcilie oder Die Gewalt der Musik

I

Kleists Novelle wird zu unterschiedlichen Zeiten unterschiedlich gelesen. Jeder Leser bezieht aus ihr eine Bestätigung für seine Fragen und Probleme; er wird seine Projektion für objektiv halten, bis eine neue Lektüre durch einen anderen Zeitgenossen sie korrigiert und überzeugender aktualisiert.

Um 1970 konnte die Sympathie des Lesers den vier *Kaufmannsöhnen und Studenten* gelten, die Kleist zu der Kaiserstadt Aachen aufbrechen ließ, um dieser Stadt *das Schauspiel einer Bilderstürmerei zu geben*.[63] Die Bevölkerung soll während einer Messe aufgerufen werden, *keinen Stein auf dem anderen zu lassen*. Doch die ikonoklastische Aggressivität wird durch den Einsatz der Musik abgewendet. Das von der Kapellmeisterin intonierte Oratorium schlägt die Bilderstürmer *wie durch unsichtbare Blitze* in den Bann und es scheint *als ob die ganze Bevölkerung der Kirche tot sei*. Die Macht der Kunst hat bewirkt, dass *auch der Staub auf dem Estrich nicht verweht ward*.[64] Dem Leser von 1970 bestätigten sich in dieser Schilderung alle Vorwürfe, die man gegen eine *affirmative Kultur* erheben konnte: Ihre weihevolle, museale Inszenierung soll alle fortschrittlichen Bewegungen, alle kritischen Energien und alle utopischen Potentiale, die von wahrer Kunst eigentlich aufgeweckt werden sollten, einschläfern und still stellen. Friedrich Schiller hatte 1788 in seiner Geschichte des Aufstandes in den Niederlanden noch einen ganz anderen Einsatz der Musik für möglich gehalten: In der Antwerpener Kathedrale lässt er die Bilderstürmer einen Psalm nach einer verbotenen Melodie anstimmen und *noch während dem Singen werfen sich alle, wie auf ein gegebenes Signal, wütend auf das Marienbild, durchstechen es mit Schwertern und Dolchen, und schlagen ihm das Haupt ab; Huren und Diebe reißen die großen Kerzen von den Altären, und leuchten zu dem Werke. Die schöne Orgel der Kirche, ein Meisterstück damaliger Kunst wird zertrümmert, alle Gemälde ausgelöscht, alle Statuen zerschmettert [...]*[65] War hier der Einsatz der Musik das Signal zu einer hemmungslosen Zerstörung, so wird sie bei Kleist das *Palliativ in einer gesellschaftlichen Ordnung, die mit rationalen Argumenten allein nicht mehr zu rechtfertigen ist*.[66] Bei Schiller wird kurz vor der Französischen Revolution Kunst zum Fanal einer umstürzlerischen Erneuerungslust, bei Kleist wird sie etwa zwanzig Jahre später zum Medium einer Befriedung, in der das Gloria in excelsis jährlich *ruhig und prächtig* abgesungen wird. Alle Erwartungen, die eine zukunftsoffene Gesellschaftskritik an die Vorscheinsleistungen der Kunst knüpfen konnte, waren in Kleists Novelle dementiert. Alle Vorwürfe, die man einer Instrumentalisierung der Kunst im Dienste der bestehenden Ordnung machen konnte, waren von Kleist in der Novelle in einer emblematischen Verdichtung festgehalten.

II

Frank Stella hat 1997 Kleists Novelle *Die Heilige Cäcilie oder die Gewalt der Musik* offensichtlich ganz anders gelesen. Einen Bildersturm hat es in Amerika nie gegeben; ein ikonoklastisches Problem stand ebenso wenig zur Debat-

---

[63] Ich paraphrasiere meine eigene Deutung: Martin Warnke, Von der Gewalt gegen Kunst zu der Gewalt der Kunst. Die Stellungnahme von Schiller und Kleist zum Bildersturm, in: Martin Warnke (Hg.), Bildersturm. Die Zerstörung des Kunstwerks, München 1973 (= Kunstwissenschaftliche Untersuchungen des Ulmer Vereins für Kunstwissenschaft, Bd. 1), S. 99–107.

[64] Ich zitiere nach Heinrich von Kleist, Die Heilige Cäcilie oder die Gewalt der Musik, in: Heinrich von Kleist, Sämtliche Werke und Briefe, Hg. Helmut Sembdner, München ²1961, Bd. 2, S. 216–228.

[65] Friedrich Schiller: Geschichte des Abfalls der vereinigten Niederlande von der spanischen Regierung, in: Schillers Werke, Hg. Otto Günther / Georg Witkowski, Leipzig o. J., Bd. 13, das 4. Buch: *Der Bildersturm* auf den S. 233–263.

[66] So Warnke (wie Anm.63), S. 101.

te wie eine Umwälzung aller bestehenden gesellschaftlichen Ordnung. Deshalb treten solche Gesichtspunkte bei der Lektüre von Kleists Novelle gar nicht erst auf. Stattdessen ist eine andere Dimension heutiger Wirklichkeit, welche man durch die Novelle in aller Schärfe ins Bewusstsein gerückt finden kann, von den USA her in den Blick genommen: Die Gewalt der Medien.

Die vier Kaufmannssöhne und Studenten aus Kleists Novelle sind überwältigt von dem Einsatz eines Massenmediums. Die Kapellmeisterin Antonia spielt auf Wunsch der Äbtissin, die vorgewarnt worden war, eine uralte italienische Messe, mit der man schon öfters *die größtesten Wirkungen hervorgebracht hatte*; durch sie werden *ihre Seelen, wie auf Schwingen, durch alle Himmel des Wohlklanges* geführt. Aus Aachen waren die jungen Männer aufgebrochen, um in der Weltstadt Antwerpen ihre hinterwäldlerischen Affekte auszutoben. Diese lösen sich angesichts der allein seligmachenden Medienmacht der Kirche in Wohlgefallen auf. In der zweiten Fassung der Novelle steigert Kleist diesen Wirkungsgrad noch, indem er die Mutter von zwei Brüdern, die unter die Frevler geraten waren, nach sechs Jahren in Antwerpen auftauchen lässt, um nach ihren Söhnen zu suchen. Damit ist die Gewalt der Musik in die soziale Kernzelle der Familie hineingetrieben. Die Mutter, die aus Den Haag angereist war, findet ihre Söhne zu ihrem Entsetzen in einer Irrenanstalt wieder. Es wird ihr versichert, die Brüder seien körperlich gesund und man könne ihnen *eine gewisse, obschon sehr ernste und feierliche Heiterkeit nicht absprechen*. Die Gewalt der Musik hat sich wohltuend auf die geisteskrank gewordenen Brüder ausgewirkt. An ihnen hat sich das *zu gleicher Zeit schreckliche und herrliche Wunder* ereignet, das den Erzbischof von Trier veranlasst, es der heiligen Cäcilie persönlich zuzuschreiben. Die aufgenommene Musik setzt sich in den Brüdern in einen Zustand der frommen Gottesfürchtigkeit um. Die Mutter hat das Bedürfnis, jenes Kloster, in dessen Kirche ihre Söhne von der Musik gleichsam in einen Gnadenstand versetzt worden waren, aufzusuchen. Die Kirche selbst findet sie durch Baugerüste versperrt, so dass sie nur die *die prächtig funkelnde Rose im Hintergrund der Kirche wahrnehmen konnte*. Im übrigen aber ist hier Musik zu einem alltäglichen Stimulans geworden: *Viele hundert Arbeiter, welche fröhliche Lieder sangen, waren auf schlanken, vielfach verschlungenen Gerüsten beschäftigt, die Türme noch um ein gutes Drittel zu erhöhen, und die Dächer und Zinnen derselben, welche bis jetzt nur mit Schiefer besetzt gewesen waren, mit starkem, hellem, im Strahl der Sonne glänzigem Kupfer zu belegen. Dabei stand ein Gewitter, dunkelschwarz, mit vergoldeten Rändern im Hintergrund des Baues; dasselbe hatte schon über die Gegend von Aachen ausgedonnert, und nachdem es noch einige kraftlose Blitze gegen die Richtung, wo der Dom stand, geschleudert hatte, sank es, zu Dünsten aufgelöst, missvergnügt murmelnd im Osten herab.* Die Mutter wird selbst in den Sog dieser gewaltigen Wirkung der Medien hineingezogen und vor die Äbtissin geführt, die *eine edle Frau von stillem königlichen Ansehen* war und die auf einem herrschaftlichen Sessel saß. Seitlich des Sessels aber auf einem Pult lag die Partitur eben jenes Gloria in excelsis. Die Mutter meinte beim Anblick dieser Partitur *in die Erde zu sinken*, so als ob *der ganze Schrecken der Tonkunst, die ihre Söhne verderbt hatte, über ihrem Haupte rauschend daherzöge*. Doch die Äbtissin kann sie beruhigen, indem sie ihr mitteilt, auch der Papst habe durch Breve das Wunder der Heiligen Cäcilie zugewiesen. Die Mutter reist dankbar ab, hinterlässt ein Kapital zugunsten ihrer Söhne, und wird ein Jahr später in den Schoß der katholischen Kirche zurückkehren. *Die Söhne aber starben im späten Alter eines heiteren und vergnügten Todes, nachdem sie noch einmal ihrer Gewohnheit gemäß das Gloria in excelsis abgesungen hatten.*

Im Schicksal der beiden Brüder spiegelt sich das Schicksal heutiger Medienkonsumenten. Nur alteuropäische Bildungsrelikte, die in der Novelle durch die Mutter erinnert werden, verzögern noch die endgültige und glückliche Vereinnahmung durch die allein selig machenden Medien. Indem wir uns ihre Angebote, ihre Glückszustände und Illusionen einverleiben, steht uns der heitere und vergnügte Tod bevor, den Kleist die Brüder sterben lässt.

So etwa könnte Frank Stella die Novelle gelesen haben, als er unter seinem Bildervorrat eines aussuchte, das jener Lektüre entgegenkam. Am 19. März 1997 hatte sein Photograph Steven Sloman ein *overall* aufgenommen, das er als *untitled* bezeichnet.[67] Diese Collage hat dann, 1998, der Künstler in ein Großformat übertragen lassen und diesem, nachdem es zwischendurch auch als *Isaura* tituliert worden war,[68] schließlich den Titel von Kleists Novelle *St. Cecilia or the Power of Music* gegeben.

---

67  Die Collage (Photo mit der Nr. 3818-6 von Steven Sloman) wird in Jena zusammen mit der Übertragung in das Großformat ausgestellt.
68  Bei *Isaura* handelt es sich um die über hundertjährige Farbige, die in Brasilien noch die Sklavenzeit erlebt hatte.

III

Das sehr große Format der Collage wirkt auf den ersten Blick wie ein gewaltiger Torbogen am Eingang eines Vergnügungsparks. In der Ausstellung des Bildes in Miami hat der Künstler seine fünf Bestandteile auseinandergerückt, so dass sich der Eindruck eines Polyptichons ergab, zumal die Unterkante nahezu eben gegeben war.[69] Dennoch ergibt sich auch hier die Bogenform, die man zugleich als Triptychon mit hängenden Flügeln ansehen könnte. Während in der Kleist-Serie Formate, mit denen man Tryptichen oder Polyptichen assoziieren kann, vorkommen, wird dieses Bogenformat allein dem Cäcilienbild gegeben. In jedem Fall aber ist die eigenartige Gestalt eine Art Pathosformel, die den Betrachter zu einer Schauveranstaltung einlädt.

Die Bildfläche bietet den von allen Seiten andrängenden Formen nicht eigentlich einen Raum an, sondern belässt sie in einem Zustand der floatenden Beweglichkeit, so als suchten sie einen Ort oder eine Verbindung untereinander, innerhalb oder außerhalb des Bildes. Die undefinierten Formen sind teils konvulsivisch zu Gruppen zusammengezogen, teils frei schwebend nur durch Fäden oder Schlingen gesellig gemacht. Es gibt zwischendurch, etwa unten links der Mittelachse oder ganz links und ganz rechts außen unaufgelöste, kantige weiße Flächenreste oder kubische Ecken, die auch Ziffern tragen, so als sei ihre Verflüssigung in den allgemeinen Strudel schon programmiert.

*Verflüssigung* und *Vernetzung*, dies sind vielleicht Stichworte, die dieses Gemenge von Formen treffend charakterisieren. Es fehlen hier die splittrigen, sperrigen Elemente, die scharfen Sägeblätter und zuschlagenden schwarzen Balken, die in anderen großformatigen Bildern der Serie im Chaos der Formen wie gewalttätige Ordnungskräfte wirken. Im Cäcilienbild sperren sich die Formen nicht gegeneinander, sondern sie verbinden sich zu immer neuen Figurationen: sie verknäueln sich – wie ganz links sie verschmelzen – wie allenthalben; sie schürzen sich zusammen – wie am unteren Rand rechts oder sie kohabitieren – wie in der Bildmitte. Die Gitter- und Netzformen, die in den anderen Bildern der Kleistserie immer verstaut oder eingeklemmt sind, schweben hier frei herum und versuchen, kleinere Formen einzufangen und zwischen den größeren Formkomplexen Brücken zu schlagen. Auch die Farben haben einen milden Ton, der nicht ausgrenzt, sondern Beziehungen eingeht: Das Blau changiert vor allem in der Mittelzone zum Weiß hin und sickert untergründig allenthalben durch, während ein mildes Grau in mannigfachen Abstufungen die Formen in einer vermittelnden Grisaillelage hält. Nirgends drängt sich eine Farbe dominant hervor. Kleinere Passagen eines kräftigeren Rot, eines tieferen Blau oder eines leuchtenden Gelb (das an die *vergoldeten Ränder* bei Kleist denken lässt) tauchen nur an der Peripherie auf, als dezente visuelle Stabilimenta für das Ganze. Die Hauptzonen zeigen die Farben wie die Formen aufeinander zugehen, wie denn ein haarfein geführtes Liniengespinst alle Formen gleichermaßen überzieht, so dass diese wie in einem glänzenden Schmelz verwoben sind.

Diese wechselseitige Anziehung, welche die verschiedenen Formen und Farben aufeinander ausüben, hat auch eine inhaltliche Komponente, die auf das Kleistsche Thema verweist: Immer wieder assoziiert man Formen, die an Ohrmuscheln erinnern und Formen, die an Schalltrichter und Schallplatten alter Grammophone, Schallschwingungen in verschiedenen Frequenzen, Platten mit Rillen, Plattenteller, Oszillographen und Mikrophone denken lassen. Die scheinbare Unübersichtlichkeit klärt sich mehr und mehr zu einem Systemaustausch, in dem organische und technische Formen sich gleichsam umwerben: Ein differenziertes Gespinst von Linien, Kabeln und Drähten vernetzt die Formgattungen regelrecht miteinander. In der Mitte des Bildes sind die Hauptvertreter der organischen und technischen Formen monumental auf Achse zueinander gestellt: Unten die große Form einer Ohrmuschel und darüber so etwas wie der Schalltrichter einer Kontrabasstuba. Sie geben den Einsatz zu einer nach allen Seiten hin sich ausbreitenden Ausgrenzung und Vernetzung, rhythmischer Konvulsionen und Symbiosen, in denen immer wieder die organischen Elemente sich in technische verschleifen oder verschmelzen und die technischen Elemente organische Umrisse bekommen und ihre metallische Geschliffenheit in quallige Pilzformen übergeht.

Wie bei Kleist die *Gewalt der Musik* darin besteht, dass sie die Fähigkeit hat, durch Klang und Stimme, durch physikalische Phänomene seelische und psychische Wirkungen auszulösen, so bewirkt hier die Macht der Künste, der Medien und ihrer Formen eine universale Bereitschaft, individuelle Eigenarten und Einkapselungen aufzuheben.

---

[69]  So ist es in der Frankfurter Allgemeinen Zeitung vom 18. Januar 2000, Nr.14, S. 50 nach einem Foto des Museum of Contemporary Art in Miami abgebildet.

War es bei Kleist ein einfaches, von begeisterten Nonnenstimmen gesungenes Oratorium, das die Menschen überwältigte, ihren Eigenwillen brach, so ist es in der heutigen Technokultur ein unaufhörliches Dröhnen und Bilderfluten, welche die Menschen zu bloßen Aufnahmeorganen, zu bloßen Ohren oder Augen verwandelt – und in dieser Gestalt glücklich, heiter und vergnügt sein lässt.

IV

Stellas Bild gibt sich als Kommentar zu einer Novelle von Kleist aus. Doch es bezieht seinen Kontext nicht allein aus der Literaturgeschichte. Nicht nur hat die besondere Form dieses Bildes in Stellas Werk Vorläufer und Parallelen, sondern sein zentrales Anliegen: die Wechselwirkung organologischer und technologischer Vorstellungen, hat tiefe Wurzeln in der Geschichte der Kunst. Auch die Übersetzung musikalischer Tonfolgen oder -höhen in farbige oder formale Valeurs. Matisse, Kandinsky und andere Künstler haben immer wieder die Verwandtschaft, die Synästhesie von Farben und Tönen bis hin zur Konstruktion von Farbklavieren untersucht.[70] Zeitgenossen Kleists unter den Künstlern in Deutschland, so Caspar David Friedrich und Philipp Otto Runge, haben den Menschen in engem seelischen Austausch mit der natürlichen Landschaft gesehen.[71] Hier seien nur wenige Beispiele aus der Kunst des vorigen Jahrhunderts angeführt, die das Grundproblem unseres Bildes: die Wechselbeziehung des Organischen und Dinglich-Technischen, ebenfalls bearbeitet haben.

In einem Aquarell aus dem Jahre 1913 hat Carlo Mense (Abb. / fig. 8), der später ein Protagonist der Neuen Sachlichkeit werden wird, eine *Straße mit Fahnen* so gesehen, dass ein Zug zahlloser Menschen unmerklich übergeht in die Formenwelt der Fahnen; die Körper entleeren sich geradezu in einem Flammenmeer der Fahnen, das auch die Häuserreihen mit sich in die Höhe reißt. Die Transformation des Menschen in ein Massenwesen macht nach den massenpsychologischen Theorien der damaligen Zeit aus dem Individuum ein anderes Wesen, das die Natur der Tiere und Wilden annimmt.

Vielleicht ohne solche anthropologischen Hintergedanken hat Kandinsky in seinen abstrakten Bildern immer wieder organische und geometrische Formenwelten miteinander in Beziehung gebracht. So zeigt etwa die Farblithographie aus der Serie der *Kleinen Welten* (Abb. / fig. 9) ein Formenrepertoire, das wir auch bei Stella wiederfinden: Die Karomuster, die Kreisformen, die Schlangenlinien, die sich ebenfalls in organische und anorganische Gruppen einteilen lassen. Es fehlt aber ganz der Versuch, die oppositionellen Formen aufeinander einwirken zu lassen. Es werden Pfade zwischen ihnen gelegt, es gibt kommunizierende Linienzüge, aber es gibt keine Metamorphose von der einen Formklasse zu der anderen. Es ist ein Spannungsgefüge, das fixiert ist, während es sich bei Stella nach allen Richtungen hin wandlungs- und verknüpfungsfähig zeigt. Schon durch das Format, das nach den Seiten hin expandiert, lässt Stella die konventionellen Bildordnungen aus den Fugen laufen. Kandinskys kleines Werk ist immer noch geprägt von der disziplinierten Bildvorstellung Alteuropas. Auch die Fernseh- und Radiobilder, die Stuart Davis schon in den Dreißiger Jahren für komplexe abstrakte Figurationen nutzte (Abb. / fig. 10), haben eine stabile Struktur. Stella hat all diese Grundlagen hinter sich gelassen – und findet gerade dadurch wieder zu einem alteuropäischen Problemfeld in Gestalt des Heinrich von Kleist zurück.

Martin Warnke

---

[70] Vgl. E. Lockspeiser, Music and Painting. A Study in Comparative Ideas from Turner to Schönberg. London 1973 oder D. Lander (Hg.), Sound by Artists, Toronto 1990.

[71] Die wesentlichen Texte dazu ediert und kommentiert bei Werner Busch (Hg.), Landschaftsmalerei, Berlin 1997.

# Syntaktischer Expressionismus
# Bemerkungen zu Frank Stellas
# Collage *The Beggar Woman of Locarno* (1999)
# nach Heinrich von Kleists Erzählung
# *Das Bettelweib von Locarno* (1810)

Frank Stella hat nicht erst mit seinen Kleist-Collagen eine Serie von Bildnissen geschaffen, die in einen literarischen Titelrahmen hineingestellt sind. Seine *Moby Dick Series* (1985–1997) ließen sich ebenso schon von Melvilles Buch inspirieren. Aber weder in diesem früheren Fall noch jetzt bei den Kleist-Collagen sollte man die Korrespondenzen zwischen literarischem Bildtitel und dem Bild selbst interpretativ allzu sehr belasten. Frank Stella *illustriert* ja weder Melville noch Kleist, literarische Motive werden nicht mit malerischen Sujets beantwortet. Was Stella vielmehr gestaltet, ist gewissermaßen das *Aroma* einer Lektüre von Melville oder Kleist, also die durchaus subjektive *Atmosphäre*, in die sich Stella durch die Texte versetzt fühlte, ihr übertragbarer *Impuls*, der sich ihm in ihnen erschlossen haben mag. Frank Stella hat diese bloß impressive Korrespondenz seinerzeit mit Blick auf Melville auch ausdrücklich hervorgehoben. Ihn beeindruckte z. B. Melvilles Fähigkeit, *gleichzeitig zu sehen und zu denken*. Sein Ziel sei es daher gewesen, *den Geist des ganzen Abenteuers einzufangen. Der wirkliche Kernpunkt ist für mich nicht das Detail, sondern der Impuls, um die Metaphorik zum Fließen zu bringen.*[72]

Mehr als eine solche Impuls-Orientierung wird man auch den Kleist-Collagen Stellas nicht unterstellen dürfen. Auch hier geht es gewiss nicht um Details, um eine Visualisierung narrativer Elemente, sondern allenfalls um eine *Energieübertragung*, um einen *Impulstransfer*. Wie stellt sich aber ein solcher Impuls in Stellas Kleist-Collage *The Beggar Woman of Locarno* dar, wie vermittelt er sich dem Betrachter? Um diese Frage zu beantworten, hält man sich am besten und zunächst an die Erzählung von Kleist selbst, gerade um ihren *Impuls* zu ermitteln und sprachlich einzufangen. Worum geht es also in Kleists kleiner Erzählung?

Ein Marchese, Herr eines Schlosses in der Nähe von Locarno, von der Jagd kommend, befiehlt einer alten, kranken Bettlerin, die aus Mitleid von seiner Frau in einem der Zimmer seines Schlosses auf ein Strohlager gebettet worden war, eher beiläufig, aber unwirsch, oder, wie es bei Kleist heißt, *unwillig*, sich von ihrem Lager zu erheben *und sich hinter den Ofen zu verfügen*. Die arme Kreatur erhebt sich mühevoll von ihrem Strohlager, *glitschte* dabei *mit der Krücke auf dem glatten Boden aus*, verletzt sich lebensgefährlich, schleppt sich gleichwohl noch hinter den Ofen, sinkt aber eben dort unter Ächzen und Stöhnen nieder und stirbt.

Das Rohe und Erbarmungslose dieser gedankenlosen Anweisung des Marchese findet Jahre später seine Bestrafung in Spukereignissen. Zur mitternächtlichen Gespensterzeit werden in jenem Zimmer dreimal von mehreren Zeugen Geräusche vernommen: *es war, als ob ein Mensch sich von Stroh, das unter ihm knisterte, erhob, quer über das Zimmer ging, und hinter dem Ofen, unter Geseufz und Geröchel niedersank.* Zweimal musste auch der Marchese diesen Spuk ertragen, beim letzten mal zündet er, *vom Entsetzen überreizt*, sein Schloss an und kommt darin *auf die elendiglichste Weise* um.[73]

Spukgeschichten haben in der Regel mit ungesühnten Verbrechen zu tun. Auch hier zeigt Kleist, wie auf eine übernatürliche, Menschen jedenfalls nicht erklärliche Weise Gerechtigkeit vollstreckt wird. Ein solches überindividuelles Gerechtigkeitsvollstreckungsmuster findet sich regelmäßig bei Kleist, sehr prägnant z. B. auch in seiner Erzählung

[72] Zit. nach Robert K. Wallace, Stella and Melville: Seeing and Thinking at the Same Time, in: Frank Stella, Moby Dick Series, Ulmer Museum, 12. Nov. 1993 bis 16. Jan. 1994, p. 18–27 (deutsch), hier p. 26; p. 29–37 (engl.), hier p. 36. Zu Stella und Melville cf. zudem Anna-Maria Ehrmann-Schindlbeck, *The Quarter-Deck*, 1989, aus der *Moby Dick Series*, in: Franz-Joachim Verspohl (ed.), Pictor laureatus. In Honour of Frank Stella, Gera 1996, p. 50–55.
[73] Heinrich von Kleist, dtv-Gesamtausgabe 4: Erzählungen, ed. Helmut Sembdner, p. 179–181.

*Der Zweikampf* (1811). Über alles von Menschen Einsehbare hinaus ereignet sich nach Art einer *intervention du surnaturel* eine Gerechtigkeit, die ansonsten unerreichbar erscheint, jedenfalls, wie Kleist im *Michael Kohlhaas* (1810) prägnant dargestellt hat, von Menschen gerade nicht erzwingbar ist. Es müßte sich denn etwas Unerwartbares einstellen, um eine Ordnung zu beglaubigen, deren Herstellung nicht bewusst gelingen kann. Eine solche *intervention du surnaturel* hat daher geradezu magischen Charakter wie auch die Wirkung der Musik in Kleists Erzählung *Die heilige Cäcilie* (1810), oder sie erscheint als Spuk wie im *Bettelweib von Locarno*.

Man muss nun sehen, dass in gewisser Weise eine solche Magie oder ein solches Spukgeschehen aller Kunst zugrundeliegt. Und zwar in einem dreifachen Sinne.

*Erstens* trennen die Künste je nach ihrer Art, wie Magie oder Spuk, den Teppich unseres geschlossenen Wahrnehmungskontinuums auf: sie lassen sehen, aber nicht hören (bildende Kunst), sie lassen hören, aber nicht sehen (Musik), sie lassen sehen, aber nicht wiedererkennen (abstrakte Malerei), sie lassen hören und verstehen, aber nicht wahrnehmen (Literatur), sie lassen sehen, hören und verstehen, aber nicht anfühlen (Film), sie lassen sich etwas ereignen, aber Ursachen lassen sich nicht erkennen (Magie, Spuk und Kunst).

So liefern die Künste insgesamt Spukgebilde, vor denen wir uns nur deshalb nicht ängstigen, weil sie auf eine kollektive Wahrnehmung berechnet sind. Eine Überreizung unseres Entsetzens wie es bei Kleist dem Marchese widerfuhr, findet normalerweise nicht statt, wenn man von gelegentlichen hysterischen Effekten dieser Art nach Erscheinen von Goethes *Werther* oder von der Wirkung der Musik *Gloomy sunday* absieht.

Aber noch in einem *zweiten* Sinne tritt in der Kunst ein magischer Charakter hervor, der ebenso als ein Spukgeschehen erfahrbar ist. Ich meine hier den Pygmalion-Effekt in der Endphase der künstlerischen Gestaltung. Frank Stella hat das so beschrieben, dass gegen Ende des Gestaltungsprozesses der Künstler die Rolle des ersten und einzig notwendigen Betrachters übernimmt. In einem prägnanten Moment schaut dann der Künstler auf das, was er produziert hat, und bemerkt, das es *lebt*. Picasso und Klee hatten dies schon früher (Beuys übrigens ebenso) bestätigt. Diese seelenverleihende, animierende Betrachtung ist einzigartig, sie bedeutet das Ende des schöpferischen Prozesses, sie ist so basal, das sie, wie Stella bemerkt, gewissermaßen genetisch verankert erscheint (*guaranteed by genetic imprint*). In diesem Moment, *when the artist looks what he has made and sees it as alive*, ist das Kunstwerk in eine Selbständigkeit entlassen, die nicht mehr angetastet werden darf, auch vom Künstler nicht. Das Sinngebilde erhält eine Autonomie, die fast personalen Charakter hat, erst hier wird das Werk zum Kunstwerk: *Where there's life, there's art*.[74] Von hieraus erklärt es sich auch, dass Stella gerade diese Lebendigkeit oder Vitalität als einzig notwendiges Ingredienz aller Kunst bezeichnet (*vitality is the only necessary ingredient for art*). Oscar Wilde hatte auf dieses beseelende Moment literarisch die Probe gemacht, indem er das Bildnis von Dorian Gray altern lässt.

Ein *drittes* und letztes Moment des magischen oder spukhaften Charakters der Kunst ist in der Tat in diesem zweiten Moment schon enthalten. Nicht nur der Künstler als der erste und einzig notwendige Betrachter, auch der spätere und allemal kontingente Betrachter gewinnt nur Zugang zu einem Kunstwerk, wenn er Anschluss an das findet, was man gleichsam seine Seele nennen könnte, seinen Impuls. Auch er muss es geschehen lassen, dass es ihm gleichsam wie ein personales Ereignis entgegentritt, dass es ihm wie ein autonomer Sprecher entgegentritt, der ihm einiges zu sagen hat, Winke geben kann, aber auch vieles für sich behält, das man nur erraten kann. Jedes Kunstwerk ist für das Publikum ein delphisches Orakel.

Wenn wir unsere Beobachtungen im Ausgang von Kleist jetzt fokussieren, dann mag der gesuchte Impuls seiner kleinen Erzählung *Das Bettelweib von Locarno* in etwa der sein: ein spukhaftes Echo einer elementaren, *schreienden* Verfehlung bewirkt über alles von Menschen Erreichbare hinaus eine verzögerte Gerechtigkeit. In diesem Impuls-Schema muss nun das Echo nicht zwingend spukhaft gegeben sein, es ist nur erforderlich, dass eine ungesühnte Untat in irgendeiner verstörenden Weise memorial präsent bleibt. In die Aufgabe einer solchen verstörenden Präsenzerhaltung vergangenen Unrechts kann nun auch die Kunst eintreten. Und so in der Tat könnte Frank Stella seinen Impulstransfer bewerkstelligen. Es müsste ihm nur gelingen, eine visualisierbare Verstörungsform zu

---

74   Frank Stella, The Dutch Savannah, Lecture by Frank Stella, on Dec. 15th, 1984 at the Concertgebouw, Amsterdam, Speciale bijlage by het Stedilijk Museum Bulletin, p. 4; siehe auch Frank Stella, Working Space, Cambridge, Mass., und London 1986, p. 127–167, hier p. 127.

finden, die dieser Aufgabe gerecht werden könnte. Dies gelingt ihm, indem er in unerhört abstrakter Verdichtung ein Bild zitiert, das in seiner Weise *das* Unrecht des 20. Jahrhunderts in verstörender Präsenzerhaltung wie ein Spukgeschehen visualisiert hat. Ich meine hier Pablo Picassos Bild *Guernica* (1937) (Abb. / fig. 11, Abb. / fig. 12, auch Tafel LXV). Wenn man beide Bilder nebeneinander betrachtet, wird diese visuelle Strategie Stellas bis in die Farb- und Formgebung offenkundig.

Dass Frank Stellas Kunstwerke keineswegs in einen hermetischen Raum hineinragen, der jeden Kontakt mit der Realität, auch geschichtlichen Realität verloren hätte, bezeugen schon seine frühen Bilder *Arbeit Macht Frei* (1958), *'Die Fahne Hoch!'* (1959), *Reichstag* (1958).[75] Das Œuvre von Frank Stella bietet also auch Werke, die von einer politischen Ikonographie zu bearbeiten sind. Dazu gehört wohl auch die Kleist-Collage *The Beggar Woman Of Locarno*. Jedenfalls folgte eine solche Interpretation Frank Stellas Devise: *The act of looking at a painting should automatically expand the sense of that painting's space, both literally and imaginatively.*[76] Stella sieht gerade in der enormen Ausweitung des visuellen Raumes durch die abstrakte Kunst deren Überlegenheit, die traditionellen Bildräume der mimetischen Kunst haben ja immer Grenzen und erscheinen als Teilräume des universalen aber abstrakten visuellen Raumes: *abstraction today works to make its own space.*[77] In diesem Raum erobern gerade seine jüngeren Arbeiten mit einem neuartigen, sich bis zu den Kleist-Collagen extrem verdichtenden Stil neue Bildräume, die schon, obwohl abstrakt, die Illusion szenischer Räumlichkeit erreichen, die dem Betrachter ganze Dramen zu beherbergen scheinen. Stella selber spricht von *my new, illusionistic szenographic paintings.*[78] Der szenische Charakter seiner Arbeiten verleiht ihnen, was man schon früh bemerkt hatte, etwas Architektonisches, aber die Architektur, um die es hier geht, gehört zur Architektur im Sinne kosmischer Prozesse, explosiv oder zusammenstürzend. Der Wucht seiner Raumplastiken, ihren expressiven Farbausbrüchen kann sich niemand entziehen. Sie muten an wie Fragmente einer neuen Genesis, die im universellen, abstrakten Bildraum mit einer titanischen Geste etwas entstehen lässt, etwas einstürzen lässt, man weiß nicht was. Vielleicht steht der Bildraum selber zur Disposition? Explodiert er oder implodiert er in den Werken Stellas? Nein, er atmet in ihnen, er lebt, mit großer Gebärde, großzügig und herrisch zugleich, d. h. schön. Und wenn man es in kleiner Münze haben will: Stellas Werke sind nicht schön, sie sind sexy: *It is very hard for abstraction, or abstract figuration, to be sexy, and if it's not sexy, it's not art. Everyone knows that.*[79]

Möglich, dass man den Darstellungsstil Stellas mit dem Ausdruck *syntaktischer Expressionismus* gut charakterisieren kann, um ihn von einem gehaltlichen, semantischen Expressionismus zu unterscheiden, wie er für den klassischen Expressionismus kennzeichnend ist. Genau dann würde die ehrgeizige Ambition, die Stella für sich reklamiert, nämlich mit seiner Kunst eine produktive Verknüpfung von Kubismus und Renaissance zu etablieren,[80] eine basale Stilmöglichkeit für eine solche Verknüpfung vorgezeichnet sein. Mit seiner bildnerischen Ausschöpfung eines solchen syntaktischen Expressionismus war es ferner zunehmend unwahrscheinlich, dass Stella sich der Erinnerung an seine Kleist-Lektüre in seiner Jugend entziehen konnte, denn Kleists Werk ist seinem stilistischen Gestus nach ebenfalls von einem syntaktischen Expressionismus durchdrungen. Hier ist ein Gemeinsames wirksam, in den Werken von Kleist wie von Stella, hier fasst sich eine anonyme Identität in ihrem Darstellungsstil, bezeichnet zwar, aber nicht begriffen und eben deshalb so faszinierend. Die syntaktische Kompaktheit, sprachlich bei Kleist und visuell bei Stella, bezeugt eine ästhetische Verwandtschaft, die beide Werke als Kompressionsfiguren mit hohem Innendruck erscheinen lassen. Dieser Druck lässt Botschaften aus ihren kompressiven Wort- und Formgefügen geradezu *wetterstrahlend* (Kleist) herausfahren, vor denen man in Deckung gehen muss, um nicht ungeschützt getroffen zu werden. Es ist ein expressiv Abstraktes der Syntax auch bei Kleist, das diese Wirkung hat, und es kann überhaupt eine solche Wirkung nur von etwas Abstraktem abstrahlen. Ein verständliches literarisches Sujet, eine abbildende Bildlichkeit ist je für sich durch einen semantischen Schleier um diese Wirkungsmöglichkeit gebracht. Bekannter

---

[75] Cf. Lawrence Rubin, Frank Stella, Paintings 1958 to 1965. A catalogue raisonné, London 1986; Nr. 90 (p. 62), Nr. 35 (p. 68), Nr. 29 (p. 60). Zu diesen Bildern bemerkt Robert Rosenblum daher in seiner Einführung (p. 11): *Such elucidations helped to deny the usual early response to these paintings - that they where thoroughly hermetic and cerebral - and to confirm the growing revelation that they reflect an awareness of such universal gloom that they may even end up as younger-generation counterpart to the somber, life-denying mood of many of Rothko's own late series paintings.*

[76] Frank Stella, Working Space, Cambridge, Mass., und London 1986, p. 9 / 10.

[77] Frank Stella, The Dutch Savannah, in: ders., Working Space, Cambridge, Mass., und London 1986, p. 167.

[78] Frank Stella, Melrose Avenue, in: Tyler Graphics (Walker Art Center), Minneapolis 1997, p. 42. Es handelt sich hier um einen Vortrag, den Stella 1995 in Fukushima, Japan, (20. April) und in Columbus, Ohio, (16. Mai) gehalten hat.

[79] Working Space, op. cit., p. 77.

[80] Working Space, op. cit., p. 155: *We need* (in der Erstveröffentlichung - vgl. S. 5 Anm. 72 heißt es: *we want*) *to establish a productive tie to Cubism and its forefather, Renaissance classicism.*

Sinn bremst. Wenn es denn immer ein Abstraktes, ein Anonymes, ein Unverständliches (real unknown) ist, das wirkt, dann wird auch klar, dass mimetische Kunst nicht deshalb beeindruckt, weil sie mimetisch ist, d. h. diese oder jene Gegenstände zeigt, sondern dass sie es auf eine Weise tut, die wieder abstrakt ist, jedenfalls nicht gegenständlich. Im Wie des Zeigens kann auch ein mimetisch Gezeigtes erst beeindrucken. In diesem Sinne ist auch alle gegenständliche Kunst zugleich abstrakt. Insofern hat Stella recht, wenn er die notwendige Frage stellt: *whether abstraction is more than a necessary ingredient in the development of twentieth-century art.*[81] Der Verpflichtung, ein Abstraktes, Anonymes hervortreten zu lassen, kann sich die Kunst, auch da, wo sie gegenständlich ist, nicht mehr entziehen. Wir haben noch nicht begriffen, was das besagt, auch Stella nicht: *What we want to understand is the relationship of abstraction to the meaning and future of modernism.*[82]

Ein Kritiker des Frühwerks von Stella kritisierte ihn einmal mit der Feststellung: *These paintings are semi-icons for a spiritual blank. They make Mr. Stella the Oblomov of art, the Cézanne of nihilism, the master of ennui.*[83]

Gewiss, dieser Kritiker wollte die geometrischen Exerzitien des frühen Stella treffen, mit denen er sich von Jackson Pollock und anderen Heroen seiner Jugend absetzen musste. Ob dieser Kritiker heute noch so quietistische Vokabeln wie Oblomow der Kunst, Cézanne des Nihilismus oder Meister des ennui verwenden würde, darf bezweifelt werden, aber schöne Wendungen waren es trotzdem. Sie lassen erkennen, welch extreme Ausdrucksspannweite das Œuvre von Stella umfasst, er begann geometrisch und schwarz und ließ schließlich Form und Farbe explodieren. Beides gehört zu seinem Impuls. Vielleicht noch anderes? 1960 trug ein Bild von ihm den Titel *Avicenna.*[84] War das eine frühe Verheißung? Erschließt sich von Avicenna (980–1037 n. Chr.) aus, diesem aristotelisch-platonischen Denker und Arzt, ein metaphysischer Zugang zur modernen Kunst, zur Kunst von Frank Stella? Müssen wir auf Avicennas Neufassung der Form-Materie- und Akt-Potenz-Distinktion zurückgehen und in seinem Gedanken, dass im Stoff der Möglichkeit nach schon alle seine Formen enthalten sind, einen Schlüssel für ein neues Verständnis der modernen oder gar zukünftigen Kunst erkennen? Kunsthistoriker lieben solche Spekulationen nicht, aber Frank Stella hat mit seinem Bild *Avicenna* ja ausdrücklich die Philosophen angesprochen. Sie dürfen sich daher auch angesprochen fühlen. Und sie tun es auch.

Wolfram Hogrebe

---

[81] Working Space, op. cit., p. 110.
[82] Ibid.
[83] Zit. bei William S. Rubin, Frank Stella, New York 1970, p. 31.
[84] Lawrence Rubin, Frank Stella, Paintings 1958 to 1965. A catalogue raisonné, London 1986, Nr. 66 p. 98.

# Stella, Melville, Kleist: *The Betrothal in Santo Domingo*

Frank Stella's Heinrich von Kleist series (1998–2000) is a daunting body of work. In addition to the collages and murals named for the *Novellen* and the sculpture named for *The Prince of Homburg*, Stella has created separate sequences of painted reliefs for Kleist's *Love Letters*, his *Correspondence*, his *Anecdotes*, his *Essays and Journals*, and one of his *novellen*, Stella's *Quotations (from 'The Betrothal in Santo Domingo')*. The Kleist series is remarkable for its numerical proliferation and its visual vitality, but it also offers a pictorial response to Kleist's crisis of belief. Stella's series responds to the audacity of Kleist's ambition and to the fragility of his faith (strong in itself but subject to unbearable pressure from the outside world). In this way, as in others, the Kleist series is an apt successor to Stella's *Moby-Dick* series (1985–1997). One of the many Kleist-like images with which Melville expressed the fragility of his own faith in *Moby-Dick* emerged in *The First Lowering*. Abandoned at sea in a whaleboat after night has fallen, Ishmael and his companions extend their *imbecile candle* to an uncaring universe, *hopelessly holding up hope in the midst of despair*.[85] The epistemological crisis that runs like a fault-line from Kleist's love letters of 1801 to his death in 1811 has been as invigorating for Stella's art as was the existential adventure of Melville's 1851 whaling novel. Stella's Kleist series is a worthy successor to his *Moby-Dick* series in artistic creation, literary exploration, and post-enlightenment illumination.

Although Stella has responded to all aspects of Kleist's artistic output, he has shown particular interest in *The Betrothal in Santo Domingo*. His largest single response to the story is *Die Verlobung in Santo Domingo* (Tafel / plate LXIV), a forty-foot mural in four panels. This work corresponds to similarly expansive murals that Stella created for seven other stories.[86] For this story, however, he has also created fourteen metallic reliefs, his *Quotations (from 'The Betrothal in Santo Domingo')*. These reliefs are unique not only within the Kleist series but in Stella's career for the way in which they respond to a literary text. Whereas in his *Moby-Dick* series Stella had taken all of his titles directly from Melville's chapter titles,[87] here he has selected his titles from diverse elements within a single story. Only the four-part mural takes its title from the story as a whole. Four of the *Quotations* reliefs are named for characters in the story. Six other reliefs are named for lines of dialog. The last four *Quotations* derive from a landscape description *on the banks of the Aar*. After examining each relief in relation to the element of the story for which it is named, we will glance at the four-part mural in relation to the story as a whole.

When I asked Stella why, among all of Kleist's stories, he had been especially attracted to *The Betrothal in Santo Domingo*, the answer was clear. *In Germany they get excited about 'Michael Kohlhaas,' for example, and that story is good, but it feels mostly historical to me. Somehow 'Santo Domingo' feels more contemporary. That story is the most American of the stories. You have the French Revolution and slavery – revolution and the slave – and that is the story of America.*

Kleist's 1810 story about revolution and the slave is set on the island of Santo Domingo in 1803. Kleist addresses issues of colonial oppression, skin pigmentation, and psychological solipsism with which our multi-cultural world continues to struggle two hundred years later. In Kleist's story, Toni, a young bi-racial woman, offers humanity's best hope for a way out of the physical and psychological warfare on the island, but she is destroyed in the most brutal way by the forces she attempts to hold in her heart and keep at bay. An equally gruesome fate awaits Babo, leader of the slave revolt in Melville's *Benito Cereno*, an 1855 story also inspired, in part, by the insurrection in Santo Domingo at the beginning of the century. During the 1990s literary critics began to see *Benito Cereno* and *The Betrothal in Santo Domingo* as nineteenth-century texts that speak with particular force our need for multi-cultural understanding at the end of the twentieth-century. Not only does each story unflinchingly depict the rea-

---

85  Herman Melville, Moby-Dick; or, the Whale, ed. Charles Feidelson, Jr. (Indianapolis: Bobbs Merrill, 1964), p. 301.
86  *Earthquake in Chili, The Marquis of O-, Saint Cecilia or the Power of Music, Michael Kohlhaas, The Beggarwoman of Locarno, The Foundling*, and *The Duel*.
87  Stella created one or more art works for each of Melville's 138 chapter headings, resulting in 266 unique works of art, all of which are catalogued in my book Frank Stella's *Moby-Dick*: Words and Shapes (Ann Arbor: University of Michigan Press, 2000).

lity of slave rebellion; each does so with what can now be seen as an *anti-enlightenment* and *anti-colonialist* consciousness.[88] Stella's pictorial response to Kleist's story parallels these literary interpretations of both Melville and Kleist.

Stella's *Quotations (from 'The Betrothal in Santo Domingo')* can be interpreted by size and in pairs. The four smallest reliefs are the ones named for individual characters. Two of these are *Nanky* (Tafel / plate XLIX) and *Seppy* (Tafel / plate L). Nanky and Seppy are two illegitimate sons of Congo Hoango, master of the slave revolt on the plantation on which he had earlier been enslaved. The relatively small size of these reliefs is appropriate given that Nanky and Seppy are *small boys*.[89] They are both coming of age in a cauldron of fierce racial and nationalist strife. Nanky has played an active role in luring white-skinned Europeans to the plantation to be slaughtered, and at the end of the story he and Seppy are both taken as hostages.

Stella's *Nanky* and *Seppy* each set a brightly painted slice from a volumetric smoke-ring shape against an unpainted metallic mount. The tough, torn metallic foundation of *Nanky* suggests the implacable forces against which his own fragile fate will be played out. The smoke-ring fragments in each work still retain the casting gates with which they were fabricated at the foundry, as if to emphasize that these young lives are still in the early stages of character formation and individuation. Seppy, only five years old, is too young to act as his own agent in the story, but Nanky's character is already beginning to take shape: bright, willing, loyal, brave. *You can rely on Nanky*, he tells Toni (p. 254).

The other reliefs of similar size are *Konelly* (Tafel / plate LII) and *Komar* (Tafel / plate LI). The characters for which they are named are older members of the enslaved community that is fighting to overthrow the French. Konelly is seventeen years old and Komar is of an indeterminate middle age. Konelly and Komar are relatively minor characters in the action of the story, their importance coming primarily from their relation to Toni, the teenage heroine. When Komar married Babekan, Toni's mulatto mother, he became a responsible father to Toni, whose white father, a Frenchman from Marseilles, had disowned her at birth. Konelly is mentioned only once, as the young man who has proposed to Toni – and whom Toni refused because she is still only fifteen years old. Born a slave, Konelly is quickly amassing power and property through his revolutionary activity, but once Toni's story takes a new turn, we hear no more of him.

The reliefs Stella has named for Komar and Konelly, like those for Nanky and Seppy, juxtapose painted smoke-ring fragments against a tough metallic base. One side of *Konelly* features a swollen, red heart-like shape seemingly soaked in blood. Balanced uneasily against it is a skewered head-sized shape with slashes of red paint. *Komar* is more resolutely metallic. Only a few somber stains of paint adorn the displaced head shape at the left. The hard, cold folds of metal at the right are deepened and hardened by the brightly painted lattice design set over and against it.

The next four reliefs are twice as large, 80–90 rather than 40–50 inches high. They are much more complex in shape, structure, and literary implication. Two of them cite passages (and speakers) from early in the story, two from near the end. *'Ei, mein Himmel!' rief die Alte (Babekan)* (Tafel / plate XLVIII) and *'Ihr Name war Mariane Congreve'* (Tafel / plate XLVII) quote passages from early in the story. Babekan, the old woman who cries *'Ei, mein Himmel!'*, is the mulatto mother of Toni. Gustav, who says *'Ihr Name war Mariane Congreve'*, is a Swiss mercenary for the French who is fleeing from the revolution that has broken out across the entire island. He is offered shelter for the night by Babekan and Toni, who, unknown to him, plan to deliver him, along with the party of twelve still hiding out in the woods, to sudden death at the hands of Congo Hoango (as soon as the latter returns from his current mission against the French). Stella's *'Ei, mein Himmel!'* relief cites the speech in which Babekan lies to Gustav by claiming that she and her mestiza daughter are themselves subject to mistreatment and intimidation by Congo Hoango because their respective skin colors are not as dark as his, he being a native of Africa. Stella's *Marianne Congreve* relief is named for the passage in which Gustav tells Toni of the young woman in Strasbourg who

---

[88] See, for example, H. Bruce Franklin, Slavery and Empire: Melville's *Benito Cereno*, in Melville's Evermoving Dawn: Centennial Essays, ed. John Bryant and Robert Milder (Kent, Ohio: Kent State University Press, 1997), pp. 147–161; and David Pan, Defending the Premodern Household against the Bourgeois Family: Anti-Enlightenment Anticolonialism in Heinrich von Kleist's Die Verlobung in St. Domingo, Colloquia Germanica 32 (1999): 165–199.

[89] Heinrich von Kleist, *The Betrothal in Santo Domingo*, in *The Marquise of O-* and Other Stories, tr. David Luke and Nigel Reeves (London: Penguin, 1978), p. 234. Subsequent citations from the story will appear parenthetically in my text.

sacrificed her head at the guillotine on his behalf when he ran temporarily afoul of the revolutionary sentiment there. Babekan's lie about Congo Hoango's persecution of her and Toni encourages Gustav to trust in their house as a refuge, whereas Gustav's tale about Marianne Congreve's loyalty awakens a chord of idealism in Toni (who until this point had been employing her youthful charms to lure him, short of intercourse, toward certain death). Toni suddenly allows herself to be drawn more toward Gustav than Konelly, a situation that Gustav abuses by sexually violating this fifteen-year-old girl in an act that Kleist discreetly leaves to the reader's imagination: *There no reason to report what happened next, for it will be clear to anyone who has followed the narrative so far* (p. 247).

In *'Ei, mein Himmel!' rief die Alte (Babekan)* we begin to see larger segments of the smoke-ring shapes with which much of the Kleist series is built. This work, even more than *Komar*, is resolutely metallic. There is not a touch of paint on the elegant metallic stems that rise up into the heart of the work. A mesh of honeycomb aluminum disguises the metallic shapes lodged behind it. This mesh also distracts attention from the hidden, severed edge of the shape that swells above it (Tafel / plate XLVIII). Babekan is the one character who remains irrevocably revolutionary throughout the story, disowning her daughter Toni as a *treacherous slut* as soon as she suspects her love for Gustav (p. 257). Congo Hoango, as we shall see, is more susceptible to familial feeling, allowing the Europeans to escape at the end of the story in return for their promise of returning Nanky and Seppy.

Stella's *'Ihr Name war Mariane Congreve'* can be interpreted in response to the story of Marianne Congreve herself, or in relation to Gustave's use of her story to seduce Toni's mind before her body. Whichever way one views it, its apparent contrast with the Babekan relief could hardly be sharper. The two works do have the same spiky shapes protruding at the top, up against the wall, but the colors of the *Congreve* relief are hot, passionate, and tropical. Yet those vivid colors are also deceptive, for they disguise the fact that this relief is built of essentially the same material as its unpainted companion. Its rising smoke-ring shape is nearly identical to its counterpart in the *Babekan* relief (Abb. / fig. 13) – except that its metallic skin in the *Congreve* relief is overpainted with strong white pigment highlighted in pink, creating the optical base against which the riot of jungle green, hot pink, and tropical orange stand out. Seeing the painted overlay of the *Congreve* relief against the immaculate metallic skin of its *Babekan* companion provides an optical gloss on one of Melville's observations about color in *Moby-Dick*. In the chapter on *The Whiteness of the Whale*, Ishmael declares that *in essence whiteness is not so much a color as the visible absence of all other colors*, whereas *all other earthly hues […] are but subtle deceits, not actually inherent in substances but only laid on from without; so that all deified nature but paints like the harlot, whose allurements cover nothing but the charnal house within*. Stella marked this Kleist-like observation with three pencilled stars in his own copy of *Moby-Dick*.[90]

The next two reliefs, *'Ach', rief Toni* (Tafel / plate XLV) and *'Weshalb?' (Gustav)* (Tafel / plate XLVI), take us to the psychological heart of the love story. The lines are spoken near the end of the story, after Gustav has shot Toni through the heart, assuming that she had betrayed him when in fact she was saving his life, acting upon their secret betrothal with a love even more sacrificial than that of Marianne Congreve (since Toni, in loving Gustav, necessarily betrayed the familial, racial, and communal bonds that tied her to her mother Babekan and the entire Congo Hoango community). When Gustav, assuming the worst and understanding nothing, asks, *Why did you betray me?* she answers, *Oh, you should have trusted me* (pp. 266–67). In doing so, she voices one of the few undeniable truths in the story (most of whose apparent truths and assumptions are savagely undermined by either the restlessness of the action or the irony of the narrative strategy).

*'Ach', rief Toni* is the visible heart of Stella's *Quotations* ensemble, just as Toni's speech is the spoken heart of Kleist's story. A fully formed smoke-ring shape, richly painted yet showing all the contours of its metallic body, is set in a strong, delicate, open, supporting lattice design. Physically, the juxtaposition of this full figure against its encompassing ground is clear and simple, but the figure and ground are painted so as to blend optically, requiring that we read them closely if we are to feel the full force of the figure. How emotionally devastating is the expression of the embedded smoke-ring shape as soon as one sees, and feels, the anguish of the gaping holes in its upper body! Those torn holes and gaping wounds correspond to the visible anguish and the inner torment with which young Toni, having been shot through the heart by the man she loves, tells him with her dying breath that he should have trusted her. Stella feels that the *action* of his *Santo Domingo* reliefs *actually takes place under a kind of camouflage of color and activity*. This is especially true of the emotional action of *'Ach', rief Toni*.

---

[90] Moby-Dick, op. cit., pp. 263–264.

'Weshalb?' (Gustav) has no such clarity, coherence, or emotional resolution. The metallic substructure of Gustav's relief shares a lattice pattern with Toni's, but here that pattern is twisted, cramped, and mostly disguised by the ill-matched shapes mounted over it. Those jumbled shapes are an apt analogy for the clutter of contradictory half-truths in Gustav's mind, themselves further compromised by the love-hate ambivalence of his feelings for the two women he ostensibly loves. Gustav is broad-minded enough to fall in love with a bi-racial fifteen-year-old girl whose skin color *repels* him (p. 243), but he is crass enough to love Toni in part to guarantee his own physical safety as an *enemy* in the house. He projects a beautiful future for Toni *'on the banks of the Aar'* after they marry, but the betrothal to him is as fatal to her as it was for Marianne Congreve (with the difference that Toni's life is taken by Gustav himself rather than by the ungoverned force of a revolutionary mob). Even Herr Strömli, Gustav's Swiss uncle and rescuer, calls him a *monster* for destroying Toni and her love – a judgment that Gustav visits on himself by blowing out his own brains with a pistol blast when he realizes she had been true (p. 266).

Before leaving these two reliefs named for Toni and Gustav's love / death dialog, I would like to return to the strong, dissolving lattice shape in *'Ach', rief Toni*. Stella had first used this honeycomb lattice in one of the Wave prints in the *Moby-Dick* series. Its *crystalline* pattern was one of *the finest, richest, and most chaste* in the book on *Chinese Lattice Designs* in which he found it. Stella associated that design with the richest and most chaste space in Melville's novel, the *pristine sanctuary* of the sperm whale's head as described in *The Great Heidelburgh Tun*, the chapter for which the print is named.[91] When the whalers use their *operator's instrument* to *force* an entry into the head for the highly desired oil, its *pristine sanctuary* is violated in much the same way as Toni's inner essence at the hands of Gustav. As soon as the chamber of Toni's heart receives the shot from Gustav's pistol, Herr Strömli desperately tries to *extract the bullet* with whatever *crude instruments* are at hand, but the attempt reveals only that *the shot had pierced right through her and her soul had already departed to a better world*. It was during this process that Gustav, temporarily unobserved, *took up the other, still loaded pistol, and blew his brains out with it. [...] He it was whom they now tried to help; but the wretched man's skull was completed shattered, parts of it indeed adhering to the surrounding walls, for he had thrust the pistol into his mouth* (p. 267).

In *Working Space*, published in 1986, Stella had acknowledged *how difficult it is for the artist to nurture and manipulate the body of his creation without mutilating it*. Melville had wrestled with this difficulty when depicting the body of the whale 1851, as had Kleist when depicting the bodies of Toni and Gustav in 1810. Stella had gone on to declare that *disembodiment is the crucial element in making the success of painting*.[92] When wrote those words he was looking back to Titian's *Flaying of Marsyas* (c. 1570–1576) and Caravaggio's *David and Goliath* (1610), but he was also looking ahead to the future of his own abstract art. He was envisioning before he created them the surface mutilations and the severed shapes that would emerge in his *Moby-Dick* and then in his *Quotations (from 'The Betrothal in Santo Domingo')*. Both bodies of work give a keener edge to his own artistic instincts while also responding to those harsh realities inflicted by weapons in the respective stories: harpoons, lances, and cutting spades in the one text, pikes, swords, and pistols in the other. The brutal realism with which Kleist undercuts the fragile idealism of *The Betrothal in Santo Domingo* may be one reason why Stella finds it to be *strangely satisfying as a love story. You feel like death was all-consuming and satisfying. All of the killing is sexually, morbidly satisfying. All of the characters find satisfaction. The compulsive love makes the self-destruction both tragic and satisfying.*

We come now to the two massive reliefs that carry the ultimate burden of Stella's response to Kleist's story: *'In Sainte Lüze!'* (Herr Strömli) (Tafel / plate XLIV) and *'In Sainte Lüze!'* (Hoango) (Tafel / plate XLIII). The identical words are spoken by contrasting characters in the last paragraph of the story, allowing these two reliefs to reflect the entire drama as experienced by representative survivors on opposed sides of the struggle. *These two reliefs*, Stella recalled, *were a summation of the work I had been doing on the series. And I was taken with the idea that it was the same quote with a different person. So I could have two. It's a set-up for a pendant.*

These pendants match each other in scale and imagery as well as in their quoted words. The structure of each is at once compact and expansive, corresponding to the strength with which Herr Strömli and Congo Hoango carry their respective burdens at the end of the story. Herr Strömli safely escapes Hoango's plantation with Toni's and Gustave's dead bodies not only because Hoango has been subdued in the surprise attack encouraged by Toni but

---

[91] For an illustration of *The Great Heidelburgh Tun*, and a discussion of its relation to the chapter for which it is named, see Frank Stella's *Moby-Dick*, pp. 83–84, pl. 42.
[92] Frank Stella, Working Space (Cambridge, Mass.: Harvard University Press, 1986), pp. 100, 103.

because Hoango's love of Nanky and Seppy causes him to grant Strömli's party free passage to Port-au-Prince so that his hostage sons will be returned to him at Sainte Luce. Hoango and Strömli are partisans who would fight each other to the death, but each is also imaginatively able to see beyond the ideological positions that divide them – Hoango in making concessions to Strömli to preserve the lives of Nanky and Seppy, Strömli in honoring Toni's love for Gustav even though this complicates his escape plan, and both Hoango and Strömli in responding to Toni's mind and heart in spite of her being a mestiza, neither black nor white in the racially polarized world of Santo Domingo in 1803.

Looking at these compact, expansive, matching reliefs together, you can easily see that each features large, fully realized, and carefully painted smoke-ring shapes. One of those smoke-rings is the same size and shape in both works, though its position differs. Look at the large green smoke-ring shape that occupies most of the left side of the *Strömli* relief before its massive head emerges from the pink-and-white companion shape on the right side of the relief. If you follow its motion from the small green fist-sized shape at the lower left all the way through to the swollen, dented head at the far right, you will experience a bifurcated path of expansive convolution. The identical smoke-ring shape anchors the *Hoango* relief, though it is not so easily seen. The small fist-sized shape in this case begins at the top center of the work before swirling down through the right side of the relief until the great swerve eventually terminates in the swollen head shape at the lower left (again battered with a force that has caved in part of its cast-metal skull). This large, twisting metallic shape is somewhat harder to follow because, like its smaller counterpart in *'Ach', rief Toni*, it is painted in thin vertical slices rather than broad planar solids. Beneath it to the right is a smaller version of its own form, painted and punctured in much the same way as its precursor in *'Ach', rief Toni*. Standing out from the center of the *Hoango* relief is a silvery, metallic, two-dimensional rendering of a smoke-ring design, whose metallic counterpart is easily found at the upper right of the *Strömli* relief.

Each of these companion reliefs richly repays close attention whether standing near or afar, but here I have space to suggest only one essential contrast. In the *Herr Strömli* relief, the two large intertwining smoke ring shapes (one green with red accents, the other pink over a white base) are as prominent as are the bodies of Toni and Gustav at the end of Herr Strömli's story, first as they are carried away from the plantation and buried in Santo Domingo, then as they are memorialized in the Swiss monument that Herr Strömli erects *to the memory of his cousin Gustav, and to the faithful Toni, Gustav's bride* (p. 269). The expressive curves and gaping holes of the large pink-white smoke-ring shape on the right side of the *Herr Strömli* relief project toward the viewer even more poignantly than do their smaller counterparts in *'Ach', rief Toni*. The anguish of its twisting form becomes almost unbearable to the viewer who looks beyond the obvious voids and cavities of its frontal involutions to see, deeper in, a torn pink hole corresponding to the one Gustav had blown through Toni's heart (Abb. / fig. 14). The painting of this writhing pink-white smoke ring is optically as beautiful as that of the pink-tinged white ring in *'Ihr Name war Mariane Congreve'*. Its surface beauty is as seductive as the loyalty that Gustav celebrates in Marianne's love, but neither Stella nor Kleist allows us to rest easy with it.

In *Working Space* Stella wrote of the tension between *the beauty of presentation* and *the cruelty of revelation* in subjects such as Titian's *Flaying of Marsyas*. He argued that allowing the *beauty* to *override* the *cruelty* in such a subject would be a *sham*.[93] He therefore denies the observant viewer the kind of sentimental satisfaction with which Gustav tells his tale of Marian Congreve – or with which Herr Strömli erects his monument to the pure, undying love of Gustav and his *bride*. His abstract pictorial art, no less than Kleist's deadpan literary artistry, undercuts the *beauty of presentation* with surface mutilations and structural juxtapositions that heighten the irony and expand the ramifications of the cruelty revealed.

Kleist's story, as told, ends in the intertwining *Liebestod* apotheosis of Gustav and Toni story as memorialized by Herr Strömli for a Swiss society unaware of actual events in Santo Domingo. Kleist's story, as implied, will continue in Santo Domingo after the flight of Herr Strömli's extended family. Congo Hoango has lost three of his fingers and Babekan has lost her daughter, but the French have been driven from the island and the return of Nanky and Seppy promises new hope for the future. The major smoke-ring shape in *'In Sainte Lüze!' (Hoango)* blends into its ground more subtly than its counterpart in the *Herr Strömli* relief, but it nevertheless shapes the structure as a whole, from the small fist-sized shape that rises in defiance in the upper center of the work all the way down and around to the swollen head shape emerging at the lower left, still resistant in spite of the crushing, discoloring blows it has

---

93  Working Space, p. 102.

suffered. The silver metallic shape gleaming at the center of the structure symbolizes fresh hope in the context of such complexity and disembodiment, much as Nanky and Seppy do in Hoango's heart. Seppy, only five years old, is the *tabula rasa* in the story. But he becomes a highly symbolic presence from the time Toni lifts him sleeping out of bed to serve as hostage to her and Gustave's love – even while only being passed inertly from one person to another.

The *Strömli* and *Hoango* reliefs give us opposing visions of *the beauty of presentation* versus *the cruelty of revelation*. The former corresponds to the sentimental, retrospective mythology of the European conclusion to the story as written; the latter embodies the resistant, future-oriented hope of the story's unspoken Santo Domingan aftermath. *'In Sainte Lüze!' (Hoango)* returns us to the world of the *Nanky, Seppy, Konelly,* and *Komar* reliefs. This relief completes the sequential design in which the figurative fragments and metallic grounds of those smaller *Quotations* reliefs find their ultimate meaning.

Is all of this too much of a narrative load to put on Stella's painted, metallic, largely abstract reliefs? I think not. Stella has shown clear intentionality in the respective sizes, shapes, and names of the ten increasingly large *Santo Domingo* reliefs that conclude with the *Herr Strömli* and *Hoango* pendants. He has employed increasingly large and expressive smoke-ring shapes, from the small sections introduced in *Nanky* and *Seppy* to the fully achieved shapes in *'Ach', rief Toni* and in the *'In Sainte Lüze!'* pendants, creating a pictorial sequence whose abstract narration matches the verbal action of Kleist's story. In their association with the Kleist story, the smoke-ring shapes of the *Quotations* sequence extend not only the narrative effect but the figurative potential of the wave shapes that Stella had deployed sequentially in the abstract designs of the *Moby-Dick* series. In the summer of 1999, an interviewer asked Stella if he would comment on the figurative element that seemed to be more prominent in his more recent abstract art. *The smoke rings*, he answered, *if they do not stand for the human figure, I do not know what does*.[94]

Stella sees the painted reliefs that he named for Gustav's phrase *'… an den Ufern der Aar'* (Tafeln /plates LIII-LVI) as different in kind from his other *Quotations (from 'The Betrothal in Santo Domingo')*. These four reliefs are *different* in that *the other reliefs have figurative references whereas these are more just the landscape, kind of a reference to the landscape*. Originally, he had designated them as the *Domed Backgrounds*, after the *Dome* prints in the *Moby-Dick* series whose paper molds provided the shape from which their metallic bases were cast. These four reliefs are distinguished from each other by Stella's parenthetical citations of the *Felder, Gärten, Wiesen und Weinberge"* (fields, gardens, meadows, and vineyards) that Gustav envisions for his and Toni's future happiness (p. 247). In Kleist's story, these are the utopian future equivalent of Gustav's retrospective sentimental evocation of Marianne Congreve's sacrificial love. Projecting happiness and fruition on the banks of the Aar, they relate not only to the monument that Herr Strömli will erect to the memory of Gustav and Toni after returning to Switzerland but also to the paradise on earth that Heinrich von Kleist had attempted to create on the banks of the Aar during his epistolary courtship of Wilhelmine von Zenge in 1801. Ironically, the fictional *fields, gardens, meadows, and vineyards* that Gustav von der Ried envisions for Toni *'… on the banks of the Aar'* in the 1810 story are echoed in the ecstatic letter that Heinrich von Kleist will write to Henriette Vogel in Berlin a year later in anticipation of the double suicide they will enact near the banks of Lake Wannsee. Heinrich associates Henriette with *my castles, acres, meadows, and vineyards* in the rapturous salutation of the letter he writes to her in November 1811, the month in which he will end their lives by shooting a bullet through her heart before putting the pistol to his own head.[95]

Stella's *Felder, Gärten, Wiesen und Weinberge* reliefs provide a landscape epilogue to the *Congreve* and *Strömli* reliefs on the European side of Kleist's story. They are similar in size, but opposed in spirit, to *Nanky, Seppy, Konelly*, and *Komar* – the four reliefs that provide a figurative prelude to the *Babekan* and *Hoango* reliefs on the Santo Domingan side of the story. In contrast to the contrasting quartets of small reliefs, representing the opposing sides of the story, are the four panels of *Die Verlobung in Santo Domingo* (Tafel / plate LXIV), encompassing the story as a whole. Running through the four panels are two-dimensional versions of some of the smoke-ring shapes we have

94  Norbert Lynton, *I started, and I think I am going to finish, as a committed abstractionist* (interview with Frank Stella), The Art News-paper 94 (July–August 1999): 67. The occasion of the interview was an exhibition of new work at the Bernard Jacobson Gallery in London (for which a reproduction of *'Ach', rief Toni* was featured in the publicity materials).
95  Letter to Henriette Vogel, Berlin, November 1811, in An Abyss Deep Enough: Letters of Heinrich von Kleist, tr. Philip B. Miller (New York: E. P. Dutton, 1982), p. 204.

already seen in 3-D. But I will focus here on the way in which the action of this mural offers abstract insight into the nature of color and pigment – the overriding contemporary issue for us today in the racially conflicted world of Kleist's story. From the infinitely complex colorization of the mural as a whole, we will examine four contrasting details.

One detail from panel I (Abb. / fig. 15) presents color as a black-and-white cage. This corresponds to the way in which Kleist's unreliable narrator narrates the action, separating characters into fixed categories of black or white, a process that begins in the opening sentence, which sets the story in *the time when the blacks were killing the whites* (p. 231). The narrator consistently depicts the white characters (and their ostensibly high ideals) as imprisoned within the evil actions perpetrated by treacherous, murderous blacks.

A detail from panel II (Abb. / fig. 16), presents a contrasting cage, a color cage corresponding to the diversity of human pigmentation that is actually present in world of Kleist's story (rather than in the mind of its narrator). Its infinite variety of shades suggests the infinite potential of human pigmentation along a continuum from white to black (neither of which symbolic endpoints represents the actual color of any individual human's skin). There is room in this pictorial cage for the lightest-colored European as well as a the darkest-colored Santo Domingan, as well as for such bi-racial characters in Kleist's story as Babekan and Toni (who in this multi-colored context become more the norm than the exception). When I saw the *Santo Domingo* mural at the Locks Gallery in Philadelphia in October 2000, I was not alone in being magnetically attracted to its multi-colored cage. As I was taking notes on a Saturday afternoon, one person after another gravitated to this small section of the second panel, several reaching out to test its tactile texture with their finger tips. But the beautiful variety of colors in this pictorial cage, no less than that of the living characters in Kleist's story, does necessarily express itself in the fictional and historical context of slavery and revolution. Their expressive shapes still take the form of an interlocking cage, however liberating their rich coloration would otherwise seem to be.

In one large area of the forty-foot mural, across the gap separating panels II and III, Stella enacts a fluid flow of shape and color that temporarily escapes the prison of confined categories. This flow creates a visual exhilaration similar to that felt by Gustav and Toni as they break free of their assigned racial categories long enough to be transported by actual love. This loving center, however, can hold in the mural no longer than in the story, where the unexpected return of Hoango provokes the bloody denouement. The animated shapes that achieve a fluid harmony in the middle of the mural reach abrupt dead ends in the last panel. On the far right side of panel IV, however, Stella offers two sections of color that present rich alternatives to the black-and-white world view within which the unreliable narrator of Kleist's story is categorically confined.

The upper right quadrant of the panel features interrelated ovals of brown (Abb. / fig. 17). These are a visible counterpart to the solidarity of the non-white persons who are fighting for liberty on the island of Santo Domingo. The strength and harmony of the related shades of brown are heightened by the pure white arcs that cut through the smaller ovals, these joining with the black band that runs inside the edge of the larger oval to create a continuous black/white dissonance within the overriding harmonies of brown (a rich interaction further supported by a magnified, energized section of the multi-colored cage from panel II). Immediately after leaving the Locks Gallery on that Saturday afternoon, I found myself in front of the Mother Bethel church of the American Methodist Episcopal denomination on Sixth Street. Visiting that historic African-American church the next morning, I saw three stained-glass windows whose interrelated circles in various shades of brown were glowing in the October sun. When I asked Stella if he had ever visited that church or seen those windows, he said, *No, but maybe I should have.*

The lower right quadrant of the last panel of Stella's *Verlobung* mural contains the most rigid right angles in the entire *Santo Domingo* œuvre (Abb. / fig. 18). Their solid black squares and rectangles locked in place by white right angles are Mondrian-like in their regularity. Their severe pigmental regulation and geometric rigidity set off the sensuous blending of the red and black shapes that rise above them. Kleist was raised to believe in the power of the logical categories of the human mind to effectively shape human thought and experience. This is evident in the rational formulas for achieving conceptual truth that he dictates to Wilhelmine von Zenge in his love letters to her (including the one he wrote from Frankfurt-on-Oder on May 30, 1800, no. 1 in Stella's *Love Letter* sequence). The Kant crisis in Kleist's epistemological thought, combined with a whole series of mysterious and inexplicable failures in his personal and professional life, pushed him beyond the right-angled black-and-white certainties in which he had been raised into a mode of artistic expression by which he suddenly brought the whole rational structure of European enlightenment culture into question. Nowhere does he represent this shift more presciently than in

*The Betrothal in Santo Domingo*, whose enlightenment narrator is entirely blind to the socially-constructed categories in which he imprisons his story of Gustav and Toni's love – the same categories that half a century later will blind the unreliable narrator of Melville's *Benito Cereno* to the racist, imperialist, colonialist, misogynist, divide-and-conquer psychology in which he, along with his culture, is solipsistically trapped.

From the bottom right corner of Stella's *Santo Domingo* mural, the rising eye moves from a black-and-white right-angled world into one whose infinite range of blending shapes and colors freely move in organic ease. These abstract shapes of complex, yet fluid beauty correspond to the *pristine sanctuary* of Kleist's own most precious creative instincts. Stella, of course, began his own artistic career with the black-and-white, right-angled canvases of his Black Paintings (1958–1960). His own career can be seen, like Kleist's, as an attempt to escape, transcend, and deconstruct the abstract categorical certainties in which he came of age. No wonder he was so deeply drawn, among all of Kleist's works, to the radical instability and exploratory humanity of *The Betrothal in Santo Domingo*.

The large writhing smoke-ring shapes that weave through the 3-D *Santo Domingo* reliefs show how organically Stella's imagery has evolved from the straight-line right-angled forms of his early stripe paintings. So do the twisting spiral shapes that play off against the smoke-ring shapes in many of the reliefs – from the tiny spiral above the smoke-ring fragment in *Nanky* to the more conspicuous spirals of the *Congreve, Gustav,* and *Strömli* reliefs and the *Banks of the Aar* landscapes. Stella had first been mesmerized by smoke-ring shapes in the early 1980s when visiting Harvard University to deliver the Norton Poetry Lectures that he later published as *Working Space*. Alone in his room on a cold night, he had blown smoke rings from his cigar into the space of his steam-heated hotel room. The rings held suspended in the moistened air and then broke into beautiful bifurcations, a phenomenon he subsequently replicated in a studio photobox. The resulting two-dimensional photographs he then converted back into three-dimensional smoke-rings that he fabricated in cast aluminum. The twisting spiral shape derives from a foam rubber hat that Stella found on a beach in Rio de Janiero in the late 1980s. Its two-dimensional surface was incised with cut-out lines that converted it into a spiral hat when pulled over the head, a *soaker* hat whose purpose is to cool off a hot head on a sun-struck beach. Each of these shapes had first found artistic expression in the *Moby-Dick* series, the twisted spiral in the 1990 relief that Stella called *Epilogue D (Summer)*, the rising smoke ring in *The Cabin. Ahab and Pip,* a 1993 sculpture named for one of the most racially apocalyptic chapters of the novel. [96]

I find it interesting that the two most conspicuous shapes in the Heinrich von Kleist series derive from such contrasting real-life situations: one from warm smoke pulled into and blown out of a lone body on a chilly night in a Massachusetts hotel, the other from a rubber hat made to cool off a pleasurably hot body at one of the world's most public places, the beach in Rio. So one day I asked Stella if he saw any significance in the contrasting real-life sources of these two images. *Yes*, he immediately replied, *they could both kill you. You could suffocate from the one, and drown from the other*. The cleverness of this quick response did not disguise the nervous edge in Stella's voice. This fanciful contemplation of his own double death made me think of Kleist's double suicide in November 1811. That reminded me of the opening paragraph of *Moby-Dick*, where Ishmael confesses that he has taken to the sea to save himself from suicide. He articulates the symptoms of his suicidal impulse with Kleist-like clarity: *Whenever it is a damp, drizzly November in my soul, whenever I find myself involuntarily pausing before coffin warehouses, and bringing up the rear of every funeral procession I meet*. Going to sea, Ishmael tells us, is *my substitute for pistol and ball* (*Moby-Dick*, p. 23). One wonders of Melville had Kleist's *pistol and ball* in mind. [97]

Stella's artistic career has differed greatly from that of Kleist, who took his life at age 34, or Melville, who had lost his audience by the age of 33 (with the successive failures of *Moby-Dick* and *Pierre*). When Stella turned 34 in 1970 he was preparing his newest Protractor paintings for a retrospective of his youthful career at New York's Museum

---

[96] For illustrations and discussions of these works, see Frank Stella's *Moby-Dick*, figs. 50 and 64, pp. 200–202, 235.

[97] The implements of Kleist's suicidal act would not have been well known in New York City when Melville published *Moby-Dick* in 1851, but in 1849 Melville had struck up a strong friendship one of the few New Yorkers who would have been intimately acquainted with Kleist's life and art. Dr. George Adler (1821–1868) was a native of Leipzig who became a professor of philology at the University of New York when only in his twenties. Adler had published his two-volume Dictionary of the German and English languages shortly before a four-week, storm-blown, New York-to-Liverpool voyage in which he and Melville had long discussions on *Fixed Fate, Free-Will, and foreknowledge absolute*, with special attention to *Hegel, Schlegel, and Kant*. Adler subsequently published some of the first American translations of writings by Goethe, Schiller, Hoffmann, and Tieck in spite of being confined in the Bloomingdale Asylum for the Insane. Melville attended his funeral in 1868. For an overview of their relationship, and an argument for Adler's strong influence on Moby-Dick, see Sanford E. Marovitz, More Chartless Voyaging: Melville and Adler at Sea, Studies in the American Renaissance, 1986, 373–383.

of Modern Art. For another thirty years since then, he has been continuously inventive, productive, and acclaimed in galleries and museums around the world (an international success aptly symbolized by his Heinrich von Kleist exhibition and symposium in Jena in 2001). So why is this eminently successful artist drawn to Kleist, a writer whose crisis of faith in an alien world became intolerable at an early age? One answer must be the difficulty, and the inner isolation, of making good, lasting art even in the midst of a highly successful career.

When I asked Stella what had drawn him so strongly to Kleist, he said that *The Prince of Homburg and the stories were great, and the correspondence too, but the love letters were the turning point. They were brutally painful. To actually read all the love letters, it's really a masochistic endeavor. People pretend that they're literature and there are ideas in them, but actually they're love letters. And that's like what the artist makes, for better or worse – love letters to someone like Wilhelmine. The artist's relationship to the outside world, and to the art world, is exactly like Kleist's relationship to Wilhelmine. It's pitiful to need that kind of attention in that kind of way.*

In *Working Space* Stella noted that Titian had painted the *Flaying of Marsyas* at the end of a *perpetually successful* career. Even so, Titian depicted *details of human suffering* that we might prefer not to see. He risked the depiction of disembodiment because *there has to be a convincing exchange of vitality between the viewer and the painting if both are to live*. Kleist and Melville have each helped Stella's art to live through their own risky discharges of disembodied vitality. No less than Titian and Caravaggio among painters, these two writers have helped to inspire that *transfer of responsibility between generations of creative artists* which *must be endured to ensure the vitality of art* (*Working Space*, p. 102–103).[98]

Robert K. Wallace

---

[98] In his catalog essay for the exhibition at the Locks Gallery in Philadelphia, Robert Hobbs also interprets Stella's most recent work in the context of the discussions of Titian and Caravaggio in Working Space. See *Frank Stella: Matrixed Space and Real Space* in Frank Stella: Recent Work (Philadelphia: Locks Gallery, October 13–November 25, 2000), pp. 7–9.

## *The Hudson River Valley Series*
## Frank Stella

**Tafel / plate LXXX**
*Newburgh*
1995
Stainless steel with carbon steel / Rostfreier Stahl mit unlegiertem Stahl
155 x 169 x 138" / 393 x 429 x 350 cm
Jena, Ernst Abbe-Platz, JENOPTIK AG

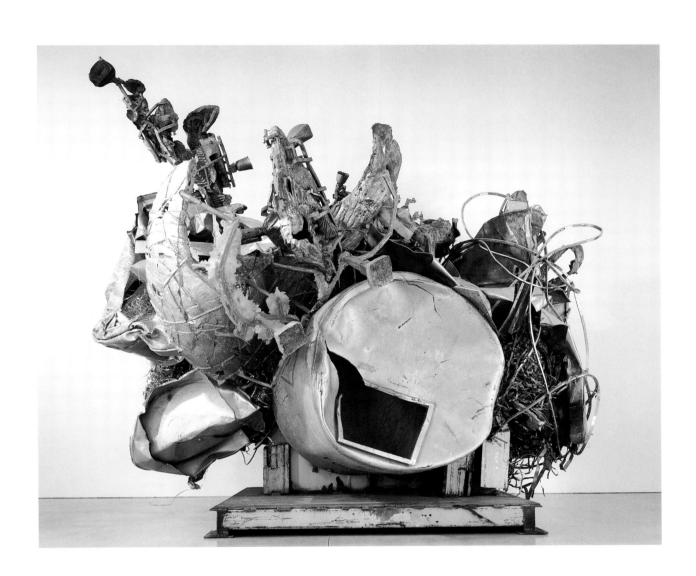

**Tafel / plate LXXXI**
*Fishkill*
1995
Stainless steel with carbon steel / Rostfreier Stahl mit unlegiertem Stahl
147 x 174 x 130" / 373 x 441 x 330 cm
Jena, Ernst Abbe-Platz, lent by Frank Stella

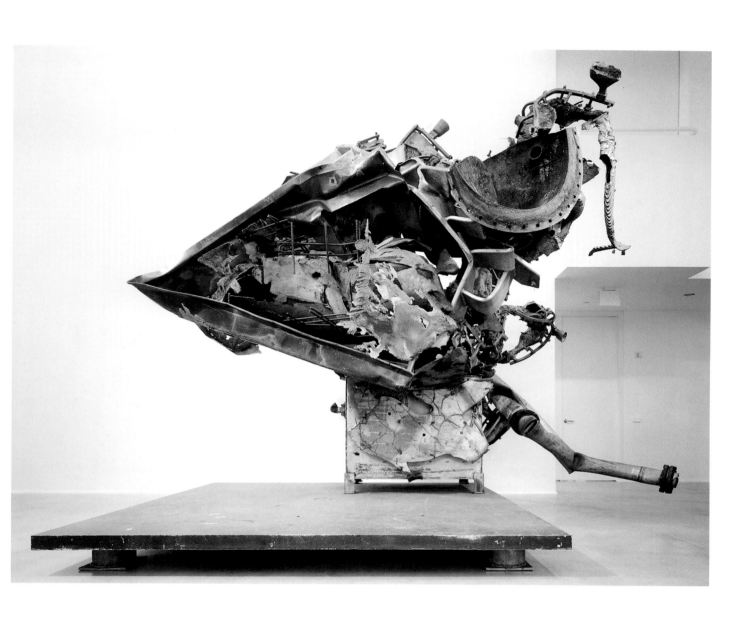

**Tafel / plate LXXXII**
*Bear Mountain*
1995
Stainless steel, carbon steel, and bronze / Rostfreier Stahl, unlegierter Stahl und Bronze
98 x 214.5 x 214.5" / 248 x 543 x 543 cm
Jena, Ernst Abbe-Platz, lent by Frank Stella

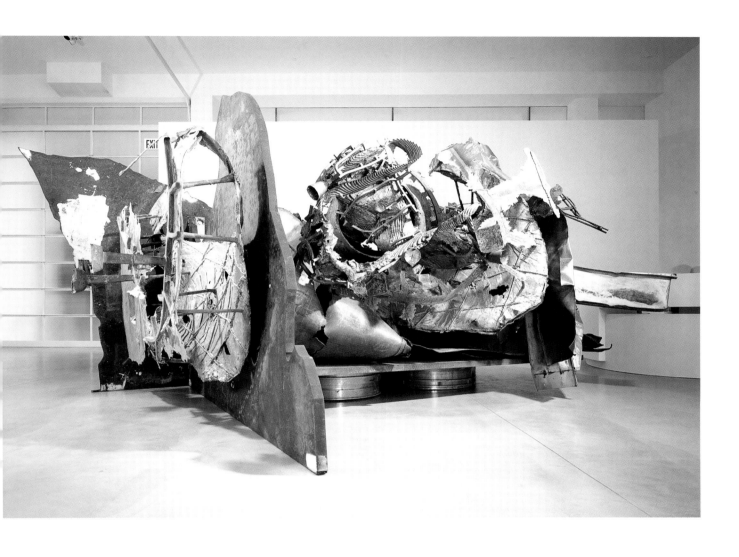

**Tafel / plate LXXXIII**
*Peekskill*
1995
Stainless steel with carbon steel / Rostfreier und unlegierter Stahl
88.5 x 112 x 61.5" / 223 x 284 x 154 cm
Jena, Ernst Abbe-Platz, lent by Frank Stella

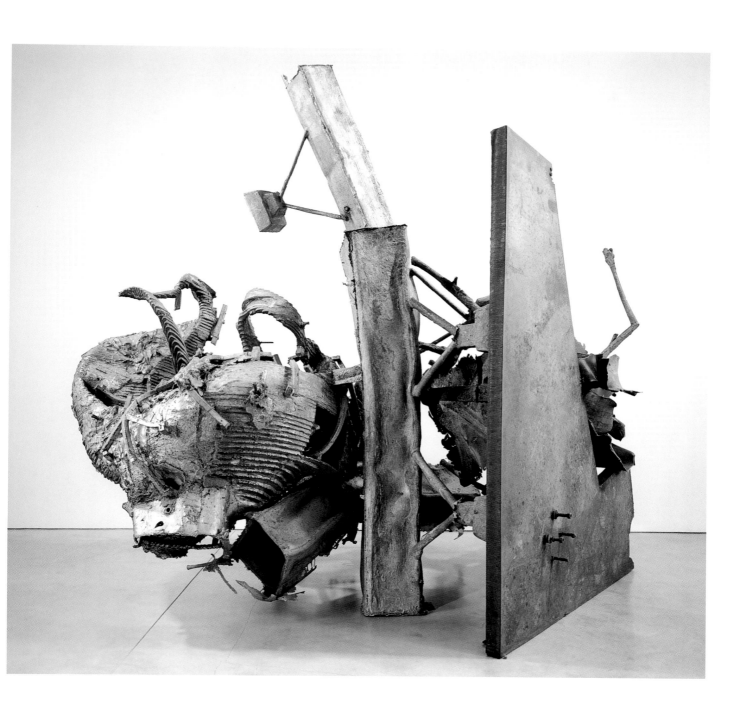

**Tafel / plate LXXXIV**
*Garrison*
1995
Stainles steel / Rostfreier Stahl
81 x 64 x 63''' / 205 x 162 x 172 cm
Jena, Ernst Abbe-Platz, Friedrich Schiller-Universität, gift of Frank Stella

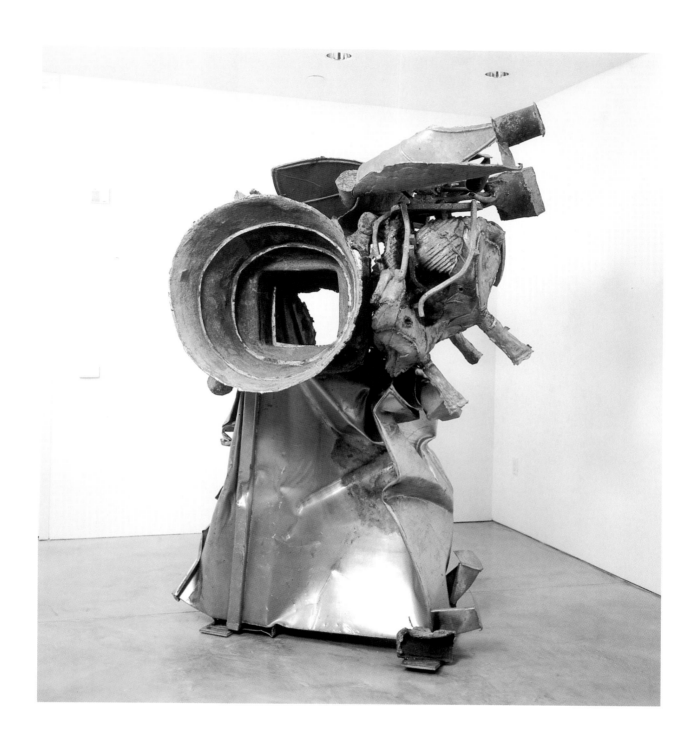

**Tafel / plate LXXXV**
*Wappingers Falls*
1995
Stainless steel, alumabronze, and carbon steel / Rostfreier Stahl, Aluminiumbronze und unlegierter Stahl
81 x 159 x 114" / 206 x 163 x 173 cm
Los Angeles, Gagosian Gallery

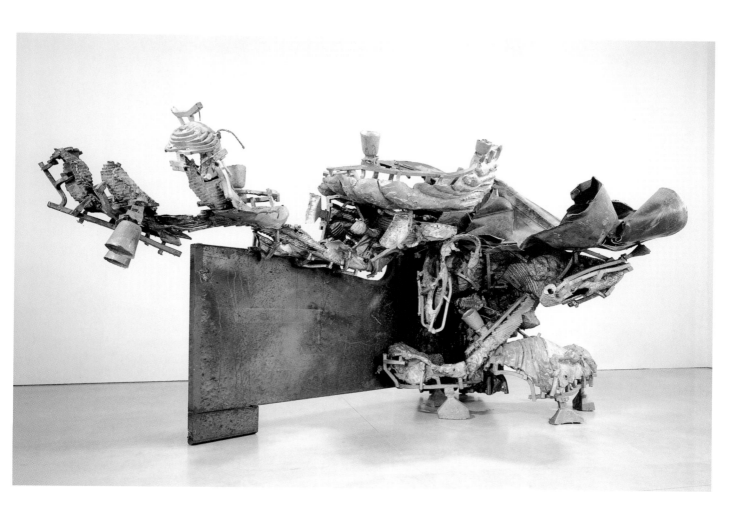

# Frank Stella in Jena – Rückblick und Ausblick[99]

Der Anlass des ersten Besuchs von Frank Stella in Jena

Der Ernst Abbe-Platz in Jena, vormals Hauptwerksgelände der Firma Zeiss, steht seit seiner Fertigstellung der Öffentlichkeit und den Universitätsangehörigen als Campus zur Verfügung und darf seit der Aufstellung von fünf Skulpturen Frank Stellas als singuläres Ensemble gelten. Bei den Werken Frank Stellas handelt es sich – nur die Arbeit *Wappingers Falls* fehlt – um das gesamte plastische Œuvre des Jahres 1995, dem der Künstler den Titel *Hudson River Valley Series* verlieh. Die einzelnen Arbeiten erhielten Namen nach Städten und einem markanten Landschaftsmotiv am nördlich von New York City gelegenen Hudson River Valley, die im Umkreis der Gießerei Tallix in Beacon im Staate New York liegen, wo Frank Stella mit seinen Mitarbeitern an den Skulpturen arbeitete und sie schließlich gießen ließ.

Die Entscheidung, die Skulpturen nach Jena zu geben, fällte der Künstler zwischen dem 6. Februar 1996, da ihm die Würde eines Doctor philosophiae honoris causa der Philosophischen Fakultät der Friedrich Schiller-Universität verliehen wurde,[100] und seinem zweiten Besuch in Jena am 22. / 23. April des gleichen Jahres, als er dem Vorsitzenden des Vorstandes der JENOPTIK AG, Lothar Späth, einigen seiner Mitarbeiter und einem Mitglied der Hochschule den Plan eröffnete, das Werk *Garrison* der Alma mater Jenensis als Geschenk, die Skulptur *Newburgh* der Jenoptik zum Ankauf und die Arbeiten *Fishkill*, *Bear Mountain* und *Peekskill* als Leihgaben für die Dauer von fünf Jahren zu überlassen. Am Tage nach der Verleihung der Ehrendoktorwürde besuchte Frank Stella das Goethe-Haus und die Kunstschule Henry van de Veldes in Weimar und sah bei einer Fahrt über Land die von Lyonel Feininger als Bildmotiv geschätzte Dorfkirche von Mellingen, die ihn spontan den Bezug zu seinem Lehrer Patrick Morgan herstellen ließ, der noch Feiningers Schüler in den USA war. Bei der Jenoptik zu Gast, mit der er ein Gespräch über den möglichen Ankauf eines seiner Werke führte, blickte er vom Dach des renovierten Verwaltungsgebäudes aus dem Jahre 1935 auf den entstehenden Ernst Abbe-Platz, wobei sich sein Interesse an der Mitwirkung bei der Platzgestaltung trotz des Druckes seiner bevorstehenden Retrospektive in München, die wenige Tage später, am 9. Februar, im Haus der Kunst eröffnet werden sollte und mit deren Hängung er sich noch intensiv befasste, bereits abzeichnete. Die späteren Gespräche über die Vorschläge der Platzgestaltung und Skulpturenaufstellung mit den verantwortlichen Planern führten schließlich zu der jetzigen Präsentation. Bisher waren die Arbeiten nur einmal zu sehen. Sie wurden in der von Richard Meier erbauten *Larry Gagosian Gallery* in Los Angeles zur Eröffnung des Neubaues der Galerie im Oktober 1995 unter dem Titel *Frank Stella. New Sculpture* gezeigt.

Die Skulpturen der *Hudson River Valley Series* wie überhaupt die freistehend dreidimensionalen Werke Frank Stellas scheinen auf den ersten Blick zu seiner vorausgehenden Malerei in keinem Verhältnis zu stehen. Der Künstler stellte zum ersten Male Skulpturen im Dezember 1990 in der New Yorker Galerie *65 Thompson Street* aus, obwohl er bereits seit mehreren Jahren an nicht vor einer Wand hängenden Konstruktionen arbeitete, für die sein Interesse durch sein erstes Architekturprojekt von 1988, den Entwurf einer Fußgängerbrücke über die Seine in Paris, gesteigert worden sein könnte.[101] Nach der unmittelbaren Rezeption durch die überraschte Öffentlichkeit erfuhren seine Bozzetti und Projektvorschläge schnelle Bewunderung, aber auch Kritik, die dem Künstler erneut die Durchkreuzung seiner frühen bildnerischen Ideale unterstellte. Die Einwände blieben unspezifisch und ähnelten Hilton Kramers Vorwurf von 1986, Frank Stella habe in den 70er Jahren die Malerei zu Gunsten der Skulptur aufgegeben, seine neueren Werke seien *a species of sculpture relief that incorporates, often very effectively, certain elements of pictorial illusionism within a three-dimensional structure.*[102] Nach der Ausstellungseröffnung von neuen Skulpturen im Herbst 1992 in der Galerie Knoedler, New York, lautete die Schlagzeile der Tagespresse *Stella's Comic Muddling of 60's Nostalgia, 90's Opportunism.*[103]

---

[99] Der Text wurde bereits 1996 erstmals publiziert in Franz-Joachim Verspohl, Frank Stella. New Sculpture. The Hudson River Valley Series, Jena 1996.

[100] Über die Verleihung der Ehrendoktorwürde an Frank Stella informiert Pictor laureatus. In Honour of Frank Stella. Frank Stella zu Ehren, Minerva. Jenaer Schriften zur Kunstgeschichte, Bd. 2, 1996.

[101] Vgl. Abb. bei Sidney Guberman, Frank Stella. An Illustrated Biography, New York 1995, S. 217.

[102] Zit. n. William Rubin, Frank Stella 1970 - 1987, New York 1987, S. 18.

[103] Zit. n. Sidney Guberman, S. 213; vgl. zum malerischen Frühwerk Frank Stellas Lawrence Rubin, Frank Stella. Paintings 1958 to 1965. A catalogue raisonné, New York 1986.

# Frank Stella in Jena – Survey and Prospect[161]

The Occasion of Frank Stella's First Visit to Jena

The installation of five sculptures by Frank Stella, which he created in 1995, in the newly reconstructed Ernst Abbe-Platz in the former main factory complex of the Zeiss Company in Jena gave this public place a unique character. For in the works of Frank Stella we have – only the work *Wappingers Falls* is absent – the complete plastic works of 1995, which the artist named the *Hudson River Valley Series*. The individual works received the names of cities and of a remarkable landscape motif of the Hudson River Valley, which lies north of New York City, where Frank Stella worked on and eventually cast the sculptures with his assistants.

Frank Stella made his decision to give the sculptures to Jena between 6 February 1996, when he was conferred with the honor of a Doctor philosphiae honoris causa from the faculty of humanities,[162] and his second visit to Jena on the 22nd and 23rd of April of the same year when he revealed his plan to Lothar Späth, the chairman of the board of JENOPTIC AG, some of his assistants and a member of the university to leave the Alma mater Jenensis the work *Garrison* as a gift, the sculpture *Newburgh* to Jenoptik as a purchase and the works *Fishkill*, *Bear Mountain* and *Peekskill* as five-year loans. On the day after the conferment of the honorary doctorate the artist visited the Goethe House and the art school in Weimar, which was designed by Henry van de Velde, and saw on his ride through the countryside the village church of Mellingen, which was honored as a pictorial motif by Lyonel Feininger, which, in turn, brought Stella to spontaneously make the association with his instructor Patrick Morgan, who was Feininger's student in the USA. As a guest of Jenoptik, with whom he was discussing the possible purchase of one of his works, he at one point looked down from the roof of the renovated administrative building, built in 1935, onto the evolving Ernst Abbe-Platz, at which point his interest in participating in the designing of the site already became apparent, in spite of the pressure of his upcoming retrospective in Munich that was to be opened a few days later, on the 9th of February in the *Haus der Kunst*, the hanging of which he was still intensively involved. The later discussions concerning the proposals for the design of the site and arrangement of the sculptures with the responsible planners finally led to the present presentation. Up until now the works have only been seen once. They were displayed in the *Larry Gagosian Gallery,* built by Richard Meier, in Los Angeles at the opening of the gallery's new building in October 1995 under the title, *Frank Stella. New Sculpture*.

The sculptures of the *Hudson River Valley* Series - as with the free-standing, three-dimensional works of Frank Stella in general – appear at first sight not to have any relationship to his earlier paintings. Frank Stella exhibited sculptures for the first time in December of 1990 in the New York gallery *65 Thompson Street*, although he already had been working on three-dimensional, free-standing constructions that do not hang in front of a wall. His interest in such constructions could have been aroused by his first architectural project in 1988, the design of a pedestrian bridge[163] over the Seine in Paris. After the initial reception by the surprised public, his models and project proposals found quick admiration, but also negative criticism, which insinuated the thwarting of his early painterly ideals. The objections remained vague and were based on the same assumptions that Hilton Kramer made when he wrote in 1986, that in the 1970s Frank Stella gave up painting in favor of sculpture, and that his new works are *A species of sculpture relief that incorporates, often very effectively, certain elements of pictorial illusionism within a three dimensional structure*.[164] After the opening of the exhibition of new sculptures in the fall of 1992 in the Knoedler Gallery, New York, the headlines in the daily press were *Stella's Comic Muddling of 60's Nostalgia, 90's Opportunism*.[165]

161 The essay was first published in 1996. See Franz-Joachim Verspohl, Frank Stella. New Sculpture. The Hudson River Valley Series, Jena 1996.
162 On the conferment of the honorary doctorate see Pictor laureatus. In Honour of Frank Stella. Frank Stella zu Ehren, Minerva. Jenaer Schriften zur Kunstgeschichte, vol. 2. (Gera: Rhino, 1996).
163 See the illustration in Sidney Guberman, Frank Stella. An Illustrated Biography (New York: Rizzoli, 1995), p. 217.
164 Quoted in Rubin, Frank Stella 1970–1987 (New York: Museum of Modern Art, 1987), p. 18.
165 Quoted in Sidney Guberman, p. 213; on Frank Stella's early artistic work, see Lawrence Rubin, Frank Stella. Paintings 1958 to 1965. A catalogue raisonné (New York: Tabori, 1986).

Doch angesichts der ersten monumentalen Werke und Serien, die nach Bozzetti in Stahl und Aluminium mit hohem Aufwand vergrößert und zahlreichen Abweichungen gegenüber den Modellen ausgeführt wurden, fiel diese Wertung in sich zusammen. Denn die Skulpturen *Sarreguemines*, 1993, von der Hypobank in Luxembourg bestellt und vor ihrem von Richard Meier errichteten Gebäude aufgestellt,[104] *Werner Herzog Eats His Shoe*, 1993, im Sommer des gleichen Jahres in Rom in einer Arkade des Eingangs des Palazzo delle Esposizioni gezeigt,[105] *Fitzcaraldo*, 1993, *Yawata Works*, 1993, im gleichen Jahr vor dem Kitakyushu Municipal Museum of Art aufgerichtet,[106] *Burden Dreams*, 1993, in der Lobby des Ralph H. Metcalfe Federal Building in Chicago installiert ebenso wie *The Town-Ho's Story*, und *The Cabin. Ahab and Pip*, 1994, und die parallel verlaufende Weiterführung der Malerei in großformatigen Wandgemälden, etwa *Polombe*, 1994,[107] sowie Fassadenbildern und Gesamtausstattungen, beispielsweise des Theaters *The Princess of Wales* in Toronto, 1992–1993,[108] veranschaulichen eine schöpferische, in der Gegenwartskunst selten anzutreffende Mannigfaltigkeit.

Frank Stellas skulpturale Arbeiten sind eine Fortführung seiner Malerei mit anderen Mitteln. Er hat seine Theorie der Bildlichkeit keineswegs aufgegeben, sie sogar in die Architektur verlängert. Er denkt die Kunstgattungen nicht von ihren Rändern her, ihrer Entgrenzung, sondern von ihrem eigentlichen Zentrum, dem seit dem ausgehenden 18. Jahrhundert verfeinerten und experimentell erprobten Autonomiegedanken des Bildes. Dessen Kraft reaktiviert er am Ende dieses Jahrhunderts noch einmal. Die Malerei stellt er an die Spitze der Gattungen und macht sie zum Motor der bildenden Künste.[109]

*Hudson River Valley Series*

Waren die Gemälde von Reihungen, geometrischen oder ornamental wirkenden Formen geprägt, denen bei aller aufgewandten gestalterischen Freiheit Regelhaftigkeit ablesbar ist, versagen sich die Güsse jeder dekorativen Einprägsamkeit. Man könnte sie informell nennen, da vorgefundene Formen gegossen, montiert und mit Legierungen überschüttet worden sind, ergänzt um Reste von Gittern der Gusskanäle und Gusstrichter, perforierte Metallfolien und Stahlbandknäuel, die wie Draperien die Zwischenräume der Metallkörper ausfüllen und Höhlen schaffen für Einblicke in Innenräume mit sperrigen Binnenformen. Wie Extremitäten ragen aus den aufgebrochenen Formen einzelne Objektteile kantig heraus, die von vorgegebenen Gebrauchsformen abgegossen sind und sich relativ leicht auf ihren ehemaligen industriellen Verwendungszweck zurückführen lassen, etwa Stützen, Verschalungen, Behälter, Bänder, Gitter und Rohre, deren Formen mit der freien Entfaltung jener Elemente korrespondieren, die durch Schütten des flüssigen Metalls entstanden. Ungeachtet der Rückführbarkeit einzelner skulpturaler Elemente auf alltägliche Gegenstände bleibt ihre Gestaltqualität in der spezifischen Form der Anordnung unbestimmt. Im Gesamt verschleifen sich die funktionalen Bezüge der Elemente zu Gunsten einer informellen Struktur.

*Newburgh* und *Fishkill* ragen von Bodenplatten auf, die noch am ehesten an Skulpturensockel erinnern. Doch widerspricht die weitere Installation dem klassischen Prinzip von Tragen und Lasten. Eine flache, vertikal aufgehende Metallwand in *Newburgh* und ein rissiges, in eine Ecke der Platte gesetztes Gehäuse in *Fishkill* werden zum eigentlichen *Träger* des Aufbaues. Über diesen *Stützen* verliert sich das Auge an Einzelformen, ohne mit Gewissheit sagen zu können, welche Form der anderen Halt gibt. Sind es die größeren geschwungenen Hohlkörper, die wie Verstrebungen eingesetzten, gewinkelten oder gebogenen Metallstreifen, oder die Bügel, oder gar die kleinteiligen wie Drahtknäuel eingehängten Füllmassen und Gitter, oder die offensichtlich über die Rohform gegossenen, flüssigen Legierungen, die sich selbst am Vorhandenen geformt haben? Der skulpturale Aufbau scheint die Schwere zu überwinden, das Gebilde hängt in der Luft, besser noch, es schwebt.

---

[104] Abb. bei Sidney Guberman, S. 235; dort fälschlich auf 1992 datiert.
[105] Abb. in Ausst.-Kat. Rom 1993, Richard Meier. Frank Stella. Arte e Architettura, Palazzo delle Esposizioni, S. 276.
[106] Vgl. Sidney Guberman, S. 215 f; Abb. S. 236.
[107] Abb. in Ausst.-Kat. München 1996, Frank Stella, Haus der Kunst, S. 224 f.
[108] Abb. bei Sidney Guberman, S. 218 f.
[109] Zu den Anfängen der Geschichte des Rangstreites der Kunstgattungen vgl. Leonardo da Vinci, Sämtliche Gemälde und die Schriften zur Malerei, Hg. André Chastel, München 1990, bes. S. 201 ff., zu seiner Fortsetzung Iain Pears, The Discovery of Painting. The Growth of Interest in the Arts in England, 1680–1768, New Haven / London 1988, Herbert Beck / Peter C. Bol / Eva Maek-Gérard (Hg.), Ideal und Wirklichkeit der bildenden Kunst im späten 18. Jahrhundert, Berlin 1984, Robert Rosenblum, Transformations in Late Eighteenth Century Art, Princeton 1967.

Faced, however, with the first monumental works and series, which were constructed along the lines of models in steel and aluminum, enlarged with great effort, and with numerous deviations from the models, this evaluation collapses. For the sculptures *Sarreguemines,* 1993, ordered by the HypoBank in Luxembourg and installed in front of their building, designed by Richard Meier;[166] *Werner Herzog Eats His Shoe*, 1993, shown in the Summer of the same year in Rome in an arcade at the entrance of the Palazzo delle Esposizioni;[167] *Fitzcaraldo*, 1993; *Yawata Works*, 1993, installed in the same year in front of the Kitakyushu Municipal Museum of Art;[168] *Burden Dreams*, 1993, installed in the lobby of the Ralph H. Metcalfe Federal Building in Chicago; as well as *The Town-Ho's Story*, and *The Cabin. Ahab and Pip*, 1994; and the parallel continuation of large-format wall paintings, like *Polombe*,[169] 1994; as well as facade paintings and complete appointments, for example, the theater *The Princess of Wales* in Toronto,[170] 1992–1993, display a creative multiplicity that is seldom seen in contemporary art.

Irrespective of the criticism, an attempt will be undertaken below to show that Frank Stella's sculptural works are a continuation of his painting by other means and that he in no way has given up his theory of pictorial quality, but rather that he has even extended it into architecture. He does not consider the art forms starting from their margins, from their delimitation, but rather from their actual center: the idea of the autonomy of the image that has been refined and experimentally explored since the end of the 18th century. Stella is reactivating the power of this idea once again at the end of this century. He is placing painting at the pinnacle of the art forms and making it into the driving force of the fine arts.[171]

*Hudson River Valley Series*

Whereas the paintings were characterized by the lining up of geometric or ornamental forms, whose rule-governed quality can be seen even with all of the employed freedom in construction, the castings refrain from any impressive decorative quality. One could call them informal because already present forms were cast, mounted and covered with metal alloy, supplemented with the filling funnels and filling channels, perforated metal foil and tangled steel bands that fill out the gaps between the metal bodies and create holes for views into the internal spaces which have unwieldy internal forms. Like limbs, individual parts jut out at an angle from the broken up forms, which have been cast from the already present, everyday forms and that are relatively easy to identify with their former industrial purpose, for example, supports, framework, receptacles, bands, grating, and pipes, whose forms correspond to the free development of these elements which have arisen through the pouring of the liquid metal. Despite the retraceability of individual sculptural elements to everyday objects, their formal quality remains undetermined in the particular form of arrangement. On the whole, the functional references of the elements are slurred in favor of an informal structure.

*Newburgh* and *Fishkill* loom up from baseplates that are most likely to remind us of sculpture socles. However, the rest of the installation contradicts the classic principle of support and load. A flat, vertically ascendant metal wall in *Newburgh* and a cracked casing set in the corner of the plate in *Fishkill* become the actual supporters of the construction. Above these supports the eye loses itself in individual forms without being able to determine with certainty which form supports the other. Is it the larger waved hollow bodies, the brace-like, inlaid, bent or bowed metal strips, or the hangers, or even the small-piece filling and grating hung like wire balls, or the liquid alloys obviously poured over the raw form and which have formed themselves on the already at hand? The sculptural arrangement appears to defy gravity. The structure hangs in the air; better yet, it floats.

---

[166] Illustration in Sidney Guberman, p. 235; there falsely dated at 1992.
[167] Illustration in the Rome exhibition catalogue, 1993, Richard Meier. Frank Stella. Arte e Architettura (Rome:Palazzo delle Esposizioni), p. 276.
[168] See Sidney Guberman, p. 215 f; illustration, p. 236.
[169] Illustration in the Munich exhibition catalogue, 1996, Frank Stella, p. 224 f.
[170] Illustration in Sidney Guberman, p. 218 f.
[171] On the beginning of the history of the border struggle of the art forms, see Leonardo da Vinci, Sämtliche Gemälde und die Schriften zur Malerei, Ed. André Chastel (Munich: Schirmer / Mosel, 1990) especially p. 201 ff., on the continuation of this debate see Iain Pears, The Discovery of Painting. The Growth of Interest in the Arts in England, 1680–1768 (New Haven / London: Yale UP, 1988); Herbert Beck / Peter C. Bol / Eva Maek-Gérard (Eds.) Ideal und Wirklichkeit der bildenden Kunst im späten 18. Jahrhundert (Berlin: Gebrüder Mann, 1984); Robert Rosenblum, Transformations in Late Eighteenth Century Art (Princeton: Princeton UP, 1967).

In *Bear Mountain* und *Peekskill* sind die Bodenplatten gleichsam in die Vertikale überführt. Zwischen massiven, an den Oberkanten in unregelmäßigem Kontur geschnittenen Stahlplatten hängen aus rostfreiem Stahl gegossene Einzelformen, die trotz ihrer spröden Oberfläche silbrig hell glänzen. Um das optisch instabile Verhältnis zwischen flächigen Großformen, Hohl- und Kleinformen zu steigern, ist in *Bear Mountain* eine Platte so in Schräglage gebracht, dass die auf ihr aufruhende, schrundige und mit zerbrochenen und verformten Armaturen überzogene Großform zu rutschen scheint. In *Peekskill* hängen die Gussformen *lastend* nach einer Seite über, gleichsam zusammengezogen von einer schweren senkrecht stehenden Eisenplatte, die selbst wieder mit einem starken, vierkantigen Metallrohling verstrebt ist, an dem die bizarre Gussform aus Edelstahl wie ein Gegengewicht zieht.

*Garrison* kommt dem an historischen Beispielen geschulten Auge zunächst optisch entgegen. Im unteren Teil sind die Edelstahlplatten gefaltet und so zusammengesetzt, daß sie einen, wenn auch unregelmäßig pyramidalen Hohlkörper ergeben. Auf ihm liegt horizontal eine Gussform auf, die sich aus einem hohlen Kegelstumpf und einem vierseitigen, ebenso hohlen Pfeilerstumpf zusammensetzt. Gebogene Metallschienen umklammern die Form und halten sie in ihrer fragilen Lage, die noch dadurch kompliziert wird, dass die Gussformen zu einer Seite der Skulptur, überdeckt von einem wellenförmig gebogenen Metallblech, weiterwuchern. Erinnert der Unterbau zuerst an Skulpturen von John Chamberlain, der Karosserieteile von Autos zusammenpresste,[110] so lässt der obere Teil den Vergleich nicht mehr zu. Mit seinen Löchern, in und durch die man schaut, sichtbaren, aber uneinsehbaren Hohlstellen, spitz und kantig vorkragenden Einzelformen, an denen das Auge unruhig entlanggleitet und keinen Halt findet, ist er äußerst heterogen. Auch das taktile Empfinden, das klassische Skulptur immer anreizt, erfährt eine Zurückweisung. Zwar nimmt der Betrachter die verschiedenen Oberflächenstrukturen wahr, die glänzende, die matte Hülle, die Rauheit und Schrundigkeit, aber es wird ihn kaum danach verlangen, mit der gleitenden Hand über die Flächen zu streifen.

Die gesteigerte Vielteiligkeit und räumliche Ausdehnung der Arbeiten scheint geradezu das Gegenteil dessen bewirken zu wollen, was Skulptur im üblichen Sinne leistet: die Unterscheidung von Tragen und Lasten, die vertikale Gestaltentwicklung von unten nach oben und die Entfaltung in den Umraum. Scharfkantig und linear, wirken sie doch malerisch und scheinen angesichts der unterschiedlichen Oberflächenstrukturen von Lichtreflexion und Lichtabsorption zu handeln. Die fünf Werke sind zwar räumlich präsent, deuten in ihrer Materialität auch haptische Qualitäten an, doch werden diese immer wieder dadurch geschluckt, dass die Anschlüsse der einzelnen skputuralen Elemente nicht kontinuierend verlaufen. Obwohl die Werke jeweils ein beträchtliches Gewicht haben und solide montiert sind, verraten sie ihre Schwere nicht unmittelbar. Groß und Klein, als nachvollziehbare Werte, spielen eine untergeordnete Rolle. Volumina existieren im klassischen Sinne nicht. Alles ist Fläche, nichtkörperhaft, oder löst sich in lineare Gebilde wie die Stahlbandknäuel auf. Frank Stella setzt mit flächigen Formen durch Drehung, Verschiebung und Bündelung Räumlichkeit und Dynamik frei. Sind die Sockel oder Bodenplatten von *Newburgh* und *Fishkill* nicht horizontalisierte Bildrahmen? Und hat der Künstler bei den drei anderen Werken vielleicht nur den Kunstgriff angewendet, sie gleichsam von der Wand zu nehmen und aufzustellen? Insofern stellten die Skulpturen eine Synthese seines Bildbegriffs dar und oszillierten zwischen Malerei und Skulptur.

Unter den wiedererkennbaren Gussformen fallen die Gusstrichter besonders auf. Sie erinnern zunächst an kleine Sockel von Stützen, wie man sie aus Absperrungen in Parks, Gärten und auf Plätzen kennt. Es handelt sich jedoch um die erhaltenen Einfüllstutzen der Metalllegierungen, die der Künstler ebenso wenig entfernt hat wie die Gusskanäle. Die eigentliche Gussform hängt gleichsam in einem Raster der beim Gießen erforderlichen Kanäle. In *Garrison* ist das Element gleich mehrfach erhalten, ja sogar in Verbindung mit den Gusskanälen zu erkennen. In *Newburgh* zielt es wiederholt, einer Nadel vergleichbar, in das Innere der Plastik, obwohl sie keinen Kern, kein eigentliches Zentrum hat. Greift dieses Prinzip der Erhaltung des Rohlings der Gussform nicht jedem haptischen Anreiz vor? Soll es dazu beitragen, die *Unbegehbarkeit* der Skulpturen bildhaft vorzuführen und sie malerisch erscheinen lassen?

Gerade die monumentalen Werke des Jahres 1993 legen die rein optische Wahrnehmung nahe, wenn man darunter versteht, dass sie stärker auf die malerischen Werte ausgeht. In ihrer Gesamtheit sind die Skulpturen nur aus gewissem Abstand wahrzunehmen. Aus der Nähe überragen sie den Betrachter erheblich und überschütten ihn kaskadenhaft in ihrer Vielteiligkeit, so dass es schwer fällt, die Materialien und Formen zu überblicken, zu ordnen und in ein Verhältnis zu bringen. Ein taktiles Überprüfen ist kaum möglich.

---

[110] Vgl. Abb. in Ausst.-Kat. Köln 1986, Europa / Amerika. Die Geschichte einer künstlerischen Faszination seit 1940, Museum Ludwig, S. 351.

In *Bear Mountain* and *Peekskill* the baseplates are made virtually perpendicular. Individual forms made of stainless steel, that shine brightly, despite their fissured surfaces, hang between massive steel plates whose upper edges are cut into an uneven contour. To increase the optically unstable relationship between massive, planar forms, hollow forms and small forms a plate is brought into an angled position in *Bear Mountain*, such that the fissured massive form that is covered with broken and deformed attachments appears to slide. In *Peekskill* the foundry molds hang oppressively to one side, pulled together, as it were, by a heavy, vertical iron plate that is itself braced by a sturdy, tetragonal metal forging, on which the bizarre foundry mold made of stainless steel pulls like a counterweight.

*Garrison* meets the eye schooled on historical examples optically above all. The stainless steel plates are folded at the bottom and connected such that they produce a, although uneven, pyramidal, hollow body. A foundry mold that is composed of a hollow stub of a truncated cone and a four-sided, equally hollow, pillar stump lies horizontally upon it. Bowed metal rails bracket the form and hold it in a fragile state that is further complicated in that the foundry molds, which are covered by a wave-shaped, bowed sheet metal, further proliferate to one side of the sculpture. Although the substructure initially reminds us of sculptures by John Chamberlain, who pressed together auto body parts,[172] the upper part no longer displays parallels to his works. With its holes in and through which one looks, visible but impenetrable hollow spaces, individual parts that are pointy and jut out at angles, and along which the eye is restlessly led but cannot find any resting place, it is extremely heterogeneous. The tactile senses, which are always stimulated by classical sculptures, experience a rebuff. For sure the viewer perceives the various surface structures, the shiny ones, the dull casing, the rawness and chappedness, but it will hardly bring him to stroke the surfaces with a quietly accompanying touch.

The increased multipartite quality and spatial expansion of the works appears to want to effect precisely the opposite of that which sculpture usually achieves: the differentiation of support and load, the vertical development of the form from bottom to top and the unfolding into the surrounding space. Sharply angled and linear, they have a pictorial effect and appear, in light of the different surface structures, involve the reflection and absorption of light. The five works are in fact spatially present, and also indicate, in their materiality, haptic qualities; nonetheless, these are always absorbed in that the annexations of the individual sculptural elements do not run continuously. Although the works weigh relatively a lot and are solidly mounted, they do not reveal their weight directly. Large and small, as identifiable values, play a subordinate role. Volumes do not exist in the classic sense. Everything is surface, non-corporeal, or vanishes in a linear structure, such as a ball of steel band. With planar forms Frank Stella sets spatiality and dynamics free through rotation, dislocation and bundling. Are not the socle or base plates of *Newburgh* and *Fishkill* horizontal picture frames, and did the artist not use a trick in the three other works, taking them from the wall and standing them up? As such the sculptures would represent a synthesis of his concept of painting and oscillate between painting and sculpture.

Among the reoccurring foundry molds, the filling funnels, remind of conically tapered socle forms, with a square, tapered shaft. In *Garrison* the element is employed numerous times, yes, even in combination with its horizontal brace. In *Newburgh* it levels at, like a needle, the center of the sculpture, although it does not have a core, an actual center. Does it not inhibit the haptic stimulus? Will it assist in vividly displaying the inaccessibility of the sculptures and allowing them to appear painterly?

Precisely the monumental works of 1993 suggest purely optical perception, if one understands by this, that they terminate more strictly in pictorial values. In their totality the sculptures are only to be contemplated at a certain distance. From up close they powerfully overwhelm and sweep one into their multipartite construction like a cascade, so that it is difficult to oversee and order the materials and forms and to bring them into relationship with one another. Tactile investigation is hardly possible.

---

[172] See the illustration in the Cologne exhibition catalogue, 1986, Europa / Amerika. Die Geschichte einer künstlerischen Faszination seit 1940 (Cologne: Museum Ludwig), p. 351.

Die große Skulptur *Werner Herzog Eats His Shoe*, 1993, stellte Frank Stella als Bild mit Tableaucharakter in eine Arkade des Eingangs des Palazzo delle Esposizioni in Rom,[111] montiert auf einer doppelwandigen Stahlplatte, die selbst wiederum auf vier, zu zwei Paaren zusammengelegten Stahlträgern aufruht. Allein dieser Unterbau widerspricht skulpturaler Konvention selbst in der Gegenwartskunst. Richard Serras massige Stahlplatten gründen, so instabil ihre Anordnung erscheint, auf festem Grund, den auch die Minimal Art Donald Judds oder Carl Andres nicht in Frage stellt. Sie setzen das Fundament bedingungslos voraus, während Frank Stella es, wie in seiner Malerei den Malgrund, als das Werk konstituierende Größe anerkennt. Er vermeidet im Aufbau der Skulpturen sowohl die Großflächigkeit von Formen wie lastendes Volumen weitestgehend, wohingegen Richard Serra mit gewalzten planen oder konkav-konvex gekrümmten Stahlplatten Volumina und Räume erzeugt. Dagegen ist es für Frank Stella charakteristisch, Skulptur fragil auf gegeneinander versetzte Stahlplatten zu montieren, etwa in *The Cabin. Ahab and Pip*, 1993, sich als Assemblage auf flachem Sockel entfalten zu lassen wie in *Sarreguemines*, 1993, vor der Luxembourger Hypobank installiert, oder auf gitterartige Gestelle zu heben wie bei *The Town-Ho's Story* oder *Burden Dreams* in Chicago. Seine freistehenden, dreidimensionalen Werke sind optisch nicht wirklich an Fundamente gebunden und ebenso wenig an Hängekonstruktionen, wie etwa die *Mobiles* von Alexander Calder. Vielmehr schweben sie gleichsam im Raum, zumal sie bei ihrer Höhe aus der Nahdistanz unteransichtig wahrgenommen werden. Dann vermitteln sowohl der Unterbau als auch die aufgehenden Elemente den Eindruck verwirrender Luftigkeit, da sie den Blick auf instantan wirkende Formen freigeben, die sich dem Wechsel von Öffnungen und Füllungen verdanken.

Als die Skulpturen *Burden Dreams* und *The Town-Ho's Story* 1993 im Chicagoer Metcalfe Federal Building installiert wurden, gestand Frank Stella: *The best buildings and, it seems to me, the best sculpture are in some way open from underneath. It is as though a work was made and then lowered by a crane to a resting place. I like it when the base of a sculpture is not quite solid, when it opens up. And I think we did a good job on this. The base here is like a bridge - or a gridwork.*[112] Die Basis der Skulptur als *Gitterwerk* aufgefasst, erinnert an Frank Stellas Bilder, die seit 1976 entstanden und ebenfalls an Gitterkonstruktionen hängen, und zwar häufig so tief, dass die vorkragenden Formen den Boden beinahe berühren.[113] Erlaubt diese konstruktive Parallele es, die Skulpturen als Bilder aufzufassen? Kann ihre Konstitution aus der Genese von Frank Stellas Bildschöpfungen und seinem Begriff der Bildlichkeit abgeleitet werden?

Abkehr von der *Form follows function*-Doktrin

Als er anlässlich seiner in mehreren amerikanischen und europäischen Städten gezeigten Ausstellung *Frank Stella 1970–1987* in Houston mit der Meinung konfrontiert wurde, manche wollten seine dreidimensionalen Werke eher als Skulpturen, zumindest aber als Wandreliefs verstanden wissen, antwortete der Künstler: *They're paintings because they function in a pictorial way. They float. Sculpture never floats. You look at them in the same way you look at paintings. They are organized in a pictorial way.*[114] Auch von seinen Architekturentwürfen sagte Frank Stella: *It's pretty obvious that my way of dealing with site plan problems was the same as my way of dealing with schematized painting ideas,*[115] und betonte nachdrücklich: *What's interesting is that, as a painter, I want to bring what I know to architecture. I'm willing to try to understand it on its own terms.*[116] Und auch in dieser Gattung sei es unter derartigen Prämissen möglich, ergänzt er, *to animate architecture – to assemble and manipulate its solid forms in such a way that they at least appear capable of motion.*[117] Selbst von seiner Arbeit als Graphiker sagt der Künstler: *I have to work at printing the same way I work at painting.*[118]

Schon diese wenigen Äußerungen belegen, wie konsequent Frank Stella seiner frühen Entscheidung für eine autonome, ungegenständliche und nichtillusionistische Malerei treu geblieben ist. Sie deuten auf eine Übertragung ihrer Maximen auf die anderen Gattungen hin und betonen die Vorrangstellung der Malerei. Zugleich beschreiben

[111] Auf einer Fotomontage steht sie im Innenhof vor Sant'Ivo alla Sapienza in Rom. Vgl. Ausst.-Kat. Rom 1993, S. 217.

[112] Frank Stella nach Alan G. Artner, Stella attraction. Metcalfe Building site of sculptor's latest work, in: Chicago Tribune, 15. September 1993, Section 1.

[113] Vgl. die niedrige Hängung der Cones and Pillars in Ausst.-Kat. Stuttgart 1988 / 1989, Frank Stella. Black Paintings 1958 - 1960, Cones and Pillars 1984 - 1987, Staatsgalerie, S. 76, 80 ff. Bei der Hängung seiner Bilder für die Münchner Retrospektive ließ der Künstler alle Bilder niedriger plazieren, als die Kuratoren vorgesehen hatten.

[114] Frank Stella nach Susan Chadwick, What you see is Frank Stella, in: The Houston Post, 10. Februar 1989, S. C - 11.

[115] Frank Stella, Broadsides, Manuskript des Jenaer Vortrages am 6. Februar 1996, unpubl., S. 21.

[116] Frank Stella, Broadsides, S. 3.

[117] Frank Stella, Broadsides, S. 7.

[118] Ausst.-Kat. München 1996, S. 226.

Frank Stella placed the large sculpture *Werner Herzog Eats His Shoe*, 1993, as a picture with the quality of a tableau, in an arcade of the entrance of the Palazzo delle Esposizioni in Rome,[173] mounted on a double-walled steel plate that itself rests upon four steel girders laid together in two pairs. This substructure alone contradicts sculptural conventions, even in contemporary art. Richard Serra's massive steel plates are founded on, as unstable as their arrangement may appear, on solid ground, which even the Minimal Art of Donald Judd or Carl Andres does not question. They unconditionally assume the foundation, while Frank Stella considers it, as when he paints the ground, as the significant element that constitutes the work. He avoids, in general, in the construction of the sculptures, the extensiveness of forms as well as burdensome volumes, whereas Richard Serra cultivates volumes and spaces with milled planes or concavely-convexly bent steel plates. By comparison it is characteristic of Frank Stella to mount sculptures gingerly onto steel plates that are leaned up against each other, like in *The Cabin. Ahab and Pip*, 1993, to allow them to enfold as an assemblage on flat bases like in *Sarreguemines*, 1993, installed in front of the Luxembourg Hypobank, or to lift them onto grid-like stands, like in *The Town-Ho's Story* or *Burden Dreams* in Chicago. His free standing, three-dimensional works are optically not really bound to a foundation and just a little to hanging constructions, like, for example, the *Mobiles* by Alexander Calder. They rather float in space, even with their height when they are viewed close-up from below. In that case the supporting structure as well as the ascendant elements give the impression of confusing lightness, because they free up the gaze for instantaneously effective forms that owe their existence to the alternation between openings and fillings.

As the sculptures *Burden Dreams* and *The Town-Ho's Story* were installed in 1993 in the Chicago Metcalfe Federal Building, Frank Stella admitted: *The best buildings and, it seems to me, the best sculpture are in some way open from underneath. It is as though a work was made and then lowered by a crane to a resting place. I like it when the base of a sculpture is not quite solid, when it opens up. And I think we did a good job on this. The base here is like a bridge - or a gridwork.*[174] The basis of sculpture conceived of as gridwork reminds us of the paintings of Frank Stella's that have been produced since 1976 and similarly hang on gridwork constructions, and, in fact so low that the projecting forms almost touch the ground.[175] Does this instructive parallel allow us to consider the sculptures as paintings? Can their constitution be derived from the genesis of Frank Stella's pictorial creations and from his concept of pictorial quality?

Departure from the *Form follows function* doctrine

When he was confronted in Houston on the occasion of his exhibition *Frank Stella 1970 - 1980* (which was exhibited in several American and European cities) with the idea that many wanted to consider his three-dimensional works as sculptures, at least as wall reliefs, the artist answered: *They're paintings because they function in a pictorial way. They float. Sculpture never floats. You look at them in the same way you look at paintings. They are organized in a pictorial way.*[176] Frank Stella said about his architectural plans as well, *It's pretty obvious that my way of dealing with site plan problems was the same as my way of dealing with schematized painting ideas,*[177] and emphatically emphasized: *What's interesting is that, as a painter I want to bring what I know to architecture. I'm willing to try to understand it on its own terms.*[178] And in this genre as well it is possible, according to the same premises, he adds, *To animate architecture – to assemble and manipulate its solid forms in such a way that they at least appear capable of motion.*[179] Even of his work as a graphic artist the artist says, *I have to work at printing the same way I work at painting.*[180]

These few statements already establish how consistently Frank Stella remained true to his early decision for an autonomous, non-objective and non-illusionist painting. They point to the transferal of its maxims to the other forms of art and emphasize the primacy of painting. Actually they describe the departure from a doctrine that con-

---

[173] In the photograph it was mounted in the interior court in front of Sant'Ivo all Sapienza in Rome. See the Rome exhibition catalogue, 1993, p. 217.

[174] Frank Stella according to Alan G. Artner, *Stella attraction. Metcalfe Building site of sculptor's latest work*, Chicago Tribune, 15 September 1993, Section 1.

[175] See the low hanging of Cones and Pillars in the Stuttgart exhibition catalogue 1988 / 1989, Frank Stella. Black Paintings 1958 - 1960, Cones and Pillars 1984 - 1987 (Stuttgart: Staatsgalerie), p. 76, 80 ff. At the hanging of his paintings for the Munich retrospective the artist had all of the paintings hung lower than the curators had planned.

[176] Frank Stella according to Susan Chadwick, *What you see is Frank Stella*, The Houston Post, 10 February 1989, Section C-11.

[177] Frank Stella, Broadsides, manuscript of the Jena speech on 6 February 1996, (unpublished), p. 21.

[178] Frank Stella, Broadsides, p. 3.

[179] Frank Stella, Broadsides, p. 7.

[180] Exhibition catalogue, Munich 1996, p. 226.

sie die Abkehr von einer Doktrin, welche die Tafelmalerei eher vermittelt betraf und ihr daher leichter die Möglichkeit der Besinnung auf ihre Eigendynamik einräumte, dafür aber die anderen Gattungen um so zwingender in die Pflicht nahm, obgleich Künstler und Architekten sich stets der auferlegten Zwänge zu erwehren suchten und in der Regel wussten, dass Gestaltung ästhetische Setzung ist. Maler forderten eher selten - wie etwa Paul Klee und Wassily Kandinsky, als sich das *Bauhaus* 1928 mit seinem Direktor Hannes Meyer vollends der Unterordnung aller Gattungen unter den Anwendungszweck verschrieb -,[119] dass nicht die Funktion die Form bestimmen solle, sondern umgekehrt die Form die Funktion, eine Maxime, die Frank Stella aus der Sicht der Vorrangstellung der Malerei als bindend betrachten musste: *I can imagine an architecture opposing the popular engineering maxim form follows function, an architecture where function follows form.*[120]

Mit seiner kategorialen Bestimmung der Malerei und dem Bruch mit der Funktionalisierungsdoktrin der bildenden Künste erhebt Frank Stella die Gesetze der Bildlichkeit zum Schlüssel komplexer und offener künstlerischer Form, die nicht auf die Zweidimensionalität des Flächenbildes begrenzt bleiben muss, sondern raumgreifend werden und alle Gegenstandsbereiche der Kunst erfassen kann, wie er es an der Gesamtausstattung des *Princess of Wales Theatre* in Toronto erprobte. Denn, so hat Frank Stella häufiger betont, der Gestaltqualität der Malerei sei das räumliche Moment inhärent: *The question of space is an inherent one, not the subject matter.*[121] Wenn sie Raum illusioniert, Raumtiefe vortäuscht oder durch Verschattung und Aufhellung Volumina bildet, verdoppelt sie in diesem Verständnis lediglich, was ihr ohnehin schon eigen ist; sie verhält sich, so darf man folgern, tautologisch.

Schweben

Mit dieser Erkenntnis rückt der eigentliche Aspekt von Frank Stellas Denken und Werk in den Vordergrund. Wenn er, wie bereits zitiert, von seinen Bildern als schwebenden spricht und die starren Formen der Architektur als zur Bewegung fähig zur Geltung bringen möchte, so will er sie gleichsam als selbsttätige erscheinen lassen. Sie sollen aus ihrem statischen Gefüge herausgelöst werden, was der herkömmlichen Architektur und Skulptur am wenigsten möglich ist, da sie im Prinzip des Tragens und Lastens gründen, das die künstlerische Formgestaltung mit den klassischen Mitteln nur selten so überspielen kann, wie es etwa Michelangelo Buonarroti und Gianlorenzo Bernini in ihrem skulpturalen oder Carlo Borromini in seinem architektonischen Œuvre gelang, da sie die Statik ihrer Werke durchaus vergessen machen.[122] Frank Stella stellte im Gespräch mit Richard Meier fest, das Problem von Malerei und Skulptur sei, dass sie nicht begehbar seien und ihre Formen daher zunächst statisch wirken müssten. Es gelänge nur, das Material durch Öffnungen in Bewegung zu versetzen: *We are trying to keep it open, to keep some of the mass of conventional sculpture, but we are also not drawing in space. We are not making open, linear sculpture.*[123] Skulptur bewegt sich für ihn zwischen den Gradus von Linearität, Fläche und Volumen – nicht anders als die Malerei.

Stellas These überrascht kaum, wenn man einen Blick auf die Kunstgeschichte des 20. Jahrhunderts wirft. Die mit *Öffnungen* arbeitende Malerei Paul Cézannes, des Kubismus, Paul Klees, Piet Mondrians, Wassily Kandinskys und Jackson Pollocks, um nur einige Repräsentanten anzuführen, die die Bildfläche nicht mehr als geschlossene Form anerkannten, setzte für das Bildverständnis Kräfte frei, die ihre Wirkung auch auf die anderen Künste nicht verfehlen sollten. Die Reduktion der Malerei auf das, was sie ist, Fläche und Malschichten,[124] schuf die Voraussetzung dafür, nicht nur innerbildliche Dynamik zu erkennen, sondern zugleich auch die außerbildlichen Bezüge neu zu definieren: die Wand des Kunstwerks, den Umraum und schließlich die gebaute Hülle selbst, deren Begrenzungen für Ludwig Mies van der Rohe zu Flächen und Öffnungen wurden und sich bei strikter Anwendung des Prinzips in ihrer Wechselwirkung dynamisierten, worin ihm der amerikanische, seit 1959 mit Frank Stella freundschaftlich und künstlerisch verbundene Architekt Richard Meier wie kein zweiter Gegenwartsarchitekt nahe steht. Für ihn konstituiert sich das Bauwerk ebenfalls aus Flächen und Öffnungen, die sich wie selbstverständlich an Nahtstellen gegeneinander verschieben und räumlich werden und das innere Anliegen der Architektur begünstigen, Licht und Schatten zu gestalten.[125]

---

[119] Vgl. Eberhard Roters, Maler am Bauhaus, Berlin 1965, S. 16 f.
[120] Frank Stella, Broadsides, S. 5.
[121] Ausst.-Kat. München 1996, S. 227.
[122] Vgl. Frank Stellas Interesse an der italienischen Kunst in Ausst.-Kat. Rom 1993, S. 208 ff, 225.
[123] Ausst.-Kat. Rom 1993, S. 234.
[124] Vgl. Franz-Joachim Verspohl, Von Malgründen und Malschichten, in: Minerva. Jenaer Schriften zur Kunstgeschichte, Bd. 3, 1996, S. 45 ff.
[125] Ausst.-Kat. Rom 1993, S. 231 f.

cerned panel painting rather indirectly and allowed it the possibility more easily of meditating on its own dynamic, but therefore disciplined the other art forms all the more strictly, although artists and architects always attempted to defend themselves against the impositions and knew actually that creation is aesthetic placement. Painters demanded rather seldomly – as, for example, Paul Klee and Wassily Kandinsky, as soon as *Bauhaus* prescribed in 1928, with its director Hannes Meyer, the absolute subordination of all forms of art under the application purpose –[181] that function should not determine form, but rather the other way around, the form the function. A maxim that Frank Stella had to consider as obligatory from the perspective of the primacy of painting: *I can imagine an architecture opposing the popular engineering maxim form follows function, an architecture where function follows form.*[182]

With his categorical determination of painting and the break with the doctrine of functionalization of the fine arts, Frank Stella elevates the laws of pictorial quality to the key to complex and open artistic form, which must not remain limited to the two-dimensionality of the canvas, but rather must become spatially appropriating and can encompass all areas of art, as he tested in the complete appointment of the *Princess of Whales Theatre* in Toronto. Frank Stella has often claimed that the spatial moment is inherent to the formal quality of painting: *The question of space is an inherent one, not the subject matter.*[183] When it fakes space, feigns spatial depth or forms volume through shadow and light, it doubles, in this sense, actually that which is already without question its own. It behaves, so we can conclude, tautologically.

Floating

With this realization the central characteristic of Frank Stella's thinking and work comes to the fore. If he, as just quoted, speaks of his paintings as floating and would like to give effect to the rigid forms of architecture as capable of movement, while letting them appear self-active at the same time. They should be freed from their static structures, which was least possible for the architecture and sculpture of the past because they are based on the principle of support and load, that artistic design can very seldom outmaneuver with the classic means, as was possible for Michelangelo Buonarotti and Gianlorenzo Bernini in their sculptures or Carlo Borromini in his architectural works, because they help to teach how to forget the statics of their work.[184] Frank Stella asserted in a conversation with Richard Meier that the problem of painting and sculpture is that they are not accessible and their forms therefore actually have to have a static effect. It would suffice to bring the material in motion through openings: *We are trying to keep it open, to keep some of the mass of conventional sculpture, but we are also not drawing in space. We are not making open, linear sculpture.*[185] Sculpture fluctuates, for him, between the grades of linearity, surfaces and volumes, no different than painting.

Stella's thesis does not surprise then when one considers 20th century art history. Paul Cezanne's painting, which works with openings, Cubism, Paul Klee, Piet Mondrian, Wassily Kandinsky and Jackson Pollock, only to mention a few representative figures, who no longer considered the painting surface as a closed form, and set forces free for the understanding of painting whose effects on the other arts would not fail. The reduction of painting to that which it is, surfaces and layers of paint,[186] created the precondition for perceiving not only internal pictorial dynamics but also for defining the external pictorial relations anew: the wall of the work of art, the surrounding space and finally the constructed shell itself whose limitations, for Ludwig Mies van der Rohe, became planes and openings and became dynamic with a strict application of the principle of their interaction, wherein the American architect Richard Meier – who had, since 1959, artistic and personal connections to Frank Stella – was like him like no other contemporary architect. For him the building constitutes itself equally out of surfaces and openings that shove against each other at boundaries as if it were self understood and become spatial and support the central concern of architecture: to create light and shadows.[187]

---

[181] See Eberhard Roters, Maler am Bauhaus (Berlin: Rembrandt, 1965), p. 16 f.
[182] Frank Stella, Broadsides, p. 5.
[183] Munich exhibition catalogue, 1996, p. 227.
[184] See Frank Stella's interest in Italian art in the Rome exhibition catalogue, 1993, p. 208 ff, 225.
[185] Rome exhibition catalogue, 1993, p. 234.
[186] See Franz-Joachim Verspohl, *Von Malgründen und Malschichten*, in: Imi Knoebel: Jena Bilder, Minerva. Jenaer Schriften zur Kunstgeschichte, Bd. 3, (Gera 1996) p. 45 ff.
[187] Rome exhibition catalogue, 1993, p. 231 f.

Auch für die Skulptur leistete die Bilderkenntnis des frühen 20. Jahrhunderts die Überprüfung der ihr scheinbar dauerhaft eignenden Merkmale. Ihr sich gegenüber der Hierarchie der Materialien öffnendes Verhältnis und eine neue Materialästhetik waren dabei von eher nachgeordneter Bedeutung. Entscheidender waren der Bruch mit dem statischen Prinzip von Tragen und Lasten, die Aufgabe des Sockels und der Gewinn des Ephemeren, Hinweise auf die möglichen instantanen Gestaltmerkmale des Kunstwerks, das nicht auf den deutenden Anblick zielt, sondern optisch bewegt und haptisch kontrollierend zugleich gesehen werden will. Konstatierte schon Guillaume Apollinaire über Pablo Picassos kubistische Malerei 1913: *Indem Picasso die Flächen nachahmt, um die Rauminhalte darzustellen, gibt er von den verschiedenen Elementen, aus denen sich die Gegenstände zusammensetzen, eine so vollständige und so genaue Aufzählung, dass sie keineswegs dank der Bemühung der Betrachter, die notgedrungen die Gleichzeitigkeit wahrnehmen, sondern eben auf Grund ihrer Anordnung die Gestalt eines Objektes gewinnen,*[126] so darf die Behauptung erst recht für Frank Stellas nichtfigurative Kunst in Anspruch genommen werden. In ihr setzt sich die Bildstruktur gleichsam von selbst zusammen, sind die einzelnen bildlichen Elemente selbst aktiv, nicht nur weil sie in einem jeweils autonomen Zustand gehalten sind und selbstreferentiell bleiben, sondern erst recht, weil sie, obwohl sie zunächst ausschnitthaft und beliebig erweiterbar zu sein scheinen, absolut begrenzt sind und in dieser Begrenzung vor der Wand hängen und schweben. Sie sind im Hier und Jetzt lesbar, verlangen keine über den Umriß hinausgehende Ergänzung, wie dies die Kunstgeschichte häufig unterstellt hat,[127] sondern existieren vollends aus der Simultaneität ihrer Erscheinung, der in ihrer Flächigkeit Volumen und Raum eingeschrieben sind, aber auch Zeitstrukturen, die bei den frühen Bildern Rhythmik und Gestik der Farbstreifen aufheben und die bei den späteren Werken in den geschwungenen Formen fortleben, welche Schnitte durch stereometrische Körper sind, die sich gleichsam in der Verflächigung spiegeln.

Frank Stellas Bilder benötigen weder eine über sie hinaus verlängerbare Verweisfunktion, noch bedürfen sie einer symbolisch oder metaphorisch aufgeladenen Kunsttheorie, wie Barnett Newman sie für seine Werke reklamierte. Im Gespräch mit Richard Meier kritisierte Frank Stella Barnett Newmans Bemühungen, seinen aus dem malerischen Denken entwickelten und bildlich gedachten Werken mehr zu unterstellen, als dass sie gut gemalt seien.[128] Er grenzte sich ebenso strikt gegen die durch Barnett Newman erweiterte Theorie des *Sublimen* wie gegen eine Theorie des *Pittoresken* ab und beugte damit Interpretationen vor, die ihn in die Nähe der Colour field-Malerei brachten oder ihm eine Wiederbelebung des Ornaments nachsagten.[129] Er baute jeder derartigen Inhaltsdeutung vor, indem er pragmatisch die Dinghaftigkeit der Kunstwerke, die in den Raum vorkragen und den Weg verstellen können, betonte: *Meine Malerei gründet in der Tatsache, dass nur das auf der Leinwand ist, was man dort auch sehen kann. Es ist in Wirklichkeit ein Objekt. Jedes Bild ist ein Objekt, und jeder, der sich genügend in diese Sache einlässt, muss der Objekthaftigkeit dessen, was er macht, ins Gesicht sehen, was immer dies auch sei. Er macht ein Ding.*[130] Die berühmte Schlussfolgerung dieser Erkenntnis für den Betrachter, dass *man sieht, was man sieht,*[131] stellt in diesem Zusammenhang einen entlastenden Umgang mit Kunst dar, da das Werk ganz in seiner sinnlichen Präsenz und Gegenwärtigkeit aufgeht. Es ist nicht *emblematisch,* sondern *expressiv* in dem Sinne, wie sich schon Thomas Whately 1770 die Bilder des Landschaftsgartens vorstellte: *Ihre Anspielung sei nicht die Hauptsache; sie sollte als von der Szene hervorgebracht erscheinen, ein vergängliches Bild, das ohne Widerstände eingeht; das nicht erforscht, nicht erarbeitet werden muss, und das die Kraft einer Metapher hat, frei von den Einzelheiten einer Allegorie.*[132]

Analog geht es Frank Stella in der Kunst nicht nur um die Sichtbarmachung einer unbezweifelbaren, sinnlich und geistig fassbaren Bildrealität im *simultané,* sondern, da dem Bild Raum inhärent ist, um die Schaffung *bewohnbarer Illusionen … Man muss das Gefühl haben, in dem Gemälde, der Skulptur oder dem Gebäude leben zu können – in Harmonie mit sich, mit dem, was man sieht, und mit der Welt außen rum. Man muss in jedes dieser Bilder hineinmarschieren und ein Teil davon werden können.*[133] Wenn es, wie Frank Stella zuvor konstatierte, nicht

[126] Guillaume Apollinaire, Die Maler des Kubismus, Frankfurt am Main 1989, S. 34.
[127] Vgl. Max Imdahl, Frank Stella Sanbornville II, Stuttgart 1970, S. 11 ff.
[128] Ausst.-Kat. Rom 1993, S. 228.
[129] Vgl. Frank Stella, Broadsides, S. 5.
[130] Frank Stella zit. n. Gregory Battcock (Hg.), Minimal Art. A Critical Anthology, New York 1968 (1), 1995 (2), S. 158, dt. n. Sandro Bocola, Die Kunst der Moderne. Zur Struktur und Dynamik ihrer Entwicklung. Von Goya bis Beuys, München / New York 1994, S. 480.
[131] Zit. n. Gregory Battock (Anm. 31), S. 158; vgl. auch Jordan Mejias, Warum muß Kunst sexy sein, Mister Stella?, in: F. A. Z. Magazin, 5. Juni 1987, S. 87; vgl. auch Ausst.-Kat. Stuttgart 1988 / 1989, S. 13 ff.
[132] Thomas Whately, Observations on Modern Gardening, London 1801, S. 83 f, zit. dt. n. Werner Busch, Das sentimentalische Bild. Die Krise der Kunst im 18. Jahrhundert und die Geburt der Moderne, München 1993, S. 479.
[133] Frank Stella zit. n. Ulf Poschardt, Es gibt hier keine Ideen. Interview, in: Süddeutsche Zeitung Magazin, 9. Februar 1996, S. 41.

The knowledge of painting of the early 20th century accomplished for sculpture the examining of the characteristics that appeared to be eternally its own. Its quality of being open in terms of the hierarchy of materials and a new material aesthetic were of rather secondary importance. More decisive was the break with the static principle of support and load, the function of the socle and the victory of the ephemeral: hints of the possible instantaneous formal characteristics of the art work that do not aim at interpreting contemplation but rather want to be seen as optically moved and haptically controlling simultaneously. Already in 1913, Guillaume Apollinaire noted about Pablo Picasso's cubist painting: *Because Picasso imitated surfaces in order to represent the contents of space, he provides such a complete and exact inventory of the various elements out of which the objects constitute themselves that the elements attain the shape of an object in no way thanks to the efforts of the contemplators – who are forced to perceive the simultaneity – but rather as a result of their arrangement.*[188] The claim can be applied even more to Frank Stella's non-figurative art. In it the structure of the painting assembles itself by itself. The individual pictorial elements are self active, not only because they are maintained in a relatively autonomous state and remain self-referential, but rather even more because they are absolutely delimited, although they actually appear expandable in a cutout and arbitrary manner, and in this delimitation hang in front of the wall and float. They are legible in the Here and Now, do not demand a suplementation that goes beyond the outline – as art history often asserted[189] – but rather exist entirely as a result of the simultaneity of their appearance in whose planarity volume and space are inscribed, but also because of time structures that are sublated in the early paintings in the rhythm and gesture of the painted stripes and live on in the later works in the floating forms that are cuts through stereometric bodies that reflect themselves in the flattened out form.

In so far Frank Stella's paintings need neither a referential function that points beyond them nor a symbolically or metaphorically loaded art theory, like Barnett Newman appealed for his works. In conversation with Richard Meier Frank Stella criticized Barnett Newman's efforts to credit his works, which are developed from his painterly considerations and thought of pictorially, with more than the assertion that they are well painted.[190] He strictly distances himself as well from the theory of the *Sublime* that has been expanded by Barnett Newman as from the theory of the *Picturesque* and thereby precluded interpretations that associated him with color field painting or associated him with a revival of ornament.[191] He counteracted every such interpretation of content by pragmatically highlighting the thingness of the artworks, which can project into space and be obstructive: *My painting is based on the fact that whatever is on the canvas can be seen. In reality it is an object. Every painting is an object and everyone who immerses himself sufficiently in this issue must realize the objective quality of that which he makes, whatever it may be. He is making a thing.*[192] The famous consequence of this insight *that one sees what one sees,*[193] represents, in this context, a freed up dealing with art for the viewer, because the work is totally exhausted in its sensual presence and contemporaneity. It is not *emblematic* but rather *expressive* in the sense that Thomas Whately imagined the paintings of the land-scape garden already in 1770: *The allusion should not be principal; it should seem to have been suggested by a scene: a transitory image, which irresistibly occurred; not sought for, not laboured; and have the force of a metaphor, free from the detail of an allegory.*[194]

Analogously, for Frank Stella, in art it is not only a matter of making visible an indubitable, sensual and spiritually comprehensible pictorial reality in simultaneity, but rather, because space is inherent to the painting, it is about the creation of *inhabitable illusions ... One must have the feeling to be able to live in the painting sculpture or building – in harmony with oneself, with that which one sees and with the world outside. One must be able to march into every one of these paintings and be able to become a part of it.*[195] If it is not accessible, as Frank Stella already

---

[188] Guillaume Apollinaire, Die Maler des Kubismus (Frankfurt am Main:Luchterhand 1989), p. 34.

[189] See Max Imdahl, Frank Stella *Sanbornville II* (Stuttgart: Reclam, 1970), p. 11 ff.

[190] Rome exhibition catalogue, 1993, p. 228.

[191] See Frank Stella, Broadsides, p. 5.

[192] Frank Stella quoted in Gregory Battock (ed.), Minimal Art. A Critical Anthology (Berkeley: University of California Press, 1968 [1], 1995 [2]), p. 158.

[193] Quoted in Gregory Battock; 158; see also Jordan Mejias, *Warum muss Kunst sexy sein, Mister Stella?*, in: F.A.Z. Magazin, 5 July 1987: 87; see also the Stuttgart exhibition catalogue, 1988 / 1989, p.13 ff.

[194] Thomas Whately, Observations on Modern Gardening (London, 1801), p. 83 f.

[195] Frank Stella, quoted in Ulf Poschardt, *Es gibt hier keine Ideen*. Interview, in: Süddeutsche Zeitung Magazin, 9 Februar 1996, p. 41. Translation, Kenneth Munn.

begehbar ist, muss es sich gleichsam in den Raum wölben und vorschieben, so dass es den Betrachter bildhaft umgibt. Nun ist es nicht mehr *vor* ihm, was bereits Jackson Pollock und WOLS erkannten, sondern wie die Welt um ihn herum.[134] Es konstituiert sich in ihr und mit ihr, aber nach der Kunst eigenen Gesetzen, wie Frank Stella feststellt: *Alle Dinge, die von außerhalb der Kunst kommen, müssen komprimiert werden, um Teil dieser Kunst zu werden. So komprimiert, dass man sie nicht mehr wiedererkennen kann, obwohl sie da sind [...]. Ich glaube, dass man keine große Kunst hervorbringen kann, wenn man nicht Einflüsse von außen in seine Arbeit integriert [...]. Es ist eine mächtige Idee, ein mächtiger Antrieb, Dinge ausschließen zu wollen. Es ist ein ebenso großer Spaß, Dinge auszuschließen, wie sie einzubringen.*[135] Frank Stella beschreibt hier Kunst als absolute Form, die in der Malerei ihre höchste Stufe erreicht, weil sie den Schwebezustand zwischen gewordener Naturform und geschaffener Gebrauchsform in vollkommener Weise hält. Sie kann deshalb für die übrigen Gattungen Vorbild sein, weil diese nach dem Prinzip von *function follows form* ebenfalls Aussonderungen adhärenter Strukturen vornehmen können.

Malerei

Die Malerei des Ausschließens und Einbringens hat Frank Stella von Beginn an befähigt, die Defizite der anderen Gattungen zu sehen und als Ursache ihres Mangels ihre Funktionsbestimmtheit zu erkennen: *It shouldn't surprise us that every day practices of painting mirror the more desparate architectural efforts.*[136] Ausgehend vom Minimalismus der Form, den man fälschlicherweise für einen *Bildersturm* gehalten hat, isolierte Frank Stella zuerst in seinen *Black Paintings*, 1958–1960, die Grundelemente des Bildes, den Malgrund und die Farbschichten, die er in Streifen so parallelisierte, dass sie sich weder hierarchisch subsumieren lassen, noch zur Leinwandfläche in ein konkurrierendes Verhältnis treten. Reihungen, Geometrisierung und Symmetrien trugen dazu bei, das Bild von Raumillusionen zu befreien, gaben ihm aber mit der malerischen Qualität des Schwarz und dank des starken Keilrahmens eine optische wie haptische Qualität. Mit den zwischen den Farbstreifen sichtbar gelassenen Leinwandstrukturen entdeckte Frank Stella das bildstrukturierende Prinzip des Malgrundes, das nichts mit der Begrenzung der Leinwand zu tun hat, sondern mit ihrer Vorhandenheit überhaupt.

In den *Black Paintings* wird sichtbar, dass die Malfläche das Bild ebenso entscheidend konstituiert wie die schwarzen Streifen und deren Verlauf. Die Begrenzung des Bildes sollte nicht verschwinden, im Gegenteil, sie sollte das Bild von der Wand abheben und zu ihr in ein Spannungsverhältnis setzen und dem statischen Prinzip ein virtuell dynamisches entgegenstellen, begünstigt durch das Wechselverhältnis von opaken und transparent erscheinenden Flächen. Denn die *Black Paintings* arbeiten unversehens mit einer Umkehrung. Die sichtbaren Leinwandstreifen wirken durchscheinend, obwohl sie Malgrund sind, und die schwarzen Malstreifen undurchsichtig, obwohl sie Malschicht sind. Licht und Schatten scheinen schon hier eine entscheidende Rolle zu spielen.

Mit der Entdeckung der Gleichrangigkeit der Bildelemente war die Voraussetzung dafür gegeben, das shaped canvas zu erfinden, das Bild von innen heraus zu denken und nicht von seinen äußeren Dimensionen her zu bestimmen. Durch diese Entlastung und Befreiung des Bildes von adhärenten, ihm nicht eigenen Strukturen konnte es eine neue Dynamik gewinnen. Denn Stella gelang es auf diesem Wege, mit einfachsten Mitteln den Bildaufbau zu verflüssigen. Die Erkenntnis des sich bedingenden Verhältnisses von Malgrund und Farbschichten ermöglichte es ihm, den transitorischen Charakter des Bildes zu verstärken, ohne nach Hans Hofmanns Methode der *push-pull*-Spannung mit intensiven Farben arbeiten zu müssen.[137] Zwar begrenzt, aber nicht von außen her definiert, treten die Binnenflächen, Malgründe und Shapes in Wettstreit miteinander. Von ihrer jeweils dienenden Funktion befreit, fördern sie eine neue Bildqualität zutage. Sie schaffen Raum aus sich selbst heraus und machen das Bild zu einem Schauspiel, in dem sich bald dieses, bald jenes Konstituens des Bildes vorwagt und dann wieder in den Hintergrund tritt, weil das nächste sein Recht beansprucht.

---

[134] Deren Gemälde nahmen Phänomenologen wie Maurice Merleau-Ponty zum Ausgangspunkt, ihr Erkenntnisprinzip zu begründen. Vgl. Franz-Joachim Verspohl, Die konkreten Dinge stehen im zweiten Rang .- WOLS und Sartre, in: Idea. Jahrbuch der Hamburger Kunsthalle, Bd. 6, 1987, S. 109 ff.

[135] Frank Stella zit. n. Ulf Poschardt, S. 37.

[136] Frank Stella, Broadsides, S. 15 f.

[137] Vgl. Ausst.-Kat. Bonn 1976, 200 Jahre amerikanische Malerei 1776 - 1976, Rheinisches Landesmuseum, unpag., Nr. 45. Frank Stella hat das Werk Hans Hofmanns verschiedentlich gewürdigt. Vgl. Jordan Mejias, S. 86.

asserted, it must virtually bulge and jut into the room, so that it pictorially surrounds the contemplator. Then it is not longer in front of the viewer, as Jackson Pollock and Wols already realized, but rather, like the world, it surrounds him.[196] It constitutes itself in the world and with it, but according to laws specific to art, as Frank Stella asserts: *Everything that comes from outside art must be compromised in order to become part of art. So compromised that we cannot recognize it anymore, although they are there ... I believe that one cannot create great art if one does not integrate influences from outside into one's work. ... It is a powerful idea, a powerful drive, to want to shut things out. It is just as fun to exclude things as to include them.*[197] Frank Stella is describing art here as absolute form, which attains its ultimate level in painting, because it perfectly exists in a floating condition between already-become natural form and created utility forms. It can therefore be an example for the other art forms because they can also undertake selections of adherent structures following the principle of *function follows form*.

Painting

The painting of exclusion and inclusion allowed Frank Stella from the start to see the deficits of the other art forms and to recognize their being functionally determined as the cause of their deficit: *It shouldn't surprise us that everyday practices of painting mirror the more desperate architectural efforts.*[198] Proceeding from the minimalism of form, which had falsely been considered iconoclastic, Frank Stella initially isolated in his *Black Paintings*, 1958–1960, the basic elements of painting, the ground and the layers of paint that he paralleled in stripes such that they neither allowed themselves to be hierarchically subsumed nor come into a competitive relationship on the surface of the canvas. Lining up, geometricisation and symmetries assisted in freeing the painting from spatial illusions but gave it an optic and haptic quality with the pictorial quality of black and thanks to a strong wedged stretcher. With the canvas structures that are left visible between the paint strips, Frank Stella discovered the painting structuring principle of ground that has nothing to do with the limitation of the canvas, but rather with its presence in general.

In the *Black Paintings* it becomes apparent that the painting surface constitutes the painting just as decisively as the black stripes and their course. The delimitation of the painting should not disappear, to the contrary, it should lift the painting from the wall and bring it into a relationship of tension with it and confront the static principle with a virtually dynamic one, supported through the alternating relationship of surfaces that appear opaque and transparent. The *Black Paintings* work undetected with a reversal. The visible stripes of canvas appear to shine through, although they are ground and the black painted stripes appear opaque, although they are a layer of painting. Light and shadow already appear here to play a decisive role.

With the discovery of the equality of the painting elements the precondition was given to invent *shaped canvas* to think the painting from the inside out and not to determine it from its outer dimensions in. Through this relief and liberation of the painting from adherent structures that are not its own it could win a new dynamic. Stella was successful in making the construction of the painting fluid through simple means. The recognition of the self determining relationship of ground and paint layers made it possible for him to strengthen the transitory character of painting, without having to work with intensive colors according to Hans Hofmann's method of *Push-pull-tension*.[199] Surely limited, but not defined, by the outside the internal surfaces, grounds and shapes come into conflict with one another. Freed from their respective servile function, they support a new pictorial quality into existence. They create space from out of themselves and make the painting into a play in which first this then that constituent of the painting surges forward and then returns to the background again because the next claims its right.

---

[196] Phenomenologists, like Maurice Merleau-Ponty, took their paintings as their point of departure, in order to ground their epistemological principle. See Franz-Joachim Verspohl, *Die konkreten Dinge stehen im zweiten Rang. - WOLS und Sartre*, in : Idea. Jahrbuch der Hamburger Kunsthalle, Bd. 6, (Munich: Prestel,1987), p. 109 ff.

[197] Frank Stella, quoted in Ulf Poschardt, translation Kenneth Munn, p. 37.

[198] Frank Stella, Broadsides, p. 15 f.

[199] See the Bonn exhibition catalogue, 1976, 200 Jahre amerikanische Malerei 1776 - 1976 Nr. 45, (Rheinisches Landesmuseum, 1976) unpaginated. Frank Stella has variously assessed the work of Hans Hofmann. See Jordan Mejias, p. 86.

Während Joseph Albers der Wechselwirkung von Formen und Farben auf der Leinwand, von Schwarz und Weiß im Relief nachspürte,[138] ohne den Malgrund selbst als Problem zu entdecken, dehnte Stella ihre Untersuchung auf alle Faktoren des Bildes aus und dürfte bereits um 1960 geahnt haben, dass sie nicht aneinander gebunden bleiben müssen, sondern von einander gelöst werden können, ohne ihren bildhaften Charakter zu verlieren. Zugleich aber setzte er auf diese Weise neue Elemente der Bildlichkeit frei.

Die Exerzitien, so darf man den Purismus der *Black Paintings* auch bewerten, ermöglichten es ihm, mit den das Bild bestimmenden Elementen als formbaren Größen umzugehen und sie selektiv einzusetzen, sprich ein Einzelnes wegzulassen oder seine Funktion umzuwerten. Die *Irregular Polygons* von 1965 und 1966 sind in diesem Zusammenhang besonders aufschlussreich, weil sie die Wechselwirkungen bis an die Grenze der von Stella erkannten Grundgrößen des Bildes strapazieren. Streifen, Farbflächen und Malgrund treten durch die Irregularität in ein derartiges Spannungsverhältnis, dass sie sich wechselseitig zu überlisten scheinen. Verursacht in *Tuftunboro III*, 1966,[139] das gelb umrandete Dreieck das Einknicken des grauen Streifens, oder sondert dieser es aus? Warum passt sich andererseits seine Unterkante dem Kontur des Dreieckes an? Und, weshalb schließt der Streifen links unten nicht mit dem Bildrand ab, sondern läuft in einem spitzen Winkel aus? Könnte es nicht sein, daß *irregulär* sich bei der Serie weniger auf die unregelmäßigen Formen bezieht, als vielmehr auf den Vorstoß in eine neue Dimension? Denn es will gerade an der unteren linken Ecke scheinen, als wolle der Künstler aus der strengen Zweischichtigkeit ausscheren und die Malschichten gegeneinander verschieben. So wie er später ein Papierstück binnenräumlich in Streifen schneidet und durch Verdrehen und Schieben in ein dreidimensionales Gebilde verwandelt,[140] scheint er hier Malgrund, Flächen und Bildrand so zu behandeln, dass sie sich räumlich zueinander verhalten müssen, ohne dass dies durch optische Täuschung geschähe. Auch in der nachfolgenden *Protractor*-Serie, 1967–1971, gewinnt man den Eindruck, als arbeite Frank Stella mit Überlagerungen und Schichtungen. Doch die als Gradbögen eingesetzten Streifen sind bildlich exakt fixiert und führen gegenüber den beiden anderen Bildkonstituenten kein Eigenleben, so dass sie nicht illusionistisch wirken können.

Um die Bildebene ohne täuschende Effekte zu durchbrechen, war es folgerichtig, die Reliefstruktur für die Malerei zu entdecken und die Malschichten samt den Gründen zu vereinzeln und von innen her zu verzahnen. In der *Polish Village*-Serie[141] wird dieser Weg erstmals bestritten. Die Farbflächen erhalten jeweils ihren eigenen Grund und lassen sich auf diese Weise gegeneinander versetzen. Gleichzeitig ließen sie sich in leichte Schräglagen bringen, so dass sie wie Rampen zwischen verschiedenen Ebenen vermitteln. Um aber vor Augen zu halten, dass es sich bei der Erweiterung nicht um einen Übergang von der Malerei zum Relief handelt, beschichtete Frank Stella den Malgrund – Hartfaserplatten, Holz oder Wellpappe – mit Materialien unterschiedlicher Textur – Filz, Pappe, Leinwand, monochrom farbig oder mit in informellem Pinselduktus farblich changierenden Flächen gefaßt. Auf Grund ihrer geringen Tiefe bleiben sie frontalansichtig und lassen in der Seitenansicht nur ihr Konstruktionsprinzip erkennen, eine Offenheit, die schon die *Black Paintings* haben. Die Entstehung des Bildes bleibt nachvollziehbar, der Künstler gewährt Einblick in den Werkprozeß. Indem Genese und Ergebnis zugleich gegenwärtig gehalten werden, so wie schon Pablo Picasso und Georges Braque in ihrem kubistischen Œuvre das Wechselverhältnis zwischen Arbeitsprozeß und Werk offenlegten, wird das Bild in einen Schwebezustand versetzt.

Die Frontalansicht, wie sie dem Bild als Bild entspricht, bleibt auch für die nachfolgenden Serien verbindlich, obwohl sie weit in den Raum vorkragen. Sie sind als real gewordener Bildraum zu verstehen, der sich vor einem Rahmen konstituiert, konstruiert ist. Auf diese Weise arbeitet der Künstler möglichen Illusionismen entgegen und kann sich auf Wiedererkennbarkeit berufende Evokationen neutralisieren, die unzweifelhaft durch die Titel der Serien *Exotic Birds* und *Indian Birds*[142] aufkommen können. Aber auch hier, wie bei der Folge *Cones and Pillars*,[143] steht das bildlich expressive Denken im Sinne Thomas Whatelys im Vordergrund. Was Frank Stella über seine späteren Architekturentwürfe sagt, gilt auch hier: *The form had to be pulled through a pictorial wringer... The pictorial wringer is nothing other than the history and practice of painting.*[144] Die Methode zielt auf bildgemäße Über-

138 Vgl. Joseph Albers, Interaction of Color. Grundlegung einer Didaktik des Sehens, Köln 1970.
139 Abb. in Ausst.-Kat. München 1996, S. 187, vgl. zu dieser Bilderserie auch Robert Rosenblum, Frank Stella, Harmondsworth / Baltimore 1971, S. 41 ff
140 Vgl. die Abb. des Entwurfs zu einem Gatehouse bei Sidney Guberman, S. 216.
141 Abb. in Ausst.-Kat. München 1996, S. 192 ff.
142 Abb. in Ausst.-Kat. München 1996, S. 201 ff.
143 Abb. in Ausst.-Kat. München 1996, S. 211 ff.
144 Frank Stella, Broadsides, S. 8 f, dort demonstriert an zwei Straßenpylonen, mit denen der Künstler hantiert und die Formen eines bildeinwärts und eines bildauswärts gerichteten Perspektivismus unterscheidet, dem er seine Vorstellung des Bildraumes gegenüberstellt.

Whereas Joseph Albers investigated the interaction of forms and colors on the canvas, of black and white in relief,[200] without to discover the ground itself as a problem, Stella expanded the investigations to all factors of painting and may have already sensed around 1960 that they need not remain bound to each other, but rather that they could be released from one another without losing their pictorial quality. At the same time, however, he freed in this way new elements of pictorial quality.

The exorcisms, one can consider the purism of the *Black Paintings* as such, made it possible for him to circumvent the elements that that determine the painting as a formable entity and to selectively utilize them, that is, to leave one out or to change its function. The *Irregular Polygons* of 1965 and 1966 are especially instructive in this respect because they stretch the interaction to the limit of the basic dimensions of the painting recognized by Frank Stella. Through irregularity, stripes, painting surfaces and ground come into such a relationship of tension that they appear to take turns duping each other. Does the yellow bordered triangle in *Tuftunboro III*, 1966,[201] cause the bending in of the gray stripe or does the latter select the former? Why does its lower edge adjust itself to the contour of the triangle? And why does the stripe in the lower left not end at the edge of the painting, but rather ends in a pointed corner? Could it not be that *irregular* in the series has to do less with the irregular forms as with the push into a new dimension? For it strives to appear precisely in the lower left corner as if the artist wanted to cut it out of the strict two layeredness and to shove the paint layers against each other. Just as he later cuts a piece of paper internally into stripes and turns it into a three-dimensional entity through rotation and pushing,[202] he appears here to handle the ground, surfaces and painting frame such that they must spatially interact with one another without this happening through optical illusion. In the *Protractor* series, 1967–1971, one has the impression as if Frank Stella is working with superposition and layering. However, the stripes that are introduced as graduated arcs are exactly pictorially fixed and do not lead an independent existence in contrast to both of the other constituents of the painting, so that they cannot have an illusory effect.

In order to break through the levels of the painting without deceitful effects, it was necessary to discover the relief structure for painting and to isolate the layers of painting, including the grounds and to link them together from the inside. In the *Polish Village* series[203] this path was followed for the first time. The painted surfaces each receive their own ground and allow themselves to be set off against one another in this way. At the same time they allowed themselves to be brought into slight slants so that they mediate, like two ramps, between different levels. In order to keep in mind that with the expansion we are not dealing with the transition from painting to relief, Frank Stella layered the ground - fiber board, wood or corrugated board - with materials of different textures – felt, cardboard, canvas, monochrome colored or created by surfaces consisting of an informal brush stroke. As a result of their shallow depth they remain frontally viewed and allow only their principle of construction to be seen in the side view, an openness that the *Black Paintings* already have. The genesis of the painting remains reconstructable, the artist allows insight into the process of the work. In that genesis and result simultaneously are held present as already Pablo Picasso and Georges Braque laid bare the interaction between work process and work in their cubist uvre, the painting is brought into a condition of floating.

The frontal view, as is appropriate for the painting as painting, remains binding for the following series as well, although they project far into space. They are to be understood as pictorial space that has become real, that is constituted and construed in front of a frame. In this way the artist works against possible illusions and can protect against evocations based on recognizeability, which could undoubtedly come about as a result of the titles of the series *Exotic Birds* and *Indian Birds*.[204] But here, as with the series *Cones* and *Pillars*[205] pictorially expressive thinking stands in the foreground, in Thomas Whately's sense. What Frank Stella said about his later architecture plans, is valid here as well: *The form had to be pulled through a pictorial wringer …. The pictorial wringer is nothing other than the history and practice of painting*.[206] The methods aim at translations of the three-dimensionality which are

---

[200] See Joseph Albers, Interaction of Color. Grundlegung einer Didaktik des Sehens (Cologne: DuMont, 1970).
[201] Illustration in the Munich exhibition catalogue, 1996, p.187. On this painting series see also Robert Rosenblum, Frank Stella (Harmondsworth/Baltimore: Penguin, 1971) p. 41 ff.
[202] See the illustration of the plan for his Gatehouse in Sidney Guberma, p. 216.
[203] Illustration in the Munich exhibition catalogue, 1996, p. 192 ff.
[204] Illustration in the Munich exhibition catalogue, 1996, p. 201 ff.
[205] Illustration in the Munich exhibition catalogue, 1996, p. 211 ff.
[206] Frank Stella, Broadsides, p. 8 f, there demonstrated with two street pylons, with which the artist worked and differentiated between the forms of a perspectivism oriented toward the inside of the painting and toward the outside of the painting, with which he contrasts his understanding of the space of the painting.

setzung der Dreidimensionalität, die durchaus auch zu dreidimensionalen Bildern führen kann, die sie aber ihrem Charakter nach nicht besitzen. Deshalb spricht der Künstler von ihrer *Zweieinhalbdimensionalität*.[145] Wenngleich diese Bezeichnung ein metaphorischer Behelf ist, um die Beibehaltung bildhafter Anschaulichkeit seiner dreidimensionalen Wandbilder zu unterstreichen, macht sie Stellas Anliegen verständlich.

Die Bildform unterscheidet sich von der in der Umwelt wahrgenommenen Form. Der Künstler kann sie aufgreifen, aber er übersetzt sie bildgerecht. Er reduziert nicht, wie die frühe abstrakte Kunst, überträgt nicht, wie die figurative Kunst. Vielmehr bezeichnet *Zweieinhalbdimensionalität* die Auflösung des wiedererkennbaren Vorbildes in ein optisches Kontinuum, in dem sich die Bildbezüge beständig wandeln, ja sogar transzendieren. Frank Stella hat angedeutet, er könne sich auch vorstellen, etwas von einer X-Dimensionalität in eine fellinineske *Achteinhalbdimensionalität* zu überführen.[146] Das Ergebnis bleibt immer ein Bild, ein imaginäres Ganzes. Die Serie *Imaginary Places* von 1994 und 1995 vermag diesen Transformationsprozeß zu verdeutlichen.[147] Die Collagen bestehen aus montierten und gemalten Strukturen, denen auch überformte Computerzeichnungen zur Vorlage dienten und die größtenteils gedruckt wurden. Netz- und gitterartige Strukturen sind länglich geschwungenen oder punktartigen, aufgeblasenen Formen unterlegt oder gleiten über sie hinweg.

Der Künstler dürfte auf ihre Struktur gestoßen sein, als er sich fragte, wie man einen Rauchring – er ist ein Liebhaber kubanischer Zigarren – in ein malerisches Gebilde umsetzen kann. Mit seinen Mitarbeitern Earl Childress, dem Filmer Andrew Dunn und dem Fotografen Steve Sloman baute er eine große kubische Box, an allen Wänden mittig durchlöchert. Durch zwei gegenüberliegende Öffnungen wurde der nichtreflektierende Innenraum ausgeleuchtet, durch die übrigen konnte der Künstler seine Rauchringe blasen, welche mehrere Fotoapparate simultan aufnahmen. Einen Teil der Fotografien setzte eine graphische Anstalt in Schweden in filigran exakte Stiche um, einen anderen simulierte der Computer.[148] Zahlreiche Varianten der graphischen Vorlagen ließ der Künstler drucken und verwendete sie in den Bildern der Serie *Imaginary Places*.

Vergleichbar ist dieses Verfahren den Versuchen, die seit den 50er Jahren Frei Otto unternahm, um auf pneumatischen Strukturprinzipien basierende Architekturen zu entwickeln, etwa die Berechnung der Oberfläche des *Pneu* eines Wassertropfens, deren Resultat eine Vielzahl von *Wölbkonstruktionen* war, die nicht auf dem Tragen-Lasten-Prinzip basieren, sondern *zugbeansprucht* oder in sich *biegesteif* funktionieren: *Harte Konstruktionen* gehen in *weiche* über,[149] so wie sie der Architekt in zahlreichen Bauten realisiert hat.[150] In diesem Sinne darf man sich Frank Stellas Gitter und Netzwerke in *Polombe* vorstellen, die ein fragiles Gesamt der Bildstruktur stiften und es in der Schwebe halten. Der Schwebezustand ist auch ein zentrales Motiv in Herman Melvilles Roman *Moby Dick*, über den Frank Stella nicht als erster Künstler handelte.[151]

Rückblickend lassen sich die Gitterstrukturen seit den *Exotic Birds*, wo sie eindeutig Bestandteil der Konstruktion sind, in diesem Sinne lesen, und es kann sogar von der sichtbaren Leinwand der *Black Paintings* gesagt werden, sie habe eine Netzstruktur, auf der die Farbe aufliege. So sehr also einzelne Binnenelemente in den *Imaginary Places* zunächst optische Täuschungen hervorrufen, so wenig lassen sie sich derartig im Gesamtkontinuum verstehen. Vielmehr wirken sie daran mit, den Schwebezustand des Gemäldes aufrecht, seine Formen in Fluss zu halten. Frank Stella mag sich seines bildnerischen Formprinzips versichert haben, als er die Architektur Antonio Gaudís, des Expressionismus und Erich Mendelsohns studierte, die das Prinzip des Tragens und Lastens in der Baukunst durch

---

[145] Frank Stella, Broadsides, S. 10.
[146] Frank Stella, Broadsides, S.10, 16. Wenn Frank Stella mit dem Begriff einen Filmtitel von Federico Fellini aufgreift, gibt er sich selbst nicht als Kinofan zu erkennen. Im Gegenteil, so gesteht er, gehe er lieber in Museen, um Bilder anzuschauen: Jedes ist anders und erzählt eine andere Geschichte. Im Kino gibt es drei Stunden lang nur ein und dasselbe verdammte Ding zu sehen. Zit. n. Ulf Poschardt, S. 38. Er gibt den Bildenden Künsten gegenüber den neueren Medien auf Grund ihrer Körperlichkeit (ebda., S. 37) den Vorzug. Die Übernahme des Begriffes deutet lediglich an, daß er filmische Darstellungsverfahren studiert und auf ihre Anwendbarkeit in der Malerei überprüft hat.
[147] Abb. in Ausst.-Kat. München 1996, S. 223 ff.
[148] Vgl. Sidney Guberman, S. 220.
[149] Vgl. Frei Otto, Natürliche Konstruktionen. Formen und Konstruktionen in Natur und Technik und Prozesse ihrer Enstehung, Stuttgart 1982, S. 27 ff und 56 ff.
[150] Vgl. zu Frei Otto Karin Wilhelm, Architekten heute. Portrait Frei Otto, Berlin 1985.
[151] Erinnert sei an Jackson Pollock; vgl. zur Serie Frank Stellas Ausst.-Kat. Ulm 1993, Frank Stella Moby Dick Series. Engravings, Domes and Deckle Edges, Ulmer Museum, Anna-Maria Ehrmann-Schindlbeck, The Quarter Deck, 1989, aus der Moby Dick Series, in: Pictor laureatus, S. 50 ff.

appropriate to painting and which could surely lead to three-dimensional paintings, but a quality which they do not possess in their character. Therefore the artist speaks of their two-and-a-half-dimensionality.[207] Even if this designation is a metaphorical aid meant to underline the maintenance of the pictorial vividness of his three-dimensional wall paintings, it makes Frank Stella's project understandable.

Pictorial form differs from form that is perceived in the surrounding environment. The artist can appropriate it but he translates it in a manner appropriate to painting. He does not reduce, like early abstract art and does not transfer, like figurative art. *Two-and-a-half-dimensionality* shows rather the dissolution of the recognizable model in an optical continuum, in which the pictorial relations continuously change - yes, even transcend. Frank Stella points out that he could also imagine transpose something like an X-dimensionality into a Fellinian *Eight-and-a-half-dimensionality*.[208] The result always remains a painting, an imaginary whole. The series *Imaginary Places* from 1994 and 1995 may illustrate this process of transposition.[209] The collages consist of mounted and painted structures for which transformed computer drawings served as a basis and which were for the most part printed. Net- and grid-like structures are longitudinally subsumed under swung or point-like overblown forms or glide over and away from them.

The artist may have come across their structure when he asked himself how one can transform a smoke ring – he is a connoisseur of Cuban cigars – into an pictorial object. With his assistants Earl Childress, the producer Andrew Dunn and the photographer Steve Sloman he constructed a large box that had holes in the middle of each wall. Through two counterposed openings the non-reflective interior was illuminated and through the rest the artist could blow his smoke rings, which several cameras simultaneously photographed. A graphic institute in Sweden converted some of the photographs into filigree-exact engravings and others were simulated by computer.[210] The artist had numerous variations of the graphic models printed and used them in the paintings of the *Imaginary Places* series.

The procedure is comparable to the attempts which Frei Otto had undertaken since the 1950s to develop architecture on the basis of pneumatic structural principles, like the reckoning of the surface of the *pneu* of a drop of water whose result was a multitude of corrugated constructions that were not based on the support and load principle, but rather function with tensile stress or internal resistance to bending: *hard constructions* turn into *soft* ones[211] – just as the architect has realized in many buildings.[212] In this sense one can imagine Frank Stella's grid and networks in *Polombe*, which support a fragile whole of the painting structure and keep it floating. The condition of floating is also a central motif in Herman Melville's novel *Moby Dick*, with which Frank Stella dealt with, but certainly not as the first artist.[213]

Retrospectively, the gridwork structures since the *Exotic Birds* – where they are clearly a part of the construction – allow themselves to be seen in this sense, and it can even be said of the visible canvas of the *Black Paintings* that they have a net structure upon which the paint lies. As much as individual elements in *Imaginary Places* initially call forth optical illusions, so little do they allow themselves to be understood in this same way in the entire continuum. On the contrary, they participate in maintaining the painting's condition of floating, in keeping its form in motion. Frank Stella confirmed his pictorial principle when he studied the architecture of Antonio Gaudi, Expressionism and Erich Mendelsohn who tried to replace architecture's principle of support and load through a dynamic construction

---

[207] Frank Stella, Broadsides, p. 10.

[208] Frank Stella, Broadsides, p. 10, 16. Because Frank Stella takes a film title from Federico Fellini with this concept it does not mean that he recognizes himself as a fan of film. To the contrary, so he admits, he would rather go to museums to contemplate paintings: every one is different and tells a different story. At the movies there is only one and the same damn thing to see for three hours. Quoted in Ulf Poschardt, p. 38, translation. Kenneth Munn. He gives precedence to the fine arts over the newer media because of their corporeality (p. 37). The appropriation of the concept allegedly indicates that he has studied cinematic representational techniques and tested them for their applicability in painting.

[209] Illustration in the Munich exhibition catalogue, 1996, p. 223 ff.

[210] See Sidney Guberman, p. 220.

[211] See Frei Otto, Natürliche Konstruktionen. Formen und Konstruktionen in Natur und Technik und Prozeße ihrer Entstehung, (Stuttgart: Deutsche Verlagsanstalt, 1982), p. 27 ff and 56 ff.

[212] On Frei Otto see Karin Wilhelm Architekten heute. Portrait Frei Otto (Berlin: Quadriga, 1985).

[213] One should remember Jackson Pollock; on Frank Stella's series, see the Ulm exhibition catalogue, 1993, Frank Stella Moby Dick Series. Engravings, Domes and Deckle Edges (Ulm: Ulmer Museum); Anna-Maria Ehrmann-Schindlbeck, *The Quarter Deck*, 1989, aus der *Moby Dick* Series, in: Pictor laureatus, p. 50 ff.

eine dynamische Konstruktion zu ersetzen suchten und *hängende Dächer* entwickelten, ein Prinzip, das bereits in Zelten und Brückenbauten zur Anwendung kam und das Frank Stella für seine Entwürfe einer Brücke, 1988, einer *Holy Spirit Chapel*, 1992, eines *Torhauses*, 1994, und der *Kunsthalle Dresden an der Herzogin Garten,* 1992, nutzte.

Skulptur

Der Vergleich der Bilder Frank Stellas mit *zugbeanspruchten* oder *biegesteifen Konstruktionen* liegt schon deshalb nahe, weil er das Schweben, durch die Besonderheit ihrer tiefen Hängung über dem Boden unterstützt, als hervorragendes Merkmal seiner Gemälde beschreibt, das der Skulptur allerdings fehle. Wenn er diese Qualität der Skulptur abspricht, so kann er sie nur auf *harte* Skulptur in Analogie zu Frei Ottos Begriff beziehen, doch kennt die Gattung seit dem 19. Jahrhundert auch *weiche*, in jedem Einzelfalle auf unterschiedliche Weise hervorgebrachte *schwebende* Plastik: das skulpturale Werk Edgar Degas' oder Medardo Rossos, die hängenden kubistischen Plastiken Pablo Picassos, Marcel Duchamps *Trois stoppages etalons* von 1913 / 1914, das *Ecken-Gegenrelief* Wladimir Tatlins von 1915, Alexander Rodtschenkos *Hängekonstruktion*, 1920, Alexander Calders *Mobiles*, Joseph Beuys' und Robert Morris' Plastiken aus Filz, um nur einige Beispiele aus der Kunst der letzten hundert Jahre zu nennen.[152]

Wenn Bildlichkeit intendiert, das alltägliche räumliche Sehen von Gegenständen in die strikte Simultaneität der *Zweieinhalbdimensionalität* zu übersetzen und durch die Gleichzeitigkeit der Formelemente einen Raum vor den Bildern zu erzeugen, den man *Wirkungsraum* nennen kann,[153] dann müsste Skulptur die Übersetzung einer sinnlich nicht wahrnehmbaren Vierdimensionalität sein und zur *Dreieinhalbdimensionalität* werden, indem sie die Statik (Inertie) und Dynamik (Instantanität) der Dinge erfasst, ohne sie in einem funktional-zeitlichen Zusammenhang zu sehen, sondern vielmehr in einem imaginär-bildlichen Kontext als vergegenwärtigte Vision oder poetisierte Welt aus Licht und Schatten, Volumen und Leerraum, Hülle und Kern, Bewegung und Ruhe, von der mit anderen Mitteln schon die Kunst Michelangelos, des Manierismus und des Barock handeln, wie Frank Stella im Gespräch mit Richard Meier feststellt.[154]

So wie Künstler der Renaissance und des Barock in den Augen Frank Stellas bildhaft die Summe ihrer Epoche zogen, strebt auch er danach, das Kunstwerk zum Fokus der Kultur seiner Zeit werden zu lassen, die in seinem Verständnis von urbaner Energie geprägt ist. Er sieht die moderne Stadt von einem Dualismus zwischen Statik und Dynamik bestimmt, repräsentiert durch zwei Materialien: das Eisen, das die Architektur stabilisiere, und das Aluminium, das sie ummantle, ihr Leichtigkeit verleihe, sie im besten Falle dynamisiere. Die Materialien sind Synonyme der Dichte und Transparenz, deren Wirkung in *harten Konstruktionen* nicht angemessen zur Geltung komme. Daher resümiert Frank Stella: *We have very sophisticated heavy and ultra-light technologies. We have to put them together.*[155] Mit der Forderung unterscheidet er sich von Alexander Calder, John Chamberlain, Claes Oldenbourg und Richard Serra, die entweder die Leichtigkeit oder das Lasten thematisierten und Skulpturen von pittoresker oder sublimer Anmutungsqualität schufen.

Ikonographie jenseits der Ikonographie

Frank Stella jedoch sucht die bildhaft vergegenwärtigte Synthese von Dynamik und Statik in der Gegenwart. Obwohl seine Skulpturen von Verweisfunktionen befreit sind, öffnen sie sich dem imaginären Sehen für Anregungen und Inspirationen des Künstlers aus seiner Umwelt. Die *Hudson River Valley Series* lädt unversehens in jene Landschaft nördlich New Yorks ein, deren Name für eine große Gruppe amerikanischer Landschaftsmaler zwischen 1825 und 1870 einsteht, *Hudson River School* oder *Hudson River Painters*.[156] Die Maler, in Europa und an seinen Stilgepflogenheiten geschult, widmeten sich heimischen Landschaften, zu denen gerade das Tal des Hudson River zählte, der oft mit dem Rhein verglichen wurde,[157] um anzudeuten, dass die Neue Welt der Alten an natürlichem

[152] Vgl. Benjamin H. D. Buchloh, Die Konstruktion (der Geschichte) der Skulptur, in: Ausst.-Kat. Münster 1978, Skulptur Projekte in Münster 1987, Westfälisches Landesmuseum für Kunst und Kulturgeschichte, S. 329 ff.
[153] So Johannes Meinhardt in Ausst.-Kat. Stuttgart 1988 / 1989, S. 65 ff in Anlehnung an Frank Stellas Begriff Working Space, den dieser als Titel seines 1986 in Cambridge (Mass.) / London erschienenen Buches wählte.
[154] Vgl. Ausst.-Kat. Rom 1993, S. 225 und Ulf Poschardt, S. 38.
[155] Frank Stella, Broadsides, S. 17.
[156] Vgl. Jules David Prown, American Painting. From its Beginnings to the Armory Show, Lausanne 1969, S. 55.
[157] Vgl. Kat. Bielefeld 1976, The Hudson and the Rhine. Die amerikanische Malerkolonie in Düsseldorf im 19. Jahrhundert, Kunsthalle, S. 16 ff.

and therefore developed *hanging ceilings*, a principle that already had been put into practice in tents and bridge constructions and that Frank Stella used for his plans for a bridge, 1988, of a *Holy Spirit Chapel*, 1992, of a *Torhaus*, 1994, and of the *Kunsthalle Dresden* in the Dutchess Garden, 1992.

Sculpture

The comparison of Frank Stella's paintings with tensilly stressed or rigid constructions is already almost at hand because he describes the floating, which is brought about by the uniqueness of their hanging low above the ground, as the projecting characteristic of his paintings, which sculpture, however, lacks. If he denies sculpture this quality then it can only be *hard* sculpture, analogously to Frei Otto's concept, however since the 19th century the genre also knows *soft*, floating sculpture that were produced in different ways in each individual case: the sculptural work of Edgar Degas or Medardo Rosso, the hanging cubist sculptures of Pablo Picasso, Marcel Duchamp's *Trois stoppages etalons* from 1913/1914, the *Ecken Gegenrelief* of Wladimir Tatlin of 1915, Alexander Rodtschenko's *Hängekonstruktion* 1920, Alexander Calder's *Mobiles*, Joseph Beuys' and Robert Morris' sculptures from felt, only to name a few examples from the art of the last hundred years.[214]

If pictorial quality intends to translate the everyday spatial vision of objects into the strict simultaneity of two-and-a-half-dimensionality and to create space in front of the paintings, which one can call working space,[215] through the simultaneity of the formal elements, then sculpture would have to be the translation of a sensually imperceptible four-dimensionality and would have to become three-and-a-half-dimensionality, in that it apprehends the statics (inertia) and dynamics (instantaneousness) of things without seeing them in a functional-temporal context, but rather, on the contrary, in an imaginary pictorial context as a realized vision or poeticized world of light and shadows, volume and empty space, casing and core, movement and rest, with which already the art of Michelangelo, Mannerism and the Baroque had to do with by other means, as Frank Stella asserted in a conversation with Richard Meier.[216]

Just as artists of the Renaissance and Baroque, in Frank Stella's eyes, summed up their epoch, he also strives to make the artwork become the focus his contemporary culture, which, according to him, is characterized by urban energy. He considers the modern city to be determined by a dualism of statics and dynamics, represented by two materials: iron, which stabilizes architecture, and aluminum, which envelopes it, gives it lightness, makes it, under optimal conditions, dynamic. The materials are synonyms for density and transparency whose effect is not appropriately accentuated in *hard constructions*. Therefore Frank Stella reasons: *We have very sophisticated heavy and ultra-light technologies. We have to put them together.*[217] With the demand he differentiates himself from Alexander Calder, John Chamberlain, Claes Oldenbourg and Richard Serra who thematized either the lightness or the load and created sculptures with picturesquely or sublimely charming quality.

Iconography beyond iconography

Frank Stella presently searches, nevertheless, for the pictorially visualized synthesis of dynamics and statics. Although his sculptures are freed from referential functions they open themselves to imaginative vision for stimulations and inspirations the artist receives from his environment. The *Hudson River Valley Series* unmistakably invites us to this landscape north of New York, whose name stands for a large group of American landscape painters between 1825 and 1870, the *Hudson River School* or *Hudson River Painters*.[218] The painters, schooled in Europe and by its refined style, committed themselves to domestic landscapes, to which precisely the Hudson River Valley belongs, which, by the way, was often compared to the Rhine River.[219] They committed themselves to domestic

[214] See Benjamin H.D. Buchloh, Die Konstruktion (der Geschichte) der Skulptur, in: Münster exhibition cagalogue, 1978, Skulptur Projekte in Muenster 1987 (Westfälisches Landesmuseum für Kunst und Kulturgeschichte), p. 329 ff.
[215] See Frank Stella, Working Space (Cambridge: Harvard, 1986); see also Johannes Meinhardt in the Stuttgart exhibition catalogue, 1988/1989, p. 65 ff.
[216] See the Rome exhibition catalog, 1993, p. 225 and Ulf Poschardt, p. 38.
[217] Frank Stella, Broadsides, p. 17.
[218] See Jules David Prown, American Painting. From its Beginnings to the Armory Show (Lausanne: Skira, 1969), p. 55.
[219] See Bielefeld exhibition catalogue, 1976, The Hudson and the Rhine. Die amerikanische Malerkolonie in Düsseldorf im 19. Jahrhundert, (Bielefeld: Kunsthalle, 1976), p.16 ff.

und zeitgeschichtlichem Reichtum in nichts nachstehe. Der Maler Thomas Doughty konzentrierte sich auf serene, lyrisch-kontemplative Ansichten des Tales, Asher Durand interessierten Waldlandschaften bei unterschiedlichem Lichteinfall, und Thomas Cole favorisierte heroische Landschaften im Unwetter. Die Malerei dieser Begründer der Schule schwankt zwischen pittoresker und sublimer Darstellung, denen sich je nach Interesse die Nachfolger, wie Alvan Fisher, Henry Inman, Samuel F. B. Morse und später John Kensett, John Casilear, Worthington Whittredge und George Inness anschlossen. Aber auch Thomas Moran und Albert Bierstadt, die die grandiosen Landschaften des *Far West* entdeckten, sind der Tradition der *Hudson River School* verpflichtet.

Obwohl als Landschaftsbilder entworfen, stehen die Werke dieser Maler für die Suche nach einer eigenständigen amerikanischen Identität nach der kolonialen und föderalen Phase des Landes. Wenn Frank Stella eine Skulptur der *Hudson River Valley Series* nach einem landschaftlich dominanten Bergmotiv *Bear Mountain* benennt, dann drängen sich Assoziationen zur Landschaft geradewegs auf. Bei den Städtenamen Newburgh, Garrison, Fishkill und Peekskill ist man versucht, an historische Ereignisse des amerikanischen Unabhängigkeitskrieges zu denken; residierte doch George Washington zwischen 1781 und 1783 in Newburgh, von wo sein entscheidender militärischer Erfolg ausging. Ebenso lassen sich Beziehungen zum Verhältnis von Landschaft und Zivilisation herstellen, da der Hudson River nicht nur bekannt ist für seine naturräumlichen Besonderheiten und die ihn umgebenden Naturparks, sondern auch für seine verkehrstechnische Bedeutung als Schifffahrtsweg einer blühenden Industrieregion mit einem entwickelten System von Verkehrswegen, unter denen kühne Brücken herausragen. Die Stadt Peekskill und den Bear Mountain State Park verbindet die Bear Mountain Bridge, eine gewaltige 1924 errichtete Hängekonstruktion, Beacon und Newburgh eine 1963 erbaute Brücke gleichen Typs. Sollten nicht alle diese Eindrücke als Bilder in die sechs Skulpturen eingegangen sein? Könnten sie nicht Fokus der dynamischen Entwicklung einer Natur- und Kulturlandschaft sein?

Skulptur und Architektur

In seinem anlässlich seiner Ehrenpromotion in Jena gehaltenen Vortrag hat Frank Stella am Beispiel New Yorks dargestellt, dass es darauf ankomme, in die dicht bebauten Städte Schneisen zu schlagen und sie als Plätze zu gestalten: *We must punch some holes in the urban scheme, and put new forms to work which are, at least, striving to be beautiful in those newly created gaps.*[158] Dieser Forderung sind die Planer mit der Neugestaltung des ehemaligen Hauptwerk-Geländes der Firma Zeiss nachgekommen. Unter Wahrung der kunstgeschichtlich denkwürdigen Bausubstanz entstand ein Platzensemble, für das Frank Stella die Gruppe von Skulpturen bereitstellte. Sie sind Bilder der Neuen Welt, die den auf Kontinuität und Wandel angelegten Prozess der Zivilisation fokussieren. Während das mit Frank Stellas Entwurf einer Kunsthalle für Dresden verbundene Projekt, Architektur in Pavillons aufzulösen und sie in einen Park, statt einer Grünfläche zu stellen, Idee blieb: *We were hoping to build pavilions in a park, not bunkers in a planting scheme,*[159] realisierte er in Jena ein mit den Architekturfassaden in Wechselwirkung stehendes Skulpturenensemble, das Wirkungsräume stiftet, wie sie ihm in Sachsen vorschwebten. In ihrer Bildlichkeit – *stainless has a lot of different colors to it, mainly reds and greens*[160] – möblieren die Skulpturen den Platz nicht, sondern machen ihn zum Ort sich wandelnder Bilder.

Franz-Joachim Verspohl

---

[158] Frank Stella, Broadsides, S. 11 f.
[159] Frank Stella, Broadsides, S. 23.
[160] Ausst.-Kat. Rom 1993, S. 234.

themes in order to point out that the New World did not take a back seat to the old one in terms of natural and contemporary riches. The painter Thomas Doughty concentrated on the serene, lyrically contemplative vistas of the valley, Asher Durand was interested in wooded landscapes in various shades of light and Thomas Cole preferred heroic landscapes during storms. The painting of these founders of the school varies between picturesque and sublime representation. The successors, such as Alvan Fisher, Henry Inman, Samuel F.B. Morse and later John Keenest, John Casilear, Worthington Whittredge and George Inness affiliated themselves relative to their interests. Thomas Moran and Albert Bierstadt, who discovered the grandiose landscapes of the far west, are also indebted to the tradition of the *Hudson River School*.

Although conceived of as landscape paintings the works of these painters represent the search for an independent American identity following the colonial and federal phase of the land. When Frank Stella names a sculpture of the *Hudson River Valley Series* after a scenically dominant mountain motif *Bear Mountain*, then associations with landscapes force themselves to our attention. With the city names Newburgh, Garrison, Fishkill and Peekskill one is tempted to think about historic events of the American Revolution. George Washington did indeed reside in Newburgh between 1781 and 1783, from where his decisive military victories proceeded. Similarly connections to the relationship between landscape and civilization can be made because the Hudson River is not only well know for its natural beauties and the nature parks that surround it, but also for its transportation significance as a shipping route of a blooming industrial region with a developed system of transportation routes, among which bold bridges jut out. The city of Peekskill and Bear Mountain State Park are connected by the Bear Mountain Bridge, a powerful suspension construction built in 1924; Beacon and Newburgh by a bridge of the same type built in 1963. Should not all of these impressions as images have been incorporated into the six sculptures? Could they not be the focus of the dynamic development of a natural and cultural landscape?

Sculpture and architecture

In his speech given on the occasion of his honorary promotion in Jena, Frank Stella showed through the example of New York that it is important to punch holes in the densely built cities and to design them as sites: *We must punch some holes in the urban scheme, and put new forms to work which are, at least, striving to be beautiful in those newly created gaps.*[220] The planers of the reorganization of the former main works complex of the Zeiss company heeded this demand. With the preservation of the art-historically significant structure, a site ensemble arose for which Frank Stella prepared the group of sculptures. They are images of the New World that focus on the process of civilization, which involves continuity and change. While Frank Stella's proposal for an art museum for Dresden – which was connected to his project to dissolve architecture into pavilions and to place buildings in a park instead of in a field – remained an idea: *We were hoping to build pavilions in a park, not bunkers in a planting scheme.*[221] In Jena he realized a sculpture ensemble that exists in a state of interaction with the architectural facades, which creates working spaces, like those that floated before him in Saxony. In their pictorial quality – *Stainless has a lot of different colors to it, mainly reds and greens*[222] – the sculptures do not furnish the site, but rather make it into a place of changing images.

Franz-Joachim Verspohl
Translator Kenneth E. Munn

---

220 Frank Stella, Broadsides, p. 11 f.
221 Frank Stella, Broadsides, p. 23.
222 Rome exhibition catalogue, 1993, p. 234.

# Biography of Frank Stella with a Selection of One-Man and Group Exibitions
# Biographie Frank Stellas mit einer Auswahl der Einzel- und Gruppenausstellungen

**1936**

Born May 12 in Malden, Massachusetts, as Frank Philip Stella. His father is gynecologist, his mother had attended art school.

**1950–1954**

Attends Phillips Academy, Andover, Massachusetts; studies painting with Patrick Morgan, a pupil of Lyonel Feininger. At Andover meets Carl Andre and Hollis Frampton.

**1954**

Enters Princeton University, Princeton, New Jersey.

**1955**

Attends William Seitz' open painting studio. Visits galleries and museums in New York City.

**1956**

Studies with the painter Stephen Greene, artist-in-residence at Princeton. Meets Michael Fried, who is also a student at Princeton.

**1958**

Graduates from Princeton with Bachelor of Arts' degree in history. Sees Flag and Target paintings by Jasper Johns at the Leo Castelli Gallery in New York. In spring, paints a number of works influenced by Adolph Gottlieb and Mark Rothko. In summer, moves to New York and begins *Transitional Paintings* and *Black Paintings*.

**1959**

Continues black series paintings. Sees Barnett Newman's paintings for the first time at an exhibtion at French & Co. Exhibits professionally for the first time in a group show at the Tobor de Nagy gallery. Dorothy Miller, curator at The Museum of Modern Art, visits Stella's studio. She is accompanied by Leo Castelli. Miss Miller, who is organizing *Sixteen Americans* exhibition, returns for a second visit with the museum's director Alfred Barr. She invites Frank Stella to participate in exhibition. Through art historian Robert Rosenblum meets painters Jasper Johns and Robert Rauschenberg. Also meets Kenneth Noland and art historian Barbara Rose.

Exhibits four *Black Paintings* in *Sixteen Americans*. First museum purchase: *The Marriage of Reason and Squalor*, by The Museum of Modern Art, New York City.

New York City, Tibor de Nagy Gallery. *Selections*. 7 April – 25 April.
Oberlin, OH. Oberlin College. Allen Memorial Art Museum. *Three Young Americans*. [Frank Stella / Jerrold David / B. Pickard Pritchard]. 11 May – 30 May 1959. [Catalogue].
Malden, MA. Malden Public Library. *Frank Stella*. 15 June – 30 June.
New York City. Leo Castelli Gallery. *Opening of the New Gallery*. 6 October – 17 October.
New York City. National Arts Club. *Metropolitan Young Artists Show*. 9 December – 7 January 1960.
New York City. Museum of Modern Art. *Sixteen Americans*. 16 December – 14 February 1960.

**1960**

Finishes black series. Begins the series *Aluminum Paintings*, first shaped canvases. First one-man exhibition in New York: Aluminum Paintings at Leo Castelli Gallery, New York City. Begins the series *Copper Paintings*. Applies for Fulbrigh Grant to study in Japan.

Baltimore, MD. Morgan State College Art Gallery. *The Calculated Image*. 5 May – 15 May.
New York City. Leo Castelli Gallery. *Summary 1959–1960*. 31 May – 25 June.
Paris, France. Galerie Neufville. *New American Painting*. 3 May – 31 May.
New York City. Leo Castelli Gallery. *Frank Stella*. 27 September – 15 October.

**1961**

Begins the *Benjamin Moore* series. Travels to Florida with Sidney Guberman. In fall, makes first trip to Europe: travels to England, Frabce, Spain, as well as Morocco, where he makes sketches for what became the *Concentric Squares* and *Mazes* series. Marries Barbara Rose in London. First one-man exhibition in Europe: paintings from the *Benjamin Moore* series at Galerie Lawrence, Paris.

Chicago, IL. Art Institute of Chicago. *64th American Exhibition*. 6 January – 5 February.

New York City. Four Seasons Restaurant. *Temporary Loan*. Summer.

Akron, OH. Akron Art Institute. *Explorers of Space*. 8 October – 13 November. [Traveled to Louisville, KY, J. B. Speed Museum, 4 December – 25 December; Winter Park, FL, Rollins College, Morse Gallery, 8 January – 28 January 1962; Stanford, CA, Stanford University, 11 February – 4 April 1962; Houston, TX, Contemporary Arts Association of Houston, 17 April – 7 May 1962].

Houston, TX. Contemporary Arts Museum. *Ways and Means*. October – November.

New York City. Leo Castelli Gallery. 22 September – 14 October.

New York City. Solomon R. Guggenheim Museum. *American Abstract Expressionists and Imagists*. 13 October – 31 December.

Paris, France. Galerie Lawrence. *Frank Stella*. November. [Catalogue].

New York City. Museum of Modern Art. *Recent Acquisitions*. 19 December – 12 February 1962.

## 1962

Daughter Rachael born. Begins drawings which will later become *Irregular Polygon* series.

New York City. Four Seasons Restaurant. *Temporary loan*. January – April.

New York City. Whitney Museum of American Art. *Geometric Abstraction in America*. 20 March – 13 May. [Catalogue].

New York City. Leo Castelli Gallery. *Works by John Chamberlain, Edward Higgins, Frederick Kiesler, Roy Lichtenstein, Robert Moskowitz, Robert Rauschenberg, Frank Stella, Cy Twombly*. 7 April – 21 April.

New York City. Leo Castelli Gallery. *Drawings*. 26 May – 30 June.

Seattle, WA. Seattle World's Fair. *Art Since 1950 – American and International*. 21 April – 21 October. [Traveled to Waltham, MA, Brandeis University, Rose Art Museum, 21 November – 23 December.] [Catalogue].

New York City. Leo Castelli Gallery. *Frank Stella*. 28 April – 19 May.

Hartford, CT. Wadsworth Atheneum. *American Painting and Sculpture from Connecticut Collections*. 25 July – 9 September.

New York City. Leo Castelli Gallery. 22 September – 13 October.

New York City. Leo Castelli Gallery. *John Chamberlain / Frank Stella*. 16 October – 7 November.

## 1963

Artist-in-residence at Dartmouth College; teaches advanced painting. Paints *Dartmouth* series. In fall, travels in Iran with Henry Geldzahler, curator at the Metropolitan Museum of Art. On return to New York, paints *Purple* series.

Chicago, IL. Art Institute of Chicago. *66th Annual American Exhibition. Directions in Contemporary Painting and Sculpture*. 11 January – 10 February. [Catalogue].

Washington, DC. Corcoran Gallery of Art. *The 28th Biennial Exhibition of Contemporary American Painting*. 18 January – 3 March.

Schenectady, NY. Union College. 21 March – 21 April.

New York City. Leo Castelli Gallery. *Works by John Chamberlain, Edward Higgins, Frederick Kiesler, Roy Lichtenstein, Robert Moskowitz, Robert Rauschenberg, Frank Stella, Cy Twombly*. 2 April – 18 April.

Los Angeles, CA. Ferus Gallery. *Frank Stella*. 18 February – closing date unknown.

New York City. Jewish Museum. *Towards a New Abstraction*. 19 May – 15 September. [Catalogue].

New York City. Leo Castelli Gallery. *Drawings*. 20 May – 29 June.

Washington, DC, Washington Gallery of Modern Art, *Formalists*. 6 June – 7 July. [Catalogue].

Lausanne, Switzerland. Le Musée Cantonal des Beaux-Arts *Ier Salon International des Galeries Pilotes*. 20 June – 6 October. [Catalogue].

Hanover, NH. Dartmouth College. Hopkins Art Center. *Tal Streeter / Frank Stella*. 10 August – 12 September.

Waltham, MA. Brandeis University. Poses Institute of Fine Arts. *New Directions in American Painting*. [Traveled to Utica, NY, Munson-Williams-Proctor Institute, 1 December – 5 January 1964; New Orleans, LA, Isaac Delgado Museum of Art, 7 February – 8 March 1964; Atlanta, GA, Atlanta Art Association, 18 March – 22 April 1964; Louisville, KY, J. B. Speed Art Museum, 4 May – 7 June 1964; Bloomington, IN, Indiana University, June – September 1964; St. Louis, MO, Washington University Gallery of Art, 5 October – 30 October 1964; Detroit, MI, Detroit Institute of Arts, 10 November – 6 December 1964.] [Catalogue].

San Francisco, CA. San Francisco Museum of Art. *Directions American Painting*. 20 September – 20 October.

New York City. Whitney Museum of American Art. *Annual Exhibition 1963. Contemporary American Painting*. 11 December – 2 February 1964.

New York City. Jewish Museum. *Black and White*. 12 December – 5 February 1964. [Catalogue].

## 1964

Begins *Moroccan*, *Running-V* and *Notched-V* series. Included in *Post Painterly Abstraction* exhibition, curated by Clement Greenberg, at the Los Angeles County Museum of Art. Included in U. S. A. section of XXXII Biennale at Venice.

New York City. Leo Castelli Gallery. *Frank Stella*. 4 January – 6 February.

Hartford, CT. Wadsworth Atheneum. *Black, White, and Gray*. 9 January – 9 February.

Los Angeles, CA. Ferus Gallery. *A View of New York Painting, including Major Works by Jasper Johns, Robert Rauschenberg, Andy Warhol, Ellsworth Kelly, Frank Stella, Roy Lichtenstein, and Larry Poons*. January – closing date unknown.

Cologne, West Germany. Galerie Denise René. *Hard Edge*. January – closing date unknown.

New York City. Sidney Janis Gallery. *The Classic Spirit in 20th Century Art. Painters and Sculptors from Brancusi and Mondrian to Today*. 4 February – 29 February. [Catalogue].

New York City. Leo Castelli Gallery. 8 February – 29 February.

Philadelphia, PA. University of Pennsylvania. Institute of Contemporary Art Collections. *The Atmosphere of '64*. 17 April – 1 June.

Los Angeles, CA. Los Angeles County Museum of Art. *Post Painterly Abstraction*. 23 April – 7 June. [Traveled to Minneapolis, MN, Walker Arts Center, 13 July – 16 August; Toronto, Ontario, Canada, Art Gallery of Ontario, 20 November – 29 December; Waltham, MA, Brandeis University, Rose Art Museum, dates unknown.] [Catalogue].

Washington, DC. Corcoran Gallery of Art. *Modern Paintings and Sculptures in Washington Collections*. 30 April – 24 May.

Chicago, IL. Art Institute of Chicago. *The 24th Annual Exhibition by the Society for Contemporary American Art*. 8 May – 31 May.

Paris, France. Galerie Lawrence. *Frank Stella*. 12 May – 2 June.

New York City. Leo Castelli Gallery. *Works by Bontecou, Chamberlain, Daphnis, Higgins, Johns, Lichtenstein, Rauschenberg, Scarpetta, Stella, Twombly, Tworkov*. 6 June – 30 June.

Philadelphia, PA. University of Pennsylvania. Institute of Contemporary Art Collections. *The Biennale Eight (USA)*. 20 June – 26 July.

Venice, Italy. XXXII Esposizione Biennale Internazionale d'Arte, U.S.A.. *Four germinal painters, Morris Louis, Kenneth Noland, Robert Rauschenberg, Jasper Johns / Four younger artists, John Chamberlain, Claes Oldenburg, Jime Dine, Frank Stella*. 20 June – 18 October. [Catalogue].

Dayton, OH. Dayton Art Institute. *An International Selection 1964 - 1965*. 11 September – 11 October.

New York City. Leo Castelli Gallery. 26 September – 22 October.

London, England. Kasmin Limited. *Frank Stella. Recent Paintings*. 29 September – 24 October.

Turin, Italy. Galleria Notizie. *Noland e Stella*. 16 November – 20 December. [Catalogue].

New York City. Solomon R. Guggenheim Museum. *The Shaped Canvas*. 9 December – 3 January 1965.

## 1965

In fall, travels to Rio de Janeiro and São Paulo. Makes drawings for works which will become *Protrator* series.

Los Angeles, CA. Ferus Gallery. *Frank Stella in an Exhibition of New Work*. 26 January – February.

New York City. Museum of Modern Art. *The Responsive Eye*. 23 February – 25 April. [Traveled to St. Louis, MO, City Art Museum of St. Louis , 20 May – 20 June; Seattle, WA, Seattle Art Museum, 15 July – 23 August; Pasadena, CA, Pasadena Art Museum, 25 September – 7 November; Baltimore, MD, Baltimore Museum of Art, 14 December – 23 January 1966. [Catalogue].

Cambridge, MA. Harvard University. Fogg Art Museum. *Three American Painters. Kenneth Noland, Jules Olitski, Frank Stella*. 21 April – 30 May. [Traveled to Pasadena, CA, Pasadena Art Museum, 6 July – 3 August.] [Catalogue].

Ridgefeld, CT. Aldrich Museum of Contemporary Art. *Art of the '50s and '60s. Selections from the Richard Brown Baker Collection*. 25 April – 5 July.

Detroit, MI. Detroit Institute of Art. *Painting and Sculpture. 40 Key Artists of the Mid-20th Century*. 4 May – 29 May.

São Paulo, Brazil. Museu de Arte Moderna. *VIII Bienal de São Paulo*. 4 September – 28 November. [Catalogue].

Washington, DC. Washington Gallery of Modern Art. 17 September – 24 October.

Buenos Aires, Argentina. Centro des Artes Visuales, Instituto Torcuato di Tella. *Premio Nacional e Internacional 1965*. 27 September – 24 October.

New York City. Leo Castelli Gallery. 2 October – 21 October.

San Francisco CA. San Francisco Museum of Art. *Colorists 1950-1965*. 15 October – 21 November. [Catalogue].

San Francisco, CA. San Francisco Museum of Art. *Art. An Environment for Faith*.15 November – 15 December. [Presented by The Union of American Hebrew Congregations on the occasion of its 48th General Assembly *Reform Judaism, A Faith for Our Time*.].

New York City. Whitney Museum of American Art. *1965 Annual Exhibition of Contemporary American Painting*. 8 December – 30 January 1966.

Portland, OR. Portland Art Museum. *Primacy of Color. Contemporary Paintings from the Collection of Edward Cauduro*. 15 December – 6 January 1966.

Stockholm, Sweden. Moderna Museet. *Den innre Och de yttre Rymden*. [The Inner and Outer Space. An Exhibition Devoted to Universal Art] 26 December – 13 February 1966.

## 1966

Son Michael born. Performs in Robert Rauschenberg's *Open Score*, a composition consisting of a tennis game played with racquets wired to transmit sound and light.

Washington, DC. National Collection of Fine Arts. *United States of America VIII São Paulo Biennial*. 27 January – 6 March.

Washington, DC. Corcoran Gallery of Art. *30th Biennial Exhibition of Contemporary American Painting*. 24 February – 9 April.

New York City. Four Seasons restaurant. Temporary Loan. April – July.

Amsterdam, Netherlands. Stedelijk Museum. *Vormen van de Kleur*. 19 November – 15 January 1967. [Traveled to Stuttgart, West Germany, Württembergischer Kunstverein, 18 February – 26 March 1967; Bern, Switzerland, Kunsthalle, 14 April – 21 May 1967].

San Francisco, CA. San Francisco Museum of Modern Art. *The Current Moment in Art. Six from the East*. 15 April – 22 May.

Toronto, Ontario, Canada. David Mirvish Gallery. *Frank Stella*. 15 April – 8 May.

New York City. Cordier and Ekstrom. *Seven Decades 1895–1965 / Crosscurrents in Modern Art. 1955–1965*. 26 April – 21 May.

New York City. Leo Castelli Gallery. *Frank Stella*. 5 May – 2 June.

New York City. Leo Castelli Gallery. 14 June – 30 June.

New York City. Jewish Museum. *The Harry N. Abrams Family Collection*. 29 June – 5 September.

Chicago, IL. Art Institute of Chicago. *68th Annual American Exhibition*. 19 August – 16 October.

New York City. Solomon R. Guggenheim Museum. *Systemic Painting*. September – November. [Catalogue].

Tokyo, Japan. National Museum of Modern Art. *Two Decades of American Painting*. 15 October – 27 November. [Traveled to Kyoto, Japan, National Museum of Modern Art, 12 December – 22 January 1967; New Delhi, India, Lalit Kala Academy, 25 March – 15 April 1967; Melbourne, Australia, National Gallery of Victoria, 6 June – 8 July 1967; Sydney, Australia, Art Gallery of New South Wales, 17 July – 20 August, 1967.] [Catalogue].

Pasadena, CA. Pasadena Art Museum. *Frank Stella. An Exhibition of Recent Paintings*. 18 October – 20 November. [Traveled to Seattle. Art Museum Pavilion, 12 January –12 February.] [Catalogue. Text by Michael Fried].

Flint, MI. Flint Institute of Arts. *The First Flint Invitational. An Exhibition of Contemporary Painting and Sculpture*. 4 November – 31 December.

Kansas City, MO. Nelson Gallery-Atkins Museum. *Sound, Light, Silence. Art That Performs*. 4 November – 4 December. [Catalogue].

London, England. Kasmin Limited. *Frank Stella. A Selection of Paintings and Recent Drawings*. 11 November – 3 December.

## 1967

Appointed artist-in-residence at the University of California at Irvine, but does not teach because of refusal to sign state loyalty oath. Makes first prints at Gemini G.E.L. in Irvine, California. Designs sets and costumes for Merce Cunningham's *Scramble*, perfomed 5 August at the Connecticut College Dance Festival. Travels in Canada and teaches painting at Emma Lake Workshop, University of Saskatchewan, Saskatoon.

Santa Barbara, CA. Santa Barbara Museum of Art. *Three Young Collections. Selections from the Collections of Donald and Lynn Factor, Dennis and Brooke Hopper, André and Dory Previn*. 15 January – 26 February.

New York City. Leo Castelli Gallery. *Leo Castelli. Ten Years*. 4 February – 26 February.

Zürich, Switzerland. Galerie Bischofsberger. *Frank Stella*. 17 February – 18 March.

Washington, DC. Corcoran Gallery of Art. *30th Biennial Exhibition of Contemporary American Painting*. 24 February – 9 April.

Tampa, FL. University of South Florida Art Galleries. *Mid-Twentieth Century Drawings and Collages. A Selection from the Collection of Richard Brown Baker*. 7 March – 6 April.

New York City. Leo Castelli Gallery. *New Work*. 1 April – 10 May.

Lincoln, NE. Sheldon Memorial Art Gallery. *Paintings and Sculpture from the Collection of Philip Johnson*. 4 April – 30 April.

Detroit, MI. Detroit Art Institute. *Color Image Form*. 11 April – 15 May.

Montreal, Quebec, Canada. Expo '67, United States Pavilion. *American Painting Now*. 29 April – 27 October. [Traveled to Boston, MA, Horticultural Hall, 15 December – 10 January 1968.

Irvine, CA. University of California at Irvine. University Art Museum. *A Selection of Paintings and Sculptures from the Collection of Mr. and Mrs. Robert Rowan*. 2 May – 7 July.

Washington, DC. Washington Gallery of Modern Art. *A New Aesthetic*. 6 May – 25 June. [Catalogue].

Trenton, NJ. New Jersey State Museum and Cultural Center. *Focus on Light*. 20 May – 10 September. [Catalogue].

Hamburg, West Germany. Kunstverein Hamburg. *Vom Bauhaus bis zur Gegenwart. Meisterwerke aus deutschem Privatbesitz*. 20 May – 9 July. [Traveled to Frankfurt, West Germany, Frankfurter Kunstverein, 21 July – 10 September.] [Catalogue].

San Francisco, CA. San Francisco Museum of Art. *American Art of the Sixties*. 2 June – 2 July.

New York City. Museum of Modern Art. *The 1960s. Painting and Sculpture from the Museum Collection*. 28 June – 24 September.

Pittsburgh, PA. Museum of Art, Carnegie Institute. *The 1967 Pittsburgh International Exhibition of Contemporary Painting and Sculpture*. 27 October – 7 January 1968.

Eindhoven, Netherlands. Stedelijk van Abbemuseum. *Kompas 3. Painting after 1945 in New York*. 9 November – 17 December. [Traveled to Frankfurt, West Germany, Frankfurter Kunstverein, 30 December – 11 February 1968.] [Catalogue].

Stanford, CA. Stanford University Museum of Art. *Young Artists of the Sixties, Paintings and Sculptures from the Collection of Charles Cowles*. 13 November 1967 – 21 January 1968.

Los Angeles, CA. Irving Blum Gallery. *Paintings and Sculpture from the Gallery Collection*. December 1967.

New York City. Whitney Museum of American Art. *1967 Annual Exhibition of Contemporary American Painting*. 13 December – 4 February 1968.

## 1968

Receives *Annual Creative Arts Award* from Brandeis University, Waltham, Massachusetts. Designs stained glass windows for projected building by Philip Johnson.

Ridgefield, CT. Aldrich Museum of Contemporary Art. *Cool Art – 1967*. 7 January – March.

Montreal, Quebec, Canada. Galerie du Siècle in Collaboration with David Mirvish Gallery, Toronto, Ontario, Canada, and Galerie Agnes Lefort. *Jack Bush, Helen Frankenthaler, Morris Louis, Kenneth Noland, Jules Olitski, Frank Stella, Robert Murray*. February.

Washington, DC. Washington Gallery of Modern Art. *Frank Stella. Recent Paintings and Drawings*. 28 February – 31 March.

Los Angeles, CA. Irving Blum Gallery. *Frank Stella*. March – closing date unknown.

Berlin, West Germany. Haus am Waldsee. *Ornamentale Tendenzen in der zeitgenössischen Malerei*. 1 March – 15 April. [Traveled to Leverkusen, West Germany, Städtisches Museum, 26 April – 3 June; Wolfsburg, West Germany, Kunstverein Wolfsburg, 22 June – 14 July. [Catalogue].

Buffalo, NY. Albright-Knox Art Gallery. *Second Buffalo Festival of the Arts Today*. 2 March – 17 March.

Buffalo, NY. Albright-Knox Art Gallery. *Plus by Minus. Today's Half-Century*. 3 March – 14 April.

New York City. Finch College Museum of Art. *Betty Parsons' Private Collection*. 13 March – 24 April. [Traveled to Blommfield Hills, MI, Cranbrook Academy of Art, 21 September – 20 October; Memphis, TN, Brooks Memorial Art Gallery, 1 November – 1 December.]

Toronto, Ontario, Canada. David Mirvish Gallery. *Frank Stella. Recent*. 7 March – April 1968.

Chicago, IL. Art Institute of Chicago. *28th Annual Exhibit by the Society for Contemporary Art*. 16 April – 19 May.

Bennington, VT. New Gallery, Bennington College. *Frank Stella*. 13 May – 28 May.

Ridgefield, CT. Aldrich Museum of Contemporary Art. *Highlights of the 1967–68 Art Season*. 16 June – 15 September.

Washington, DC. National Gallery of Art. *Paintings from the Albright-Knox Art Gallery, Buffalo, New York*. 18 May – 21 July.

Kassel, West Germany. *4. Documenta Internationale Ausstellung*. 27 June – 6 October. [Catalogue.]

Budapest, Hungary. U.S. Embasssy. *Art in Embassies*. Sponsored by the International Program, Museum of Modern Art, New York City. July – April 1970.

Ottawa, Ontario, Canada. National Gallery of Canada. *Group Show of American Art*. July – September.

Scarborough, Ontario, Canada. Scarborough College. *Major Works from the David Mirvish Gallery*. 1 July – 30 September.

New York City. The Museum of Modern Art. *The Art of the Real. USA 1948–1968*. 3 July – 8 September [Traveled to Paris, France, Grand Palais, 14 November – 23 December; Zurich, Switzerland, Kunsthaus, 19 January – 23 February 1969; London, England, Tate Gallery, 22 April – 1 June 1969.] [Catalogue].

Pasadena, CA. Pasadena Art Museum. *Serial Imagery*. 17 September – 27 October. [Traveled to Seattle, WA, University of Washington, Henry Art Gallery, 17 November – 22 December; Santa Barbara, CA, Santa Barbara Museum of Art, 25 January – 23 February 1969.] [Catalogue].

London, Ontario, Canada. University of Western Ontario, McIntosh Memorial Art Gallery. *Kenneth Noland and Frank Stella – New York Painters*. November.

Philadelphia, PA. Philadelphia Museum of Art. *The Pure and Clear. American Innovations*. 13 November – 21 January 1969.

Groningen, Netherlands. Groninger Museum vor Stadt en Lande. *Keuze uit aanwinsten 1965–1968 van het Stedelijk van Abbemuseum Eindhoven*. 19 December – 26 January 1969.

## 1969

In spring, as *Saltzman Visiting Artist* at Brandeis University, Waltham, Massachusetts.

Toronto, Ontario, Canada. Art Gallery of Ontario. *Three by Noland – Three by Stella*. 4 January – 2 February.

Vancouver, British Columbia, Canada. Vancouver Art Gallery. *New York 13*. 22 January – 16 February.

St. Paul, MN. St. Paul Art Center. *Twentieth-Century Painting and Sculpture*. 30 January – 16 March. [Organized by Walker Art Center, Minneapolis, MN.].

New York City. Lawrence Rubin Gallery. *Opening Exhibition*. 1 February – 26 February.

Hamilton, Ontario, Canada. McMaster University. *5 by 5*. March.

Helsinki, Finland. Art Museum of Ateneum. *Ars 69 Helsinki*. 8 March – 13 April.

Mayaguez, PR. University of Puerto Rico. *Frank Stella*. April.

St. Louis, MO. Washington University, Steinberg Hall, Gallery of Art. *The Development of Modernist Painting*.

*Jackson Pollock to the Present*. 1 April – 30 April. [Organized by National Collection of Fine Arts, Washington, DC.].

Waltham, MA. Rose Art Museum, Brandeis University, *Recent Paintings by Frank Stella*. 2 April – 11 May.

Burlington, VT. University of Vermont, Robert Hull Fleming Museum. *Group Show*. 4 April – 27 April.

Bratislava, Czechoslovakia. Slovak National Gallery. *The Disappearance and Reappearance of the Image. American Painting Since 1945*. 14 April – 15 June. [Traveled to Prague, Czechoslovakia, National Galleries, Wallenstein Palace, 1 July – 15 August; Brussels, Belgium, Palais des Beaux-Arts, 21 October – 16 November.]

Irvine, CA. University of California at Irvine, University Art Museum. *New York. The Second Breakthrough, 1959–1964*. 18 March – 27 April. [Catalogue].

Minneapolis, MN. Dayton's Gallery 12. *Castelli at Dayton's*. 19 April – 17 May.

Poughkeepsie, NY. Vassar College Art Gallery. *Concept*. 30 April – 11 June.

Andover, MA. Phillips Adademy, Addison Gallery of American Art. *7 Decades, 1900–1970. 7 Group Shows – Paintings and Sculpture by Alumni of Phillips Academy*. 23 May – 6 July.

New York City. Museum of Modern Art. *Twentieth Century Art from the Nelson Aldrich Rockefeller Collection*. 26 May – 1 September.

Toronto, Ontario, Canada. York University. *American Art of the Sixties in Toronto Private Collections*. 31 May – 28 June.

New York City. Lawrence Rubin Gallery. June.

Tokyo, Japan. National Museum of Modern Art. *Contemporary Art, Dialogue Between the East and the West*. 12 June – August.

New York City. Leo Castelli Gallery. 31 June – 31 July.

Syracuse, NY. Everson Museum of Art. *Contemporary American Painting and Sculpture from the Collection of Mr. and Mrs. Eugene M. Schwartz* 13 July – 16 November. [Traveled to New New York City. Lawrence Rubin Gallery. 12 September – 1 October.].

New York City. Leo Castelli Gallery. 20 September – 11 October.

Worcester, MA. Worcester Art Museum. *The Direct Image in Contemporary American Painting*. 16 October – 30 November. [Catalogue].

Buenos Aires, Argentina. Museo Nacional de Bellas Artes. *109 Works from the Albright – Knox Art Gallery*. 23 October – 30 November.

New York City. Metropolitan Museum Of Art. *New York Painting and Sculpture. 1940–1970*. 18 October – 8 February 1970. [Catalogue].

Minneapolis, MN. Dayton's Gallery 12. *Stella / Noland / Caro*. 6 November – 6 December. [Catalogue].

Pasadena, CA. Pasadena Art Museum. *Painting in New York 1944–1969*. 24 November – 11 January 1970.

New York City. Leo Castelli Gallery. *Frank Stella*. 25 November – 23 December.

Albany, NY, State University of New York, University Art Gallery, 3 December – 10 January 1970. [Catalogue].

## 1970

Retrospective exhibition, curated by William S. Rubin, opens at The Museum of Modern Art in New York. Exhibtions travels to London, Amsterdam, Pasadena, and Toronto. In fall, during unexpectedly protracted hospital stay, makes drawings for that will become *Polish Village* series.

Zürich, Switzerland. Galerie René Ziegler. *Frank Stella*. 27 January – February.

New York City. Museum of Modern Art. *Frank Stella*. 26 March – 31 May. [Traveled to London, England, Hayward Gallery, 25 July – 31 August, under a seperate catalogue; Amsterdam, Netherlands, Stedelijk Museum, 2 October – 23 November; Pasadena, CA, Pasadena Art Museum, 15 January – 28 February 1971; Toronto, Ontario, Canada, Art Gallery of Ontario, 9 April – 9 May 1971. Circulated by the International Council of the Museum of Modern Art in cooperation with the Arts Council in London.].

Princeton, NJ. Princeton University, Art Museum, *American Art Since 1960*. 6 May - 27 May. [Catalogue].

Minneapolis, MN. Dayton's Gallery 12. *New Acquisitions. Fourteen Important Works by Andre, Flavin, Kelly, Lichtenstein, Noland, Stella, Warhol*. 6 May – 6 June. [Catalogue].

Paris, France. Fondation Maeght. *L'Art Vivant aux Etats-Unis*. 16 July – 30 September. [Catalogue].

New York City. Leo Castelli Gallery. 30 July – 28 August.

Darmstadt, West Germany. Landesmuseum. *3. Internationale der Zeichnung*. 15 August – 11 November. [Catalogue].

New York City. Leo Castelli Gallery. *Benefit for Referendum '70*. 19 September - 26 September.

Pasadena, CA. Pasadena Art Museum. *Selections from the Mr. and Mrs. Robert A. Rowan Collection*. 21 September – 11 November.

New York City. Leo Castelli Gallery. 3 October – 18 October.

## 1971

During year, travels to Brazil, Paris, and London.

Stockholm, Sweden. Galerie Buren. *Kelly, Lichtenstein, Stella*. 9 January - closing date unknown.

Milwaukee, WI. Milwaukee Art Center. *Contemporary American Painting and Sculpture. Selections from the Collection of Mr. & Mrs. Eugene M. Schwartz*. 22 January – 28 February. [Catalogue].

Birmingham, AL. Birmingham Museum of Art. *Contemporary Selections 1971*. 24 January – 20 February. [Catalogue].

New York City. Noah Goldowsky. *Group for March*. March.

Toronto, Ontario, Canada. David Mirvish Gallery. *Frank Stella*. April.

Wilmington, DE. Delaware Art Museum. *American Painting Since World War II*. 8 June – 11 July.

Basel, Switzerland. *Art Fair 1971 Basel-America*. 24 June – 29 June.

New York City. Leo Castelli Gallery. 26 June – 24 September.

Humlebaek, Denmark. Louisiana Cultural Centre and Museum of Contemporary Art. *Amerikansk Kunst 1950–1970*. 11 September – 23 October.

Brussels, Belgium. Palais voor Schone Kunsten. *Europalia. Stedelijk '60–'70. Buitenlandse Kunst*. 20 October – 22 November.

Dublin, Ireland. Royal Dublin Society. *ROSC '71*. 24 October – 29 December. [Catalogue.]

Düsseldorf, West Germany. Galerie Hans Strelow. *Formen und Strukturen der Farbe*. 27 November – 23 December.

## 1972

Travels to London.

Birmingham, AL. Birmingham Museum of Art. *American Watercolors 1850–1972*. 16 January – 13 February. [Traveled to Mobile, AL, Mobile Art Gallery, 22 February – 31 March]. [Catalogue].

Amherst, MA. Amherst College. Mead Art Building. *Color Painting. A Special Loan Exhibition*. 4 February – 3 March. [Catalogue].

New York City. Leo Castelli Gallery. 19 February – 25 March.

Toronto, Ontario, Canada. Edmonton Art Gallery. *Masters of the Sixties*. 4 May – 4 June. [Traveled to Winnipeg, Manitoba, Canada, Winnipeg Art Gallery, 15 June - 15 July]. [Catalogue].

New York City. Leo Castelli Gallery. 21 June – 14 September.

New York City. Leo Castelli Gallery. 23 June – 22 September.

Pasadena, CA. Pasadena Art Museum. *Post 1950 Paintings*. 25 July – 3 September.

Chicago, IL. Art Institute of Chicago. *70th American Exhibition*. 24 June – 20 August. [Catalogue].

Philadelphia, PA. Philadelphia Museum of Art. *American Art Since 1945*. 15 September – 24 October.

New York City. Leo Castelli Gallery. 17 June – 23 September.

Portland, OR. Portland Art Museum. *60s to '72. American Art from the Cauduro Collection*. 29 September – 29 October.

Paris, France. Espace Cardin 1ére. *Collection X*. Fall.

New York City. Leo Castelli Gallery. 30 September – 21 October.

New York City. Leo Castelli Gallery. 7 October – 21 October.

Pasadena, CA. Pasadena Art Museum. *Post 1945 Paintings*. 17 October – 21 January 1973.

Buffalo, NY. Albright-Knox Art Gallery. *Recent American Painting and Sculpture in the Albright-Knox Art Gallery*. 17 November – 31 December.

## 1973

Travels to London, Geneva, and Lisbon.

New York City. Leo Castelli Gallery. 6 January – 27 January.

Chicago, IL. University of Chicago. *Art of the Sixties*. 13 February – 16 March.

Providence, RI. Museum of Art, Rhode Island School of Design. *Small Works. Selections from the Richard Brown Baker Collection of Contemporary Art*. 5 April – 6 May.

Pasadena, CA. Pasadena Art Museum. *A Look at New York*. 12 June – 22 July.

Seattle, WA. Seattle Art Museum. *American Art. Third Quarter Century*. 22 August – 14 October. [Catalogue].

San Francisco, CA. San Francisco Museum of Art. *A Selection of American and European Paintings form the Richard Brown Baker Collection*. 14 September – 11 November. [Traveled to Philadelphia, PA, University of Pennsylvania, Institute of Contemporary Art, 7 December – 27 January 1974].

New York City. Leo Castelli Gallery. 22 September – 16 October.

New York City. Leo Castelli Gallery, *Venice Biennale Benefit Show*. 18 October – 11 November.

Houston, TX. Institute for the Arts, Rice University. *Gray Is the Color*. 19 October – 19 January 1974.

Washington, DC. Phillips Collection. *Frank Stella*. 3 November – 2 December. [Catalogue].

New York City. Solomon R. Guggenheim Museum. *Futurism. A Modern Focus, The Lydia and Harry Lewis Winston Collection, Dr. and Mrs. Barnett Malbin*. 16 November – 3 February 1974. [Catalogue].

## 1974

Paints *Diderot* series, the largest of the *Concentric Square* pictures. Travels to Genoa and Milan, and Germany. Begins work at Tylor Graphics, Ltd., Bedford, New York. In June receives honorary degree from Minneapolis College of Art and Design.

Portland, OR. Portland Center for the Visual Arts. *Frank Stella. Recent Works*. 13 January – 10 February 1974. [Traveled to Henry Gallery, University of Washington, Seattle, WA, 15 February – 17 March 1974; Ace Gallery, Vancouver, British Columbia, Canada, 1 April 1974 – closing date unknown.]

Houston, TX. Museum of Fine Arts. *The Great Decade of American Abstraction. Modernist Art 1960–1970*. 15 January – 10 March. [Catalogue].

Miami, FL. University of Miami. Lowe Art Museum. *Less Is More. The Influence of the Bauhaus on American Art*. 7 February – 10 March. [Catalogue].

New York City. Leo Castelli Gallery. 16 February – 2 March.

San Diego, CA. Fine Arts Gallery of San Diego. *Monumental Paintings of the Sixties*. 19 April – 16 June. [Catalogue].

New York City. Marlborough Gallery. *Selected Works from the Collection of Carter Burden*. 9 May – 1 June.

New York City. Leo Castelli Gallery. *Frank Stella*. 21 June – 14 September.

Albany, NY. Executive Mansion. *Twentieth Century American Painting*. September – December.

New York City. Leo Castelli Gallery. *In Three Dimensions*. 21 September – 12 October.

Richmond, VA. Virginia Museum. *Twelve American Painters*. 30 September – 27 October.

London, England. Tate Gallery. *Picasso to Lichtenstein. Masterpieces of Twentieth Century Art from the Nordrhein-Westfalen Collection in Düsseldorf*. 2 October – 24 November.

Paris, France. Palais Galliera. *L'art au présent*. 2 October – 10 November. [Catalogue].

Washington, DC. Hirshhorn Museum and Sculpture Garden, Smithsonian Institution. *Inaugural Exhibition*. 4 October – 3 November.

Santa Barbara, CA. Santa Barbara Museum of Art. *Selections from the Collection of Mr. and Mrs. Robert Rowan*. 2 November – 24 November.

## 1975

Daughter Laura born to Shirley De Lemos Wyse in January. In May, travels to Califoria where he buys an elaborate set of mechanical drawing templates which he will use to execute drawings for *Exotic Bird* series. During year, travels to London, Paris, and Germany.

Caracas, Venezuela. Museo de Bellas Artes, Caracas Agosto Exposicion of The International Council of the Museum of Modern Art of New York y La Sociedad des Amigos del Museo de Bellas Artes de Caracas, *El Languaje del Color*. Dates unknown. [Traveled to Bogotá, Colombia, Museo de Bellas Artes, 14 February – 16 March; São Paulo, Brazil, Museo de São Paulo, 18 April – 18 May; Rio de Janeiro, Brazil, Museo de Rio de Janeiro, 12 June – 20 July; Mexico City, Mexico, Museo de Mexico City, 22 September – 26 October.]. [Catalogue].

Washington, DC. Corcoran Gallery of Art. *34th Biennial of Contemporary American Painting*. 22 February – 6 April.

Bethlehem, PA. Lehigh University. Alumni Memorial Gallery. *Contemporary American Painting. 21st Annual Exhibition*. 13 April – 18 May. [Catalogue].

New Haven, CT. Yale University Art Gallery. *Richard Brown Baker Collects! A Selection of Contemporary Art from the Richard Brown Baker Collection*. 24 May – 22 June. [Catalogue].

New York City. Leo Castelli Gallery. 7 June – 20 September.

New York City. Whitney Museum of American Art. *American Abstract Painting. Selections from the Whitney Museum Collection*. 23 July – 26 October.

Houston, TX. Janie C. Lee Gallery. *Frank Stella. Variations on the Square 1960–1974*. 27 September – October.

Paris, France. Galerie Daniel Templon. *Frank Stella. Recent Paintings*. 21 October – 15 November.

Milan, Italy. Galleria dell'Areite. *Frank Stella*. November 1975.

Venice, CA. Ace Venice. *Frank Stella. High-Relief Aluminum*. November.

New York City. M. Knoedler & Co. *American Works on Paper 1945–1975*. November -December.

New York City. Leo Castelli Gallery. *Frank Stella*. 22 November – 15 December.

## 1976

One-man exhibition at Baltimore Museum of Art, Baltimore, MD, reuniting most of the Black Paintings. Creates design for BMW car, which is then painted in Munich by BMW. During year, travels to London, Paris, and Florida Everglades with future wife Dr. Harriert McGurk for bird-watching, a new interest reflected in the titels of *Exotic Bird* paintings.

Zürich, Switzerland. André Emmerich Gallery. 17 January – 28 February. [Traveled to Basel, Switzerland. Kunsthalle Basel. 17 March – 11 April].

New York City. Solomon R. Guggenheim Museum. *Twentieth Century American Drawing. Three Avant-Garde Generations*. 23 January – 23 March. [Traveled to Baden-Baden, West Germany, Staatliche Kunsthalle, 27 May – 11 July; Bremen, West Germany, Kunsthalle Bremen, 18 July – 29 August]. [Catalogue].

Chicago, IL. Sears Bank and Trust Company. *Frank Stella. Paintings and Graphics*. 1 March – 30 April.

Lowe Miami, FL. University of Miami. Art Museum. *Today / Tomorrow*. 4 March – 11 April.

Buffalo, NY. Albright-Knox Gallery. *Heritage and Horizon. American Painting 1776–1976*. 6 March – 11 April. [Traveled to Detroit, MI, Detroit Institute of Arts, 5 May – 13 June; Toledo, OH, Toledo Museum of Art, 4 July – 15 August; Cleveland, OH, Cleveland Museum of Art, 8 September – 10 October].

Chicago, IL. Art Institute of Chicago *Second American Exhibition*. 13 March – 9 May.

Basel, Switzerland. Kunsthalle Basel. *Frank Stella. Neue Reliefbilder – Bilder und Graphik*. 17 March – 11 April. [Catalogue].

New York City. School of Visual Arts. Visual Arts Museum. *American Color. 1961–1964*. 29 March – 21 April. [Catalogue].

Sydney, Australia. David Jones Ltd. *Aspects of 20th Century Art*. 10 May – 29 May.

New York City. Leo Castelli Gallery. *Frank Stella*. 19 June – 10 September.

Berlin, West Germany. Staatliche Museen Preussischer Kulturbesitz. Nationalgalerie. *New York in Europa*. 4 September – 7 November.

New York City. M. Knoedler & Co. *Frank Stella. Recent Paintings*. 2 October – 28 October.

New York City. Solomon R. Guggenheim Museum. *Acquisition Priorities. Aspects of Postwar Painting in America*. 15 October – 16 January 1977.

Baltimore, MD. Baltimore Museum of Art. *Frank Stella. The Black Paintings*. 23 November – 23 January 1977. [Catalogue].

Toronto, Ontario, Canada. David Mirvish Gallery. *Frank Stella. An Historical Selection*. 4 December – 4 January 1977.

New York City. Leo Castelli Gallery. 11 December – 22 December.

New York City. M. Knoedler & Co. *Louis – Noland – Stella*. 18 December –14 January 1977.

## 1977

In Ahmedabad, India, as guest of the Sarabhai family. Travels to Germany for auto races at Nürburgring, where he meets racing driver Ronnie Peterson and Peter Gregg. Also travels to London.

Columbus, OH. Columbus Gallery of Fine Arts. *Aspects of Postwar Paintings in America*. 17 January – 29 February.

Cologne, West Germany. Hans Strelow and Rudolf Zwirner. *Frank Stella. Metal Reliefs from the Year 1976*. 4 February – 12 March.

San Francisco, CA. John Berggruen Gallery. *American Paintings and Drawings*. 30 March – 7 May.

Cambridge, MA. Harvard University. Fogg Art Museum *Master Paintings from the Fogg Collection*. 1 April – August .

New York City. Sidney Janis Gallery. *Less Is More*. 7 April – 7 May.

Bielefeld, West Germany. Kunsthalle Bielefeld. *Frank Stella. Werke 1958–1976* .17 April – 29 May. [Traveled to Tübingen, West Germany, Kunsthalle Tübingen, 9 June – 24 July]. [Catalogue].

San Francisco, CA. San Francisco Museum of Modern Art. *Collectors, Collecting, Collection. American Abstract Art Since 1945*. 22 April – 5 June.

Oxford, England. *Aluminum Reliefs 1976–77*. 23 April – 29 May. [Traveled to Edinburgh, Scotland, Fruit Market Gallery, 11 June – 9 July]. [Catalogue].

Cambridge, England. Fitzwilliam Museum. *Jubilation. American Art During the Reign of Elizabeth II*. 10 May – 18 June.

New York City. Leo Castelli Gallery. *Recent Work*. 15 June – 17 September.

Denver, CO. Denver Art Museum. *Colorado Collections*. 24 June – 21 August .

New York City. Whitney Museum of American Art. *20th Century American Art from Friends' Collections*. 27 July – 27 September.

St. Louis, MO. Greenberg Gallery. September – October.

Chicago, IL. Museum of Contemporary Art. *A View of a Decade*. 10 September – 10 November.

Miami, FL. Museum of the American Foundation for the Arts. *Pattern and Decorative Painting*. 7 October – 30 November.

Albany, NY. New York State Museum. *New York. The State of the Art*. 8 October – 28 November.

San Francisco, CA. John Berggruen Gallery. *Frank Stella. Paintings and Recent Prints*. 23 November – 31 December.

Washington, DC. Smithsonian Institution. National Collection of Fine Arts. *New Ways with Paper*. 2 December – 20 January 1978.

London, England. Knoedler Gallery. *Frank Stella. Paintings, Drawings, and Prints, 1959–1977*. 8 December – closing date unknown.

La Jolla, CA. La Jolla Museum of Contemporary Art. *Recent Acquisitions. Selected Works 1974–1977*. 10 December – 22 January 1978.

Worcester, MA. Worcester Art Museum. *Four Collectors 1977*. 10 December – 8 January 1978.

## 1978

Marries Dr. Harriet McGurk in New York. Travels to Florida, London, Munich, Rome, and Basel with his wife. Travels with BMW Formula II racing team from Munich to Sicily.

Flint, MI. Flint Institution of Art. *Art and the Automobile*. 12 January – 12 March.

St. Louis, MO. Ronald Greenberg Gallery. *Castelli at Greenberg*. 15 January – 28 February.

Los Angeles, CA. Margo Leavin Gallery. *Three Generations. Studies in Collage*. 26 January – 4 March.

Lucerne, Switzerland. Kunstmuseum Luzern. *Serielles Prinzip*. 28 January – 11 June.

Boston, MA. Thomas Segal Gallery. *Salute to Merce Cunningham, John Cage, and Collaborators*. 8 February – 4 March.

Baltimore, MD. Baltimore Museum of Art. *Selections from the Meyerhoff Collection*. 14 February – 9 March.

Worcester, MA. Worcester Art Museum. *Between Sculpture and Painting*. 23 February – 9 April.

Chicago, IL. Museum of Science and Industry. *Art in Architecture 1978*. March.

Amherst, MA. Amherst College. Mead Art Gallery. *New York Now*. 9 March – 12 April.

Fort Worth, TX. Fort Worth Art Museum. *Stella Since 1970*. 19 March – 30 April. [Traveled to Newport Beach, CA, Newport Art Museum, 24 June – 20 Au-

gust; Montreal, Quebec, Canada, Montreal Museum of Fine Arts, 5 November – 15 December; Vancouver, British Columbia, Canada, Vancouver Art Gallery, 21 January – 4 March 1979; Washington, DC, Corcoran Gallery of Art, 13 April – 27 May 1979; Jackson, MS, Mississippi Art Museum, 28 June – 5 August 1979; Denver, CO, Denver Art Museum, 9 September – 21 October 1979; Minneapolis, MN, Minneapolis Institute of Art, 9 January - 17 February 1980; Des Moines, IA, Des Moines Art Center, 17 March – 27 April 1980]. [Catalogue].

Sarasota, FL. Ringling Museum of Art. *The Permanent Collection of Contemporary Art*. April – May.

New York City. Whitney Museum of American Art. *American Art 1950 to Present*. 3 May – 12 September.

Dallas, TX. Northpark National Bank. *Leo Castelli at Northpark National Bank*. 15 June – 15 August.

Akron, OH. Akron Art Institute. *Ten Paintings and Sculptures from the Hirshhorn Museum*. July – August.

New York City. Leo Castelli Gallery. *Summer Group Show*. 5 July – 23 September.

New York City. Whitney Museum of American Art. *Art About Art*. 19 July – 24 September. [Traveled to Raleigh, NC, North Carolina Museum of Art, 15 October – 26 November; Los Angeles, CA, University of California, Frederick S. Wright Art Gallery, 17 December – 11 February 1979; Portland, OR, Portland Art Museum, 6 March – 15 April 1979].

La Jolla, CA. La Jolla Museum of Contemporary Art. *Permanent Collection*. August.

Nagoya, Japan. Galerie Valeur. *Frank Stella*. 21 August – 2 September.

Arhus, Denmark. Arhus Art Museum. *America, America*. 2 September – 24 September.

Paris, France. Galerie Daniel Templon. *10-Year Anniversary Exhibition*. 7 October – 16 November.

New York City. School of Visual Arts. Visual Arts Museum. *Frank Stella. The Series within a Series*. 10 October – 20 October.

Buffalo, NY. Albright-Knox Art Gallery. *American Painting of the 1970s*. 8 December – 14 January 1979. [Traveled to Newport Beach, CA, Newport Harbor Art Museum, 3 February – 18 March 1979; Oakland, CA, Oakland Art Museum, 10 April – 20 May 1979; Cincinnati, OH, Cincinnati Art Museum, 6 July – 26 August 1979; Corpus Christi, TX, Art Museum of South Texas, 9 September – 21 October 1979; Champaign, IL, University of Illionois, Krannert Art Museum, 11 November 1979 - 2 January 1980.]. [Catalogue].

Memphis, TN. Brooks Memorial Art Gallery. *Art Today. American Masters of the Sixties and Seventies*. 9 December – 28 December. [Catalogue].

New York City. Pace Gallery, *Grids*. 16 December – 2 January 1979. [Traveled to Akron, OH, Akron Art Institute, 24 March – 6 May 1979].

## 1979

*Receives Claude Morre Fuess Award for distinguished contribution to public service* from Phillips Academy, Andover, Massachusetts. The father of Frank Stella dies in July. Travels to Basel, London, Daytona, and Germany.

Tampa, FL. Tampa Bay Art Center. *Post Painterly Abstraction*. 13 January – 15 February.

New York City. Leo Castelli Gallery, *Indian Birds. Painted Reliefs*. 6 January – 27 January.

Claremont, CA. Scripps College / Pomona College. Lang Art Gallery. *Black and White Are Colors. Paintings of the 1970s*. 28 January – 7 March.

Claremont, CA. Pomona College. Montgomery Art Gallery. *Black and White Are Colors. Paintings of the 1950s and 1960s*. 28 January – 7 March.

New York City. Susan Caldwell Gallery. *Generation. Twenty Abstract Painters Born in the U.S. Between 1929 and 1946*. 2 February – 3 March.

New York City. Whitney Museum of American Art. *Biennial Exhibition*. 14 February – 1 April.

Lincoln, MA. De Cordova Museum. *Born in Boston*. 18 February – 22 April.

New York City. Castelli Graphics. *Drawings by Castelli Artists*. 3 March – 24 March.

Boston, MA. Institute of Contemporary Art. *The Reductive Object. A Survey of the Minimalist Aesthetic in the 1960s*. 7 March – 29 April.

New York City. Museum of Modern Art. *Frank Stella. The Indian Bird Maquettes*. 12 March – 1 May.

Long Island City, NY. Institute for Art and Urban Resources, P.S. 1. *Great Big Drawing Show*. 25 March – 1 April.

Boston, MA. Thomas Segal Gallery. *Paper, Clay, and Tapestry. Explorations into New Media*. 28 April – 2 June.

Waltham, MA. Brandeis University. Rose Art Museum. *Metallic Reliefs.* 13 May – 1 July.

Chicago, IL. Art Institute of Chicago. *73rd American Exhibition*. 9 June – 5 August.

New York City. Leo Castelli Gallery. *Summer Group Show*. 23 June – 15 September.

Binghamton, NY. Robertson Center for the Arts and Sciences. *Treasure House. Museums for the Empire State*. 1 July – 9. September 1979. [Traveled to Albany, NY, State Education Department, New York State Museum, 15 October – 5 February 1980].

New York City. Metropolitan Museum of Art. *Summer Loan Exhibition*. 17 July – 30 September.

Regina, Saskatchewan, Canada. University of Regina. Norman MacKenzie Art Gallery. *American Painting 1955–1976. Twenty-five Selections from the Collection of the Albright-Knox Art Gallery, Buffalo, New York*. 14 September – 28 October. [Traveled in Canada to Winnipeg, Manitoba, Winnipeg Art Gallery, 9 Novem-

ber – 6 January 1980; Saskatoon, Saskatchewan, Mendel Art Gallery, 18 January – 2 March 1980; Victoria, British Columbia, Art Gallery of Greater Victoria, 21 March – 4 May 1980; Calgary, Alberta, Glenbow Museum, 23 May – 13 July 1980]. [Catalogue].

Milwaukee, WI. Milwaukee Art Center. *Emergence and Progression. Six Contemporary American Artists.* 11 October – 2 December. [Traveled to Richmond, VA, Virginia Museum of Fine Arts, 16 January – 2 March 1980; Louisville, KY, J. B. Speed Museum, 1 April – 29 June 1980; New Orleans, LA, New Orleans Museum of Art, 25 July – 14 September 1980].

Essen, West Germany. Villa Hügel. *Von Picasso bis Lichtenstein – Meisterwerke aus dem Besitz der Kunstsammlung Nordrhein-Westfalen, Düsseldorf.* 23 October – 16 December.

New York City. School of Visual Arts. Visual Arts Museum. *Shaped Paintings.* 30 October – 26 November.

New York City. M. Knoedler & Co. *Selections from the Collection of Mr. and Mrs. Eugene M. Schwartz.* 31 October – 28 November. [Catalogue].

Nagoya, Japan. Galerie Valeur. *Frank Stella. 8 Drawings. 1976 Sketch Variation / 1977 Exotic Bird Series.* 5 November – 30 November.

## 1980

Survives an autocrash with Peter Gregg on way to Le Mans racetracks. Visits repeatedly Pablo Picasso: A Retrospective at The Museum of Modern Art in New York.

Columbus, OH. Ohio State University. Sullivan Hall Gallery. *Six Approaches to Topographical Painting.* 8 January – 3 February .

Syracuse, NY. Syracuse University. Joe & Emily Lowe Art Gallery. *Current / New York.* 27 January – 24 February.

New York City. Whitney Museum of American Art. Downtown Branch. *Painting in Relief.* 30 January – 7 March.

Aspen, CO. Aspen Center for the Visual Arts. *Color in Colorado.* 2 February – 6 April.

New York City. Museum of Modern Art. *Printed Art. A View of Two Decades.* 14 February – 1 April.

Bay Harbor Islands, FL. Galerie Ninety-Nine. *Frank Stella. Paintings and Prints.* 16 February – 8 March.

Richmond, VA. Virginia Commonwealth University. Anderson Gallery. *Contemporary Art at Paine Webber.* 20 February – 15 March.

Purchase, NY. State University of New York. Newberger Museum, *Hidden Desires.* 9 March – 15 June.

Tokyo, Japan. Koh Gallery. *Frank Stella.* 17 March – 30 April.

Chicago, IL. Museum of Contemporary Art. *The Decorative Impulse.* 21 March – 4 May.

Amherst. MA. University of Massachusetts. Fine Arts Center. *Sculpture on the Wall. Relief Sculpture of the Seventies.* 29 March – 4 May.

London, England. Knoedler Gallery. *Frank Stella. Works on Paper.* April.

Montgomery, AL. Montgomery Museum of Fine Arts. *American Painting of the '60s and '70s. The Real, the Ideal, the Fantastic.* 4 April – 25 May.

Washington, DC. Smithsonian Institution. National Collection of Fine Arts. *Recent Acquisitions. Prints Drawings, and Watercolors.* May – 22 June.

Nagoya, Japan. Galerie Valeur. *Frank Stella. Recent Works.* 6 May – 24 May.

Bordeaux, France. Centre d'Arts Plastiques Contemporains de Bordeaux. *Frank Stella. peintures 1970–1979.* 9 May – 26 July. [Catalogue].

Basel, Switzerland. Kunstmuseum Basel. *Frank Stella. Working Drawings / Zeichnungen 1956–1970.* 22 May – 27 July. [Catalogue. Text by Christian Geelhaar].

Washington, DC. Smithsonian Institution. Hirshhorn Museum and Sculpture Garden. *The Fifties. Aspects of Painting in New York, 1950–1960.* 22 May – 21 September.

Atlanta, GA. High Museum of Art. *American Art 1940–1980.* 19 June – 24 August.

San Francisco, CA. San Francisco Museum of Modern Art. *Twenty American Artists.* 24 July – 7 September.

Chicago, IL. Museum of Contemporary Art. *Three-Dimensional Painting.* 2 August – September.

Nagoya, Japan. Akira Ikeda Gallery. *Frank Stella.* 4 August – 23 August.

Washington, DC. Smithsonian Institution. National Collection of Fine Arts. *Recent Acquisitions. Prints Drawings, and Watercolors.* May – 22 June.

Washington, DC. National Gallery of Art. *The Morton G. Neumann Family Collection.* 31 August – 31 December. [Traveled to Chicago, IL, Art Institute of Chicago, 21 February – 19 April].

Philadelphia, PA. University of Pennsylvania. Institute for Contemporary Art. *Drawings. The Pluralist Decade.* 4 October – 18 November.

New York City. Getler / Pall Gallery. *Frank Stella.* 21 October – 15 November.

Brooklyn, NY. Brooklyn Museum. *MoMA at Brooklyn.* 7 November – April 1981.

## 1981

Travels to Zürich, St. Moritz, Moscow, Leningrad, Stockholm, Paris, and London in January. Receives Honorary Fellowship from Bezalel Academy of Fine Arts and Design in Jerusalem in May. Receives Medal for Painting of the Skowhegan School for Painting and Sculpture, Skowhegan, ME.

London, England. Royal Academy of Arts. *A New Spirit in Painting.* 15 January – 18 March.

Washington, DC. Corcoran Gallery of Art. *37th Biennial Exhibition of Contemporary American Painting*. 19 February – 5 April. [Catalogue].

Chicago, IL. Art Institute of Chicago. *The Morton G. Neumann Family Collection*. 21 February – 19 April.

Cologne, West Germany. Museen der Stadt. *West-Kunst*. May – August. [Catalogue].

Nagoya, Japan. Akira Ikeda Gallery. *Frank Stella / Works. Painting, Drawings, and Maquettes*. 1 June – 27 June.

Ulm, West Germany. Ulmer Museum. *Internationale Kunst seit '45*. 3 July – 16 August.

Düsseldorf, West Germany. Kunsthalle Düsseldorf. *Schwarz*. 16 October – 12 December. [Catalogue].

Brussels, Belgium. Palais des Beaux-Arts. *Moderna Museet à Bruxelles*. 23 October – 27 December.

New York City. M. Knoedler & Co. *Frank Stella. Metal Reliefs*. 28 October – 18 November.

New York City. Holly Solomon Gallery. *George Bellows, Franz Kline, Barnett Newman, Frank Stella, and Andy Warhol*. 28 November – December..

Düsseldorf, West Germany. Galerie Hans Strelow. *Frank Stella. New York*. 10 December – 16 January 1982.

## 1982

Son Peter born. Mayor's Award of Honor for Arts and Culture, 10 February, presented by Edward I. Koch, mayor of New York City. In September, as Painting Fellow at American Academy of Fine Arts and Letters, begins residency in Rome.

Tokyo, Japan. Akira Ikeda Gallery. 30 January – 20 February. [Catalogue].

New York City. Rosa Esman Gallery. *A Curator's Choice. A Tribute to Dorothy C. Miller*. 4 February – 6 March.

Boston, MA. Museum of Fine Arts. *A Private Vision. Contemporary Art from the Graham Gund Collection*. 9 February – 4 April. [Catalogue].

Nagoya, Japan. Akira Ikeda Gallery. *Frank Stella. New Reliefs*. 8 March – 31 March.

Tokyo, Japan. Akira Ikeda Gallery. *Frank Stella. Recent Work*. 8 March – 31 March.

Amsterdam, Netherlands. Stedelijk Museum. *60–'80. Attitudes / Concepts / Images. A Selection from Twenty Years of Visual Arts*. 9 April – 11 July.

La Jolla, CA. La Jolla Museum of Contemporary Art. *Castelli and His Artists*. 23 April – 6 June. [Traveled to Aspen, CO, Aspen Center for Visual Arts, 16 June – 15 August; New York City, Leo Castelli Gallery, 11 September – 9 October; Portland, OR, Portland Center for Visual Arts, 19 October – 29 November; Austin, TX, Laguna Gloria Museum, 16 December – 10 February 1983].

London, England. Knoedler Gallery. *Frank Stella*. 25 May – 3 July.

New York City. Leo Castelli Gallery. *New Works by Gallery Artists*. June – 19 September.

Zürich, Switzerland. Galerie Bruno Bischofsberger. *Homage to Leo Castelli*. June -September.

Basel, Switzerland. *Art 13 '82*. 16 June – 21 July.

New York City. M. Knoedler & Co. *Summer Group Exhibiton*. 21 June – 20 September.

New York City. Solomon R. Guggenheim Museum. *The New York School. Four Decades, Guggenheim Museum Collection, Major Loans*. July – 22 August.

Andover, MA. Phillips Academy. Addison Gallery of American Art. *Frank Stella. From Start to Finish*. 23 October – 17 December. [Catalogue].

Kitakyushu, Japan. Kitakyushu Municipal Museum of Art. *Frank Stella. Working Drawings from the Artist's Collection*. 3 November – 29 November. [Catalogue].

Berlin, West Germany. Martin-Gropius-Bau. *Zeitgeist*. 15 October – 19 December. [Catalogue].

New York City. Leo Castelli Gallery. *Exhibition of South African Mines*. 30 October – 20 November.

## 1983

In January named Charles Eliot Norton Professor of Poetry at Harvard University, Cambridge, MA. Delivers a series of six lectures entitled *Working Space* from October 1983 through April 1984: 12 October 1983, 9 November 1983, 6 December 1983, 6 February 1984, 5 March 1984, and 4 April 1984. Travels to Malta to research lectures. Travels also to Tulsa, Fort Worth, San Antonio, London, Paris, Brussels, Antwerp, Amsterdam, Raleigh, Vienna, and Munich. In June, finishes residency at American Academy of Arts and Letters in Rome.

New York City. Jewish Museum. *Frank Stella. Polish Wooden Synagogues – Constructions from the 1970s*. 9 February – 1 May. [Catalogue].

San Francisco, CA. San Francisco Museum of Modern Art. *Resource / Response / Reservoir. Stella Survey 1959–1982*. 10 March – 1 May. [Catalogue].

New York City. Paula Cooper Gallery. *A Painting Exhibition*. 18 January – 23 February.

Zürich, Switzerland. M. Knoedler AG. *Abstract Painting*. 23 April – 4 June.

Ridgefield, CT. Aldrich Museum of Contemporary Art. *Changes*. 22 May – 11 September. [Catalogue].

New York City. Whitney Museum of American Art. *Minimalism to Expressionism*. 2 June – 18 September.

Pittsfield, MA. Berkshire Museum. *New Decorative Art*. 4 June – 31 July. [Traveled to Albany, NY, State University of New York, University Art Gallery, 6 September – 23 October.]

New York City. CDS Gallery. *Artists Choose II*. 7 June – 16 July. [Frank Stella chose Dennis Ashbaugh.]. [Catalogue.]

Paris, France. Musée National d'Art Moderne. Centre

National d'Art et de Culture Georges-Pompidou. *Bonjour Monsieur Manet*. 8 June – 19 September.

Youngstown, OH. Butler Institute of American Art. *47th Annual National Mid-year Exhibition*. 26 June – 28 August.

Stratford, Ontario, Canada. The Gallery. *American Accents*. 6 July – 7 August. [Traveled in Canada to Toronto, Ontario, College Park, 18 August – 17 September; Quebéc, Musée du Québec, 22 September – 26 October; Halifax, Nova Scotia, Art Gallery of Nova Scotia, 5 January – 6 February 1984; Windsor, Ontario, Art Gallery of Windsor, 23 February – 25 March 1984; Edmonton, Alberta, Edmonton Art Gallery, 15 April – 13 May 1984; Vancouver, British Columbia, Vancouver Art Gallery, 5 July – 30 October 1984; Montreal, Quebec, Musée d'Art Contemporain, 29 November 1984 – 30 January 1985]. [Catalogue].

Buffalo, NY. Albright-Knox Art Gallery. *Frank Stella – Works from the Permanent Collection*. 22 July – 5 September.

Tokyo, Japan. Akira Ikeda Gallery. *Frank Stella. Reliefs*. 8 August – 31 August. [Catalogue].

Los Angeles, CA. Hebrew Union College. Skirball Museum. *Focus on Frank Stella. Nasielk II, A Polish Wooden Synagogue Construction*. 11 October – closing date unknown.

Los Angeles, CA. Los Angeles County Museum of Art. *Selctions from the Twentieth Century Art Collection*. 10 November – 18 December.

Los Angeles, CA. Museum of Contemporary Art. *The First Show. Painting and Sculpture from Eight Collections 1940–1980*. 20 November – 18 February 1984. [Catalogue].

Cambrigde, MA. Harvard University Art Museum. Fogg Art Museum. *Frank Stella. Selected Works*. 7 December – 26 January 1984.

Zürich Switzerland. M. Knoedler AG. *Frank Stella. Recent Work*. 14 December – 21 January 1984. [Traveled to Vienna, Austria, Galerie Würthle, 23 February – 29 March 1984.]

## 1984

Receives honorary degree from Princeton University. In November, son Patrick is born.

Palm Springs, CA. Palm Springs Desert Museum. *Frederick R. Weisman Foundation Collection of Contemporary Art*. 7 January – 26 February. [Catalogue].

Hartford, CT. Wadsworth Atheneum. *The Tremaine Collection. 20th Century Masters*. 26 February – 29 April.

Paris, France. Galeries Nationales du Grand Palais. *La rime et la raison. les collections Menil (Houston – New York)*. 17 April – 30 July. [Catalogue].

Bochum, West Germany. Museum Bochum. *Sammlung Helmut Klinker*. 12 May – 1 July 1984. [Catalogue].

Los Angeles, CA. Los Angeles County Museum of Arts. *Olympian Gestures*. 7 June – 7 October.

Santa Barbara, CA. Santa Barbara Museum of Art. *Art of the States. Works from a Santa Barbara Collection*. 22 June – 26 August. [Catalogue].

Katonah, NY. Katonah Gallery. *Transformations / Bronze Works of Willem de Kooning, Nancy Graves, Toni Putnam, Michael Sterner, Frank Stella Cast at the Tallix Foundry*. 21 August – 14 October.

Providence, RI. Brown University. List Art Center. Bell Gallery. *Brown Works. From the Permanent Collection*. 8 September – 3 October.

New York City. Galerie Maeght Lelong. *Metals, Modules, and Paint*. 18 September – 27 October.

New York City. Whitney Museum of American Art. *Blam! The Explosion of Pop, Minimalism, and Performance 1958–1964*. 20 September – 2 December. [Catalogue].

Zürich, Switzerland. M. Knoedler AG. *Frank Stella / Franz Gertsch*. 29 September – 10 November.

Nagoya, Japan. Akira Ikeda Gallery. *BLACK. Jasper Johns, Frank Stella, Richard Serra, Yae Asano, Noriyuki Haraguchi, Isamu Wakabayashi*. 1 October – 30 October. [Traveled to Tokyo, Japan, Akira Ikeda Gallery, 4 February – 28 February]. [Catalogue].

New York City. William Beadleston, Inc. *Acquisition Priorities for the Private Collector. An Exhibiton of Contemporary Paintings and Sculpture*. 25 October – 20 November.

Tampa, FL. Tampa Museum. *Icons of Postwar Art. Painting and Sculpture from the Norman and Irma Braman Collection*. 18 November – 10 February 1985.

## 1985

In September, receives honorary degree from Dartmouth College, Hanover. In May, travels to Dublin, London, and Edinburgh. In October, receives Award of American Art from Pennsylvania Academy of Fine Arts. Works on tapestries.

New York City. Marisa del Re Gallery. *Recent Acquisitions*. January.

Bordeaux, France. Musée d'Art Contemporain. *Art Minimal I*. 2 February – 21 April. [Catalogue.]

Princeton, NJ. Princeton University. Art Museum. *Selections from the Ileana and Michael Sonnabend Collection. Works from the 1950s and 1960s*. 3 February – 9 June. [Traveled to Austin, TX, University of Texas, Archer M. Huntington Art Gallery, 8 September – 27 October; Minneapolis, MN, Walker Art Center, 23 November – 9 March 1986].

Tokyo. Akira Ikeda Gallery. *Black. Jasper Johns. Frank Stella. Richard Serra*. 4 – 28 February. [Catalogue. Texts by Masaharu Ono, Kyosuke Kuroiwa].

New York City. M. Knoedler & Co. *Frank Stella. Relief Paintings*. 26 January – 23 February.

Cambridge MA. Massachusetts Institute of Technology. *Giacometti to Johns. Selections from the Ibert and Vera List Family Collection*. 1 March – 21 April.

Providence, RI. Rhode Island School of Design. *Fortissimo! Thirty Years of the Richard Brown Baker Collection of Contemporary Art*. 1 March – 28 April. [Traveled to San Diego, CA, San Diego Museum of Art, 29 June – 11 August; Portland, OR, Portland Art Museum, 1 October –10 November.]

Fort Worth, TX. Fort Worth Art Museum. *Grand Compositions. Selections from the Collection of David Mirvish*. 10 March – 1 May. [Catalogue].

Tokyo, Japan. Akira Ikeda Gallery. *Frank Stella*. 15 March – 20 April.

Houston, TX. Janie C. Lee Gallery. *Modern American Masters. Helen Frankenthaler, Nancy Graves, Ellsworth Kelly, Robert Motherwell, Robert Rauschenberg, Frank Stella*. 10 April – 4 June.

London, England. Knoedler Gallery. *Frank Stella. Ceramic Reliefs and Steel Reliefs*. 15 May – 15 June.

London, England. Institute of Contemporary Arts. ICA Gallery. *Frank Stella. Works 1979–1985 and New Graphics*. 17 May – 7 July [Traveled to Dublin, Ireland, Douglas Hyde Gallery, 8 August – 14 September.]

Aspen, CO. Aspen Art Museum. *American Paintings 1975–1985. Selections from the Collection of Aron and Phyllis Katz*. 6 July – 25 August. [Catalogue].

Los Angeles, CA. L. A. Louver. *American / European Painting and Sculpture 1985. Part I*. 16 July – 17 August.

Los Angeles, CA. Larry Gagosian Gallery. *Actual Size. An Exhibition of Small Paintings and Sculptures*. 24 September – 16 October.

New York City. Museum of Modern Art. *Contrasts of Form. Geometric Abstract Art 1910–1985*. 7 October – 7 January 1986. [Catalogue].

## 1986

Begins *Wave* series of reliefs, utilizing wave motif that appeared in *Had Gadya* prints. Chooses titels after chapters from Herman Melville's *Moby Dick*. Receives honorary degree from Brandeis University, Waltham, MA. Travels to Europe for auto races in December.

Tokyo, Japan. Akira Ikeda Gallery. *Frank Stella: New Reliefs*. 6 May – 31 May. [Catalogue].

## 1987

In October, second retrospective exhibition Frank Stella 1970–1987, organized by William S. Rubin, opens at The Museum of Modern Art, New York, and subsequently travels to Amsterdam, Paris, Minneapolis, Houston, Los Angels.

New York City. The Museum of Modern Art. *Frank Stella: 1970–1987*. 10 October – 5 January 1988 [Catalogue. Text by William H. Rubin].

## 1988

Continues *Wave* series, now called *Moby Dick* series.

Amsterdam, Netherlands. Stedelijk Museum. *Frank Stella: 1970–1987*. 13 February – 10 April.

Santa Monica, CA. James Corcoran Gallery. *Frank Stella: Reliefs*. 28 April – 28 May.

Berlin, Germany. Nationalgalerie. Positionen heutiger Kunst. 23 June – 18 September. [Catalogue. Text by Hans Strelow *Frank Stellas Malerei vom Schwarzen Bild zum Drama im Raum*, pp. 78–101].

New York City. Leo Castelli Gallery, 142 Greene Street. *Last Show*. 17 September – 22 October.

Rochester, NY. Nan Miller Gallery. *Frank Stella: The Waves*. November.

Taura, Japan. Akira Ikeda Gallery. *Frank Stella*. 5 November – 30. April 1989. [Catalogue].

Stuttgart, Germany. Staatsgalerie. *Frank Stella: Black Paintings, 1958–1960. Cones and Pillars, 1984 – 1987*. 20 November – 2 February 1989. [Catalogue].

## 1989

Nagoya, Japan. Akira Ikeda Gallery. *Frank Stella: The Waves*. 11 January – 28 January. [Catalogue. Text by Kikuko Amagasaki].

New York City. Knoedler Gallery. *Frank Stella: New Work*. 4 February – 2 March.

Houston, TX. Contemporary Arts Museum. *Frank Stella: 1970–1987*. 10 February – 23 April.

São Paulo, Brazil. Parco Ibirapuera. *20th International São Paulo Biennial*. 14 October – 10 December. [Catalogue].

Los Angeles, CA. Richard Green Gallery. *Frank Stella: Waves II*. 31 October – 25 November.

London, England. Waddington Graphics. *Frank Stella: Waves*. 1–25 November. [Catalogue].

## 1990

Kitakyushu, Japan. Municipal Museum of Art and Kawamura Memorial Museum of Art. *Frank Stella*. 19 October 1990 – 1 December 1991.

## 1991

Designs and creates the model for the New Groningen Museum in collaboration with Peter Rice, Alexander Cott, Earl Childress and Bob Kahn, and for a Kunsthalle and Garden, consisting of five buildings in the former *Herzogin (Duchess) Garden* in Dresden, commissioned by Rolf and Erika Hoffmann.

## 1992

Murals, dome painting and reliefs of the *Princess of Wales Theater*, Toronto. Outdoor sculptures in Luneville, Kawamura, and Luxembourg.

Tokyo, Japan. Akira Ikeda Gallery. *Frank Stella: Sculpture and Collage*. 16 June – 18 July.

New York City. Knoedler Gallery. *Frank Stella: New Work: Projects and Sculpture*. 10 October – 11 November.

Mount Kisco, NY. Tyler Graphics. *Frank Stella: The Fountain*. 1997. [Flyer. Text by Philip Larson].

## 1993
Creates outdoor sculpture *Yawata Works* with Nippon Steel as part of a recycling project for the Kitakyushu Municipal Museum of Art.

Mount Kisco, NY. Tyler Graphics. *Frank Stella: Moby Dick Deckle Edges*. 1993. [Catalogue. Text by Jacquelynn Baas].

## 1994
Decision of the Philosophische Fakultät of the Friedrich Schiller-Universität Jena on 22 November to honor Frank Stella with a honorary doctorate.

London, England. Waddington Galleries. *Frank Stella: Imaginary Places. New Work: Painting, Relief, and Sculpture*. 22 June – 23 July.

## 1995
Teaches advanced studio class as Visting Professor at Yale School of Architecture. Travels to Fukushima on occasion of opening of Tyler Graphics Archive Collection, and delivers lecture *Melrose Avenue* at Keio University.

Dijon, France. L'Usine. *Frank Stella*. 22 June – 12 August.
Los Angeles, CA. Gagosian Gallery. *Frank Stella: New Sculpture*. 18 October – 25 November.
Mount Kisco, NY. Tyler Graphics. *Frank Stella. Imaginary Places*. 3 June – 11 August. [Catalogue. Text by Sidney Guberman].
New York City. Knoedler Gallery. *Frank Stella: Imaginary Places, New Paintings and Prints*. 8 November – 6 January 1996.
New York City. Leo Castelli Gallery. *Free Standing Murals*. 11 November – 16 December.
Singapore, Singapore. Wetterling Teo Gallery. Frank Stella: New Works. 23 November – 25 January 1996. [Catalogue].

## 1996
Receives honorary doctorate of the Friedrich Schiller-Universität in Jena on 6 February. Gives a lecture delivered at the academic public, entitled *Broadsides*. Opening of the retrospective in Munich on 9 February. Stay in Jena on 22 and 23 April. Opening of the installation of five sculpture on the Ernst Abbe-Platz in Jena on 6 November.

Nagoya, Japan. Akira Ikeda Gallery. *Frank Stella*. 1 February – 27 April. [Catalogue].
Nagoya, Japan. Aichi Prefectural Museum of Art. *Richard Meier – Frank Stella. Architecture and Art*. 2 February – 7 April. [Traveled to Hiroshima]. [Catalogue. Texts by David Galloway, Lois Nesbitt, Earl Childress, Clare Farrow, Seiken Fukuda].
Munich, Germany. *Frank Stella*. Haus der Kunst. 10 February – 21 April. [Catalogue. Texts by Judith Goldman, Juan Ljosé Lahuerta, Hubertus Gaßner].
Jena, Germany. JENOPTIK AG. *Frank Stella. New Sculpture. Hudson River Valley Series*. 6 November. [Catalogue. Text by Franz-Joachim Verspohl].
Mount Kisco, NY. Tyler Graphics. *Frank Stella: Imaginary Places II. Project Notes*. November. [Catalogue].

## 1997
Houston, TX. University of Houston, Blaffer Gallery. *Stella in Studio: The Public Art of Frank Stella, 1982 – 1997*. 18 January – 23 March.
New York City. Gagosian Gallery. *Frank Stella: New Sculpture*. 15 March – 26 April.
Kagoshima, Japan. City Museum of Art. *Frank Stella*. 25 April – 25 May. [Catalogue. Text by Yuzo Yaguchi].
Mount Kisco, NY. Tyler Graphics. *Frank Stella: Juam. Juam, State I from Imaginary Places*. 1997. [Catalogue. Text by Robert K. Wallace].

## 1998
Andover, MA. Addison Gallery of American Art. *Frank Stella at Tyler Graphics*. 18 September – 1 January 1999.
London, England. Bernard Jacobson Gallery. *Frank Stella: New Paintings*. 5 June – 18 July.
Takamatsu, Japan. City Museum of Art. *Frank Stella and Kenneth Tyler: A Unique 30-Year Collaboration*. 17 April – 17 May. [Catalogue. Texts by Nobuyuki Hiromoto, Siri Engberg, Frank Stella].

## 1999
Visits Jena from 19 till 22 March. Gives a lecture on *Exalted Art (first draft)* at the XXV. Congress of German Art Historians in Jena on 20 March. Offers to show his recent work in Jena and speaks on his relation to Heinrich von Kleist on a tour to Thuringian villages.

Miami, FL. Museum of Contemporary Art North Miami. *Frank Stella at two thousand. Changing the Rules*, 19 December – 12 March 2000. [Catalogue. Texts by Bonnie Clearwater, Frank Stella].
London, England. Bernard Jacobson Gallery. *Frank Stella: Easel Paintings*. 9 June – 10 July.
New York City. Sperone Westwater. *Frank Stella: New Work*. 10 November – 11 December.

## 2000
Vistis Jena on 7 and 8 February for planing his ex-

hibition *Heinrich von Kleist by Frank Stella* in 2001. Chooses among earlier gouaches one as tapestry design for the Auerbach house in Jena. Comes again from 30 April till 2 May, visiting also Bad Frankenhausen and the Kyffhäuser Monument. Comes for a third time on 3 December making proposals for the project.

Chicago, IL. Richard Gray Gallery. *Frank Stella: Recent Paintings and Sculpture*. 11 May – 31 August.
London, England. Royal Academy. *Summer Exhibition 2000*. Royal Academy of Arts. 29 May – 7 August.
Philadelphia. Locks Gallery. *Frank Stella. Recent Works*. 13 October – 25 November. [Catalogue. Text by Robert Hobbs].
San Francisco, CA. San Francesco Museum of Modern Art. *Celebrating Modern Art: The Anderson Collection*. October – January 2001.
New York City. Barbara Mathes Gallery. *Frank Stella. Love Letters and Correspondance*. 28 October – 22 December. [Flyer].

**2001**
Gold Medal of the National Arts Club on 24 January in New York. Visits Jena from 19 to 28 March with his family and friends for opening of his exhibition and giving a lecture on Heinrich von Kleist in the symposium *Romanticism in Modernism*. Further participants are Robert Rosenblum, Irving Lavin, Robert K. Wallace, Martin Warnke, Wolfram Hogrebe, Horst Bredekamp and professors of the Friedrich Schiller-Universität.

Jena. JENOPTIK Gallery / Kunsthistorisches Seminar mit Kustodie. *Heinrich von Kleist by Frank Stella / Die Heinrich von Kleist-Serie*. 25 March – 4 June. Jena / Köln: Kunsthistorisches Seminar mit Kustodie / Verlag der Buchhandlung König (Minerva. Jenaer Schriften zur Kunstgeschichte. Band 11). [Werkverzeichnis der Heinrich von Kleist-Serie / Catalogue Raisonné of the Heinrich von Kleist Series. Texts by Franz-Joachim Verspohl, Martin Warnke, Wolfram Hogrebe, Robert K. Wallace].

# Selected Bibliography / Auswahlbibliographie

## I. Published Writings by Frank Stella / Publizierte Schriften Frank Stellas

**1959**
*An Artist Writes to Correct and Explain (letter to the editor)*. New York Herald Tribune. 22 December, sec. 4, p. 7 [Response to E. Genauer, 16 December 1959].

**1971**
*Lecture delivered at Pratt Institute, Brooklyn, New York, January 1960*. First published in Robert Rosenblum. *Frank Stella*. Harmondsworth, England: Penguin.

**1983**
*On Caravaggio*. New York Times Magazine. 3 February, p. 38. Shards by Frank Stella.
Text by Richard Meier. New York and London: Petersburg Press.

**1986**
*Working Space. Charles Eliot Norton lecture series, Harvard University*. Cambrigde, MA, and London: Harvard University Press.

**1993**
*Surface Complexes*. Connaissance des Arts. September, pp. 93–102.

**2001**
*The Writings of Frank Stella / Die Schriften von Frank Stella*. Ed. Franz-Joachim Verspohl. Jena / Köln : Kunsthistorisches Seminar mit Kustodie / Verlag der Buchhandlung Walter König (Minerva. Jenaer Schriften zur Kunstgeschichte, Volume / Band 12).

# II. Catalogues, Essays, Books on Frank Stella / Kataloge, Texte, Bücher über Frank Stella
## [For catalogues mainly see the biography of the artist]

## 1959

Genauer, Emily.*16-Artist Show Is On Today at Museum of Modern Art*. New York Herald Tribune. 16 December, p. 26.

Leon, Denis. *Melting Pot / '16 Americans' on View*. Philadelphia Inquirer. 27 December.

Miller, Dorothy C. *Sixteen Americans*. New York: Museum of Modern Art.

N. N. *Art*. New York Herald Tribune. 20 December, sec. 4, p. 3.

N. N. *Allen Memorial Art Museum. 'Three Young Americans.'* In: Allen Memorial Art Museum Bulletin: Oberlin College. Fall.

N. N. *The Shape of Things to Come*. New York Times. 20 December, sec. 2, p.11.

Preston, Stuart. *Sixteen Americans*. New York Times. 16 December, p. 50.

## 1960

Canaday, John. *Miniature of Contemporary Movements*. New York Times. 21 December, p. 40.

Donnelly, Tim. *But Is That Avalanche on Everest Really Necessary?* Washington News. 9 February.

Genauer, Emily. *Modern Art Museum's New Show Presents a 12-Foot Pin Stripe Canvas It Calls 'Exciting'*. New York Herald Tribune. 21 December, p. 23.

Key, Donald. *Stripe Painting Has Been Rough Road*. Milwaukee Journal. 12 June.

Mott, Helen de. *In the Galleries*. Arts. October, p. 64.

N. N. *The Higher Criticism*. Time. 11 January 1960, p. 59.

Petersen, Valerie. *Reviews and Previews*. ARTnews. November, p. 17.

Picard, Lil. Die Welt. 24 November.

Preston, Stuart. *Housing in Art's Many Mansions*. New York Times. 2 October, sec. 2, p. 21.

Sandler, Irving H. *New York Letter*. Art International. 1 December, p. 25.

## 1961

Ashbery, John. *Can Art Be Excellent If Anybody Could Do It?* New York Herald Tribune. 8 November, p. 11.

Genauer, Emily. *Isms Die in Their Fashion*. New York Herald Tribune. 15 October, sec. 4, p. 10.

N. N. *It's Exciting*. Newsweek. 9 January, p. 78.

## 1962

Campbell, Lawrence. *Reviews and Previews*. ARTnews. Summer, p. 17.

Fried, Michael. *New York Letter*. Art International. 25 November, p. 54.

Judd, Donald. *In the Galleries*. Arts. September, p. 51.

Kozloff, Max. *Art*. Nation. 21 April, pp. 364–366.

Raynor, Vivien. *In the Galleries*. Arts. December, p. 46.

Sandler, Irving H. *Reviews and Previews*. ARTnews. December, p. 54.

Swenson, G. R. *Reviews and Previews*. ARTnews. May, pp. 55–56.

## 1963

Ashton, Dore. *New York Commentary*. Studio. February, p. 67.

Factor, Donald. *Los Angeles*. Artforum. May, p. 44.

Langsner, J. *Los Angeles Letter*. Art International. 25 March, pp. 75–76.

O'Doherty, Brian. *Abstract Confusion*. New York Times. 2 June, sec. 2, p. 11.

## 1964

Coplans, John. *Post-Painterly Abstraction: The Long-Awaited Greenberg Exhibition Fails to Make His Point*. Artforum. Summer, pp. 4–9.

Fried, Michael. *New York Letter*. Art International. 25 April, pp. 58–59.

Gassiot-Talabot, Gerald. *La Panoplie de l'Oncle Sam à Venise*. Aujourd'hui, Art et Architecture. October, p. 30–32.

Genauer, Emily, and John Gruen. *Art Tour. The Galleries, A Critical Guide*. New York Herald Tribune. 11 January, p. 9.

Gruen, John. *The Canvas Shape-Up*. Sunday New York Herald Tribune Magazine. 20 December, p. 34.

Judd, Donald. *Black, White and Gray*. Arts. March, pp. 36–38.

Kozloff, Max. *New York Letter*. Art International. 25 April, p. 14.

Lippard, Lucy R. *New York*. Artforum. March, p. 18.

Lynton, Norbert. *London Letter*. Art International. December, pp. 44–45.

N. N. *La Galleria. Notizie di Torino presenta:Kenneth Noland e Frank Stella*. Borsa d'Arte (Turin). December, p. 4.

O'Doherty, Brian. *Frank Stella and a Crisis of Nothing-ness*. New York Times. 19 January, sec. 2, p. 21.
Swenson, G. R. *Reviews and Previews*. ARTnews. February, p. 11.

**1965**
Baro, Gene. *London*. Arts. January, p. 73.
Constable, Rosalind. *The Mid 60s/Art: Is It Painting or Is It Sculpture?* Life International (Paris). 20 December, pp. 131–134.
Creeley, Robert. *Frank Stella: A Way to Go*. Lugano Review. Summer, pp. 189–197.
Judd, Donald. *In the Galleries*. Arts. February, pp. 56–57.
Lassaigne, Jacques. *8e Biennale de São Paulo – 8th São Paulo Biennial*. Cimaise (Paris). October – January 1966, pp. 48 - 53.
Leider, Philip. *Small but Select*. Frontier. March, pp. 21–22.
Lippard, Lucy R. *New York Letter*. Art International. March, p. 46.
Marmer, Nancy. *Los Angeles Letter*. Art International. May, pp. 43–44.
N. N. *Frank Stella*. Artforum, pp. 24–26.
Rosenblum, Robert. *Frank Stella. Five Years of Varia-tions on an Irreducible Theme*. Artforum. March, pp. 21–25.
Whittet, G. S. *The Dynamic of Brazil: The VIII Biennial of São Paulo*. Studio International. October, pp. 136–143.

**1966**
Ashton, Dore. *Art*. Arts and Architecture. May, p. 5.
Ashton, Dore, *Art*. Arts and Architecture. November, pp. 7–8.
Bochner, Mel. *In the Galleries*. Arts. May, p. 61.
Bourdbon, David. *A New Direction*. Village Voice. 24 March, p. 17.
Campbell, Lawrence. *Reviews and Previews*. ARTnews. May, p. 22.
Fried, Michael. *Shape as Form: Frank Stella's New Paint-ings*. Artforum. November, pp. 18–27.
Glaser, Bruce. *Questions to Stella and Judd*. Ed. Lucy R. Lppard. ARTNews. September 1966, pp. 55–66.
Gruen, John. *Art Tour*. New York Herald Tribune. 12 March, p. 6.
Kozloff, Max. *Art*. Nation. 28 March, pp. 370–372.
Kramer, Hilton. *Representative of the 1960's*. New York Times. 20 March, sec. 2, p. 21.
Krauss, Rosalind. *New York*. Artforum. May, pp. 47, 49.
Lippard, Lucy R. *New York Letter*. Art International. Summer, p. 113.
Lucie-Smith, Edward. *Studies in Severity*. Art and Artists. November, pp. 55–57.
N. N. *Conditioned Historic Reactions*. Studio Interna-tional. May, pp. 204–207.
N. N. *Marketing Techniques in the Promotion of Art*. Studio International. November, pp. 271–273.

**1967**
Battcock, Gregory. *Painting Paintings for Corners*. Westside News and Free Press. 7 December.
Cone, Jane Harrison. *Frank Stella's New Paintings*. Art-forum. December, pp. 34–41.
Kozloff, Max. *Art*. Nation. 18 December, pp. 667–668.
Kramer, Hilton. *Frank Stella: 'What You See Is What You See.'* New York Times. 10 December, sec. 2, p. 39.
Livingston, Jane. *Frank Stella, Lithographs, Gemini*. Art-forum. November, pp. 66–67.
N. N. *Painting: Minimal Cartwheels*. Time. 24 Novem-ber, pp. 64–65.
Perreault, John. *Blown Cool*. Village Voice. 7 December, pp. 18–19.

**1968**
Battcock, Gregory, Ed. *Minimal Art – A Critical Antho-logy*. New York: Dutton.
Bourdon, David. *New Cut in Art*. Life. 19 January, pp. 44–58.
Castle, Frederick. *What's That, the '68 Stella? Wow!* ARTnews. January, pp. 46–47, 68–71.
Christophe, Andreae. *Frank Stella*. Christian Science Monitor. 23 September, p. 8.
Davis, Douglas. *Stella: 'Only What Can Be Seen There Is There.'* National Observer. 25 March, p. 20.
Fischer, John. *In the Galleries*. Arts. February, p. 59.
Gold, Barbara. *Stella Exhibits in Washington*. Baltimore Sun. 3 March, p. D6.
Kane, George. *Stripes and Shapes by Stella*. Boston Sunday Globe, Sunday Magazine. 14 July, pp. 28–32.
Kozloff, Max. *Renderings: Critical Essays on a Century of Modern Art*. New York: Simon & Schuster.
Lanes, Jerrold. *Current and Forthcoming Exhibitions*. Burlington Magazine. February, p. 112.
Lippard, Lucy R. *Constellation By Harsh Daylight: The Whitney Annual*. Hudson Review. Spring, pp. 174–182.
N. N. *Stella's Art Takes a New Shape*. America Illustrat-ed. December, pp. 4–9. [Russian issue no. 146, Polish issue no. 119.]
Russell, John. *Frank Stella*. Artscanada. June, p. 45

**1969**
Calas, Nicolas. *Art & Strategy*. Arts. March, pp. 36–38.
Driscoll, Edgar J., Jr. *Stella Shines at Brandeis*. Boston Morning Globe. 15 April, p. 25.
Guilano, Charles. *Mr. Stella d'Oro of the Art World*. Boston After Dark. 16 April, p. 11.
Kennedy, R. C. *London Letter*. Art International. 20 February, pp. 38–39.
Masheck, Joseph. *Frank Stella at Kasmin*. Studio Inter-national. February, pp. 90–91.
N. N. *Frank Stella, the Theologian*. Arts. December / January 1970, pp. 29–31.
Rose, Barbara. *American Painting. The Twentieth Cen-tury*. Lausanne 1969.

Rosenblum, Robert. *Frank Stella: An Exhilarating Adventure*. Vogue. 15 November, pp. 114–117, 160.

Ruiz de la Mata, Ernesto J. *Frank Stella*. San Juan Star, Sunday Magazine. 23 March.

### 1970

Alloway, Lawrence. *Art*. Nation. 4 May, p. 540.

Ashton, Dore. *New York Commentary*. Studio International. June, p. 275.

Baker, Elizabeth C. *Frank Stella Perspectives*. ARTnews. May, pp. 46–49, 62–64.

Burr, James. *London Galleries*. Apollo. September, p. 224.

Davis, Douglas. *The Art Part*. Newsweek. 13 April, p. 98.

Denver, Bernard. *London Letter*. Art International. November, p. 76.

Domingo, Willis. Arts. April, p. 55.

Fuller, Peter. Connoisseur. October, p. 148.

Hilton, Timothy. *Commentary*. Studio International. September, pp. 100–101.

Imdahl, Max. *Frank Stella: Sanbornville II*. Universal-Bibliothek. Stuttgart: Philipp Reclam.

Kramer, Hilton. *2 Men's Dazzling Abstractions*. New York Times. 31 January.

Leider, Philip. *Literalism and Abstraction: Reflections on Stella Retrospective at the Modern*. Artforum. April, pp. 44 –51.

Marandel, J. Patrice. Art International. May, p. 53.

N. N. *A Retrospective of Frank Stella*. New York Times. 25 March, p. 34.

Pincus-Witten, Robert. *New York*. Artforum. January, pp. 66–67.

Reeves, Jean. *Stella, An Artist Who Assaults Our Optical Senses*. Buffalo Evening News. 7 March, p. B9.

Rosenberg, Harold. *The Art World*. New Yorker. 9 May, pp. 103–116.

Rubin, Wiliams S. *Letter to the editor*. Artforum. June, pp. 10–11 [Response to. P. Leider, April 1970].

Rubin, William S. *Frank Stella*. New York: Museum of Modern Art.

### 1971

Baker, Elizabeth C. *Frank Stella: Revival and Relief*. ARTnews. November, p. 34.

Baker, Kenneth. *Untitled*. Christian Science Monitor. 11 November.

Calas, Nicolas, and Elena Calas. *Icons and Images of the Sixties*. New York: Dutton.

Domingo, Willis. Arts. November, p. 60.

Kramer, Hilton. *Two Uses of the Shaped Canvas*. New York Times. 16 October, p. 25.

Kraus, Rosalind. *Stella's New York and the Problem of Series*. Artforum. December, pp. 40–44.

Ratcliff, Carter. *New York Letter*. Art International. 20 December, pp. 59–60.

Rosenblum, Robert. *Frank Stella*. Harmondsworth, England: Penguin.

### 1972

Denver, Bernard. *London Letter*. Art International. January, p. 50.

Elderfield, John. *UK Commentary*. Studio International. January, pp. 30–31.

Sandler, Irving. *Stella at Rubin*. Art in America. January – February, p. 33.

### 1973

Finkelstein, Louis. *Seeing Stella*. Artforum. June, pp. 67–70.

Forgey, Benjamin. *Starring Stella*. Washington Star News. 23 November, p. E1.

Hahn, Otto. *Le retour de la peinture*. L'Express. 26 November – 2 December.

Hess, Thomas. New York, 3 December.

Kingsley, April. *New York Letter*. Art International. April, pp. 53–54.

Masheck, Joseph. Artforum. April, pp. 80–81.

Richard, Paul. *Stella: Not So Simple Anymore*. Washington Post. 10 November, p. C1.

Schjeldahl, Peter. *Frank Stella: The Best and the Last of His Breed?* New York Times. 21 January, sec. 2, p. 23.

Siegal, Jeanne. ARTnews. February, p. 78.

Stitelman, Paul. *New York*. Arts. May – June, p. 58.

White, Edmund. *Frank Stella Explores a New Dimension*. Saturday Review of the Arts. 3 March, pp. 53–54.

### 1974

Bell, Jane. Arts. January, p. 67.

Campbell, Lawrence. ARTnews. February, p. 104.

Gilbert-Rolfe, Jeremy. Artforum. February, pp. 67–68.

### 1975

Battcock, Gregory. *Da New York Notizie – Assailing Technology*. Domus. September, p. 53.

Bourdon, David. *Frank Stella*. Village Voice. 19 May.

Frank, Peter. ARTnews. September, p. 113.

Herrera, Hayden. Artforum. September, p. 67.

Millet, Catherine. *Un peintre: Frank Stella histoire (ou contre-histoire) de l'espace literal*. Art Press. November – December, pp. 14–15.

Russell, John. *New Shows of Riley, Stella, Sander and Baizerman*. New York Times. 18 May, p. 35.

Smith, Roberta. *Frank Stella's New Paintings: The Thrill Is Back*. Art in America. November – December, pp. 86–88.

Zimmer, William. Arts. September, p. 12.

### 1976

Alloway, Lawrence. *Art*. Nation. 20 November, pp. 541–542.

Andre, Michael. ARTnews. December, p. 115.

Frackman, Noel. *Frank Stella's Abstract Expressionist Series: A Reading of Stella's New Paintings*. Arts. December, pp. 124–126.

Hess, Thomas B. *Stella Means Star*. New York. 1 November, p. 62.

Hopkins, Budd. *Frank Stella's New Work: A Personal Note*. Artforum. December, pp. 58–59.

Perrone, Jeff. Artforum. December, p. 74.

Russell, John. *Art Beyond Good and Bad Taste*. New York Times. 8 October, p. C17.

## 1977

Feaver, William. *The Stella Collection*. Observer (London). 8 May.

Goldin, Amy. *Frank Stella at Knoedler*. Art in America. January - February, p. 126.

Lucie-Smith, Edward. *Stella – The Defiant Giant*. Evening Standard. 21 December, p. 27.

Maloon, Terence. *Frank Stella: From American Geometry to French Curves*. Artscribe (London). July, pp. 11–14.

McEwen, John. *Star Struck*. Spectator (London). 14 May, pp. 27–28.

N. N. *Pinch-Pots and Skateboards*. Spectator (London). 24 December, p. 33.

N. N. Art Monthly (London). May, p. 16.

Overy, Paul. *Frank Stella's Exhilarating Vitality*. Times (London). 17 May.

Richard, Paul. *Frank Stella at Forty: A Fierce and Entertaining Logic*. Washington Post. 9 January, pp. 141–142.

Rippon, Peter, Terence Maloon and Ben Jones. Artscribe (London). July, pp. 14–17.

Steyn, Juliet. *Frank Stella Talks About His Recent Work*. Art Monthly (London). May, pp. 14–15.

Wahl, Kenneth. *On Abstract Literalist Works*. Arts. April, pp. 98–101.

## 1978

Ashbery, John. *Birds on the Wing Again*. New York. 11 September, pp. 90–91.

Hobbs, Robert and Gail Levin. *Abstract Expressionism: The Formative Years*. New York: Whitney Museum.

Hughes, Robert. *Stella and the Painted Bird*. Time. 3 April, pp. 66–67.

Hunter, Janet. *Frank Stella in a New Light*. Dallas Morning News. 11 March, p. F1.

N. N. Artforum. February, p. 72.

N. N. *Stella's Captivating Color*. Dallas Morning News. 15 March, p. F1.

Kramer, Hilton. *Frank Stella's Vigorous Reaffirmation*. New York Times. 14 May, p. D 27.

Leider, Philip. *Stella Since 1970*. Art in America. March – April, pp. 120–130.

Marvel, Bill. *Stella at Fort Worth*. Horzion. May, pp. 40–47.

N. N. *Frank Stella: A Rebel Rebels Against His Own Art*. Dallas Times Herald. 26 March.

N. N. *Stella Since 1970*. Artweek West. 8 April.

Nichols, Carol. *Frank Stella Show to Open at Art Museum*. Fort Worth Star Telegram. 26 February.

Nizon, Virginia. *Stella Shows Abstract Art Isn't Painted into a Corner*. Gazette (Montreal). 24 November, p. 20.

Russell, John. *Stella Shows His Metal in Soho*. New York Times. 19 January, pp. C1–16.

Siegel, Jeanne. *Recent Colored Reliefs*. Arts. September, pp. 152–154.

Stevens, Mark. *Stella: Letting Go*. Newsweek, 1 May, pp. 94–95.

Toupin, Gilles. *Frank Stella: évolution ou révolution?* La Presse (Montreal). 11 November, p. D 21.

Viau, Rene. *Frank Stella au Musée des Beaux-Arts*. Le Devoir. 22 November, p. 12.

## 1979

Baker, Kenneth. *Stella by the Cold Light of Day: New Paintings That Holler*. Boston Phoenix, 22 May, sec. 3, p. 10.

Gibson, Eric. *Frank Stella*. Art International. March, pp. 50–51.

Hughes, Robert. *Ten Years That Buried the Avant-Garde*. Sunday Times Magazine (London). 30 December, pp. 16–21, 41–47.

Kingsley, April. *Frank Stella Off the Wall*. Village Voice. 29 January, p. 70.

Kramer, Hilton. *Frank Stella's Brash and Lyric Flight*. Portfolio. April – May, pp. 48–55.

Lawson, Thomas. *Frank Stella*. Flash Art. March – April, p. 23.

Lawson, Thomas. *Paintings in New York: An Illustrated Guide*. Flash Art. October – November, Illus. on cover and p. 6.

Levin, Kim. *Frank Stella*. Arts. March, p. 22.

Lincoln, MA. De Cordova Museum. *Born in Boston: Sixteen Prominent Artists Who Were Born or Raised in the Boston Area but Who Developed Their Careers Elsewhere*.

Nahum, Katherine. *Stella's Gigantic Metal Reliefs at Brandeis*. Newton Times. 30 May, pp. 13, 15.

Nisselson, Jane. *Stella's Indian Birds*. Art World. Januar – 4 February, p. 8.

Richard, Paul. *Stella the Daring: Stalking into the Unknown Worlds of Abstract Art*. Washington Post. 21 April, pp. B1, B4.

Taylor, Robert. *Frank Stella Hits His Stride*. Boston Sunday Globe. 27 May, pp. 17, 20.

Whelan, Richard. *Frank Stella (Castelli)*. Art News. March, p. 182.

## 1980

Basel, Switzerland. Kunstmuseum Basel. *Frank Stella: Working Drawings / Zeichnungen, 1956–1970*. Basel: Kunstmuseum Basel. [Text by Christian Geelhaar]

Bordeaux, France. Centre d'Arts Plastiques Contemporains de Bordeaux. *Frank Stella: Peintures 1970 / 1979*.

Cambridge, MA. Harvard University. Fogg Art Museum *Master Paintings from the Fogg Collection*. 1 April – August .

**1981**

Forgey, Benjamin. *The Clarity of the Corcoran Biennial*. Washington Star. 22 February, pp. E 1–2.

Kramer, Hilton. *Frank Stella*. New York Times. 6 November.

Larson, Kay. *The Odd Couple*. New York. 23 November, pp. 73–77.

Peters, Marsha. *Prints with the Painting in Mind*. Providence Journal. 3 May.

**1982**

Amsterdam, Netherlands. Stedelijk Museum. *'60–'80: attitudes / concepts / images*. Amsterdam: Van Gennep.

Axsom, Richard H. *Grand Prix print*. ARTnews. September, cover, p. 62.

Boston, MA. Museum of Fine Arts. *A Private Vision: Contemporary Art from the Graham Gund Collection*. 1982. [Text by Graham Gund]

Carter, E. Graydon. *People*. Time. 8 November, p. 53.

Antonio, Emile de. *Frank Stella: A Passion for Painting*. GEO. March, pp. 13–16.

Feinstein, Roni. *Stella's Diamonds: Frank Stella's New Work*. Arts. 14 January, p. C 22.

Frackman, Noel. *Tracking Frank Stella's Circuit Series*. Arts. April, pp. 134–137.

Raynor, Vivien. *Frank Stella Exhibits at His Alma Mater*. New York Times, 7 November, p. H 23.

Robins, Corinne. *American Urban Art Triumphant: The Abstract Paintings of Arthur Cohen. Al Held, Phoebe Helman and Frank Stella*. Arts. May, pp. 86–89.

Ruhe, Barnaby. *Frank Stella*. Art World. November, pp. 1, 8.

Smith, Roberta. *Abstraction: Simple and Complex*. Village Voice. 23 November, p. 106.

**1983**

Axsom, Richard H. *Prints of Frank Stella: A Catalogue Raisonné, 1967–1982*. New York: Hudson Hills Press.

Berman, Avis. *Artist's Dialogue: A Conversation with Frank Stella*. Architectural Digest. September, pp. 70, 74 ,78.

Corbett, Patricia. *Frank Stella*. Art and Auction. February, pp. 59–61. [Interview]

Curtis, Charlotte. *Frank Stella and Art*. New York Times. 28 June, p. C 10.

Feinstein, Roni. *Frank Stella's Prints, 1967–1982*. Arts. March, pp. 112–115.

Glueck, Grace. *Frank Stella's Prints at the Whitney*. New York Times. 14 January, p. C 22.

Hughes, Robert. *Expanding What Prints Can Do*. Time. 28 February, p. 60.

Jacksonville, FL. Jacksonville Art Museum. *Frank Stella: Recent Works*.

Kalin, Diane. *Stella Performances: Frank Stella and the Face of Abstract Art*. Boston Ledger, Arts and Entertainment Section. 19–26 December, pp. 21, 34.

Meier, Richard. *Shards by Frank Stella*. New York and London: Petersburg Press.

N. N. *Art: Best*. Boston Sunday Globe. 25 December.

Ratcliff, Carter. *Stella: Flirting with Geometry*. Vogue. February, p. 53.

Rayport, Jennifer. *From Art School to Playskool*. [Publication and date unknown].

Rosenblum, Robert. *Stella's Third Dimension*. Vanity Fair. November, pp. 86–93.

San Francisco, CA. San Francisco Museum of Modern Art. *Resource / Response / Reservoir. Stella Survey 1959–1982*.

Seattle, WA. Seattle Art Museum. *American Art: Third Quarter Century*. [Teyt by Jan van der Marck]

Silverthorne, Jeanne. *Frank Stella*. Artforum. February, pp. 81–82.

Smith, Roberta. *A Dourble Dose*. Village Voice. 22 March p. 106.

Taylor, Robert. *Fogg to Mount Stella Exhibit*. Boston Globe. 22 November, p. 18.

Taylor, Robert. *Frank Stella: Fresh, Brilliant and Abstract*. Boston Globe. 11 December, pp. A 25, 36.

Wolff, F. Theodore. *Frank Stella: As Important a Printmaker as He Is a Painter*. Christian Science Monitor. 25 January, p. 19.

**1984**

Baker, Kenneth. *The Shape of Things to Come: Frank Stella's Past Performances*. Boston Phoenix. 17 January, pp. 5, 12.

Caarten, Michael. *Corporate Culture: What Art Does Biz Buy?* Daily News. 13 November, pp. 1, 8.

Haskell, Barbara. *Blam! The Explosion of Pop, Minimalism, and Performance 1958–1964*. New York and London: Whitney Museum and Norton.

Hennessy, Richard. *The Man Who Forgot How to Paint*. Art in America. Summer, pp. 13–25.

Kutner, Janet. *Stella: Abstract Update*. Dallas Morning News. 16 October, pp. E1, 2.

McGill, Douglas C. *Art People: Office Tower Gets Stellas*. New York Times. 9 November, p. C17.

Micha, Rene. *Lettre de Paris. Les Collections Menil*. Art International. September – November, pp. 45–48.

Muchnic, Suzanne. *A Monumental Affair by First-Rate Artists*. Los Angeles Times. 11 June, sec. IV, pp. 1, 17.

Solway, Diane. *Frank Stella: Speaking in the Abstract*. M. July, pp. 154–157.

Tomkins, Calvin. *The Space Around Real Things*. New Yorker. 10 September, pp. 53–97.

Stella, Frank. *Illustrations after El Lissitzky's Had Gadya, 1982-1984*. London: Waddington Graphics.

**1985**

Cohen, Ronny. *Frank Stella*. ARTnews. May, p. 115.

Cramer, George W. *Letter to the editor*. Art in America. May, p. 5 [Response to C. Ratcliff, February].

Flam, Jack. *The Gallery: Surprises from Frank Stella.* Wall Street Journal. 12 February, p. 28.

O'Brien, Glen. *Frank Stella, Knoedler Gallery.* ARTforum. May, pp. 108–109.

Parker, William. *Identity Packages Made in USA.* Financial Times (London). 4 June, p. 85.

Providence, RI. Rhode Island School of Design. *Fortissimo! Thirty Years from the Richard Brown Baker Collection of Contemporary Art.* [Text by Richard Brown Baker.]

Ratcliff, Carter. *Frank Stella: Portrait of the Artist as Image Administrator.* Art in America. February, pp. 94–106.

Richardson, Brenda. *Letter of the editor.* Art in America. May, p. 5 [Response to C. Ratcliff, February].

Russell, John. *The Power of Frank Stella.* New York Times. 1 February, pp. C1, 22.

Storr, Robert. *Frank Stella's Norton Lectures: A Response.* Art in America. February, pp. 11–15.

Wedemeyer, Dee. *Lobbies with Stellas: The Developer's Choice.* New York Times. 12 May.

### 1986

Halley, Peter. *Frank Stella and the Simulacrum.* Flash Art. February – March, pp. 32–35.

Kramer, Hilton. *The Crisis in Abstract Art.* Atlantic Monthly. October, pp. 94, 96–98.

Rubin, Lawrence. *Frank Stella. Paitings 1958–1965. A Catalogue Raisonné.* New York: Stewart, Tabori and Chang.

Tokyo. Akira Ikeda Gallery. *Frank Stella: New Reliefs.* 6 May – 31 May. [Catalogue].

### 1987

Axsom, Richard H. *Frank Stella at Bedford.* Martin Friedman. Ed. *Tyler Graphics: The Extended Image,* pp. 161–188. New York: Abbeville.

Golding, John. *The Expansive Imagination.* Times Literary Supplement. March 27, pp. 311–312.

### 1988

Stuttgart. Staatsgalerie. *Frank Stella: Black Paintings, 1958–1960. Cones and Pillars, 1984–1987.* 20 November – 2 February 1989. [Catalogue].

Tomkins, Calvin. *Post- to Neo-: The Art World of the 1980s.* New York: Penguin.

### 1989

Bode, Peter M. *Kalkül und chaotische Leidenschaften.* Art. Das Kunstmagazin. September 189, pp. 32–50.

Dormer, Peter. *Frank Stella Paintings as Tapestry.* Apollo. February, pp. 110–113.

Strelow, Hans. *Frank Stella.* Künstler. Kritisches Lexikon der Gegenwartskunst. Munich: Weltkunst and Bruckmann, No. 7, pp. 1–16.

### 1990

Leider, Philip. *Shakespearean Fish.* Art in America. October, pp. 172–191.

St. Louis. Greenberg Gallery. *Frank Stella Works: 1972–1990.* 30 October – 1 January 1991.

Stockholm. Heland Wetterling Gallery. *Frank Stella: New Works.* 19 November – 15 January 1991. [Catalogue].

### 1991

Basel. Galerie Beyeler. *Roy Lichtenstein / Frank Stella.* 9 March – 30 May. [Catalogue].

Düsseldorf. Galerie Hans Strelow. *Frank Stella.* 12 April – 18 May.

Nakahara, Yusuke. *Frank Stella.* Tokyo: Shinchosa.

Osaka. National Museum of Art. *Frank Stella: Painting and Reliefs.* 6 July – 6 August. [Catalogue].

Paris. Galerie Daniel Templon. *Frank Stella: Recent Sculpture.* 25 September – 26 October. [Catalogue. Text by Catherine Millet].

Sakura. Kawamura Memorial Museum of Art. *Frank Stella: 1958–1990.* 27 April – 16 June. [Catalogue. Text by Junichi Nakashima].

Sommerschuh, Jens-Uwe. *Maler Frank Stella als Baumeister in Dresden.* Art. Das Kunstmagazin, November.

Taura. Akira Ikeda Gallery. *Frank Stella: Recent Works.* 27 April – 21 September.

Wallace, Robert K. *Sightings of the White Whale.* Contemporanea. January, pp. 60–67.

### 1992

Galloway, David. *Report from Dresden: A City Reborn.* Art in America. April, pp. 55 63.

Venice, CA. Bobbie Greenfield Fine Art. *Frank Stella: Domed Prints.* March.

Wallace, Robert K. *Frank Stella's Embassy Print. The Symphony.* The Print Collector's Newsletter 23. July – August, pp. 88–90.

### 1993

Berlin. Nationalgalerie. *Wege der Moderne. Die Sammlung Beyeler.* 30 April – 1 August. [Catalogue].

New York. Archives of American Art. *Stella!* 26 October – 21 January 1994.

Rome. Palazzo delle Esposizione. *Richard Meier / Frank Stella. Art and Architecture.* 8 July – 3 October. [Catalogue includes *Richard Meier and Frank Stella: A Conversation between Architect and Artist,* and Earl Childress *A Relationship in the Industry of Excellence*].

### 1994

Feinstein, Roni. *Stella and the Princess of Wales.* Art in America. July, p. 37.

Green, Denise. *Painterly Thought and the Unconscious.* Art Press. February, pp. E 1 – E 6.

Stella, Frank. *A Vision for Public Art.* Sakura: Tankosha Publishing Co.

Stephens, Suzanne. *Portrait: Frank Stella – Blurring the Line Between Art and Architecture.* Architectural Digest, July, pp. 30–34, 37.

**1995**

Diehl, Carol. *Frank Stella: Knoedler*. Artnews. January, p. 160.

Drolet, Owen. *New York: Frank Stella / Knoedler*. Flash Art. January – February, pp. 95–95.

Edelman, Robert. G *Frank Stella at Knoedler and American Fine Arts*. Art in America. January, pp. 99–101.

Guberman, Sidney. *Frank Stella: An Illustrated Biography*. New York: Rizzoli.

**1996**

Aichi. Prefectural Museum of Art. Richard Meier / Frank Stella. Architecture and Art. 2 February 2 – 7 April. [Catalogue. Texts by David Galloway, Lois Nesbitt, Clare Farrow, Seiken Fukuda].

Hofmann, Rolf / Erika. Ed. *Kunsthalle Dresden – ein Projekt. Kunsthalle Dresden. A Project*. Köln: Verlag der Buchhandlung Walther König.

Jena. JENOPTIK AG. *Frank Stella. New Sculpture. Hudson River Valley Series*. 6 November. [Catalogue. Text by Franz-Joachim Verspohl].

Munich. *Frank Stella*. Haus der Kunst. 10 February – 21 April. [Catalogue. Texts by Judith Goldman, Juan Ljosé Lahuerta, Hubertus Gaßner].

**1997**

Manger, Klaus. Ed. *Frank Stella in Jena*. Jena: Friedrich Schiller-Universität (Jenaer Universitätsreden 3)

N. N. *Stella-Skulpturen-Park in Jena*. Artis 49. February – March, pp. 6 – 7.

Smith, Evan. *Stella Houston*. Houston Chronicle. 26 September, D 1, D 6.

Villani, John. *Visual Riddle: Pixels and Patterns Build Multiple Dimensions in a Frank Stella Mural*. Continental. June, pp. 36–39.

**1998**

Newhouse, Victoria. *Towards a New Museum*. New York: Monacelli. [Includes *Frank Stella: Projects*, pp. 120–129.].

**1999**

Feinstein, Roni. *Miami Heats Up*. Art in America. November, pp. 59–68.

Miami, FL. Museum of Contemporary Art North Miami. *Frank Stella at two thousand. Changing the Rules*, 19 December – 12 March 2000. [Catalogue. Texts by Bonnie Clearwater, Frank Stella].

**2000**

Landi, Ann. *Beach Hats and Band Shells*. ARTNews. June, pp. 130–133.

London. Royal Academy. *Summer Exhibition 2000*. Royal Academy of Arts. 29 May – 7 August.

Philadelphia. Locks Gallery. *Frank Stella. Recent Works*. 13 October – 25 November. [Catalogue. Text by Robert Hobbs].

Schulze, Franz. *Frank Stella as Architect*. Art in America. June, pp. 90–95.

Wallace, Robert K. *Frank Stella's Moby-Dick. Words and Shapes*. Ann Arbor: The University of Michigan Press. [Includes a Worldwide List of Exhibitions and Commentary].

**2001**

Jena. JENOPTIK Gallery / Kunsthistorisches Seminar mit Kustodie. *Heinrich von Kleist by Frank Stella / Die Heinrich von Kleist-Serie*. 25 March – 4 June. Jena / Köln: Kunsthistorisches Seminar mit Kustodie / Verlag der Buchhandlung König (Minerva. Jenaer Schriften zur Kunstgeschichte. Band 11). [Werkverzeichnis der Heinrich von Kleist-Serie / Catalogue Raisonné of the Heinrich von Kleist Series. Texts by Franz-Joachim Verspohl, Martin Warnke, Wolfram Hogrebe, Robert K. Wallace].

*The Writings of Frank Stella / Die Schriften von Frank Stella*. Ed. Franz-Joachim Verspohl. Jena / Köln : Kunsthistorisches Seminar mit Kustodie / Verlag der Buchhandlung Walter König (Minerva. Jenaer Schriften zur Kunstgeschichte, Volume / Band 12).

# Content / Inhalt

# Photocredits / Bildnachweis

Für alle Abb. New York, Frank Stella / Steven Sloman und Jena,
Kunsthistorisches Seminar mit Kustodie, Friedrich- Schiller-Universität

# Impressum

Heinrich von Kleist by Frank Stella / Werkverzeichnis der Heinrich von Kleist-Serie

herausgegeben von Franz-Joachim Verspohl
in Zusammenarbeit mit Anna-Maria Ehrmann-Schindlbeck und Ulrich Müller

Minerva. Jenaer Schriften zur Kunstgeschichte:
hg. von Franz-Joachim Verspohl
Bd. 11. Heinrich von Kleist by Frank Stella / Werkverzeichnis der Heinrich von Kleist-Serie

Heinrich von Kleist by Frank Stella / Werkverzeichnis der Heinrich von Kleist-Serie
Mit Beiträgen von Franz-Joachim Verspohl, Martin Warnke… Hg. Franz-Joachim Verspohl

Kunsthistorisches Seminar mit Kustodie, Jena · JENOPTIK AG · Verlag der Buchhandlung Walther König, Köln

Satz und Druck: Druckhaus Gera
(Minerva. Jenaer Schriften zur Kunstgeschichte; Bd. 11)
Katalogredaktion: Ulrich Müller und Franz-Joachim Verspohl
Photographien: Frank Stella, Steven Sloman, Kunsthistorisches Seminar mit Kustodie
Lithographie: Förster & Borries, Zwickau und Druckhaus Gera
Gedruckt auf
LuxoSatin 135 g/m$^2$
Gesamtherstellung: Druckhaus Gera

Die Deutsche Bibliothek – CIP-Einheitsaufnahme

Heinrich von Kleist by Frank Stella: Werkverzeichnis der Heinrich-von-Kleist-Serie; [anlässlich der Ausstellung des
Kunsthistorischen Seminars mit Kustodie der Friedrich-Schiller-Universität …; Jena, 27. März – 4. Juni 2001,
Galerie der JENOPTIK AG und ehemalige Arbeiter- und Bauern-Fakultät, vordem Thüringer Oberlandesgericht …
Berlin, 01. Dezember 2001 – 04. März 2002, Galerie Akira Ikeda] / mit Beitr. von Franz-Joachim Verspohl …
Hrsg. von Franz-Joachim Verspohl.
Köln: König, 2001 (Minerva; Bd. 11)
ISBN 3-88375-488-9